TYPOGRAPHY 22
The
ANNUAL
of the
TYPE DIRECTORS
CLUB

TYPOGRAPHY

21
TYPOGRAPHY OF THE TYPE DIRECTORS CLUB
THE ANNUAL OF THE TYPE DIRECTORS CLUB

TYPOGRAPHY

THE ANNUAL OF THE TYPE DIRECTORS

Typography 25

TYPOGRAPHY 25
Copyright © 2004
by the Type Directors Club

First published in 2004 by
Harper Design International,
An imprint of HarperCollins Publishers
10 East 53rd Street
New York, NY 10022-5299

Distributed throughout the
rest of the world by
HarperCollins International
10 East 53rd Street
New York, NY 10022-5299
Fax: 212-207-7654

HarperCollins books may be
purchased for educational, business,
or sales promotional use.
For information, please write:
Special Markets Department
HarperCollins Publishers Inc.
10 East 53rd Street
New York, NY 10022
ISBN 0-06-074807-9

The Library of Congress has cataloged
this serial title as follows:
Typography (Type Directors Club (U.S.))
Typography: the annual
of the Type Directors Club.–/–
New York:HDI
2004-Annual.

Typography (New York, NY)
1. Printing, Practical – Periodicals.
2. Graphic arts – periodicals.
1. Type Directors Club (U.S.)

All rights reserved. No part of this
book may be used or reproduced in any
manner whatsoever without written
permission except in the case of brief
quotations embodied in critical articles
and reviews. For information, address
Harper Design International
10 East 53rd Street
New York, NY 10022

First Printing, 2004
Printed in Hong Kong

ACKNOWLEDGMENTS
The Type Directors Club gratefully
acknowledges the following for their
support and contributions to the
success of TDC50 and TDC² 2004:

Design
Diego Vainesman

Editing
Susan E. Davis

Judging Facilities
Fashion Institute of Technology

Exhibition Facilities
Aronson Galleries, Parsons School of Design

Photography
Christian Di Lalla Photography

Photography on page 305 and endpapers
William Heuberger

TDC50 Competition (call for entries):

Design
Diego Vainesman

Printer
The Hennegan Company

Paper
Fraser Papers

Prepress Services
A to A Graphic Services, Inc.

Photographer
William Heuberger

Photoshop Artist
Javier Agostinelli

TDC² 2004 Competition (call for entries)

Design
Charles Nix

The principal typefaces used in the composition
of TYPOGRAPHY 25 are Akzidenz Grotesk
and Adobe Garamond; Revue was used for
display type.

Contents

25/50 In celebration of its fifthieth year, it was the Type Directors Club's honor to invite artists, designers, typographers, bookbuilders, and, yes, even type directors to respond to the Call for Entries for the TDC Typography Competition. What had type done in those fifty years? Has it gotten better, or worse, or simply different? Did the democratization of type mean that all users are equivalent, or are there still those practitioners of the black art who use type in better ways, who communicate better or more responsively, or more evocatively?

Here, then, in the twenty-fifth edition of *Typography, the Annual of the Type Directors Club* are the best of their responses.

Chosen in two days of intense deliberation by an able jury composed of Ray Cruz, of Young & Rubicam; Barbara deWilde, of her own studio; Peter Girardi, of Funny Garbage; Tim Hale, of Fossil; Akira Kobayashi, of Linotype Library GmbH; Joyce Nesnadny, of Nesnadny + Schwartz; and James Victore, of James Victore Inc., these entries chronicle the state of typography in 2003, from the smallest business card to the broadest campaign; from the heaviest tome to the tiniest logo.

Together, the entries affirm that, indeed, type is still moving, still alive, still set skillfully, still communicating better, responsively and evocatively; that users are typographically aware, are inventive, and are adventuresome; that type is in good hands, whether set by hand or by keyboard or even drawn. Here's to the best of 2003—and to the best to come in the next fifty years.

Gary Munch

Das Buchstaben machen

The making of letters

in jeder Form

in every form

ist mir das reinste und größte Vergnügen,

is for me the purest and the greatest pleasure,

und in unzahligen Lagen

and at many stages

und Verfassüngen meines Lebens

of my life

war es mir das,

it was to me

was dem Sänger ein Leid,

what a song is to the singer,

dem Maler ein Bild,

a picture to the painter,

oder was dem Beglückten ein Jauchzer,

a shout to the elated,

dem Bedrängten ein Seufzer ist —

or a sigh to the oppressed —

Es war und ist nur

It was and is for me

der glückliste und vollkommenste

the most happy and perfect

Ausdruck meines Lebens.

expression of my life.

Rudolf Koch Linotype Ergo & Linotype Really

(1876–1934) Gary Munch 1997 & 2000

Tim Hale Joyce Nesnadny James Victore Gary Munch
 Chairman

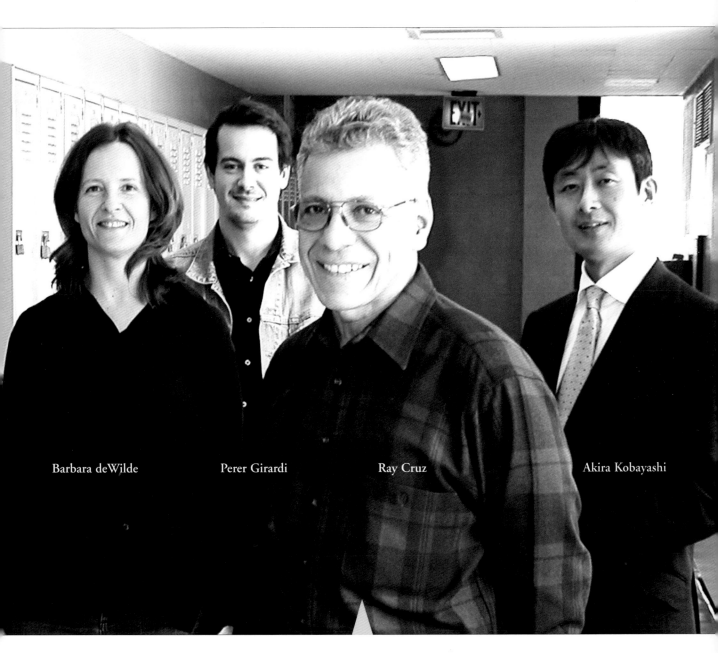

Barbara deWilde Perer Girardi Ray Cruz Akira Kobayashi

TDC50 Judges

Doble Suavidad

Ray Cruz's philosophy is "Learn by Doing." This is emphasized to his lettering students and practiced throughout his career. He mastered his craft by working in some of New York's top lettering studios. His expertise in custom lettering and typographic design has brought him notoriety from ad agencies, publishers, package designers, and corporate identity firms. In the 80s, designer Muts Yasumura commissioned Ray to produce several corporate typefaces and logos for the U.S. Postal Service that can still be seen on shipping materials and mail delivery trucks today. Ray has taught type design at Pratt-Phoenix and has been a guest lecturer at other art schools and professional organizations.

Designing new typefaces is Ray's passion. His wide variety of typestyles are currently published by Agfa/Monotype, Bitstream, and Garage Fonts. His latest project was designing an OpenType display typeface containing alternate ligatures and Central European and Cyrillic characters.

For the past six years Ray was the type director at Young & Rubicam Advertising, where he provided quality control for all print ads. His expertise in typographic design has involved him in the creation of brochures, logos, and custom typefaces for many of Y&R's most prestigious clients, including AT&T, Xerox, Pella Windows, Philip Morris, among many others.

Ray has received more than 30 graphic and type design awards from the Type Directors Club, American Institute of Graphic Arts, Art Directors Club, and other art associations. He is a member of the Type Directors Club, the Society of Typographic Aficionados (SoTA), and the Association Typographique Internationale (ATypI).

DVT
AWARENESS
MONTH
MARCH 2004

Barbara deWilde is currently the principal designer of her own studio. For the last four years she was the design director of *Martha Stewart Living* magazine. Following the successful launch of *Martha Stewart Baby* and *Martha Stewart Holiday* she began working with The Hoefler Frere-Jones Type Foundry to develop two new fonts for *Martha Stewart Living*. The redesign of the magazine launched in the fall of 2002.

Prior to her work for Martha Stewart Living Omnimedia, deWilde worked as a graphic designer in book publishing and music packaging. Her work for the Knopf publishing group, as well as for Farrar, Strauss and Giroux; Scribner; and Little, Brown has been included in the Cooper Hewitt/National Design Museum, AIGA 50 Books/50 Jackets show, the Art Directors' Club, and in various books on design. DeWilde's contributions to magazine design have been recognized by the Society of Publication Designers, ASME, AIGA 365, and American Photography.

In June of 2004 she participated in an exhibition at the Fordham University Lincoln Center gallery. The show, entitled "Against the Grain: Book Cover and Jacket Designs by Alvin Lustig, Elaine Lustig Cohen, Chip Kidd and Barbara deWilde" was exhibited through the summer.

Peter Girardi attended the School of Visual Arts in New York and began his career as a graffiti artist and designer of underground comics. Girardi was a creative director for the Voyager Company, a pioneer in CD-ROMs and laser discs, where he designed and produced covers for such works as "Maus." In 1996, Girardi and John Carlin started Funny Garbage, a digital design company based in New York. As Executive Creative Director, Girardi has made it one of the premier media developers in the world, producing work in a variety of media ranging from broadcast animation to interactive television, web sites, games, and production design. Girardi was the 1999 Daimler Chrysler Design Award winner, the youngest in its history. Girardi is a member of the American Institute of Graphic Arts national board, a digital design consultant for *I.D. Magazine*, and an adjunct professor at the School of Visual Arts in New York. Girardi's work is in the permanent collection of the Cooper-Hewitt National Design Museum.

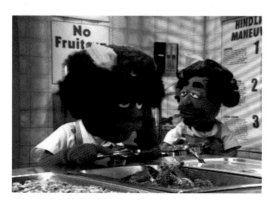

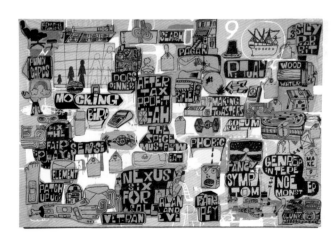

Tim Hale is a native Texan, born just 60
miles north of Dallas where he is now
employed as the senior vice president and
image director of Fossil, a leading fashion
accessories design/manufacturing label.
After graduating from Baylor University
in 1984 with a degree in communication
design, Tim moved to Dallas to start an
in-house design and production studio for
an embroidery specialty manufacturer. In
1987 Tim joined Fossil to start and head its
in-house design department. Tim's work
has been featured in all the major design
periodicals and has been recognized by the
American Institute of Graphic Arts and
the New York Art Directors Club. Not
only is Tim a popular speaker at industry
conferences and a frequent juror for design
competitions, some of his packaging work
is included in the permanent collection of
the Museum of Architecture & Design in
Chicago.

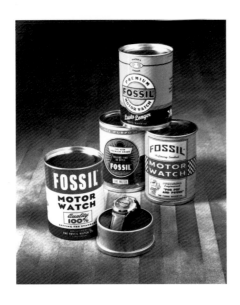

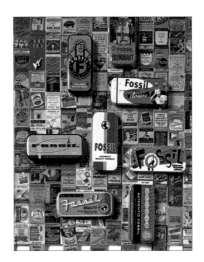

Linotype Conrad

Linotype Conrad Extrabold

HUMANIST
Constantinople
Speculum Humanæ
Transitional Roman-Gothic
German scribes and Illuminators

Linotype Conrad Bold

CLASSICAL
Printing Offices
Frankfurt am Main
Workshop of Nicolas Jenson
Monastery at Subiaco, near Rome

Linotype Conrad Regular

WOODCUTS
Imperial Roman
Conrad Sweynheym
In the palace of De' Massimi
Tusculanæ Quæstiones by Cicero

Linotype Conrad Light

GUTENBERG
Arnold Pannartz
Nuremberg Chronicle
Vigorous gotico-antiqua type
The second type of Sweynheym &

Akira Kobayashi studied at the Musashino Art University in Tokyo, and later followed with a calligraphy course at the London Colledge of Printing. Since May 2001 he has been type director at Linotype Library GmbH. He recently completed the Optima Nova typeface through close collaboration with the original designer Hermann Zapf and the Avenir Next typeface with Adrian Frutiger. Awards: Best of Category and Best of Show for the Clifford typeface in the 1998 *U&lc* magazine type design competition. 1st prize in the text category for the Conrad typeface in Linotype Library's 3rd International Digital Type Design Contest. In the Type Directors Club's type design competitions of 1998, 1999, 2000, and 2001 for ITC Woodland, ITC Japanese Garden and ITC Silvermoon, FF Clifford, and Linotype Conrad, respectively.

FF Clifford Eighteen
FOR LARGE TEXT
The Quick Brown Fox Jumps Over A Lazy Dog
& The Quick Brown Fox Jumps Over A Lazy Dog

FF Clifford Nine
FOR TEXT AROUND 9- TO 12-POINT
The Quick Brown Fox Jumps Over A Lazy Dog
& The Quick Brown Fox Jumps Over A Lazy Dog

FF Clifford Six
FOR USE IN SMALL PRINT
The Quick Brown Fox Jumps Over A Lazy Dog
& The Quick Brown Fox Jumps Over A Lazy Dog

PUBLISHED BY FONTSHOP INTERNATIONAL 1999

ITC SILVERMOON BOLD

EMPIRE
Ornaments
TWENTIETH CENTURY
Leave no space undecorated

ITC SILVERMOON REGULAR

ADELPHI
Modernism
ARCHITECTS IN THE 30S
Le Corbusier's L'Esprit Nouveau

Joyce Nesnadny is a founding partner of the Cleveland-based design communications firm Nesnadny+Schwartz. With offices in Cleveland, New York, and Toronto, Nesnadny+Schwartz specializes in innovative strategic visual communications projects for a broad client base ranging from young start-up companies to publicly traded corporations and major organizations, including The Progressive Corporation, Planned Parenthood, Vassar College, and the Rock and Roll Hall of Fame.

The work of Nesnadny+Schwartz has been featured in several international publications, and the firm has been honored with awards from such respected institutions as the American Advertising Federation, the American Institute of Graphic Arts, *Communication Arts, Graphis, ID* International Design Awards, AR100, Mead Annual Report Show, and the Society of Publications Designers.

Joyce, who is based in the firm's Toronto office, received her Bachelor of Fine Arts from Ohio University and her Masters of Fine Arts from Yale University.

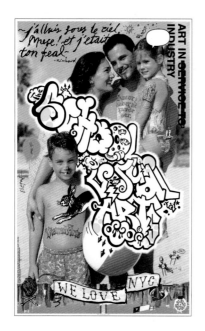

James Victore is a self-taught, independent graphic designer whose work ranges from publishing, posters, and advertising to illustration and animation. Clients include the Lower East Side Tenement Museum, Moet and Chandon, MTV, *The New York Times*, the Portfolio Center, The Shakespeare Project, and Watson-Guptill. Awards include an Emmy for television animation, a gold medal from the Broadcast Designers Association, the Grand Prix from the Brno (Czech Republic), and gold and silver medals from the New York Art Directors Club. Victore's posters are in the permanent collections of the Palais du Louvre, Paris; the Library of Congress, Washington, D.C.; and the Museum für Gestaltung, Zurich, among others. His work has been featured in magazines around the world, and recently a book of his design work was published in China. He also teaches graphic design at the School of Visual Arts in New York City.

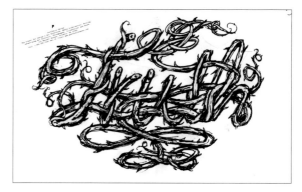

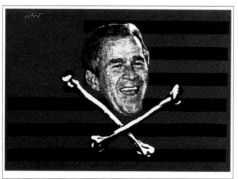

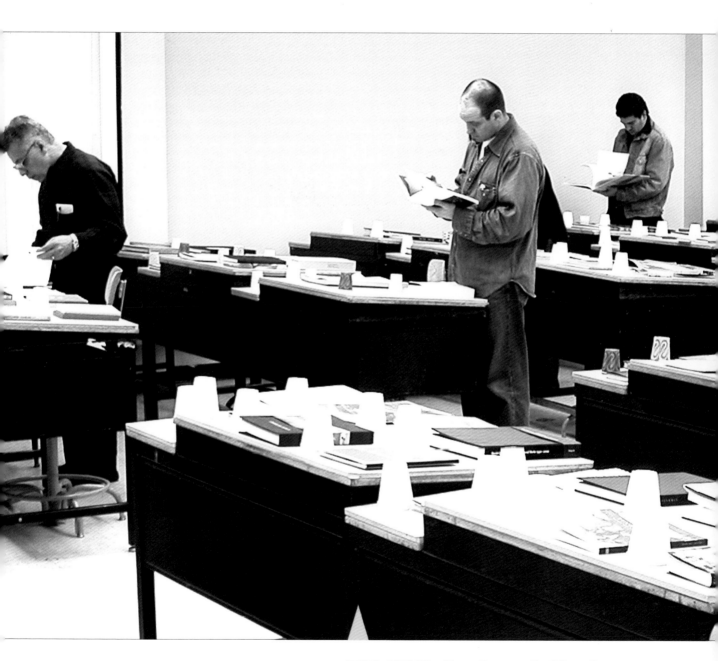

**TDC50 Judges' Choices
and Designers' Statements**

Ray Cruz Simplicity with elegance is not an easy goal to achieve.

As I walked into the judging room, I was attracted by the graphic shape of a red N on a white background. This book cover design was competing for my attention with the many books placed on the judging tables. As a type designer, letters used successfully as graphic elements are very intriguing to me.

In this case the N represents a symbol of structural strength, which is related to the topic of the book: Netzstadt, the method of analysis and evaluation of the urban environment. It is especially interesting when you view the front and back cover as a spread because it resembles the steel girders of skyscrapers we so commonly see in New York racing up to the sky.

Simplicity and elegance also prevail in the interior pages. The sans serif text is very legible, and it is surrounded by ample white space. For emphasis, an italic serif font is inserted into the sans serif text very successfully. The colors used on the chapter opener spreads are representative of an urban community. The running heads are located only on the recto page, and the folios are placed uniquely as a pair in the upper corner. The supporting charts, photos, and diagrams are all tastefully done as individual works of art floating freely on a white background.

Even though I'm not familiar with the subject of urbanity, I thoroughly enjoyed browsing through this book and sensing the flavor of the topic.

Designers Netzstadt is a method for the analysis and evaluation of urbanity. As its authors, we have designed a textbook that addresses students of architecture and engineering as well as practitioners in city planning and construction, including the fields of the natural and social sciences. We decided to develop a book that presents the sophisticated ideas of Netzstadt in the graphically most coherent and reduced way possible. Our efforts went into finding a didactically and logically convincing structure. Of course, the book should also make for exciting reading. We finally chose a typographic approach that reflects the spirit of temporary Swiss architecture.

Our thanks go to the two authors who gave us the opportunity to shape a piece of work we can feel at ease with.

Lucia Frey
and Bruno Kuster

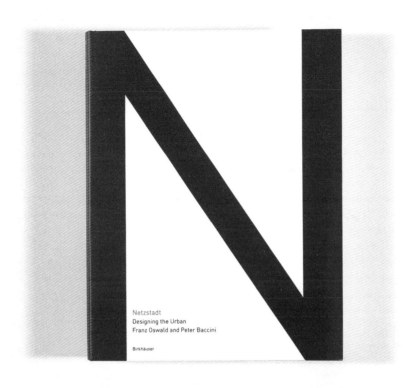

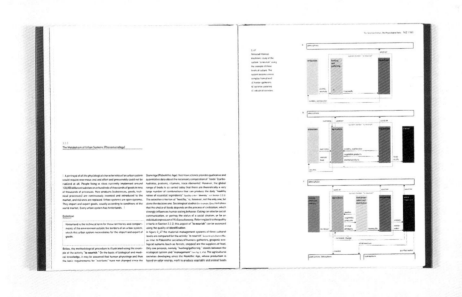

BOOK

DESIGN
Lucia Frey and Bruno Kuster
Zurich, Switzerland

ART DIRECTION
Lucia Frey and Bruno Kuster

CREATIVE DIRECTION
Lucia Frey and Bruno Kuster

DESIGN OFFICE
Lucia Frey Design

CLIENT
Professor Franz Oswald and
Professor Dr. Peter Baccini

PRINCIPAL TYPE
FF DIN and Life Italic

DIMENSIONS
8.7 x 11 in.
22 x 28 cm

Barbara deWilde Silkscreen is alive and
well and living in the studios of many
talented graphic designers. The predomi-
nance of this form among the entries in
poster design was a welcome surprise
in an age of computer-generated every-
thing. The CalArts Lecture Series posters
distinguished themselves from the pack
for their typography, of course, but more
ingeniously for the brilliant strategy of
making each layer of colorful type form
a new poster for each subsequent lecturer.
They referred to this solution as an answer
to the dilemma: the entire lecture series
had not been finalized before the posters
were needed. So as the roster filled out
they added a new name to the print, cross-
ing out the previous names and creating
a fresh poster from the last. Knowing the
back-story only makes the design better.
There is not one permutation that is better
than another as color after color is added
to the series. The edition numbers on the
bottom of each poster are as beautiful to
look at as the names of the lecturers. I did
not know any of the personalities who
were speaking, but the designs compelled
me to want to discover who they were.

The variation of vertical orientation and
horizontal orientation was not appar-
ent at the judging since all the posters
were stacked in a neat pile on top of each
other. However, I don't think this nuance
is an important element of the design.
The addition of a new layer of type is a
greater indication of time passing than the
previous orientation of the poster on the
wall. In their description of the original
problem the designers state: "We decided
to cross out the previous artist to ques-
tion the taboos between art and design." I
don't know if there are taboos between art
and design. But I do know if they hadn't
crossed out the name of the previous
speaker the audience wouldn't have a clue
which lecturer was going to appear at the
next event. Ultimately, the marriage of
the process inherent in a many-colored
silkscreen and the design for a poster
series that required six editions is brilliant.
Bravo.

Designers Practicum is a series
of lectures and workshops at California
Institute of the Arts. The initial idea
was to make one poster with five artists'
lecture information. Because the school
did not have a complete lecture schedule,
we decided to save a calculated number
of posters and overprint the names of the
new lecturers onto the previous ones. The
Art School later added a sixth artist (poster
5) after the first three posters were printed.
We compensated for that disruption of
our plan by confiscating posters during a
lecture.

The posters shift between a vertical and
horizontal format in a clockwise direction
to indicate time. We decided to cross out
the previous artist to question the taboos
between art and design.

The posters were printed in the CalArts
silk-screen lab, and ink was physically ap-
plied to the posters. Jae-Hyouk Sung
and Matthew Normand

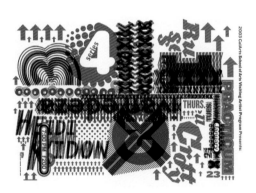

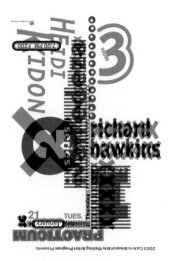

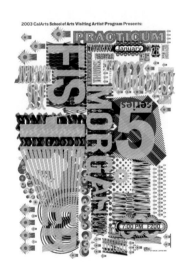

POSTER

DESIGN
Jae-Hyouk Sung and
Matthew Normand
Los Angeles, CA

ART DIRECTION
Jae-Hyouk Sung and
Matthew Normand

CREATIVE DIRECTION
Jae-Hyouk Sung and
Matthew Normand

STUDIOS
Jae-Hyouk Sung Design and
Matthew Normand Design

CLIENT
California Institute of the Arts

PRINCIPAL TYPE
Various

DIMENSIONS
24 x 36 in.
61 x 91.4 cm

Peter Girardi Gimmicks can be a double-edged sword. Usually cool the first time, kind of OK the second, and annoying the third. Alan Chan's monograph is a different story. The first thing that struck me was the balance between the old and the new. Using the ancient form of a scroll was a great way to realize this project. The narrative of his life and work literally unrolls as you unroll the scroll. It's as if this scroll is the Chan himself—a paper brain full of thoughts, art, ideas, and memories, it invites the viewer to enter his life, and it asks for a significant commitment from the viewer. The scroll can be unwieldy and cumbersome, but that's part of the enjoyment. The fact that I can't read Chinese didn't get in the way of my understanding or enjoyment of this piece. The images create such a well-paced narrative that his personal and professional history are self-explanatory.

The thing that struck me the most was how well-documented and well-photographed his life is. What a pack rat! Who keeps this many photos of their life? Most people I know don't have an exhaustive personal image archive available to them to produce a project like this. Pretty incredible.

Oh, yeah, Mr. Chan's actual design work is damn good as well.

Designer The exhibition catalog, "Chaneration," was first launched in limited edition during my retrospective exhibition, "Alan Chan: The Art of Living" at the Hong Kong Heritage Museum from July to October 27, 2003. The exhibition showcased my design projects ranging from corporate and brand identity to packaging, posters, and interior design over the past 33 years. After working over a ten-year period at four major advertising agencies in Hong Kong, I started my own design business in 1980.

To document my own life experience and accomplishments in the creative world since I was born in 1950, I designed the exhibition catalog in a traditional Chinese scroll format. That allows readers to learn about my life as they gradually unroll the scroll. About 34.5 meters long, it is believed to be the longest scroll in the world.

Alan Chan

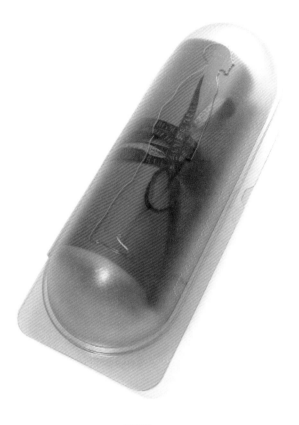

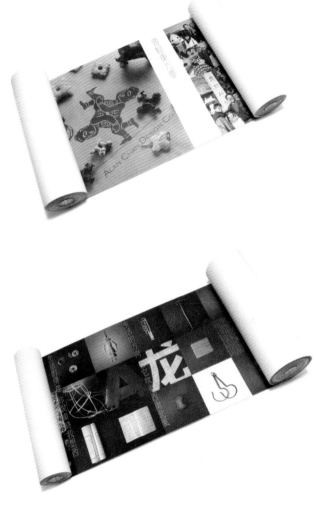

BOOK

DESIGN
Alan Chan and Peter Lo
Hong Kong

ART DIRECTION
Alan Chan

CREATIVE DIRECTION
Alan Chan

PHOTOGRAPHY
Alvin Chan, Almond Chu, Sandy Lee,
Sam Wong, and Stanley Wong

ILLUSTRATION AND PRODUCTION
Terry Chan, Yoyee Kam, Karen Ma,
and Ming Ng

PRINTER
Suncolor Printing Co., Ltd.

PAPER SUPPLIER
Tai Tak Takeo Fine Paper Co., Ltd.

COPYWRITER
anothermountainman

DESIGN OFFICE
Alan Chan Design Company

CLIENT
Hong Kong Heritage Museum

PRINCIPAL TYPE
Dax Wide Light and
News Gothic Light

DIMENSIONS
5.5 x 4.1 in.
14 x 10.5 cm

Tim Hale Across all the work submitted for the TDC this year, I was most impressed by the body of work that exhibited not only the fundamentals of good design, but the fresh homage to what I would describe as "craft." There seemed to be a good body of work that was a backlash to the onslaught of digital work, and where it is at its best is when the craft or technique is in perfect context or harmony with the content of the work itself. So the craft is not appealing in and of itself but becomes the true expression of the content. That, above all, is why I selected this piece.

I have always been enamored of this type of work: the use of make-ready press sheets and the rich layering of color and imagery that results. Add to that the addition of the bold red, transparent typography, and this poster series is arresting purely on visual merits. The kicker here is understanding the context of this series and the gripping reality and timeliness of its message. Had I not been able to translate the German text (which I could, thanks to mandatory remedial German studies in university), I would have read chaos into this piece at first glance. The reality is that the poster series is about war and the resulting chaos, destruction, and disruption of life as seen through children's eyes. The series is promoting a traveling show of images created by children after the war in Kosovo, the proceeds of which will be used to aid the youth of that war-torn country. The calamity and destruction are well captured by the use of the make-ready sheets from the catalog that goes with the show. And the bold type makes a strong, haunting statement about the reality of a child living in the midst of war: "I often think about the War."

This piece really holds up on so many levels. I commend the designer not only for the overall mission of the work but for the thoughtful social commentary that she captured through a seemingly spontaneous solution.

Designer During the making of the book, *Denke Krieg*, I often thought about war. We ordered sample prints of some pictures and double spreads from the book to help us make a decision about the paper for the poster. When I saw all these pictures of destruction and darkness as well as hope accumulated on one big sheet of paper, I thought this would be a good poster for the book and the photo exhibition.

I decided to add some red on the spreads in the headline via silkscreen, but that didn't really work because the life of these war children was so much more chaotic and emotional than that. So the next step was to gather all the tests and specimens from printing the book, which were much more expressive and colorful than the first samples.

For the type design, I matched the specimens with similar pictures and colors to be able to put the letters in the right places. In the end, the red headlines were silk-screened on the printed sheets. As a result, each poster is different.

Anna Berkenbusc

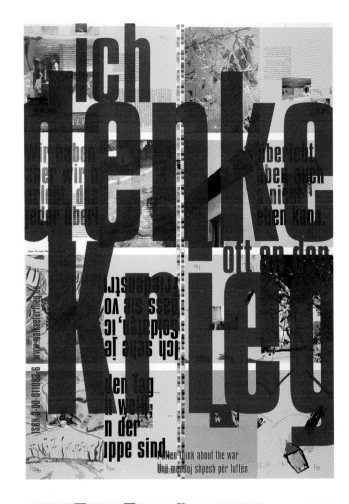

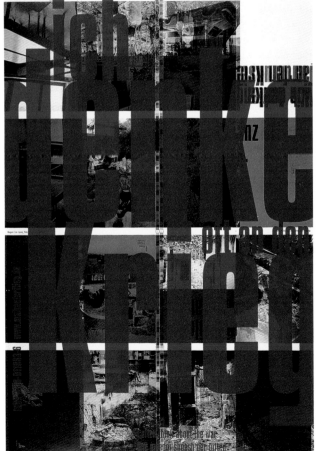

POSTER

DESIGN
Anna Berkenbusch
Berlin, Germany

ART DIRECTION
Anna Berkenbusch

CREATIVE DIRECTION
Anna Berkenbusch

STUDIO
Anna B. Design

CLIENT
Maikäfer Flieg e.V.

PRINCIPAL TYPE
Compacta

DIMENSIONS
24.4 x 34.5 in.
62 x 87.5 cm

Akira Kobayashi This is so simple but
elaborate. The letterer who put down the
words into forms of furniture made the
job so pleasant that you cannot help smil-
ing and cannot even help wanting to own
the piece of furniture.

The handwritten letterforms and the
images of the products are perfectly syn-
chronized. A perfect marriage! The freely
drawn lettering has something that makes
the already comfortable-looking sofa
appear more comfortable and the other
Arts-and-Crafts piece more stylish in such
an amusing and light-hearted way.

Today we see too many visual messages
that are unnecessarily over-elaborated,
very often with the help of some graphic
software. They try to appear chaotic,
controversial, or even shocking because
we live in the twenty-first century where
everything is more complicated than ever.
I'd rather see something else. This entry
was really a sigh of relief and eventually
became my favorite piece. Let's stop and
think. Forget all the computer skills, tips,
and tricks. Let's sit back and have a cup
of tea.

Designers These ads are part of
a beautiful campaign that features hand-
rendered copy in the shape of a featured
product. The goal was to somehow distill
a little bit of the furniture's character into
the letterforms. In this case, the Bandini
Bench's Arts and Crafts-influenced top
and Mission-influenced base opened up a
lot of doors. Beginning with letterforms
based on old Arts and Crafts typography,
we crafted an homage to the furniture's
asymmetric curves, unusual twists, and
bold rectilinear lines. That, plus a little
handmade crafting, produced a piece of
type that looks good and is comfortable
to sit on.

Tom Nynas,
Dick Mitchell,
and Jeff Hopfer

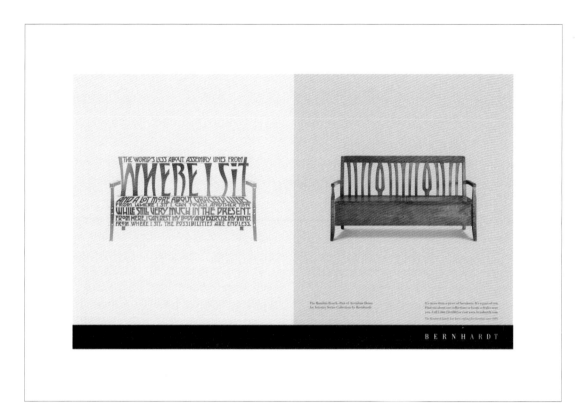

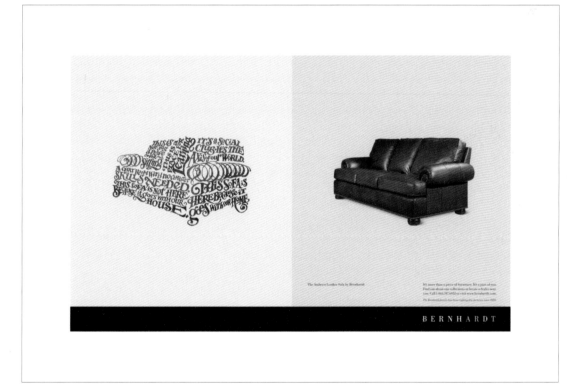

ADVERTISEMENTS

DESIGN
Tom Nynas, Dick Mitchell,
and Jeff Hopfer
Dallas, TX

CREATIVE DIRECTION
Jeff Hopfer and Mike Renfro

LETTERING
Tom Nynas

AGENCY
RBMM/The Richards Group

CLIENT
Bernhardt

PRINCIPAL TYPE
Handlettering

DIMENSIONS
10.8 x 18 in.
27.4 x 45.7 cm

Joyce Nesnadny I was drawn to the Laufladen Lübeck identity system because of its tactile quality, its simplicity, and economy of materials. Perhaps it was the noticeable absence of ink—a designer's standard issue. The concept of reusing this clear, concise image for any number of business identification documents is refreshing in its originality. A label sewn onto writing and cover stock becomes letterhead and business card.

Given my newly appointed position as "Judge Joyce," I felt duty-bound to examine this "label" more closely for content. German not being my mother tongue, I called in an expert German linguist who confirmed the meaning of "laden" as a colloquialism for small store (laufen to run + laden small store + Lübeck, the town in northern Germany = Laufladen Lübeck).

As for the information contained on the label—name, address, phone, fax, email, and website—all the mandatory identity requirements have been met. Further inquiry revealed that the label was designed to imitate those sewn into every piece of sports apparel that the store sells—from shoes to shorts. The repetition of this simple, innovative image will ensure strong product recognition for Laufladen Lübeck.

My only question is: How does it go through a laser printer?

Designer Idea: The name of the sports store is Laufladen (Running Store). The main customers are runners; the product with the strongest turnover is running shoes. One recognizable feature of all shoes is a label sewn into the insides. The label contains information about international sizes as well as manufacturing and material information. The idea for the implementation of this corporate identity project is based on this information medium—the label.

Implementation: The name and address as well as other information about the sports store are embroidered on the label, which is designed exactly like the label in the running shoes. This label is then flexibly adapted for used on all relevant business documents as well as business cards and letterhead. **Alexander Rötterink**

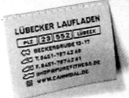

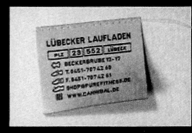

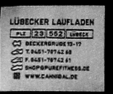

CORPORATE IDENTITY

DESIGN
Alexander Rötterink
Hamburg, Germany

ART DIRECTION
Alexander Rötterink and

James Victore I must admit that I am attracted to shiny objects. But this piece by Rose+Hopp Design from Norway appeals to me in so many ways—not just its sexy luster. The piece is a catalog of an exhibition of Princess Astrid of Norway's very beautiful wedding dress. The balance that this catalog pulls off is amazing. My masculine side digs the typographic confidence of using Lo-Res with Mrs. Eaves. The piece would be too cloying without the clumsy and brutish Lo-Res hanging around. But I think what clinched the deal for me was the appeal to my feminine side. The deft typography on icy papers (Norway, remember), the glorious and subtle photography, the metallic inks, and the use of flysheets—all these make this catalog feel like a very sexy, tasteful, timeless wedding dress.

Designer The identification tag "Fragile" was never more appropriate than on the large boxes in which these royal wedding dresses were delivered. I took my inspiration for this graphic expression from the hours during which these dresses were unpacked, after they had performed their assigned task, and were gradually revealing all their simplicity, beauty, and mystique hanging on stands.

This expression portrays the dresses in a close and direct way, and this seems to me to enhance their solemnity. As I saw the dresses hanging on the stands, the emotions that I felt emanating from them filled me with a strong sense of vulnerability. That for me is ultimate beauty. I was thus led to try to balance incompatible typography as a further description of that feeling. Mrs. Eaves vs. Lo-Res. The uniquely luminous paper Curious Metal Ice Gold also added a particular quality to the brochure.

I was allowed a rather uncompromising approach to this project. Hopefully, this freedom has contributed to the brochure's visual interest and to the show exhibited at the Museum of Decorative Arts & Design.

Gina Rose

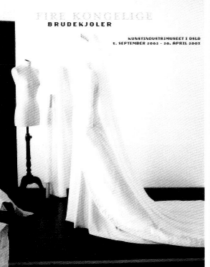

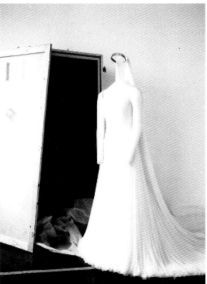

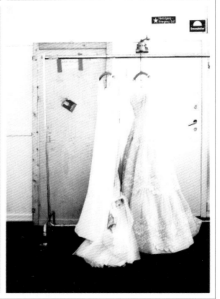

BROCHURE

DESIGN
Gina Rose
Oslo, Norway

ART DIRECTION
Gina Rose

CREATIVE DIRECTION
Gina Rose

PHOTOGRAPHY
Øivind Haug

PICTURE EDITING
Pål Bjørneby

PROJECT MANAGER
Magne Hopp

AGENCY
Rose & Hopp Design

CLIENT
Museum of Decorative Arts & Design,
Oslo

PRINCIPAL TYPE
Lo-Res and Mrs. Eaves

DIMENSIONS
7.1 x 9.5 in.
18 x 24 cm

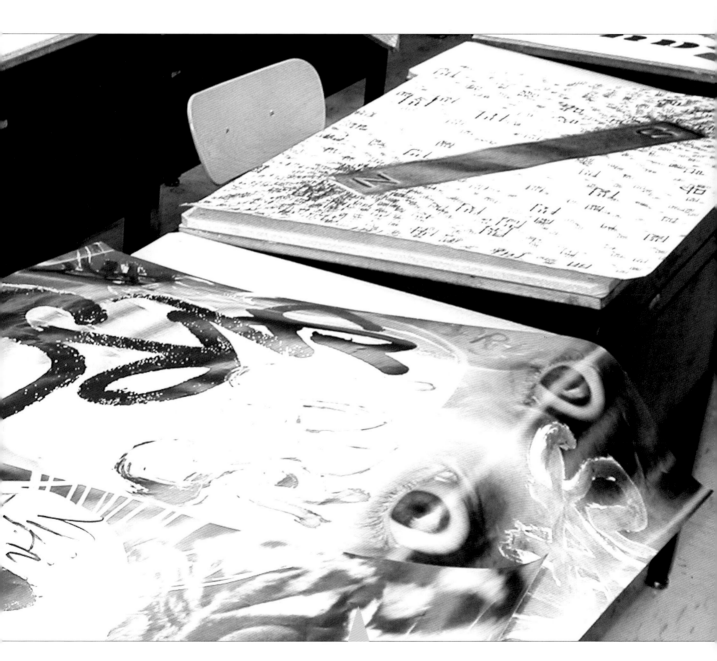

**TDC50 Entries Selected
for Typographic Excellence**

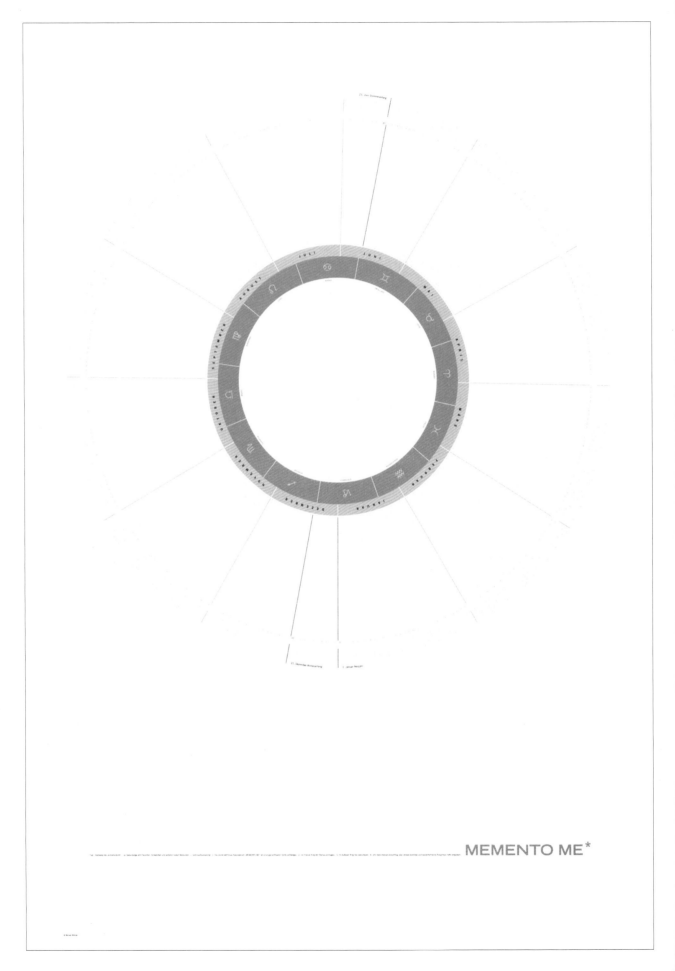

MEMENTO ME*

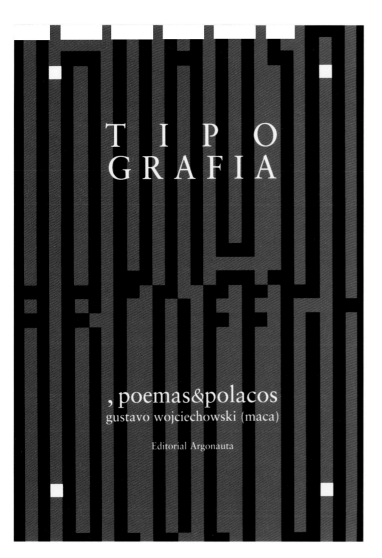

T I P O
GRAFIA

, poemas&polacos
gustavo wojciechowski (maca)

Editorial Argonauta

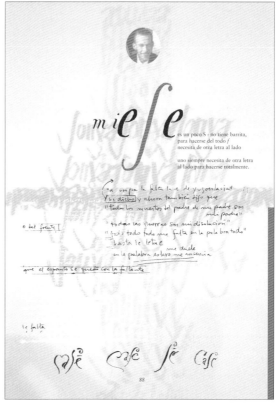

BOOK

DESIGN
Gustavo Wojciechowsky
Montevideo, Uruguay

ART DIRECTION
Daniel Wolkowicz
Buenos Aires, Argentina

LETTERING
Gustavo Wojciechowsky

CLIENT
Editorial Argonauta,
Colección de Diseño

PRINCIPAL TYPE
Bodoni, Garamond,
and Maca

DIMENSIONS
5.9 x 8.3 in.
15 x 21 cm

CALENDAR

DESIGN
Philipp Bareiss
Wiesbaden, Germany

CREATIVE DIRECTION
Michael Volkmer

DESIGN OFFICE
Scholz & Volkmer

PRINCIPAL TYPE
Astrology P03 and
Trade Gothic

DIMENSIONS
27.6 x 39.4 in.
70 x 100 cm

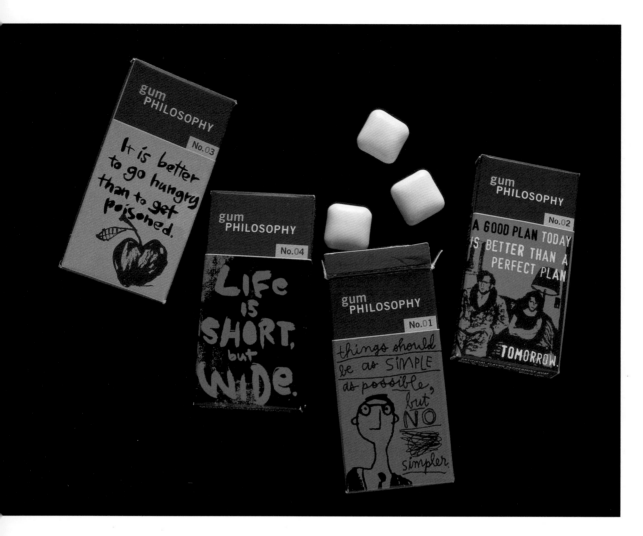

PACKAGING

DESIGN
Michelle Sonderegger
and Ingred Sidie
Kansas City, MO

ART DIRECTION
Michelle Sonderegger
and Ingred Sidie

LETTERING
Meg Cundiff, Tom Patrick,
and Ingred Sidie

DESIGN OFFICE
Design Ranch

CLIENT
Blue Q

PRINCIPAL TYPE
Handlettering

DIMENSIONS
1.4 x 2.6 x .3 in.
3.6 x 6.6 x .8 cm

POSTER

DESIGN
Rick Valicenti
and Gina Vieceli
Barrington, IL

ART DIRECTION
Rick Valicenti

LETTERING
Gina Vieceli

ILLUSTRATION
Rick Valicenti
and Chad Johnston

DESIGN OFFICE
Thirst 3ST.com

CLIENT
American Institute of
Graphic Arts
Milwaukee

PRINCIPAL TYPE
Handlettering

DIMENSIONS
24 x 36 in.
61 x 91.4 cm

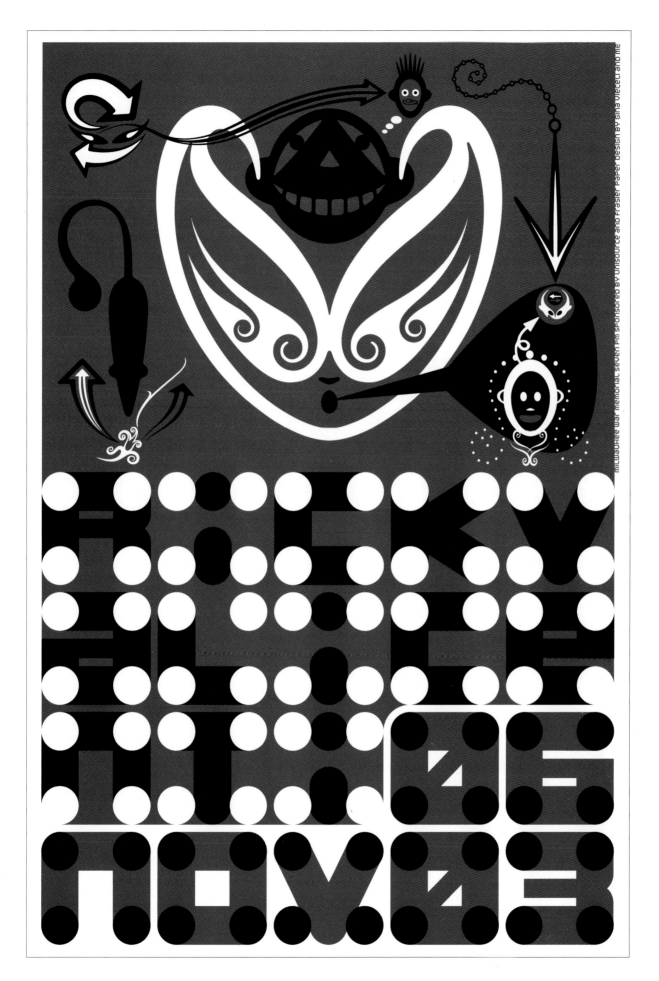

milwaukee war memorial seven pm sponsored by unisource and fraser paper design by gina vieceli and me

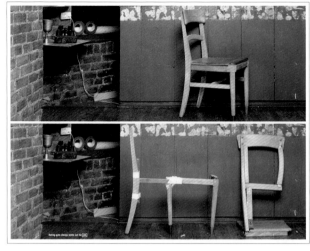

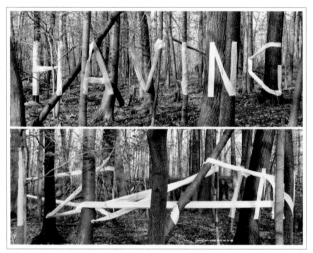

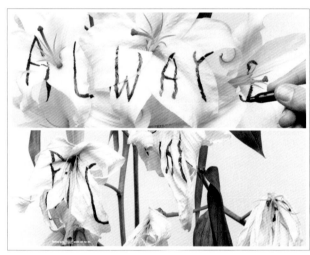

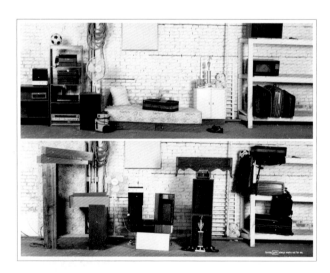

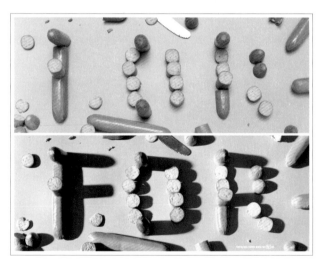

MAGAZINE SPREAD

DESIGN
Stefan Sagmeister, Bela Borsodi,
and Matthias Ernstberger
New York, NY

ART DIRECTION
Stefan Sagmeister

LETTERING
Stefan Sagmeister, Bela Borsodi,
and Matthias Ernstberger

PHOTOGRAPHY
Bela Borsodi

DESIGN OFFICES
Sagmeister, Inc. and Borsodi

CLIENT
Copy Magazine
Austria

PRINCIPAL TYPE
Handlettering

DIMENSIONS
9 x 11.5 in. 22.9 x 29.2 cm

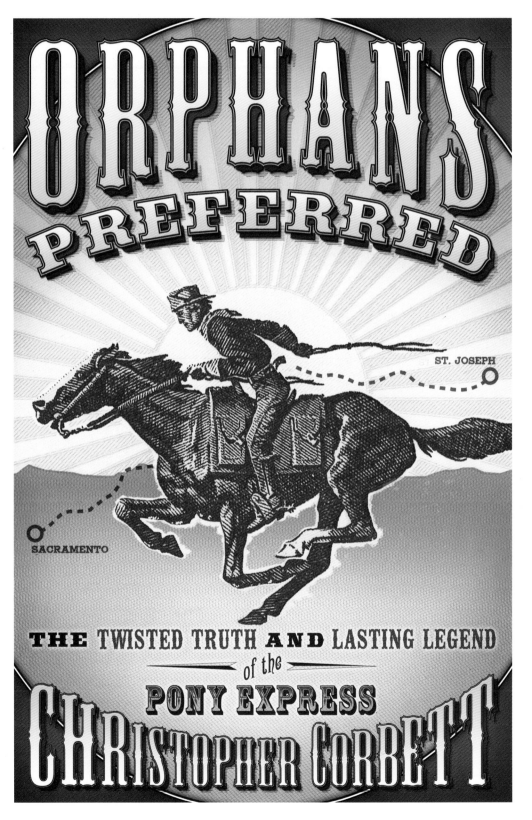

ORPHANS
PREFERRED

ST. JOSEPH

SACRAMENTO

THE TWISTED TRUTH AND LASTING LEGEND
of the
PONY EXPRESS
CHRISTOPHER CORBETT

BOOK COVER

DESIGN
Michael J. Windsor
New York, NY

ART DIRECTION
Michael J. Windsor

CREATIVE DIRECTION
John Fontana

PUBLISHER
Broadway Books

PRINCIPAL TYPE
Davison Americana and
Mesquite

DIMENSIONS
6.25 x 9.5 in.
15.9 x 24.1 cm

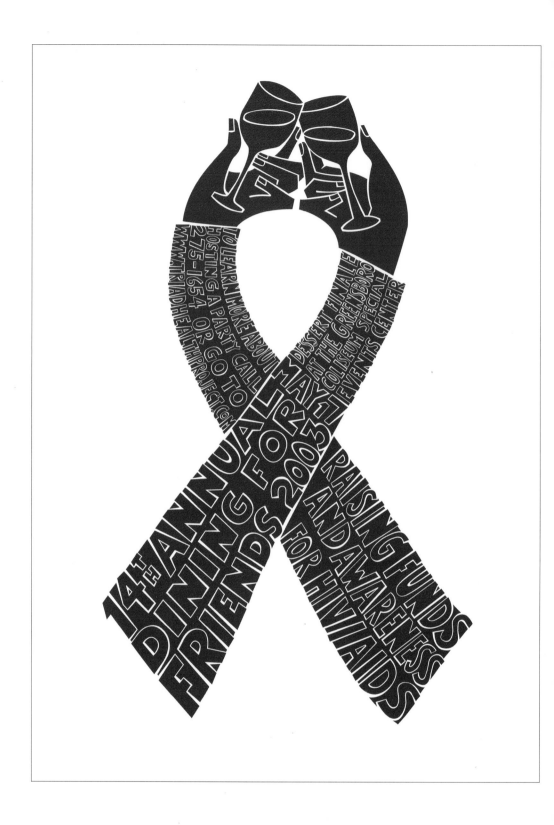

POSTER

DESIGN
Brent Piper
Winston-Salem, NC

ART DIRECTION
Hayes Henderson
and Brent Piper

LETTERING
Brent Piper

DESIGN OFFICE
HendersonBromsteadArtCo.

CLIENT
Triad Health Project

PRINCIPAL TYPE
Handlettering

DIMENSIONS
24 x 38.5 in.
61 x 97.8 cm

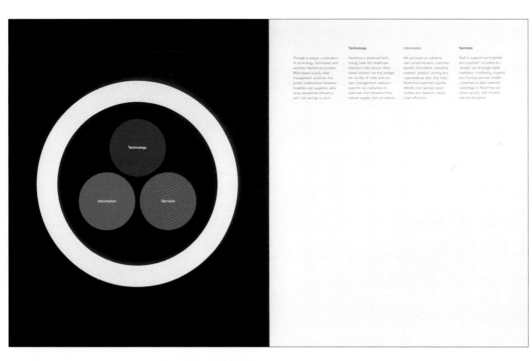

ANNUAL REPORT

DESIGN
Michael Braley
San Francisco, CA

ART DIRECTION
Bill Cahan and
Michael Braley

CREATIVE DIRECTION
Bill Cahan

PHOTOGRAPHY
Jack McDonald

COPYWRITER
Kathy Cooper Parker

DESIGN OFFICE
Cahan & Associates

CLIENT
Neoforma, Inc.

PRINCIPAL TYPE
Akzidenz Grotesk

DIMENSIONS
10 x 12 in.
25.4 x 30.5 cm

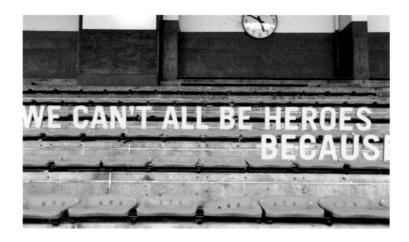

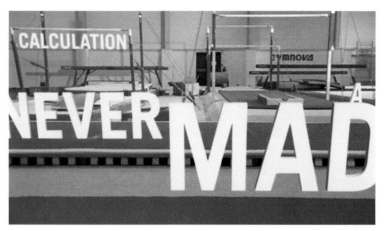

AMBIENT FILM

DESIGN
Why Not Associates
London, England

ART DIRECTION
Why Not Associates

CREATIVE DIRECTION
Why Not Associates

STUDIO
Why Not Associates

CLIENT
Nike Image Design EMEA

PRINCIPAL TYPE
Trade Gothic

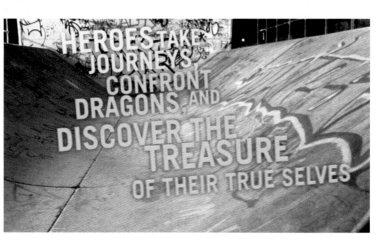

POSTER

DESIGN
Freeman Lau Siu Hong
Hong Kong

ART DIRECTION
Freeman Lau Siu Hong

CREATIVE DIRECTION
Freeman Lau Siu Hong

COMPUTER VISUALIZER
Garfield Chan

DESIGN OFFICE
Kan & Lau Design Consulta

CLIENT
Hong Kong Heritage Museu

PRINCIPAL TYPE
Handlettering

DIMENSIONS
39.4 x 27.6 in.
100 x 70 cm

A B C D E F
G H I J K
L M N
O P Q R S T U
V W X Y Z
! @

SUPERWOMANTYPE

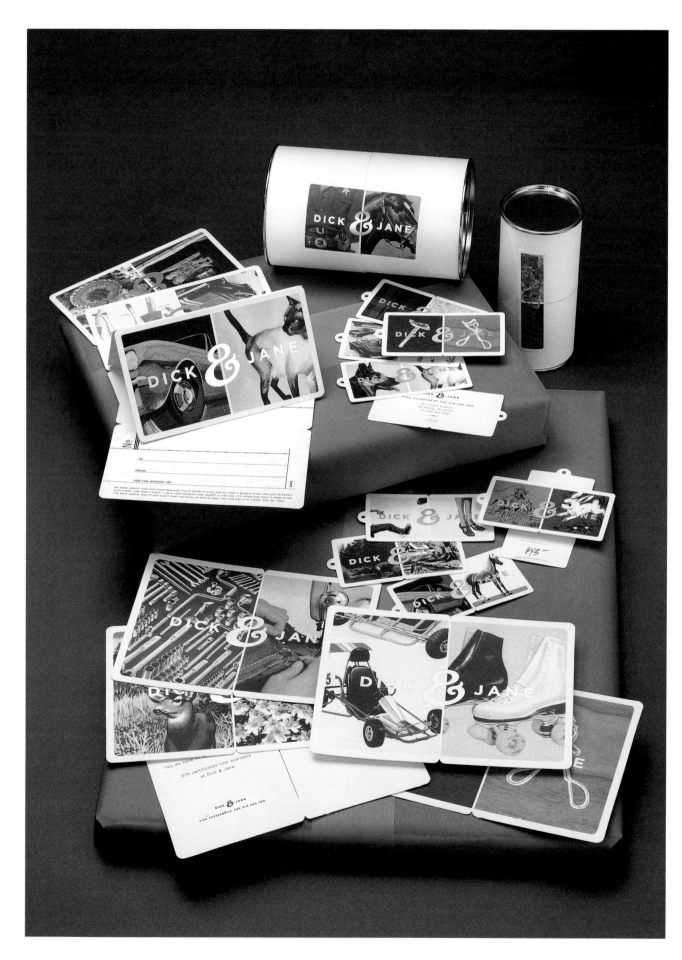

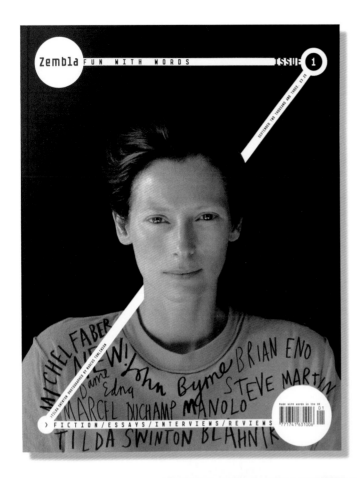

MAGAZINE

DESIGN
Vince Frost and
Matt Willey
London, England

ART DIRECTION
Vince Frost and
Matt Willey

CREATIVE DIRECTION
Vince Frost and
Matt Willey

DESIGN STUDIO
Frost Design London

CLIENT
Zembla Magazine

PRINCIPAL TYPE
Arete Mono and
Palatino

DIMENSIONS
9.1 x 11.8 in.
23 x 30 cm

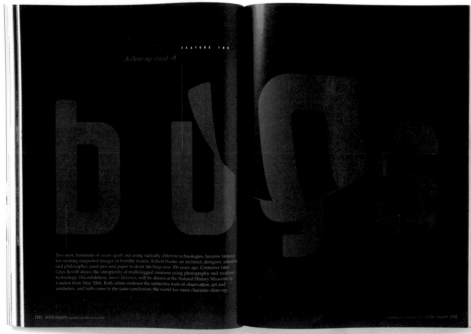

CORPORATE IDENTITY

DESIGN
Kelly English
Madison, WI

CREATIVE DIRECTION
Kevin Wade

DESIGN OFFICE
Planet Propaganda

CLIENT
Dick & Jane

PRINCIPAL TYPE
HTF Gotham Bold,
HTF Gotham Book,
and custom lettering

DIMENSIONS
Various

CD RELEASE FOR " WHITE ELEPHANT "

DORIS HENSON

friday
august 1st
Recycled Sounds · 6:00 sharp !

DESIGNED & LETTERPRESS PRINTED AT HAMMERPRESS ⊛ KANSAS CITY, MO ⊛ 816.421.1929 ⊛

CATALOG

DESIGN
Will Hackley
Winston-Salem, NC

ART DIRECTION
Hayes Henderson

CREATIVE DIRECTION
Hayes Henderson and
Kristen Wall

LETTERING
Will Hackley

DESIGN OFFICE
HendersonBromsteadArtCo.

CLIENT
American Institute of
Graphic Arts, Raleigh

PRINCIPAL TYPE
Typeka Mix and
handlettering

DIMENSIONS
11 x 17.5 in.
27.9 x 44.5 cm

POSTER

DESIGN
Brady Vest
Kansas City, MO

ART DIRECTION
Brady Vest

STUDIO
Hammerpress

CLIENT
Doris Henson

PRINCIPAL TYPE
Egyptian, Enge Wotan,
and Spartan

DIMENSIONS
14 x 22 in.
35.6 x 55.9 cm

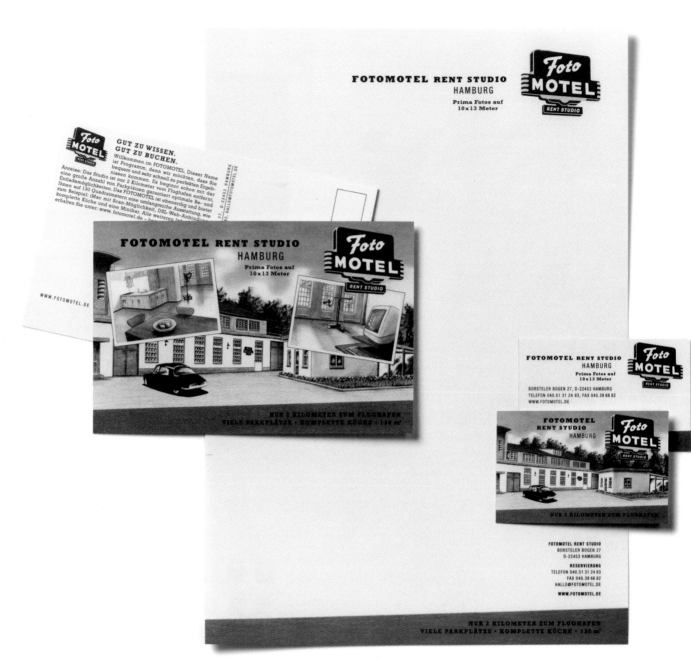

CORPORATE IDENTITY

DESIGN
Robert Neumann
Hamburg, Germany

CREATIVE DIRECTION
Robert Neumann

ILLUSTRATION
Jonas Lauströer

AGENCY
Delikatessen Agentur für
Marken und Design GmbH

CLIENT
Foto Motel Rent Studio

PRINCIPAL TYPE
Boton, Neue Helvetica,
and Rockwell

DIMENSIONS
Various

POSTER

DESIGN
Mike Joyce
New York, NY

ART DIRECTION
Mike Joyce

CREATIVE DIRECTION
Mike Joyce

DESIGN OFFICE
Stereotype Design

CLIENT
The Blakes

PRINCIPAL TYPE
Helvetica

DIMENSIONS
18 x 24 in.
45.7 x 61 cm

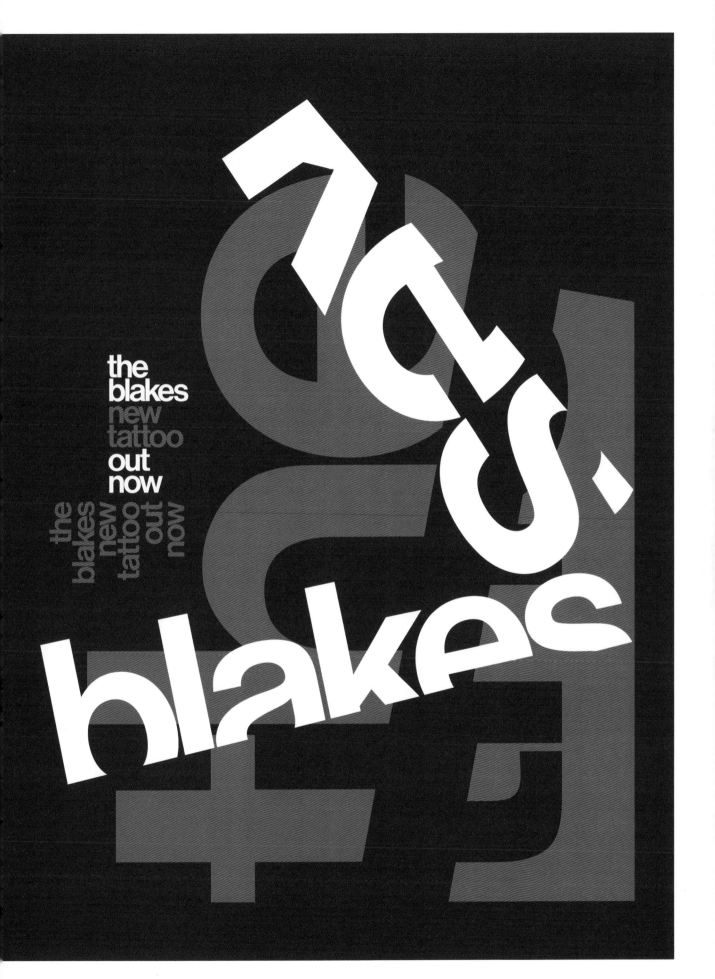

the
blakes
new
tattoo
out
now

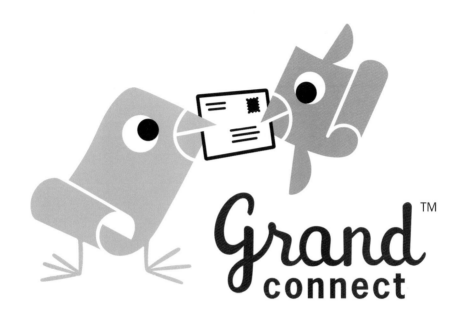

LOGOTYPE

Design
Sharon Werner
Minneapolis, MN

Art Direction
Sharon Werner

Lettering
Sharon Werner

Design Office
Werner Design Werks, Inc.

Client
Grand Connect

Principal Type
ITC Franklin Gothic

CORPORATE IDENTITY

Design
Sharon Werner
Minneapolis, MN

Art Direction
Sharon Werner

Design Office
Werner Design Werks, Inc.

Client
Grand Connect

Principal Type
School Script and
Franklin Gothic

Dimensions
Various

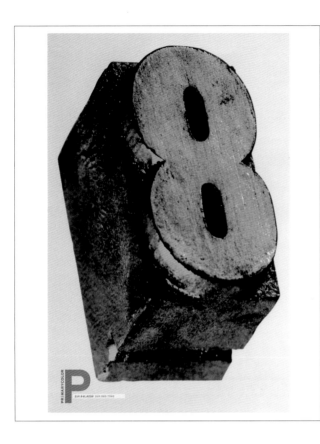

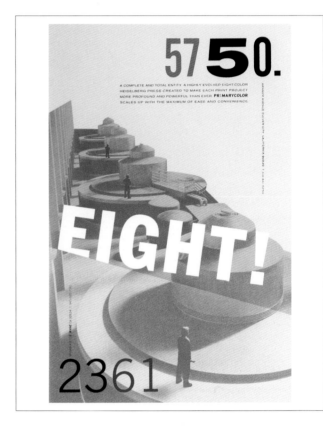

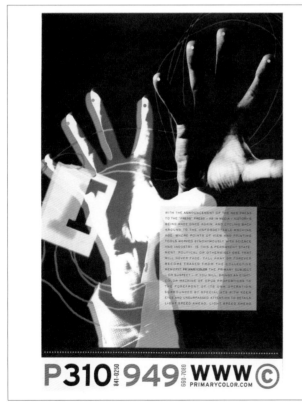

POSTERS

DESIGN
Clive Piercy and
Heather Caughey
Santa Monica, CA

ART DIRECTION
Clive Piercy and
Michael Hodgson

CREATIVE DIRECTION
Clive Piercy

DESIGN OFFICE
Ph.D

CLIENT
Primary Color

PRINCIPAL TYPE
Alternate Gothic,
Clarendon,
HTF Gotham,
Interstate, and
News Gothic

DIMENSIONS
24 x 36 in.
61 x 91.4 cm

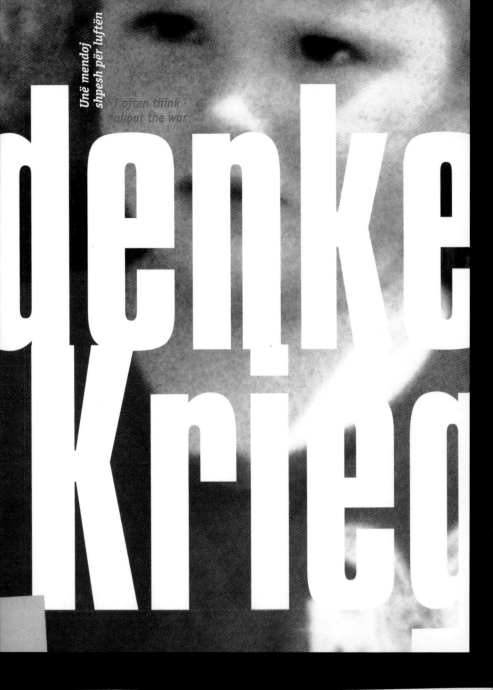

Unë mendoj
shpesh për luftën

*I often think
about the war*

denke
Krieg

BOOK

DESIGN
Anna Berkenbusch
and Tina Wende
Berlin, Germany

ART DIRECTION
Anna Berkenbusch

CREATIVE DIRECTION
Anna Berkenbusch

DESIGN OFFICE
Anna B. Design

CLIENT
Maikäfer Flieg e.V.

PRINCIPAL TYPE
Compacta,
ITC Officina Sans,
and ITC Officina Serif

DIMENSIONS
5.9 x 7.9 in.
15 x 20 cm

Wir haben überlebt,
aber wir haben auch
erlebt, dass nicht
jeder überleben kann.

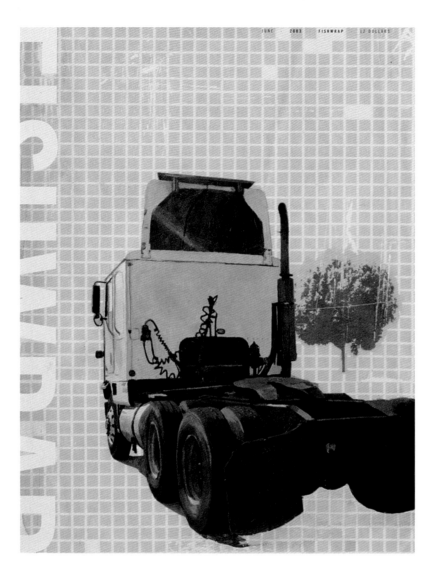

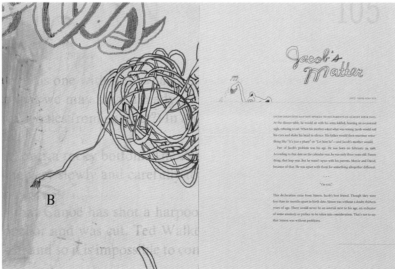

POSTER

DESIGN
Danny J. Gibson
Kansas City, MO

ART DIRECTION
Danny J. Gibson

CREATIVE DIRECTION
Danny J. Gibson

LETTERING
Danny J. Gibson

PRINTER
Danny J. Gibson
at Basement Print

DESIGN OFFICE
DJG Design

CLIENT
Kevin Eshleman
at The New Earth

PRINCIPAL TYPE
plant leaves and
plant stems

DIMENSIONS
11 x 17 in.
27.9 x 43.2 cm

MAGAZINE

**STUDENT DESIGNERS,
WRITERS, AND IMAGE MAKERS**
Aaron Amaro, Tony Blasko, Heather Culp,
Dee Dee Cushing, Trinie Dalton, Martin DePedro,
Cameron Fraser, Katrina Fraser, Frieda Gossett,
Jana Haney, John Harrington, Steve Harrington,
Erik Hillard, Caroline Hwang, Derrick Jefferson,
Tracy Sunrize Johnson, Tiffany Kosel,
Robert Kranzke, Justin Krietemeyer, Brody Larson,
Amanda Loos, Theo Morrison, Julie Murphy,
Joly Neelankavil, René Neri, Saelee Oh, Leah Park,
Allessandra Petlin, Scott Ponik, Andrew Robinson,
Aja Rowley, Christopher Russell, Souther Salazar,
Cara Snyder, Carol Song, Tamara Sussman,
Alan Traeger, and Jeanette Watson
Pasadena, CA

FACULTY ADVISOR DESIGN
Lisa Wagner-Holley

FACULTY ADVISORS IMAGE
Christian Clayton and Jason Holley

FACULTY ADVISOR EDITORIAL
Benjamin Weissman

SCHOOL
Art Center College of Design

PRINCIPAL TYPE
FF Knockout, Adobe Minion,
Trade Gothic, and Young Baroque

DIMENSIONS
7.5 x 9.5 in.
19.1 x 24.1 cm

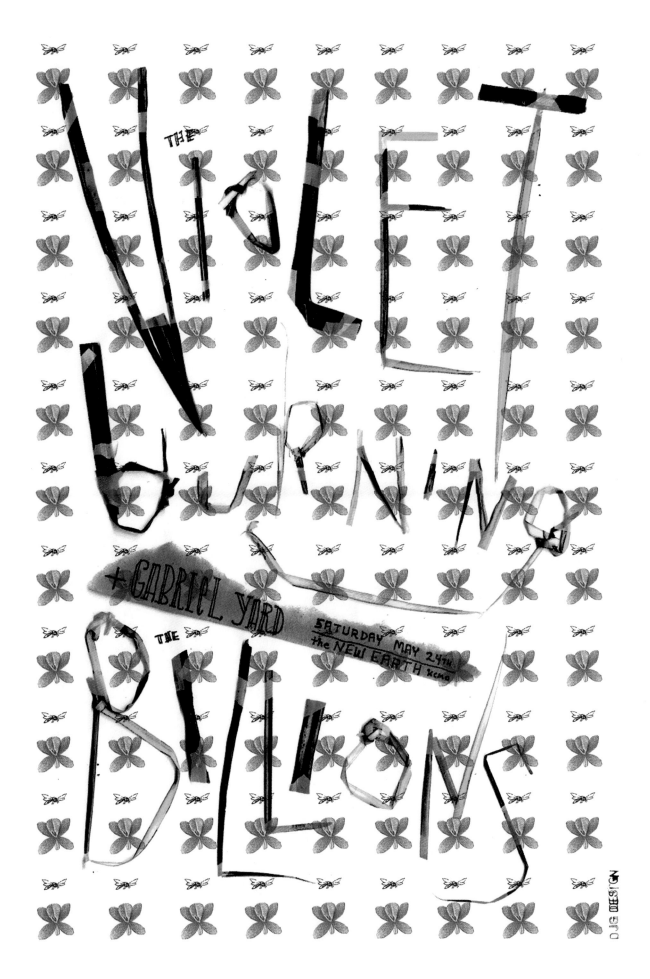

THE VIOLET BURNING

+ GABRIEL YARD

THE BILLIONS

SATURDAY MAY 24th
the NEW EARTH xcma

DJG DESIGN

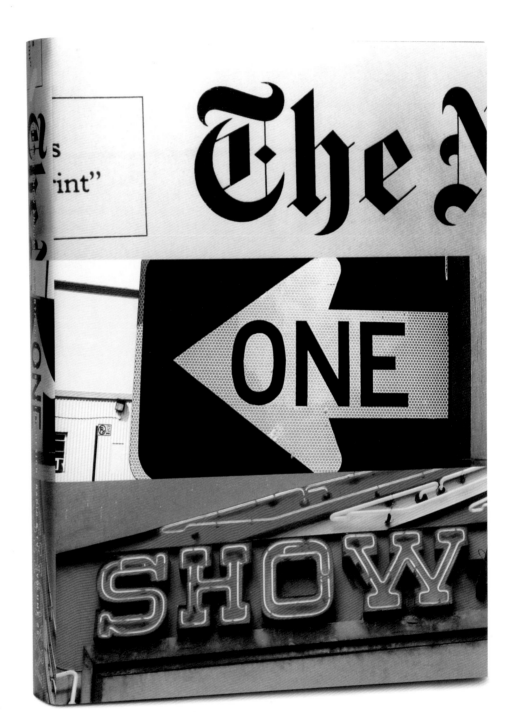

BOOK JACKET

DESIGN
Graham Clifford
New York, NY

PHOTOGRAPHY
Peter Cunningham

DESIGN OFFICE
Graham Clifford Design

CLIENT
The One Club

PRINCIPAL TYPE
ITC Conduit

DIMENSIONS
9 x 12 in.
22.9 x 30.5 cm

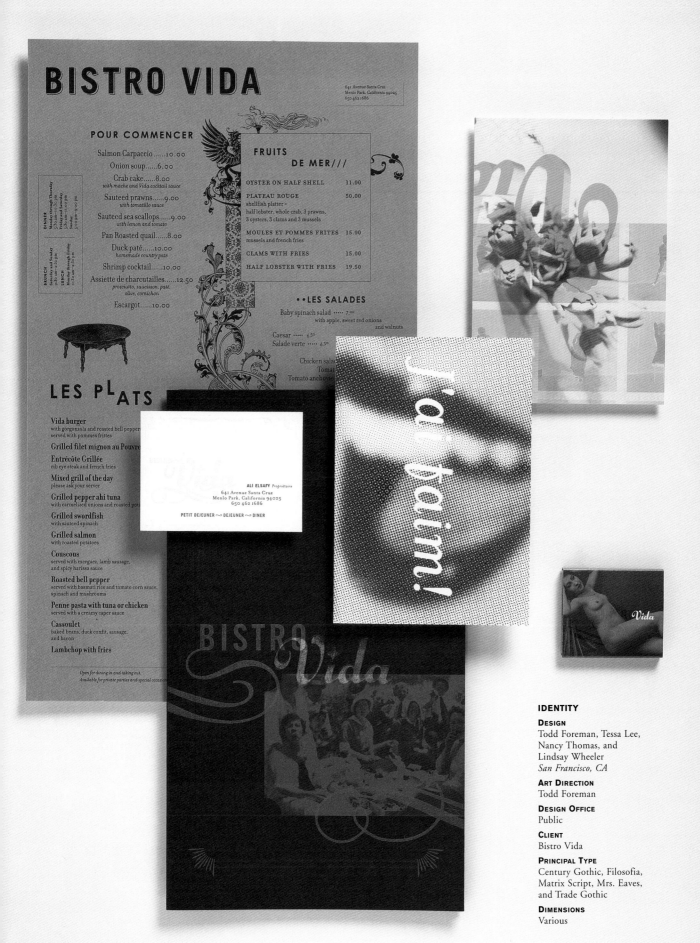

IDENTITY

DESIGN
Todd Foreman, Tessa Lee, Nancy Thomas, and Lindsay Wheeler
San Francisco, CA

ART DIRECTION
Todd Foreman

DESIGN OFFICE
Public

CLIENT
Bistro Vida

PRINCIPAL TYPE
Century Gothic, Filosofia, Matrix Script, Mrs. Eaves, and Trade Gothic

DIMENSIONS
Various

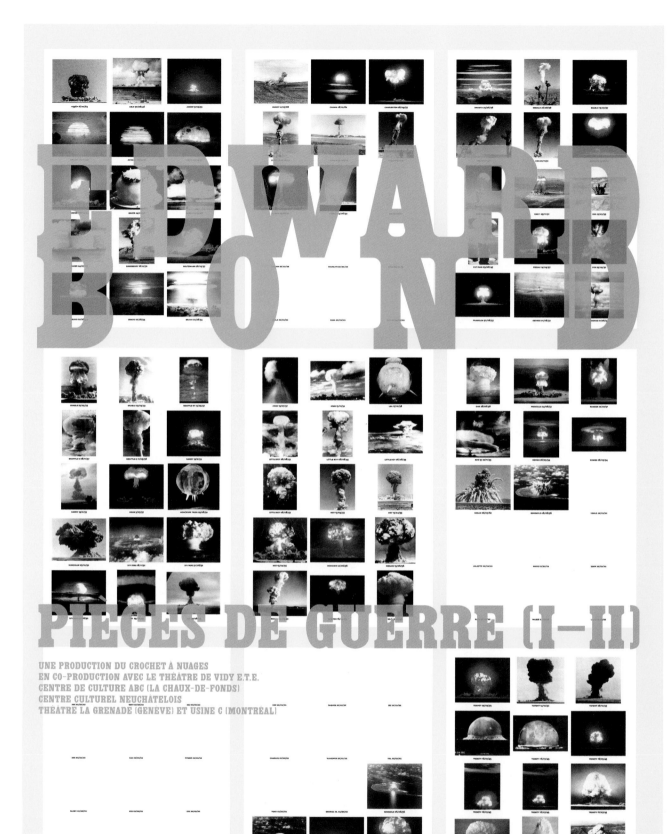

EDWARD BOND

PIÈCES DE GUERRE (I–II)

UNE PRODUCTION DU CROCHET À NUAGES
EN CO-PRODUCTION AVEC LE THÉÂTRE DE VIDY E.T.E.
CENTRE DE CULTURE ABC (LA CHAUX-DE-FONDS)
CENTRE CULTUREL NEUCHÂTELOIS
THÉÂTRE LA GRENADE (GENÈVE) ET USINE C (MONTRÉAL)

AVEC LE SOUTIEN DE LA VILLE DE LAUSANNE, LE CANTON DE VAUD, LA LOTERIE ROMANDE (VAUD ET NEUCHÂTEL), LA FONDATION NESTLE POUR L'ART, LE CONSEIL DES ARTS DU CANADA ET L'ÉCOLE SUPÉRIEURE DE THÉÂTRE DE L'UQAM (MONTRÉAL)

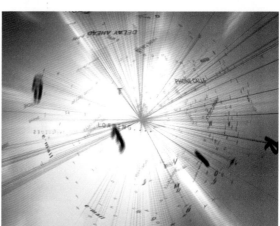

TELEVISION COMMERCIAL

DESIGN
Chris Bleackley and
Len Cheeseman
Wellington, New Zealand

ART DIRECTION
Chris Bleackley and
Len Cheeseman

CREATIVE DIRECTION
John Plimmer

ANIMATION
Garner McLennan Design
Sydney, Australia

AGENCY
Saatchi & Saatchi
New Zealand

CLIENT
Telecom New Zealand

PRINCIPAL TYPE
Various

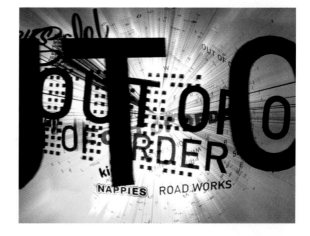

POSTER

DESIGN
Andre Baldinger
Lausanne, Switzerland

CREATIVE DIRECTION
Andre Baldinger

LETTERING
Andre Baldinger

CREDITS
U.S. Department of Energy photograph
and Hiroshima Peace Memorial Museum

DESIGN OFFICE
Conception Visuelle

CLIENT
Le Crochet à Nuages

PRINCIPAL TYPE
Header Special and Newut

DIMENSIONS
35.4 x 50.4 in.
90 x 128 cm

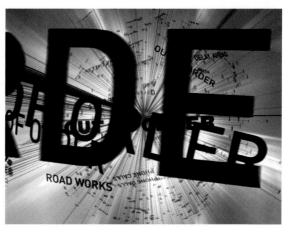

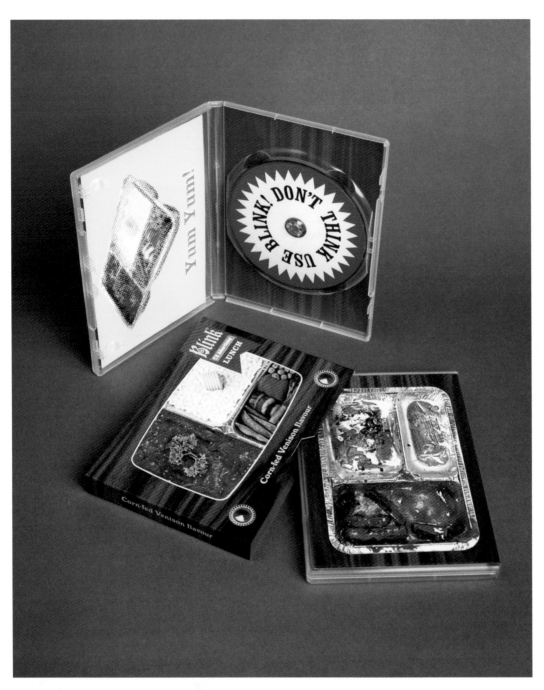

PACKAGING

DESIGN
Mark Denton
London, England

CREATIVE DIRECTION
Mark Denton

TYPOGRAPHER
Andy Dymock

CLIENT
Blink

PRINCIPAL TYPE
Clarendon and
HTF Knockout

DIMENSIONS
Various

POSTER

DESIGN
Hayes Henderson
and Will Hackley
Winston-Salem, NC

ART DIRECTION
Hayes Henderson

LETTERING
Hayes Henderson
and Will Hackley

DESIGN OFFICE
HendersonBromsteadA▮

CLIENT
Secrest Artists' Series

PRINCIPAL TYPE
Handlettering

DIMENSIONS
18.5 x 28.5 in.
47 x 72.4 cm

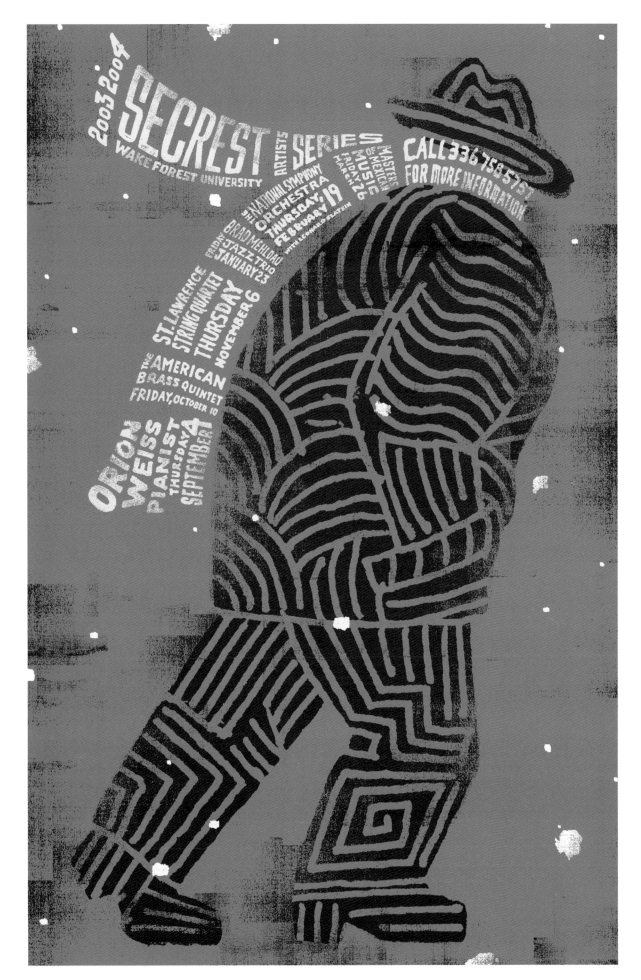

2003 2004 **SECREST** ARTISTS SERIES
WAKE FOREST UNIVERSITY

NATIONAL SYMPHONY ORCHESTRA
THURSDAY, FEBRUARY 19
WITH LEONARD SLATKIN

MASTERS OF MEXICAN MUSIC
FRIDAY, MARCH 26

CALL 336 758 5757
FOR MORE INFORMATION

BRAD MEHLDAU
JAZZ TRIO
FRIDAY, JANUARY 23

ST. LAWRENCE STRING QUARTET
THURSDAY, NOVEMBER 6

THE AMERICAN BRASS QUINTET
FRIDAY, OCTOBER 10

ORION WEISS PIANIST
THURSDAY, SEPTEMBER 4

and prepare your documents professionally

Type it Write

A *Voice* Project

BOOK

DESIGN
Scott Carslake and
Anthony De Leo
Adelaide, Australia

ART DIRECTION
Scott Carslake and
Anthony De Leo

CREATIVE DIRECTION
Scott Carslake

STUDIO
Voice

PRINCIPAL TYPE
Globale

DIMENSIONS
5.8 x 4.1 in.
14.8 x 10.5 cm

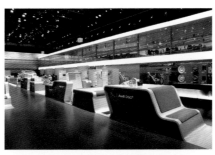

Audi TDI®

Audi FSI®

Audi magnetic ride

Audi quattro®

Audi DSG®

Audi multitronic®

Audi ASF®

Audi adaptive light
Audi LED technology

Audi adaptive light rear

Audi nanotechnology

Audi nanotechnology Water Shield

Audi nanotechnology Heat Shield

Audi MMI®

Audi Navigationssystem Plus

Audi Le Mans quattro display

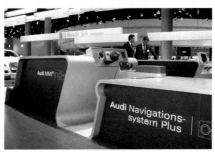

TRADE SHOW IDENTITY

DESIGN
Anna Bertermann and
Monika Hoinkis
Hamburg, Germany

ART DIRECTION
Daniel Bognar

CREATIVE DIRECTION
Johannes Plass and
Heinrich Paravicini

3-D PROGRAMMING
Andreas Neubauer
Berlin, Germany

DESIGN OFFICE
Mutabor Design

CLIENT
AUDI AG, Ingolstadt

PRINCIPAL TYPE
Audi Sans

DIMENSIONS
Various

CIRCULAR 11 CONTAINS WORK FROM THE FIVE SPEAKERS WE HAVE HAD DURING THE LAST YEAR. CHRONOLOGICALLY WE BEGAN WITH THE MAVERICK AND EXPERIMENTAL GRAPHIC THOUGHT FACILITY. THIS WAS FOLLOWED BY THE PRECISION AND DETAIL OF NORTH. IN CONTRAST ALAN FLETCHER PROVED THAT YOU DIDN'T HAVE TO BE YOUNG TO PROVIDE THE INSPIRATION. SEA WERE NEXT UP, CONTINUING THE MODERNIST THEME. WE THEN FINISHED WITH VINCE FROST WHO IS ONE OF THE FEW DESIGNERS ABLE TO STRADDLE THE 'OLD SCHOOL' IDEAS-BASED APPROACH WITH A SENSITIVITY TO THE FINAL LOOK OF THE DESIGN. PROBABLY THE BEST WAY TO DESCRIBE THIS ISSUE OF CIRCULAR IS A VISUAL SCRAPBOOK, A COMPENDIUM OF WORK SOME OF YOU MAY HAVE SEEN BUT MANY MIGHT NOT. SO WHAT HAS BEEN THE COMMON THREAD? ALL OF THEM USE TYPOGRAPHY IN DIFFERENT WAYS, TO DIFFERENT DEGREES. BUT ALL OF THEM USE IT WITH CARE. THEY ALL PUT THEIR HEART AND SOUL INTO THEIR WORK - THEY ALL HAVE INTEGRITY - ENJOY! PAIN, JOY, LAUGHTER, TEARS, BOREDOM, SEX, FUN AND EVEN DEATH... IT'S BEEN OVER A YEAR SINCE THE LAST ISSUE OF CIRCULAR AND THIS IS MY LAST ONE AS CHAIRMAN. TWO YEARS HAVE FLOWN BY - BUT HAVE I ENJOYED MYSELF? YES, BUT NOW I CAN GET ON WITH THE REST OF MY LIFE! FROM JULY OF THIS YEAR BRUNO MAAG WILL BE IN THE DRIVING SEAT AND KNOWING BRUNO HE WILL DRIVE VERY, VERY FAST. I WOULD LIKE TO THANK THE COMMITTEE - JAMES ALEXANDER, JOHN HASLAM AND JON CHECKLEY FOR ALL THEIR HARD WORK. I WOULD ALSO LIKE TO THANK EVERYONE AT LIPPA PEARCE AND ESPECIALLY ABIGAIL SILVESTRE FOR THEIR SUPPORT IN ALLOWING ME THE TIME TO INVEST IN THE CIRCLE. ALTHOUGH THE LAST YEAR HAS BEEN EXCITING WE ON THE COMMITTEE STILL FEEL WE HAVE A LOT TO DO. THE TALKS ARE NOW RUNNING QUITE SMOOTHLY WITH JAMES DOING A STERLING JOB WITH ALL THE PUBLICITY MATERIAL. A BIG THANK YOU TO GF SMITH FOR THEIR CONTINUED SUPPORT AS WELL AS BENWELL SERARD AND WHORE'S FOR THEIR HELP WITH PRINTING. BRUNO & EVERYONE AT HIS COMPANY DALTON MAAG, ESPECIALLY ANGIE GILROY, WHO HAVE WORKED SO HARD AT GETTING THE WEB SITE AS OUR CENTRAL POINT OF COMMUNICATION. MEMBERSHIP AND TICKET SALES CAN NOW BE ACHIEVED ONLINE AND WE HOPE THAT THIS MAKES OUR COMMUNICATION MORE EFFICIENT. IN ADDITION WE WILL BE ISSUING MEMBERSHIP CARDS TO EVERYONE WHOSE SUBSCRIPTION IS UP TO DATE! AS EVEN THE CIRCLE'S AMBITION HAS BEEN TO GENERATE A SERIES OF TALKS THAT WOULD INSPIRE US ALL. THE SPEAKERS WE HAVE HAD PROBABLY REFLECT MY OWN INTERESTS MORE THAN ANYTHING ELSE, BUT IT STILL HAS BEEN OUR INTENTION TO PUT ON EVENTS FROM PEOPLE WHO WE MIGHT NOT NECESSARILY HAVE HEARD FROM BEFORE. NORTH, GRAPHIC THOUGHT FACILITY, SEA AND VINCE FROST ARE ALL SMALL COMPANIES. THEY ARE PRODUCING SOME OF THE BEST GRAPHIC WORK IN THIS COUNTRY. ALAN FLETCHER IN CONTRAST HAS HAD A LIFETIME OF WORK BEHIND HIM - AN INSPIRATION TO EVERYONE. HE ALSO GAVE ONE OF THE MOST FUNNY AND INSPIRING TALKS THE CIRCLE HAS PROBABLY EVER PUT ON. SO THE COMBINATION OF EXPERIENCE AND YOUTH HAS PRODUCED A SUCCESSFUL CALENDAR OF EVENTS. I HOPE YOU ENJOY THIS VISUAL SCRAPBOOK AND WE ALL HOPE TO SEE YOU AT THE NEXT EVENT.

GRAPHIC THOUGHT FACILITY OFTEN THE REAL ENJOYMENT OF A LECTURE DEPENDS NOT SO MUCH ON THE INSPIRATIONAL WORK ON OFFER BUT MORE IN THE PRESENTATION OF IT. THE DELIVERY OF ANDY STEVENS WAS REFRESHINGLY UNPOLISHED, LIGHTLY PEPPERED WITH THOSE INEVITABLE TECHNOLOGICAL INTERRUPTIONS, & DELIVERED WITH SELF-DEPRECATING HONESTY. THERE WAS NO APPARENT SCRIPT AND THE TALK WAS ONLY JUST KEPT ON TRACK BY VIRTUE OF THE FACT THAT ANDY WAS THE VOICE-OVER TO A VIDEO FEATURING GTF'S WORK. HE EXPLAINED THAT IT WAS SHOT ESPECIALLY FOR THE LECTURE BECAUSE SO MUCH OF THEIR WORK IS TACTILE, MADE UP OF MANY COMPONENTS, AND IMPOSSIBLE TO CAPTURE WITH A SINGLE PHOTOGRAPH. THE SILENT VIDEO FEATURED A PAIR OF FOREARMS AND SOME HYPER-ACTIVE HANDS GRAPPLING WITH BROCHURES, OPENING BOOKS, UNFOLDING POSTERS AND CONSTRUCTING PRESS-KIT SIGNS. ALL SHOT FROM A FIXED OVERHEAD CAMERA. THIS WAS NOT AN UNUSUAL WAY FOR GTF TO PRESENT THEIR WORK. THEIR RECENT BOOK BITS WORLD, SHOE-HORNED A LARGE BODY OF WORK INTO A SLIM VOLUME BY BUILDING A FRAME FIXED TO A TROLLEY OVER A PATCHWORK OF SAMPLES LAID OUT ACROSS A FLOOR. PARTS OF THE WORK ARE LIT, OTHERS ARE NOT AND YOU ARE LEFT WITH THE IMPRESSION THAT THESE ARE QUITE DEFINITELY REAL THINGS THAT LIVE IN A REAL WORLD RATHER THAN COFFEE-TABLE BOOK EXAMPLES OF GRAPHIC DESIGN THAT HAVE BEEN ELEVATED WAY BEYOND THEIR INTENDED ROLE IN LIFE. FOR ME, THE NAME 'GRAPHIC THOUGHT FACILITY' HAS ALWAYS CONJURED UP A VISION OF THE GERMAN CAR LABORATORY WHERE INNOVATIVE DESIGN SOLUTIONS ARE BORN OF EXTENSIVE RESEARCH AND TESTING. 'WHERE DID THE NAME COME FROM?' I ASKED, 'GET TO F***K' REPLIED ANDY, (OBVIOUSLY AN IN THING TO WHICH I WAS NOT INVITED). THE ACRONYM GTF STUCK WITH ANDY AND HIS PARTNER PAUL NEALE FROM THEIR ROYAL COLLEGE OF ART DAYS. ELEVEN YEARS LATER IT STILL REMAINS BRASHLY PAINTED ACROSS THE FRONT DOOR OF THEIR CLERKENWELL STUDIO. THEY CITE GERT DUMBAR AND DEREK BIRDSALL AS HAVING INFLUENCED THEIR DEVELOPMENT AS STUDENTS AT THE RCA; DUMBAR HAVING JUST DEPARTED LEAVING A WAKE OF 'WHY NOT?' GRAPHIC TRICKERY, AND BIRDSALL ADMINISTERING WHAT WAS SEEN BY STEVENS AND NEALE TO BE A GOS REDUCTIVE ANTIDOTE. ALTHOUGH BIRDSALL'S TUTORING OF THE PAIR ONLY LASTED SIX MONTHS HE LEFT THEM THE STRONGEST LEGACY IN THAT THEY CONTINUE TO FORCE THEMSELVES TO LOOK CLOSER AT THE WORLD AROUND THEM FOR THE ANSWERS TO THEIR DESIGN PROBLEMS. FOR EXAMPLE, EXHIBITION GRAPHICS FOR DIGITOPOLIS AT THE SCIENCE MUSEUM EVOLVED FROM LOOKING INTO THE TECHNOLOGY USED IN ILLUMINATING CAR DASHBOARD DISPLAYS. THEIR ROYAL COLLEGE OF ARTS PROSPECTUS, WERE CONSTRUCTED FROM EXISTING PRESS CUTTINGS AND OLD RCA PUBLICATIONS. THE INSTITUTE OF CONTEMPORARY ARTS, 'STEALING BEAUTY' EXHIBITION WAS CAPTIONED USING OFF-THE-SHELF ENGRAVED PLASTIC SIGNS NORMALLY DEPLOYED AS FIRE EXIT SIGNS. PICKING UP ON THIS DESIRE TO USE UNCONVENTIONAL MATERIALS, EMILY KING DESCRIBED GTF AS 'HAVING AN UNQUENCHABLE LOVE OF STUFF' AND THEN PIGEON-HOLED THEM IN CHARLES JENCKS, ARCHITECTURAL CLASSIFICATION SYSTEM UNDER 'DADAISM'. A TERM USED TO DESCRIBE 'UNLIKELY ASSEMBLAGES, COLLECTIONS OF BITS BOLTED TOGETHER.' ADMITTEDLY, IT IS EASY TO SEE HOW THIS 'ISM' LABEL CAN BE APPLIED GIVEN THE OFTEN INCONGRUOUS JUXTAPOSITION WITH THEIR SUBJECT MATTER. EXPOSED WIRING IN A SLICK SCIENCE MUSEUM ENVIRONMENT, ROUGH AND READY PHOTOCOPIES BOUND TOGETHER FOR THE ESTEEMED ROYAL COLLEGE OF ART, AND BLAND PLASTIC CAPTIONS TO GUIDE VISITORS AROUND AN INSPIRATIONAL CONTEMPORARY ARTS VENUE. GIVEN THESE CONFLICTING MESSAGES, IT PUZZLED ME AS A PRACTICING DESIGNER TO THINK ABOUT THE UNLIKELY MARRIAGE BETWEEN A GTF CONCEPT AND A GTF CLIENT. I HAVE MET OTHER DESIGN KLEPTOMANIACS WHO HAVE A SIMILAR 'LOVE OF STUFF' YET THE FRENCH ROAD SIGN OR AFRICAN MASK RARELY MIGRATES DOWN FROM THE PRISTINE WHITEWASHED STUDIO WALLS AND BECOMES A PART OF THEIR OUTPUT. COULD GTF BE AN EXCEPTION? A VISIT TO THEIR STUDIO WOULD NOT SUPPORT THIS AS YOU WILL FIND ADMIN FOLDERS WEDGED BETWEEN THE WALL AND A WATER PIPE AND ASSORTED BUSINESS PARAPHERNALIA ATTACHED TO THE CEILING. IN WATCHING THEM WORK IT IS MORE EVIDENT THAN IN MOST STUDIOS THAT THE CREATIVE AND FOCUS OF ALL THOUGHT IS THE JOB IN HAND. THE SEARCH FOR INSPIRATION VIA THE POURING-OVER OF ASSORTED ARTIFACTS OR EPHEMERA SEEMS ABSENT. PERHAPS THAT CRITICAL SURGE TO PIGEON-HOLE EVERYTHING AND EVERYONE INTO AN 'ISM' IS USEFUL IN TRYING TO HELP US ALL UNDERSTAND WHERE WE SIT IN THE OVERALL SCHEME OF THINGS. HOWEVER, THE TERM COULD ALSO SERVE TO MASK THE SIMPLE ACTIVITIES OF A GRAPHIC DESIGNER'S DAILY GRIND. LIKE HOT AIR, THE THEORISING RISES WAY ABOVE GTF'S WELL GROUNDED OUTPUT. THE DAILY GRIND TO WHICH I REFER IS THE BÊTE NOIRE SCHOOL OF CLIENT COMMISSIONING 'I HAVE THIS AMOUNT OF MONEY, THIS DELIVERY DATE, AND I WANT TO SAY THIS. CAN YOU DO IT?' WHILE NOT ALL THEIR CLIENTS FOLLOW THE SAME COMMISSIONING PATTERN, FRUITFUL LONG TERM RELATIONSHIPS WITH ENLIGHTENED CLIENTS LIKE HABITAT STEM FROM BEING ABLE TO WORK WITHIN THE USUAL CONFINES OF THE FIRST JOB IN A WAY THAT OTHER DESIGNERS DON'T. STARTING WITH A SMALL PREVIEW INVITATION GTF SLOWLY ATTRACTED MORE AND MORE WORK FROM DIFFERENT HABITAT DEPARTMENTS BECAUSE THEY HAVE AN ABILITY TO ADDRESS PROBLEMS OF BUDGET, MONEY, TIME, AND TO WORK WITHIN THESE RESTRICTIONS. AND IT IS THESE RESTRICTIONS THAT INFLUENCE THEIR DESIGN; IT IS A CASE FOR BEING PRAGMATIC, AS OPPOSED TO DEVELOPING AN ALLEGIANCE TO 'STUFF' AND 'DADAISM'. ANDY TALKS LOOSELY ABOUT A WAY OF WORKING WITH 'IDEAS THAT DESIGN THEMSELVES', ABOUT 'METHODOLOGIES THAT MAKE THEIR OWN DECISIONS', AND 'DESIGNING OUT HASSLE'. WHEN PRESSED, HE CONFESSES THAT 'WE DON'T LIKE PUSHING TYPE AROUND AND WE'D RATHER MAKE LAWS THAT SO THAT FOR US'. IT STILL SOUNDS RATHER LIKE A LABORATORY NOT ONE WHERE DESIGN DNA REPLICATES ITSELF IN THE ABSENCE OF A DESIGNER. SO HOW DOES IT WORK? BEING PRAGMATIC IN DESIGN TERMS MEANS UNDERSTANDING THAT THE CLIENT IS GOING TO WANT TO PARTICIPATE IN THE DEVELOPMENT OF THE PROJECT, TO 'WANT THE TYPE TO BE BIGGER', AND TO MAKE CHANGES. FOR THE UGLY, GTF DEVELOPED A ROUTE THAT NOT ONLY ACCOMMODATED THE CLIENT INPUT BUT MADE IT RICHER FOR THEIR CONTRIBUTION THAT'S DESIGNING OUT THE HASSLE. PRAGMATIC ALSO MEANS THAT WHEN ASKED TO DO A BOOK BY STEPHEN BAYLEY ABOUT THE DESIGN ICONS WITH STYLE, GTF AVOIDED THE TASK OF REPRESENTING A DEFINITIVE GRAPHIC STYLE. BY OPTING TO USE FIVE DIFFERENT TYPOGRAPHIC FORMATS AND A SECOND COLOUR CHANGE ON EVERY SIXTEEN PAGE SECTION THAT'S AN IDEA THAT DESIGNED ITSELF. WHEN A CLIENT WITH LIMITED FUNDING LIKE THE FOCAL POINT GALLERY NEEDED PROMOTIONAL MATERIAL, GTF DEVELOPED A SIMPLE HOUSE STYLE CREATED BY RANGING ALL WORDS AND PICTURES FROM THE TOP LEFT DOWNWARDS. THE RESULTING RAGGED EDGE ON THE RIGHT BECAME AN INSTANTLY RECOGNISABLE AND SELF-PERPETUATING SOLUTION AND THAT'S THE METHODOLOGY THAT MAKES ITS OWN DECISIONS. ON CLOSER EXAMINATION AND DESPITE MY INITIAL PUZZLEMENT, I CAN NOW SEE THE RELATIONSHIP BETWEEN GTF CONCEPTS AND THEIR CLIENTS. YES, THE WORK IS UNEXPECTED BUT IT IS ALSO A QUITE RATIONAL AND LOGICAL RESPONSE TO A CLIENT BRIEF. ON ONE LEVEL THEIR WORK IS RICHLY TACTILE COMPOSED OF CONFLICTING ELEMENTS THAT CATCH THE EYE. ON ANOTHER LEVEL, UNDERNEATH THE SURFACE IT IS STRAIGHT FORWARD, HARD-WORKING DESIGN. GTF DON'T FALL INTO AN 'ISM', EXCEPT MAYBE GOOD-ISM. 5 MARCH 2001 FLORENCE GALLERY ROYAL INSTITUTE OF BRITISH ARCHITECTS, 320 ATTENDED, REVIEW: IAN CHILVERS.

NORTH ARE A BIT OF AN ENIGMA; BY THE END OF THEIR TALK THIS PERCEPTION HAD NOT DIMINISHED. FOUNDED BY SIMON BROWNING AND SEAN PERKINS IN EARLY 1995, NORTH HAVE RETAINED A POSITION OF (THEIR OWN CHOICE) OUTSIDE THE MAINSTREAM GRAPHIC DESIGN COMMUNITY. IN THEIR OWN WORDS THEY HAVE 'A RESOLUTELY MODERN AND EUROPEAN APPROACH TO GRAPHIC DESIGN... WHICH IS A PROGRESSIVE CONTRAST TO LAME, TRADITIONAL 'BRITISH' CORPORATE IDENTITY COMPANIES.' OVER THE YEARS THIS APPROACH HAS GENERATED SOME OF THE MOST GRAPHICALLY PURE AND POWERFUL DESIGN SEEN IN THIS COUNTRY. WIDELY KNOWN FOR THEIR GROUNDBREAKING DESIGN OF THE SAD IDENTITY, NORTH HAVE HELD FIRMLY TO THEIR SINGULARLY MODERNIST VISION OF THE SORT OF WORK THEY WANT TO PRODUCE. OFTEN HITTING ABOVE THEIR SIZE (THE FIRM CURRENTLY STANDS AT 9 PEOPLE) THEY HAVE HELD TRUE TO THEIR INTEGRITY BY PRODUCING WORK OF QUALITY AND ORIGINALITY. SUCH WAS THE INTEREST IN NORTH THAT THIS WAS ONE OF THE FASTEST SELLING TALKS LAST YEAR. THE INITIAL SURPRISE WAS THAT THE TALK WAS NOT GIVEN BY EITHER PERKINS OR BROWNING. INSTEAD THE DOUBLE ACT OF SENIOR DESIGNERS MASON WELLS AND TIM BEARD WERE HERE TO PROVIDE THE ENTERTAINMENT. WELLS AND BEARD HAVE BOTH BEEN PART OF THE NORTH SET-UP FOR A FEW YEARS NOW AND ARE AS MUCH A PART OF THE CHARACTER THAT IS NORTH AS PERKINS AND BROWNING ARE. OK, BACK TO THE 'ENTERTAINMENT' AND I USE THE TERM LIBERALLY. NORTH ARE NOT KNOWN FOR THEIR EASY-GOING DEMEANOUR OR FOR THE HUMOUR IN THEIR GRAPHICS. THEY TAKE THEIR OWN WORK VERY SERIOUSLY AND THIS CAME THROUGH IN THE FOLLOWING HOUR AND A HALF. THE WORK WAS PRESENTED IN A COOL AND PROFESSIONAL WAY - AS YOU'D EXPECT. WE SAW BEAUTIFULLY PHOTOGRAPHED PROJECTS IMMACULATELY PRESENTED IN A CRISP CLEAN WAY. ALL YOUR FAVOURITE PIECES WERE THERE - THE PHOTOGRAPHERS' GALLERY, BOOTH-CLIBBORN BOOKS, WORK FOR THE RESTAURANT NAKASAN AND AS YOU WOULD HAVE EXPECTED THEY KEPT THEIR CARDS CLOSE TO THEIR CHESTS. NOT MUCH WAS GIVEN AWAY AS TO HOW THEY WORK - IS THE WORK EQUALLY SHARED OR DO THEY WORK IN DIFFERENT TEAMS? BUT WHY SHOULD THEY REVEAL TOO MANY SECRETS! WHAT DID COME OVER MORE THAN ANYTHING WAS HOW EXPERIMENTAL A LOT OF THEIR WORK IS. THE PERCEPTION THAT THEIR TYPOGRAPHIC PALETTE EXTENDS TO JUST TWO WEIGHTS OF HELVETICA NEUE WAS QUICKLY SHATTERED. WHAT WAS ALSO REVEALED IS THEIR PASSION FOR THEIR WORK. THESE DAYS THERE'S AN EAGER EXPECTANCY THAT AT THESE EVENTS THE SECRETS OF SUCCESS WILL BE FREELY DISPENSED TO THE ADORING PUBLIC. NORTH WOULD NEVER DO ANYTHING SO PREDICTABLE. THEY DO NOT COURT PUBLICITY LIKE MOST OF THE DESIGN INDUSTRY BUT PROVE THEMSELVES THROUGH THEIR WORK, AND THIS IS THE ATTRACTION. IN ITS OWN WAY IT INCREASES THEIR POPULARITY AND THEIR SUCCESS. THE ENIGMA CONTINUES...

ALAN FLETCHER. PULL UP A CHAIR AND TAKE THE WHEELBARROW BACK TO THE GARDEN. 'THE ART OF LOOKING SIDEWAYS' ISN'T A BOOK FOR PEOPLE WITH GLASS BACKS. EVEN AFTER IT HAD ALL BEEN COMPLETED, THE COLLECTING THAT FUELLED THE CONTENTS OF FLETCHER'S RECENT BOOK CONTINUED UNABATED. THE TIRELESS CURIOSITY, THE AVID OBSERVATION. THAT WOULD HAVE BEEN WONDERFUL. STEPPING BACK FROM HIS LAYOUT COVERED STUDIO WALLS AND FINALLY CLEARING OUT HIS 72 PIGEONHOLES TO PURSUE AGAIN AN UNINTERRUPTED CURIOSITY FOR ALL THINGS CURIOUS. THAT WOULD HAVE SUITED FLETCHER PERFECTLY. BUT NO AS IS OFTEN THE WAY WITH MODERN FUNDLOVERS: FLETCHER HAD TO UNDERTAKE A HUGE BOOK TOUR. R&D WINE. AND PEOPLE WHO CAME IN TO SHELTER FROM THE RAIN. HIS MOST FREQUENTLY ASKED QUESTIONS GIVE SOME INDICATION OF THE SORTS OF NIGHTS HE ENDURED: 'WHAT DID YOU MEAN BY THAT - I DIDN'T UNDERSTAND YOU?' AND 'HOW DID YOU THINK OF THE IDEA OF THE BOOK?' ALL ON TOP OF A SITUATION ALREADY COMPLICATED BY THE FACT THAT THE BOOK WAS CERTAINLY NOT TO BE DISPLAYED IN THE DESIGN SECTION. IN WHICH CASE, WHERE? WITH 72 CHAPTERS LOOSELY BASED ON JUST ABOUT EVERYTHING, WHERE INDEED! OUR AUDIENCE WITH ALAN FLETCHER CAME AT THE END OF A SHORT RUN OF BOOK SIGNINGS THAT HE HAD BEEN USHERED THROUGH THE FIRST OF THIS SORT OF PROMOTIONAL ACTIVITY HE HAD BEEN ASKED TO ENGAGE IN BY HIS PUBLISHERS. ALTHOUGH A CONSUMMATE CROWD PLEASER (THE 300 OR SO MEMBERS GATHERED AT RIBA CERTAINLY LEFT WITH A SPRING IN THEIR STEP) THERE SEEMED EVERY LIKELIHOOD HE MIGHT LEAVE SOME ATTENDEES AT HIS BOOKSTORE EVENINGS A TAD DISAPPOINTED; WHEN THEY ASK HIM 'WHAT'S THE BOOK ABOUT?' HE HASN'T HAD THE GOOD GRACE TO WORK OUT THE ANSWER. AND FRANKLY, WHO CAN BLAME HIM. 'WORK IT OUT FOR YOURSELF' WOULD NO DOUBT BE HIS PREFERRED RESPONSE (PERHAPS WITH THE MARKETING TEAM SAFELY OUT OF EARSHOT). SOME THINGS ARE OBVIOUS ABOUT 'THE ART OF LOOKING SIDEWAYS'. IT HAD BEEN A LONG TIME IN THE MAKING, BEGINNING AS A SERIES OF 72 PIGEONHOLES AND REMAINING AS SUCH, EVEN THOUGH THE PIGEONHOLES ARE NOW CALLED 'CHAPTERS'. THE BOOK STARTS ON THE COVER IN A FORM OF 'NFT' THE SHELF ADVERTISING - IT IS THE SUM OF THE THINGS THAT GO ON IN FLETCHER'S HEAD. AND HE BELIEVES THAT SIMILAR THINGS MIGHT BE GOING ON IN OURS. OR RATHER, HE IMAGINES THEY MUST BE GOING ON IN OURS - OTHERWISE WHY ARE WE DOING WHAT WE'RE DOING? MAYBE HIS TALK, AND THIS BOOK GAVE EVERYONE A GREATER DETERMINATION NOT JUST TO SEE THESE THINGS BUT ALSO AN INCREASED READINESS TO PHOTOGRAPH OR FILE OR WRITE DOWN SIMILARLY INTRIGUING OR PECULIAR HAPPENINGS. IN PRODUCING SUCH A WORK, FLETCHER'S JACKDAW CURIOSITY HAS BEEN HIS DEFINING QUALITY. HE DIDN'T ALLOW HIMSELF TO FORGET THINGS THAT TRULY CAUGHT HIS EYE, HE PLUCKED THEM FROM THE EARTH, NEWSPAPER, BEACH OR MUSTY PAPERBACK FROM WHENCE THEY CAME AND STORED THEM; PERHAPS WITH NOTHING MORE ON HIS MIND THAN TO NOT LET THEM PASS. WITH AN AIR OF (ARGUABLY) STUDIED DETACHMENT, HE RAN THROUGH THE PRELIMINARY IDEAS FOR THE BOOKS TITLE. 'A WORD IN YOUR EYE' WAS ALMOST SIMULTANEOUSLY ADOPTED BY KEN GARLAND AND FOR WHICH HE WOULD SOUGHT AFTER BY COLLECTION OF ESSAYS, ARTICLES AND SPEECHES.'6. BOOK WITH A VIEW' DIDN'T MAKE THE GRADE. THE THIRD, AND ULTIMATELY SUCCESSFUL OPTION WAS A RATHER LAST MINUTE DECISION, BUT SEEMS THE MOST COMFORTABLE. BUT BEFORE YOU IMAGINE THAT ALL THIS FERRETING AND HOOCHING IS DONE WITH, HOLD FAST. THIS BOOK IS NEVER FINISHED. HIS SEARCH CONTINUES. WHAT A PITY THAT FLETCHER DIDN'T SNARE EITHER THESE SCORIOS OR HIS EXPANSIVE AND INTERROGATIVE MIND WITH US ALL SOONER. PERHAPS A VOLUME EVERY 5 OR SO YEARS, TO ACT NOT ONLY AS A VISUAL PRIMER, BUT AS A CATALOGUE OF THOUGHT AND IMAGES FROM SPECIFIC PERIODS THAT SEEM OTHERWISE DESTINED TO BE THE SUBJECT OF SELF-OBSESSED RETROSPECTIVES ON CHANNELS 2, 4 OR 5. A MONSTROUS PART WORK OF LIFE. THE THOROUGHLY ENJOYABLE 'BEWARE WET PAINT' WAS A USEFUL PRIMER ON HIS WORK, AND HIS OWN BELIEFS ABOUT DESIGN, CREATIVITY AND TO SOME EXTENT LIFE ITSELF. 'THE ART OF LOOKING SIDEWAYS' FEELS EITHER LIKE A MASSIVE KICK UP THE ARSE FOR THOSE WHO FLETCHER BELIEVES ARE TO INHERIT THE INDUSTRY WHEN TO SOME EXTENT HE HELPED CREATE, AND SHOULD THEREFORE BE DOING A DAMN SITE MORE WITH THEIR GREY MATTER THAN HE BELIEVES THEY ARE. BASED ON THE CURRENT EVIDENCE. IT IS NOT JUST A TUTORIAL ON GRAPHICS, NOR ON THINKING, IT OCCUPIES A LARGER SPACE THAT OF A BOOK OF ENCOURAGEMENT OR MAYBE 'IMPROVEMENT' AS THE VICTORIANS MIGHT HAVE SAID. RATHER INTELLECTUALLY SNOBBISH MAN OBVIOUSLY 'DUMBED DOWN' IT IS THE ULTIMATE DIP-IN LITERARY EXPERIENCE. IN HIS OWN BRIEF INTRODUCTION, FLETCHER DESCRIBES THE BOOK AS A JOURNEY WITHOUT A DESTINATION', WITH OUR OWN JOURNEYS SO INEVITABLY GRAVEBOUND, THESE CAN BE FEW MORE PLEASURABLE WAYS OF SPENDING IT THAN IN THE PURSUIT OF AN EXPANDED MIND, OR - AT THE VERY LEAST, A LARGE POT OF COFFEE, SOME EXCELLENT WINE, A COMFORTABLE ARMCHAIR AND 'THE ART OF LOOKING SIDEWAYS'.

AREN'T REALLY INTERESTED IN STYLE. THAT'S WHAT BRYAN EDMONSON ADMITTED IN THIS RELAXED AND ENTERTAINING TALK. SEA WAS FORMED IN 1997 BY EDMONSON AND HIS PARTNER JOHN SIMPSON. WHAT SEA ARE INTERESTED IN IS CREATING SOLUTIONS WHICH EXCITE THEMSELVES AND THEREFORE IN TURN WILL INTEREST THEIR CLIENTS. THERE IS NO ARGUMENT THAT THEY HAVE A 'SIGNATURE' OR A STYLE IN THE TYPE OF RESULTS THEY PRODUCE, BUT WHEN TACKLED WITH THIS POINT IN THE POST TALK QUESTION AND ANSWER SESSION, EDMONSON RETALIATED WITH THE ARGUMENT THAT IF IT'S OK FOR AN ARCHITECT TO HAVE A 'STYLE' WHY COULDN'T A GRAPHIC DESIGNER FAIR POINT! BUT IS THAT ENOUGH? EVERYTHING THEY HAVE PRODUCED HAS A CLARITY AND PRECISION ABOUT IT. AND THIS IS WHAT THEY'RE SELLING. PEOPLE COME TO THEM KNOWING WHAT THEY'RE GOING TO GET. INSTEAD MANY DESIGNERS THEY DON'T SEE THE TYPE THEY SEE THEY'RE HAPPY WITH WHAT THEY LIKE. INSTEAD THEY PRECOCCUPY THEMSELVES WITH THE OTHER DETAILS OF A PROJECT THE IMAGERY, THE MATERIALS, THE PRINTING THIS IS HOW THEY DIFFERENTIATE BETWEEN PROJECTS. THEREFORE, PROJECTS LIKE THEIR BOOK FOR RANKIN/GF SMITH BECOMES MORE OF A COLLABORATION WITH RANKIN'S IMAGES GIVEN FULL EMPHASIS RATHER THAN THE TYPE. LIKEWISE ANNUAL REPORTS FOR EMI FEATURE TEXTURED COVERS IN WONDERFULLY ACID, LURID COLOURS WITH GLAND EMBOSSED TYPE. THE WORK FOR THE FURNITURE COMPANY KEEN WAS AGAIN SUBTLE AND YET BEAUTIFULLY CRAFTED. WITH STRIKINGLY VIVID ILLUSTRATIONS AND PATTERNS, THE WORK CLEARLY POSITIONS SEA WITHIN THE MODERNIST CAMP. SO WHY ASK A COMPANY WITH LITTLE INTEREST IN TYPOGRAPHY TO GIVE A LECTURE TO THE TYPOGRAPHIC CIRCLE. WELL, BOUNDARIES HAVE ENGAGED AND CERTAINLY AREN'T ALL THE SEA THEY TYPE DESIGNERS ARE GREAT GRAPHIC DESIGNERS QUITE OFTEN THE OPPOSITE. THIS SEEMS TO COME THROUGH IN SEA'S WORK. MOST OF THEIR TYPE IS POSITIONED VERY TIGHTLY IN THE TOP LEFT CORNER. SET IN SOMETHING LIKE 12PT HELVETICA NEUE 55, RANGED LEFT WITH TIGHT KERNING DON'T SOMEONE SAY THAT 'TYPE IS IN THE DETAIL'.

... IS A VERY, VERY GOOD DESIGNER. LET'S GET THAT WAY OF THE WAY FROM THE OUTSET. HIS WORK PEPPERS MANY OF THE MOST PRESTIGIOUS DESIGN AWARDS AND ANNUALS WORLDWIDE. THE 36 YEAR-OLD CANADIAN BEGAN HIS CAREER WORKING FOR PENTAGRAM DESIGN. ANYONE WHO KNOWS HOW THAT COMPANY WORKS WILL SAY ITS A TOUGH TRAINING SCHOOL. ITS NOT FOR THE WEAK-MINDED. FIRST THERE'S THE LONG HOURS, AND THEN THERE'S THE TOUGH AND VERY COMPETITIVE ENVIRONMENT - ALL FOR LITTLE FINANCIAL REWARD. BUT THE REWARDS DO COME FOR THOSE WHO WAIT. A LOT OF PENTAGRAM ALUMNI'S CAN PICK AND CHOOSE WHERE THEY MOVE ON TO PENTAGRAM IS DEFINITELY A DOOR OPENER. ITS NOT A PLACE THOUGH FOR THOSE EXPECTING QUICK PROMOTIONS. ONLY A FEW DESIGNERS MAKE IT THROUGH THE RANKS (JOHN RUSHWORTH BEING ONE OF THE FEW). VINCE FROST WAS MADE AN ASSOCIATE IN 1991 - ITS YOUNGEST EVER. HOWEVER, MAKING IT TO ASSOCIATE LEVEL DOES NOT GUARANTEE ANYTHING FURTHER. THEREFORE IN 1994 FROST LEFT TO SET UP HIS OWN PRACTICE. DISCUSSING THIS RELATIONSHIP WITH HIS OLD EMPLOYERS IN A FRIENDLY, INFORMATIVE AND WITTY TALK. FROST READILY ADMITTED THE CONFIDENCE EVEN ARROGANCE OF THE PENTAGRAM STABLE WAS WITH HIM FROM THE OUTSET. WHEN HE FIRST STARTED HE BELIEVED THAT THE WORK WOULD JUST COME INTO HIM - AS IT HAD DONE FOR PENTAGRAM. IN REALITY IT DIDN'T. FROST DID HOWEVER WORK ON BIG MAGAZINE WHILST AT PENTAGRAM AND CARRIED ON ART DIRECTING THE HUGELY INFLUENTIAL MAGAZINE ONCE BY HIMSELF. THE WORK HE PRODUCED FOR BIG IN MANY WAYS HAS SET UP A PATTERN WHICH HAS CONTINUED FOR THE REST OF HIS CAREER. FIRSTLY, THERE'S THE LOVE OF WOODBLOCK TYPE. FROST READILY ADMITS TO CONSTANTLY LOOKING FOR PROJECTS TO INDULGE THIS OBSESSION WITH. STILL HAS USE OF INTELLIGENT, IDEA-BASED SOLUTIONS WHICH IS STILL EVIDENT IN HIS WORK. THERE'S BEEN THIS DEBATE WITHIN THE DESIGN INDUSTRY FOR NEARLY 20 YEARS NOW AS TO WHETHER YOU ARE AN IDEAS-BASED DESIGNER OR A STYLIST. A DESIGNER WHO USES THE DESIGN PROCESS AS A FORM OF PERSONAL EXPRESSION. WELL, FROST HAS ENABLED HIMSELF TO STRADDLE BOTH CAMPS WITHOUT DIMINISHING THE QUALITY OF HIS WORK. COMMISSIONS FOR THE INDEPENDENT, THE ROYAL MAIL, THE PUBLISHERS FOURTH ESTATE AND THE PHOTO LIBRARY PHOTONICA ARE ALL TESTAMENT TO HIS SINGULAR PURSUIT OF SOLUTIONS WHICH ARE INTELLIGENTLY SOLVED WHILST STILL LOOKING STUNNINGLY BEAUTIFUL. THE TALK CONTINUED FOR A GOOD COUPLE OF HOURS WITH PLENTY OF ANECDOTAL STORIES ABOUT EACH OF HIS PROJECTS. A BIT TOO CANDIDLY HE SHOWED SOME OF THE WORK FOR THE SPICE GIRLS. TALKING TO PEOPLE AFTERWARDS, MANY SEEMED SURPRISED BY ITS INCLUSION, ESPECIALLY AS FROST HARDLY DEEMED THE WORK AND OFFERED A SLIGHT APOLOGY FOR ITS PRESENCE. BUT THIS IS THE POINT - IT'S THE CONFIDENCE OF FROST THAT HE CAN STAND IN FRONT OF 350 PEOPLE AND DESCRIBE HOW THE PROJECT DEVELOPED WITH A SMILE ON HIS FACE. THAT IS WHAT MAKES THE DIFFERENCE. THAT TAKEN WITH THE STORY ABOUT THE DISASTROUS TRIP TO TRY AND SET UP JAPANESE VOGUE GAVE THE TALK AN OPENESS RARELY SEEN OR HEARD FROM DESIGNERS TODAY.

CIRCULAR, THE MAGAZINE OF THE TYPOGRAPHIC CIRCLE, IS POSTED FREE OF CHARGE TO MEMBERS & IS AVAILABLE TO NON-MEMBERS FOR £10 (PLUS £2 P&P). CIRCULAR IS PUBLISHED TWICE A YEAR BY THE TYPOGRAPHIC CIRCLE, C/O DALTON MAAG, UNIT 2, 245A COLDHARBOUR LANE, LONDON SW9 8RR, T +44 (0)20 7924 0633. THE VIEWS EXPRESSED IN THIS MAGAZINE ARE NOT NECESSARILY THOSE OF THE TYPOGRAPHIC CIRCLE. REPRODUCTION OF ANY ASPECT OF THIS MAGAZINE IS PROHIBITED WITHOUT THE PRIOR PERMISSION OF THE PUBLISHERS. PRODUCT NAMES MENTIONED ARE THE TRADEMARKS OF THE RESPECTIVE HOLDERS. © TYPOGRAPHIC CIRCLE 2003. PRINTED IN THE UK. CIRCULAR WELCOMES ALL CORRESPONDENCE. POSTAL MAIL TO DALTON MAAG. EDITOR: PATRICK BAGLEE, CO-EDITORS: DOMENIC LIPPA & JAMES ALEXANDER. MAGAZINE DESIGN: DOMENIC LIPPA AT LIPPA PEARCE. T +44 (0)20 8744 2100. TYPEFACES: THE ENIGMA FAMILY FROM JEREMY TANKARD & GOTISH 13. PAPER STOCK: GF SMITH COVER: ACCENT FRESCO GESSO 270GSM. TEXT: PGS 1-4 GOLDENPLAN NATURAL 150GSM, PGS 5-16 COLDERPLAN PRISTINE WHITE 150GSM, PGS 17-24 COLDERPLAN ICE WHITE 150GSM, PGS 25-32 ACCENT FRESCO GESSO 120GSM, PGS 33-40 ACCENT FRESCO CREME 120GSM, PGS 41-52 ACCENT FRESCO NATURALE 120GSM. PRINTING & FINISHING: MOORE. T +44 (0)20 7232 4700. CONTRIBUTORS TO ISSUE 11: PATRICK BAGLEE, IAN CHILVERS AND DOMENIC LIPPA. THE COMMITTEE SO FAR: JAMES ALEXANDER, PATRICK BAGLEE, JON CHECKLEY, JOHN HASLAM, DOMENIC LIPPA, BRUNO MAAG & SALLY-ANNE THEODOSIOU. POSTERS & TICKETS DESIGNED BY JAMES ALEXANDER, T +44 (0)20 7407 1010.

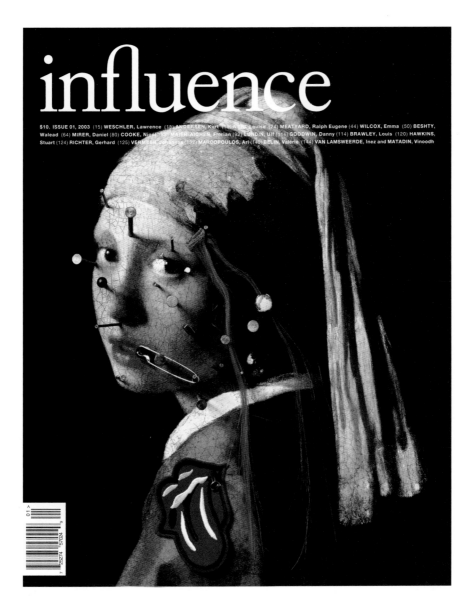

MAGAZINE

DESIGN
Nobi Kashiwagi,
Soohyen Park,
and Matias Corea
New York, NY

ART DIRECTION
Michael Ian Kaye

CREATIVE DIRECTION
Raul Martinez

DESIGN OFFICE
AR

PRINCIPAL TYPE
Adobe Caslon and
Neue Helvetica

DIMENSIONS
9 x 12 in.
22.9 x 30.5 cm

POSTER

DESIGN
Domenic Lippa
London, England

ART DIRECTION
Domenic Lippa

CREATIVE DIRECTION
Domenic Lippa

DESIGN STUDIO
Lippa Pearce Design

CLIENT
The Typographic Circle

PRINCIPAL TYPE
Gothic 13

DIMENSIONS
18.9 x 26.8 in.
48 x 68 cm

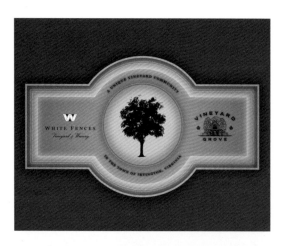

POSTER

DESIGN
Radovan Jenko
Ljubljana, Slovenia

ART DIRECTION
Radovan Jenko

CREATIVE DIRECTION
Radovan Jenko

LETTERING
Radovan Jenko

PHOTOGRAPHY
Dragan Arrigler

STUDIO
Studio Radovan Jenko

CLIENT
Andrej Rozman, KUD
France Preseren

PRINCIPAL TYPE
Handlettering

DIMENSIONS
26.8 x 38.6 in.
68 x 98 cm

WEB SITE

SENIOR DESIGNER
Jason Strong
Minneapolis, MN

CREATIVE DIRECTOR
Billy Jurewicz

3D-FLASH DEVELOPER
Marc Jensen and
Steven Stwalley

JUNIOR DESIGNER
Brian Lambert

AGENCY
Space150

CLIENT
White Fences Vineyard Grove

PRINCIPAL TYPE
Various and
Victorian ornaments

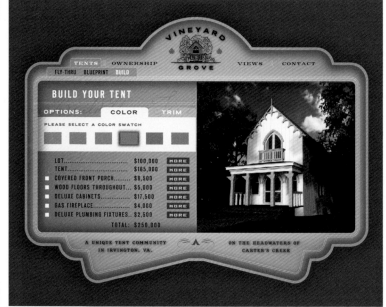

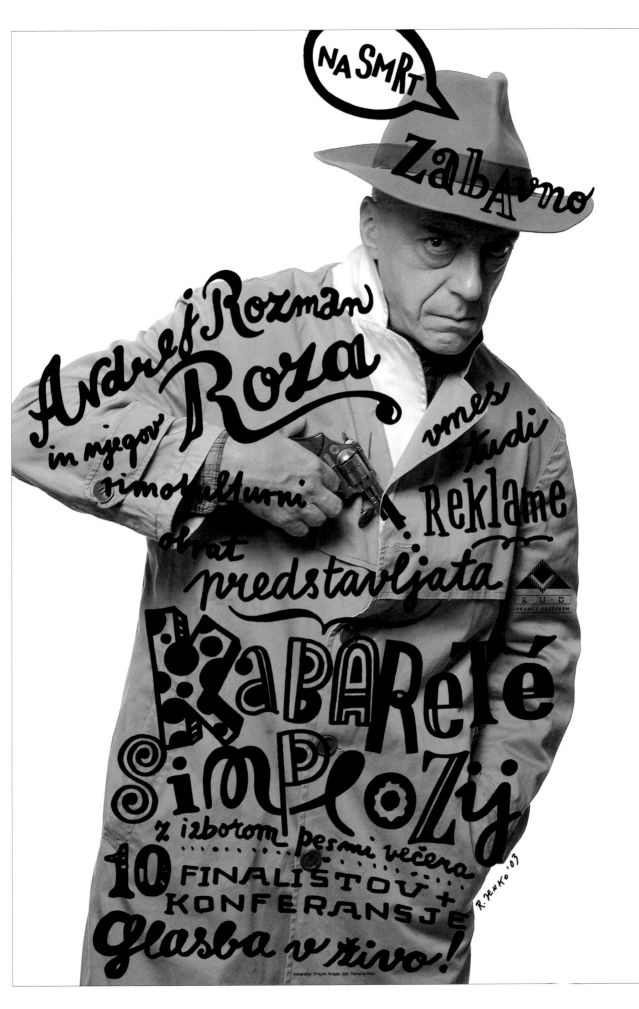

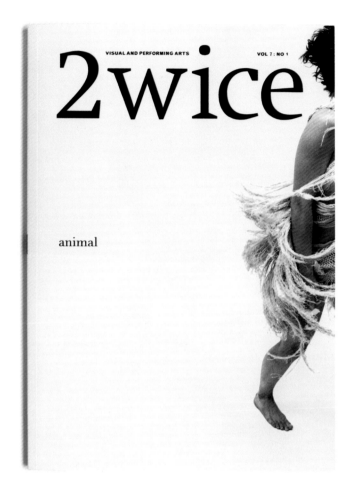

MAGAZINE

DESIGN
Abbott Miller and
Jeremy Hoffman
New York, NY

CREATIVE DIRECTION
Abbott Miller

DESIGN OFFICE
Pentagram Design, Inc.

CLIENT
2wice Arts Foundation

PRINCIPAL TYPE
Monotype Walbaum

DIMENSIONS
8.25 x 11.5 in.
21 x 29.2 cm

CLOVEN
KINGDOM

PAUL TAYLOR DANCE COMPANY
Photography by Christian Witkin

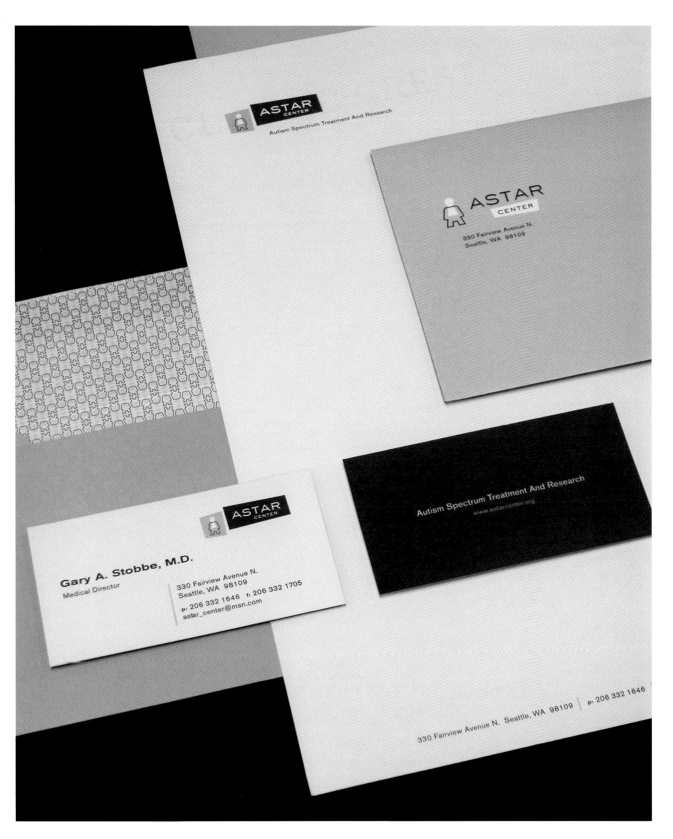

CORPORATE IDENTITY

DESIGN
Pat Snavely
Seattle, WA

ART DIRECTION
David Bates

DESIGN OFFICE
BC Design

CLIENT
ASTAR/Autism Spectrum
Treatment and Research

PRINCIPAL TYPE
Akzidenz Grotesk and
Engravers Gothic

DIMENSIONS
Various

2003

AWARDS FOR DESIGN EXCELLENCE
AMERICAN INSTITUTE OF ARCHITECTS
PHILADELPHIA

THE AWARDS FOR DESIGN EXCELLENCE RECOGNIZE SIGNIFICANT ACHIEVEMENTS B IN PLANNING, DESIGN AND EXECUTION OF ARCHITECTURAL
PROJECTS. THE PHILADELPHIA CHAPTER OF AIA ENCOURAGES MEMBER FIRMS TO SUBMIT PROJECTS OF ALL TYPES – LARGE AND SMALL,
NEW CONSTRUCTION AND REHABILITATION, INTERIOR AND EXTERIOR. THE CHAPTER INTENDS TO RECOGNIZE ANY WORK THAT EXHIBITS EXCEPTIONAL
DESIGN QUALITY AND PROMOTES PUBLIC APPRECIATION OF ARCHITECTURAL EXCELLENCE.

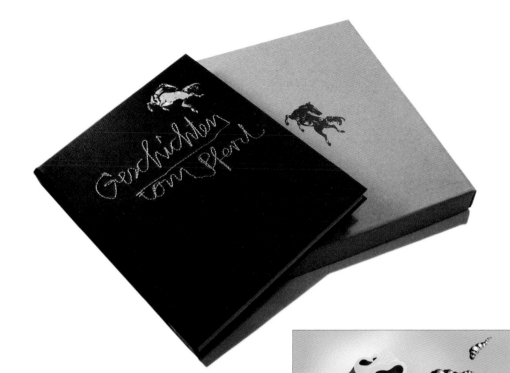

BOOK

DESIGN
Alexander Rötterink
Hamburg, Germany

ART DIRECTION
Alexander Rötterink

CREATIVE DIRECTION
Uli Gürtler

COPYWRITERS
Jens Ringena,
Constanze Rusch, and
Matthias Storath

AGENCY
Springer & Jacoby Design

CLIENT
Mustang Jeans GmbH

PRINCIPAL TYPE
Adobe Garamond and
Stamped Helvetica

DIMENSIONS
8.5 x 11 in.
21.5 x 28 cm

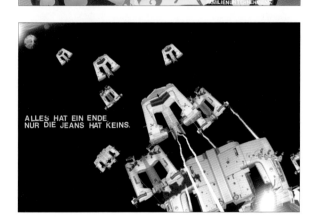

POSTER

DESIGN
Kerry Polite
Philadelphia, PA

DESIGN OFFICE
Polite Design Incorporated

CLIENT
American Institute of
Architects, Philadephia

PRINCIPAL TYPE
FF DIN Black and
FF DIN Bold

DIMENSION
18 x 24 in.
45.7 x 61 cm

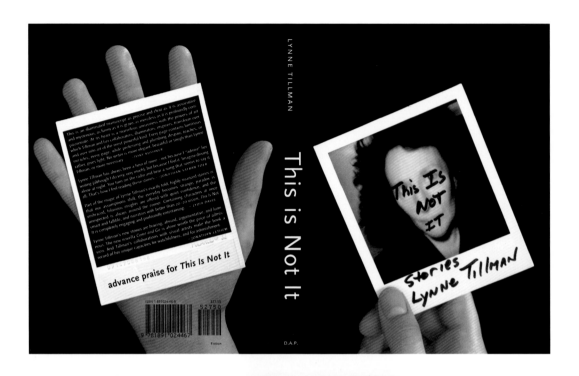

Marco Breuer, UNTITLED (HEAT/GUNS), 2002
Study for SMTWTFS. Silver gelatin paper, burned
9 x 6 inches. Collection of the artist. Courtesy of
Roth Horowitz.

MADAME REALISM'S TORCH SONG

The other night, as he sat near the fire in Madame Realism's
study, in the place where chance had made them neighbors
for a period of time, Wiley said: "Things go on we don't
know about. They happen in the dark, metaphorically some-
times, but maybe you don't want to talk about dark stuff now."

"Marilyn Manson," Madame Realism said, "told someone on
MTV that Lionel Richie was the heart of darkness."

"There's the light side. But it has a shorter life."

Wiley struck a match.

"It sparks, flares, burns, burns out."

He turned from the fireplace, where he was watching the
fire, to her. Wiley looked grave or intent. Madame Realism felt
strange, the way she often did. She hadn't known him very
long, and, for a moment, he spooked her. Then he returned his
attention to the hearth.

BOOK

DESIGN
Carole Goodman
New York, NY

STUDIO
Blue Anchor Design

CLIENT
Distributed Art Publishers, Inc.
DAP

PRINCIPAL TYPE
ITC Tactile

DIMENSIONS
6.4 x 8.75 in.
16.2 x 22.2 cm

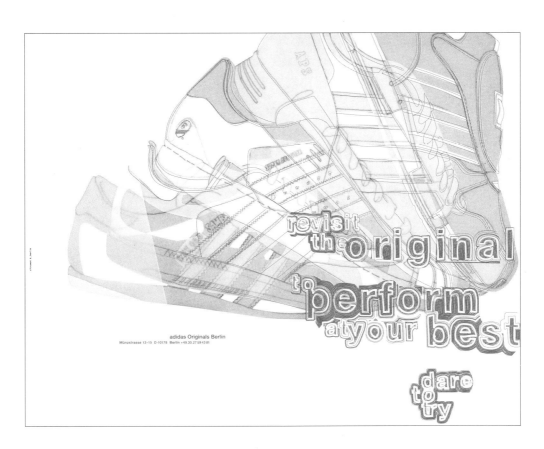

adidas Originals Berlin
Münzstrasse 13–15 D-10178 Berlin +49.30.27.59.43.81

ADVERTISEMENT

DESIGN
Thees Dohrn and
Philipp von Rohden
Berlin, Germany

ART DIRECTION
Thees Dohrn and
Philipp von Rohden

CREATIVE DIRECTION
Thees Dohrn and
Philipp von Rohden

LETTERING
Philipp von Rohden

COPYWRITER
Boris Moshkovits

DESIGN OFFICE
Zitromat

CLIENT
Adidas Originals Berlin

PRINCIPAL TYPE
Neue Helvetica and
handlettering

DIMENSIONS
16.9 x 13 in.
43 x 33 cm

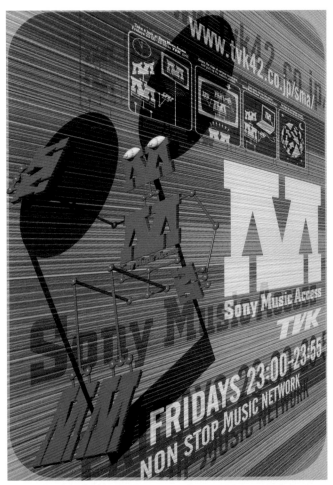

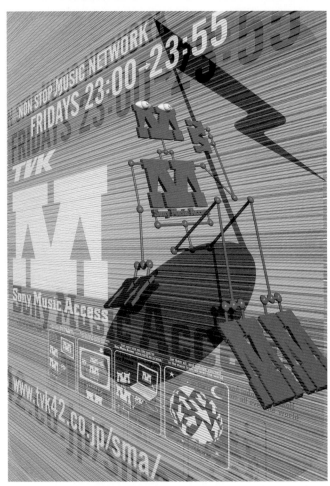

POSTER

DESIGN
Jun Takechi
Tokyo, Japan

ART DIRECTION
Jun Takechi

CREATIVE DIRECTION
Tetsuo Yamazaki
Yokohama, Japan

COPYWRITER
Etsuko Suzuki

CLIENT
Television KANAGAWA, Inc.

PRINCIPAL TYPE
Alternate Gothic No. 2
Regular

DIMENSIONS
28.7 x 40.6 in.
72.8 x 103 cm

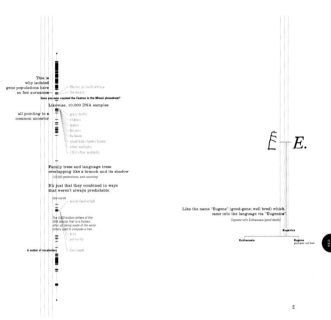

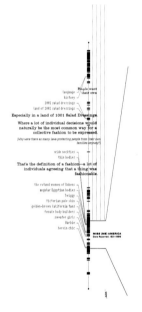

BOOK

DESIGN
Stephen Farrell
Chicago, IL

CREATIVE DIRECTION
Stephen Farrell

WRITER
Steve Tomasula
South Bend, IN

PUBLISHER
Station Hill Press

PRINCIPAL TYPE
Cholla, Clarendon,
IDE, and Univers

DIMENSIONS
5.25 x 9.1 in.
13.3 x 23.1 cm

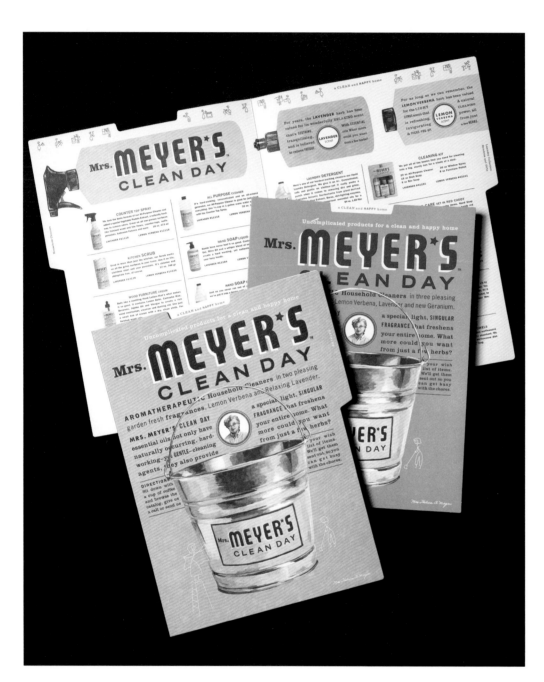

CATALOG

DESIGN
Sharon Werner
and Sarah Nelson
Minneapolis, MN

ART DIRECTION
Sharon Werner

DESIGN OFFICE
Werner Design Werks, Inc.

CLIENT
Clean & Co., LLC

PRINCIPAL TYPE
Adobe Clarendon,
Franklin Gothic,
Futura, News Gothic,
and Trade Gothic

DIMENSIONS
8.75 x 11.5 in.
22.2 x 29.2 cm

POSTER

DESIGN
Niklaus Troxler
Willisau, Switzerland

ART DIRECTION
Niklaus Troxler

LETTERING
Niklaus Troxler

DESIGN OFFICE
Niklaus Troxler Design

CLIENT
Jazz in Willisau

PRINCIPAL TYPE
VAG

DIMENSIONS
35.6. x 50.4 in.
90.5 x 128 cm

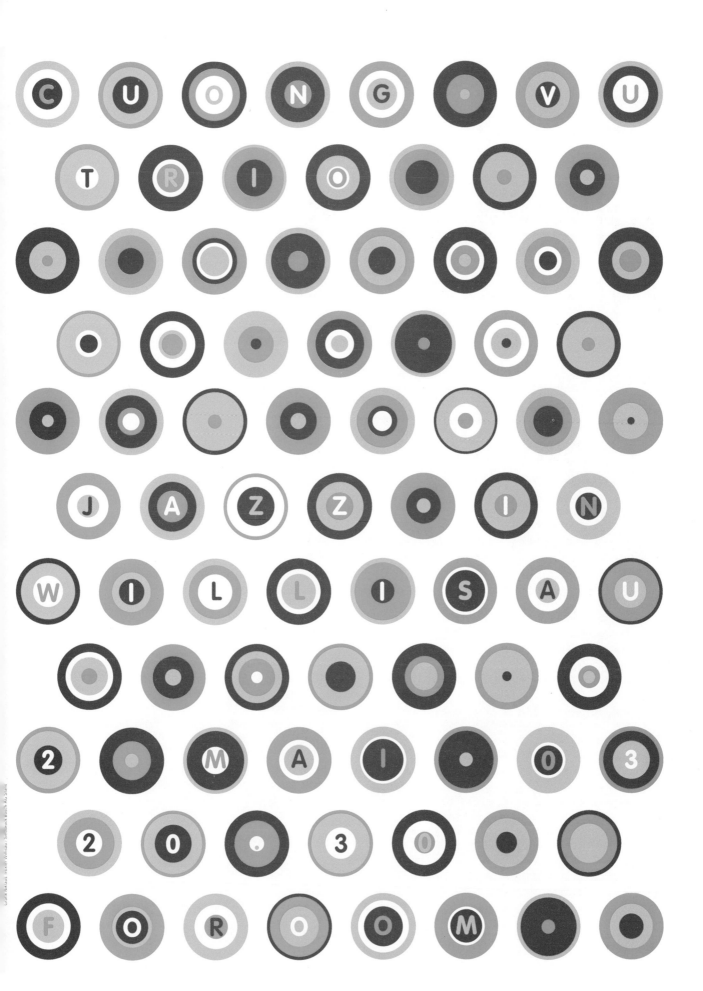

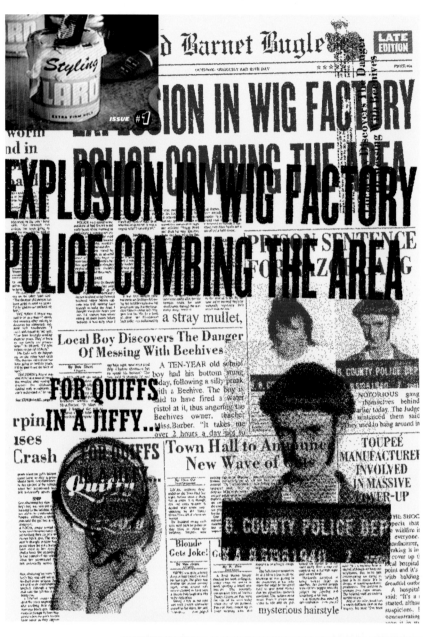

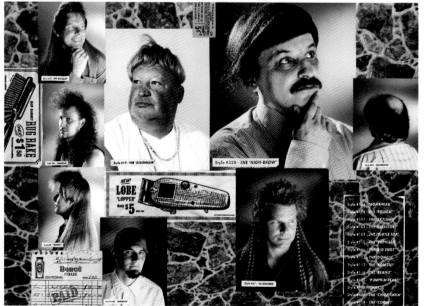

MAGAZINE

DESIGN
Mark Denton
London, England

ART DIRECTION
Mark Denton

CREATIVE DIRECTION
Mark Denton

LETTERING
Alison Carmichael

TYPOGRAPHER
Andy Dymock

DESIGN OFFICE
Mark Denton

CLIENT
Styling Lard Magazine

PRINCIPAL TYPE
Bodoni and Futura

DIMENSIONS
23.4 x 16.5 in.
59.3 x 42 cm

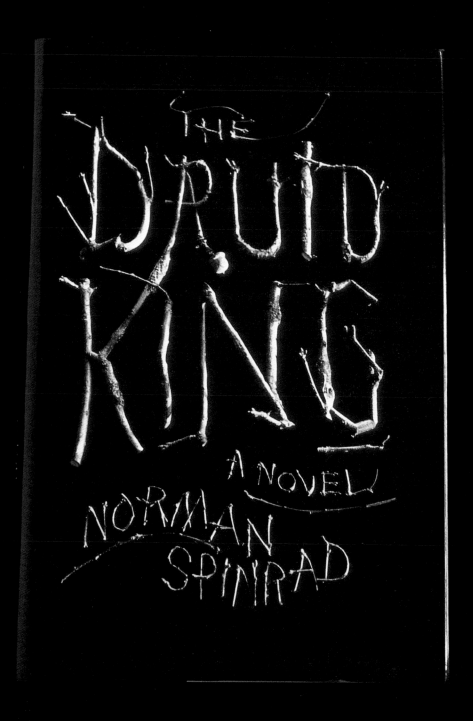

BOOK COVER

DESIGN
Stephen Doyle
New York, NY

CARPENTER
Stephen Doyle

DESIGN STUDIO
Doyle Partners

CLIENT
Knopf

PRINCIPAL TYPE
twigs

DIMENSIONS
6.5 x 9.5 in.
16.5 x 24.1 cm

POSTER

DESIGN
Dirk Wachowiak
and Paul Hoppe
New Haven, CT,
and Astoria, NY

SILK SCREEN PRINTER
Frank Kicherer
Stuttgart, Germany

CLIENT
Pforzheim University of
Applied Sciences

PRINCIPAL TYPE
Akzidenz Grotesk Extended

DIMENSIONS
23.4 x 33.1 in.
59.4 x 84.1 cm

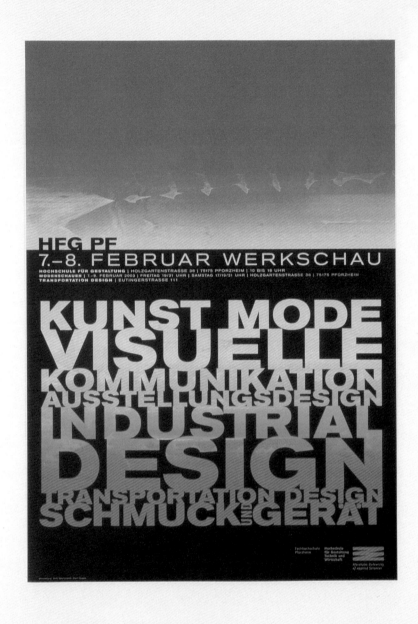

BOOK COVER

DESIGN
Ayako Akazawa
San Francisco, CA

ART DIRECTION
Sara Schneider and
Ayako Akazawa

CREATIVE DIRECTION
Sara Schneider and
Ayako Akazawa

DESIGN OFFICE
Booster Shot Cafe

PUBLISHER
Chronicle Books

PRINCIPAL TYPE
Futura and
Stempel Garamond

DIMENSIONS
5.5 x 6.5 in.
14 x 16.5 cm

WHEEL OF FORTUNE:
CHINESE ZODIAC

Chiefly the mould of a man's fortune is in his own hands.
FRANCIS BACON (1561-1626)

THE YEAR OF SHEEP

STUDENT PROJECT

DESIGN
Gee Young Lee
New York, NY

SCHOOL
School of Visual Arts

INSTRUCTOR
Sara Giovanitti

PRINCIPAL TYPE
Bauer Bodoni SC,
Futura Regular, and various

DIMENSIONS
7 x 7.75 in.
17.8 x 19.7 cm

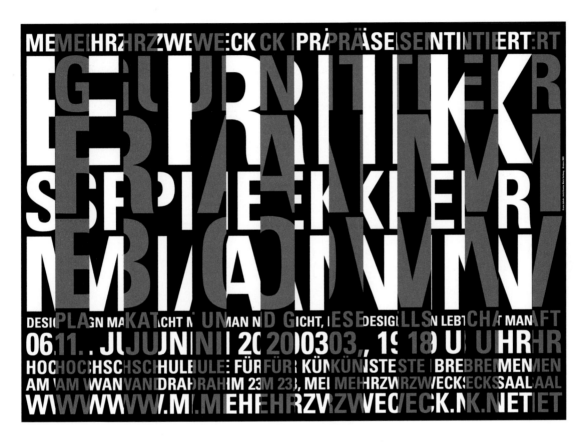

STUDENT PROJECT

DESIGN
Siena Jakobi, Jack Kraska,
and Niels Verhaag
Bremen, Germany

SCHOOL
Hochschule für Künste Bremen

PRINCIPAL TYPE
Univers Condensed

DIMENSIONS
33,1 x 23.4 in.
84.1 x 59.4 cm

VISITINGARTISTPROGRAM
LISASTRAUSFELD17SEPTE
MBERSTEVENHELLER16OC
TOBERMILTONGLASER13N
OVEMBERALLLECTURESBE
GINAT630PMKATIEMURPH
YAMPHITHEATERFASHION
INSTITUTEOFTECHNOLOGY

PACKAGING

DESIGN
Clemens Baldermann
Munich, Germany

CLIENT
Sellwell Records

PRINCIPAL TYPE
Rockwell Bold and
Rockwell Extra Bold

DIMENSIONS
12.4 x 12.4 in.
31.5 x 31.5 cm

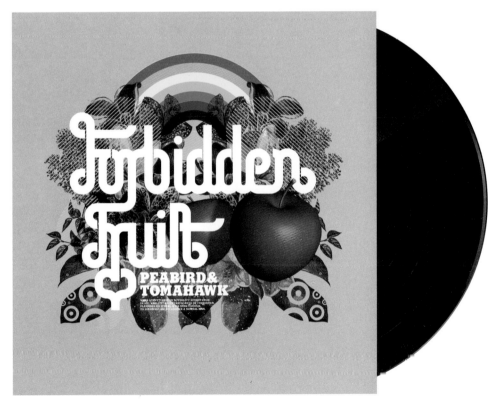

POSTER

DESIGN
Rocco Piscatello
New York, NY

ART DIRECTION
Rocco Piscatello and
Kimberly Piscatello

DESIGN OFFICE
Piscatello Design Centre

CLIENT
Fashion Institute of Technology

PRINCIPAL TYPE
Futura

DIMENSIONS
23.4 x 33.1 in.
59.4 x 84.1 cm

THURS
DY 2 00
AT
LA MARCH 1 3 TH
NOUVELLE
SCÈ NE

BEHI

DC V I D
 A R SO N

 THE

 SEN

OTTAWA
 C NADA
333 KING-EDWARD
819
777-7717

unisource

W W W . A D A - U O . M O U

ADA
ADVERTISING AND DESIGN ASSOCIATION

INVITATION

DESIGN
Mike Teixeira
Hull, Canada

ART DIRECTION
Mike Teixeira

CREATIVE DIRECTION
Manuela Teixeira

PHOTOGRAPHY
Mike Teixeira

DESIGN OFFICE
Kolegram Design

CLIENT
ADA/Advertising +
Design Association

PRINCIPAL TYPE
Johndvl

DIMENSIONS
5.5 x 4 in.
14 x 10.2 cm

POSTER

DESIGN
Mike Teixeira
Hull, Canada

ART DIRECTION
Mike Teixeira

CREATIVE DIRECTION
Manuela Teixeira

PHOTOGRAPHY
Mike Teixeira

DESIGN FIRM
Kolegram Design

CLIENT
ADA/Advertising &
Design Association

PRINCIPAL TYPE
Johndvl

DIMENSIONS
24 x 32 in.
61 x 81.3 cm

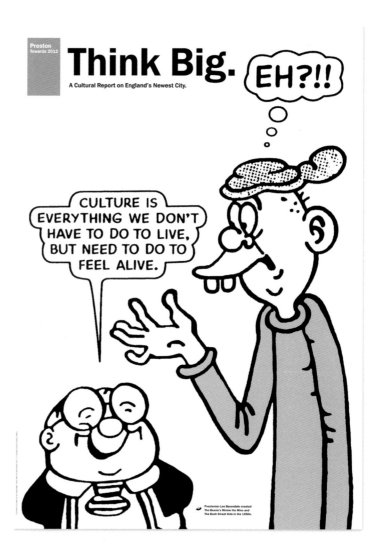

BROCHURE

DESIGN
Claire Anderton and
Ben Casey
Manchester, England

CREATIVE DIRECTION
Ben Casey

DESIGN OFFICE
The Chase

CLIENT
Preston City Council

PRINCIPAL TYPE
ITC Franklin Gothic

DIMENSIONS
27.6 x 19.7 in.
70 x 50 cm

POSTER

DESIGN
Brady Vest
Kansas City, MO

ART DIRECTION
Brady Vest

ILLUSTRATION
Michelle Dreher

STUDIO
Hammerpress

CLIENT
Eleven Productions

PRINCIPAL TYPE
Egyptian, Helenic,
Twentieth Century,
and handcarving

DIMENSIONS
14 x 22 in.
35.6 x 55.9 cm

22/4/2003 À 20H
NOUVEAU CLUB SODA DE MONTRÉAL

MONTRÉAL ★ JAZZ

Big Band

PRIX OPUS 2001 DU CQM

DIRECTION MUSICALE: PHILIPPE HUDON

★ ★ ★ ★ ★ ★ ★

PRÉSENTE SON CONCERT

PASSION

Afro-Cubaine

★ ★ ★ ★ ★ ★ ★ ★ ★

PIANISTE INVITÉE
LORRAINE DESMARAIS

PRIX OSCAR PETERSON 2002 DU FIJM

EN PREMIÈRE PARTIE, ANNE CARRIÈRE
ET LE MONTRÉAL JAZZ BIG BAND

BILLETS: 25$, 15$ (ÉTUDIANT) EN VENTE SUR LE RÉSEAU TEL-SPEC (514) 790-1111
TAXES COMPRISES, FRAIS DE SERVICE EN SUS
NOUVEAU CLUB SODA WWW.MJBB.QC.CA
1225, St-LAURENT, MONTRÉAL (514) 286-1010

★ ★ ★ ★ ★ ★ ★ ★ ★ ★

Conseil des arts
et des lettres
Québec ⊙ YAMAHA Piano Héritage Club Soda

DESIGN PAPINEAU

POSTER

DESIGN
Sebastien Bisson
Montreal, Canada

ART DIRECTION
Louis Gagnon

CREATIVE DIRECTION
Louis Gagnon

DESIGN OFFICE
Paprika Communications

CLIENT
Montreal Jazz Big Band

PRINCIPAL TYPE
Big Ed and Dalliance

DIMENSIONS
24 x 36 in.
61 x 91.4 cm

CALENDAR

DESIGN
Feldmann+Schultchen Design
Hamburg, Germany

CREATIVE DIRECTION
André Feldmann and
Arne Jacob Schultchen

LETTERING
Edgar Walthert

CONSTRUCTION
Ursula Eisen

DESIGN OFFICE
Feldmann+Schultchen Design

PRINCIPAL TYPE
OCR-B

DIMENSIONS
3.5 in.
9 cm

SELF-PROMOTION

DESIGN
Beth Middleworth
New York, NY

ART DIRECTION
Beth Middleworth

DESIGN OFFICE
Bats4bones
Design Inc.

CLIENT
C. Taylor Crothers
Photography

PRINCIPAL TYPE
Engravers Gothic and
Engravers Roman

DIMENSIONS
Various

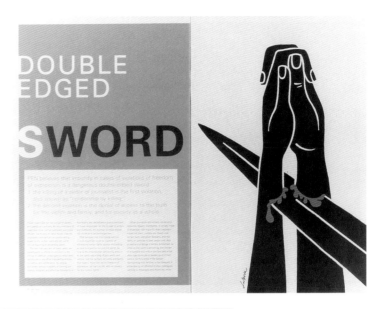

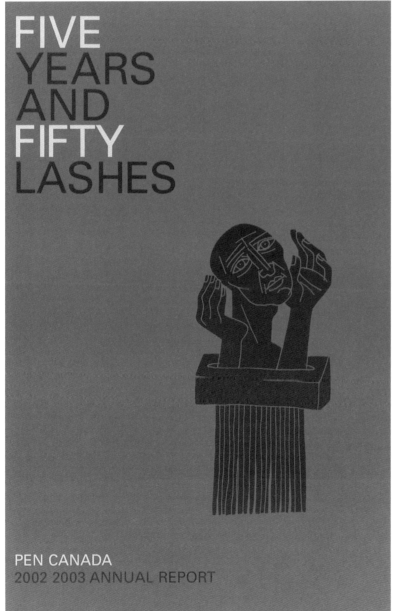

FIVE
YEARS
AND
FIFTY
LASHES

PEN CANADA
2002 2003 ANNUAL REPORT

ANNUAL REPORT

DESIGN
Jim Ryce
Toronto, Canada

ART DIRECTION
Gary Beelik

ILLUSTRATION
Luba Lukova
New York, NY

DESIGN OFFICE
Soapbox Design
Communications, Inc.

CLIENT
PEN Canada

PRINCIPAL TYPE
Adobe Univers

DIMENSIONS
11 x 17 in.
27.9 x 43.2 cm

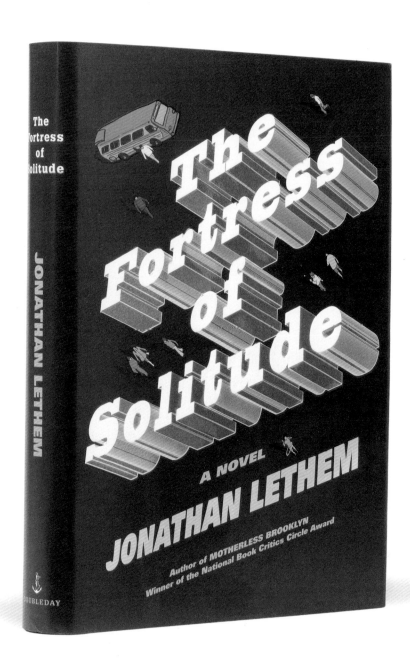

BOOK COVER

DESIGN
Marc Cozza
Portland, OR

ART DIRECTION
Umi Kenyon
New York, NY

CREATIVE DIRECTION
John Fontana
New York, NY

ILLUSTRATION
Rebecca Cohen
Portland, OR

PUBLISHER
Doubleday

PRINCIPAL TYPE
Egyptienne and
Univers

DIMENSIONS
6.4 x 9.5 in.
16.2 x 24.1 cm

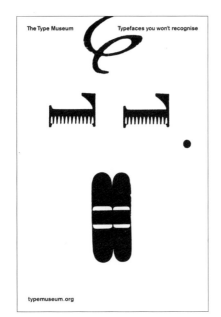

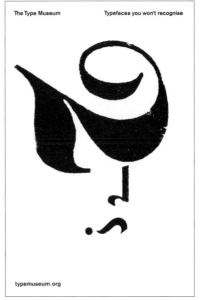

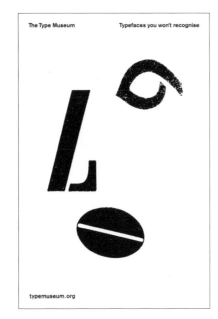

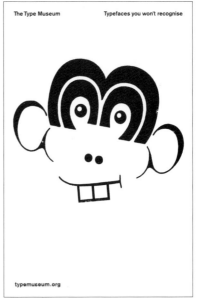

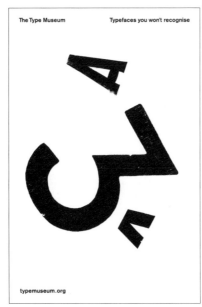

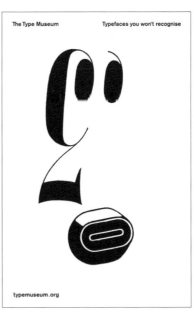

POSTER

DESIGN
Paul Belford
London, England

ART DIRECTION
Paul Belford

CREATIVE DIRECTION
Paul Belford and
Nigel Roberts

COPYWRITER
Nigel Roberts

AGENCY
AMV/BBDO

CLIENT
The Type Museum

PRINCIPAL TYPE
Various

DIMENSIONS
28.9 x 19.3 in.
73.3 x 48.9 cm

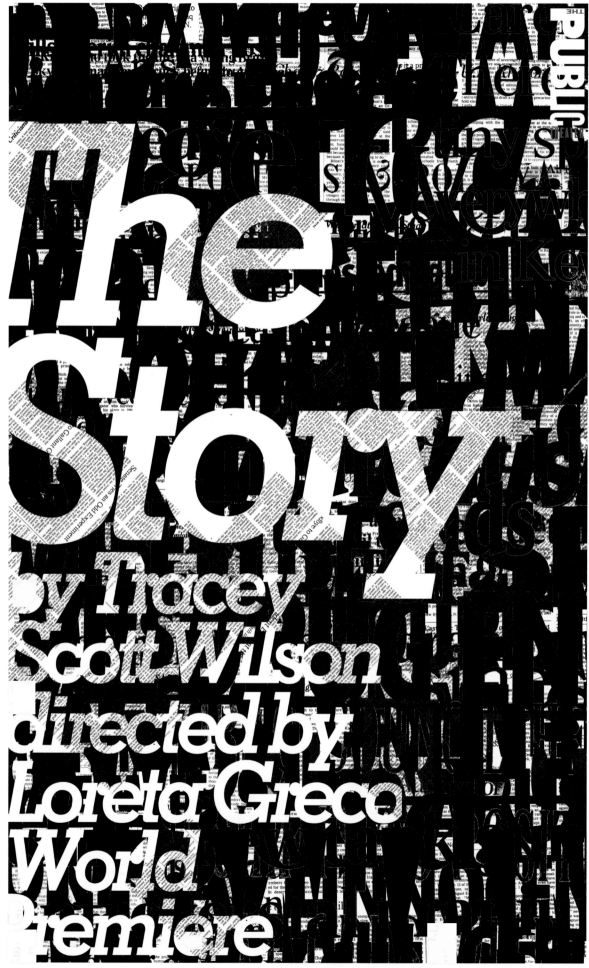

the story

by Tracey Scott Wilson

directed by Loreta Greco

World Premiere

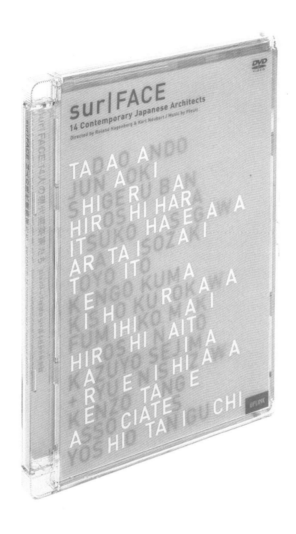

POSTER

DESIGN
Joe Marianek
New York, NY

ART DIRECTION
Paula Scher

DESIGN OFFICE
Pentagram Design Inc.

CLIENT
The Public Theater

PRINCIPAL TYPE
Memphis

DIMENSIONS
30 x 48 in.
76.2 x 121.9 cm

PACKAGING

DESIGN
Masayoshi Kodaira
Tokyo, Japan

ART DIRECTION
Masayoshi Kodaira

STUDIO
FLAME, Inc.

CLIENT
UPLINK Co.

PRINCIPAL TYPE
FF DIN

DIMENSIONS
7.4 x 5.9 in.
18.9 x 14.2 cm

PACKAGING

DESIGN
Louise Fili and
Mary Jane Callister
New York, NY

ART DIRECTION
Louise Fili

CREATIVE DIRECTION
Louise Fili

LETTERING
Louise Fili and
Mary Jane Callister

DESIGN OFFICE
Louise Fili Ltd.

CLIENT
Matt Brothers

PRINCIPAL TYPE
Handlettering

DIMENSIONS
3.9 x 4.75 in.
9.9 x 12.1 cm

Inspiration:
Where Does It Come From?

By Arthur Lubow

Raymond Loewy, the industrial designer, once said that "simplicity is the deciding factor in the aesthetic equation." So, in the spirit of good design, let's begin with a radical simplification. Artists are influenced primarily by other artists, which means that standard art history can sound like a baseball broadcast of an infield play: Velázquez to Goya to Picasso. And designers? To be sure, they are aware of the products of other designers, but their attention is not so narrowly focused. When, near the end of his life, Isamu Noguchi, who straddled the boundary between art and design, created a sculpture garden in Costa Mesa, Calif., he was unquestionably recalling the manipulations of space and perspective in the Zen gardens of Kyoto and the geometric sculptures in the observatory in Jaipur. At the same time, he was thinking of the ways in which the sets he designed as a young man for theatrical stages had, through clever lighting and placement, made a constricted space seem vast. And he was acutely conscious of the function of this sculpture garden

This letter R is made from the pieces of plastic used to keep a hat on a pair of socks from a shop display item, found in a London clothing store.

Initial letters by Paul Elliman

The Shape of Jackets to Come

To create a new world of clothing, Olivier Theyskens started with the greatest of notions — a new silhouette.

By Lynn Hirschberg

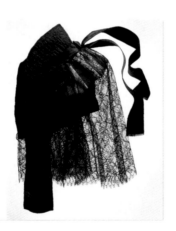

Olivier Theyskens, a 26-year-old Belgian designer, is renowned for a kind of High Goth. Marie Antoinette meets Morticia Addams sensibility, and when he received a call from the house of Rochas in early 2002, he was a little surprised. Rochas was a fine fashion name, a company known mostly for the creation of its galglee (a long-line girdle that smoothed the curves of women like Marlene Dietrich) and, more enduringly, for creating perfume that arrived in a pale pink box decorated in black lace. Although Rochas had manufactured a dress since 1960, they were not fashion. "When they phoned to ask me if I was interested in the job," Theyskens (pronounced THEGH-skins) said, calling from his atelier in Paris, "I remembered the perfume and its box. I have a passionate relationship with black lace. My grandmother, who is French, would collect black lace for me as a child. I would save it. And now I wonder if my interest started with her Rochas box. I think I have that lost in my distant memory."

The fashion world is full of moribund houses, companies that once flourished, usually from the efforts of a now-departed designer. These houses can be revived, fresh wit witnessed by the success of a bonding called the baguette. And designers from Karl Lagerfeld (at Chanel) to Stella McCartney (at Chloé) have taken classic labels and modernized them. The most vivid example of reinvigoration is Gucci, which was nearly dead when Tom Ford took over 10 years ago. Ford created some beautiful clothes and accessories, but he

Photograph by Toby McFarlan Pond

Flying in the Face
Of Mediocrity

A boutique airline called Song hired the handbag designer Kate Spade to put style in the sky. Now if only the flight attendants would stop cracking jokes.

By Jonathan Dee

Airplane travel is one of the black holes of American design. With 12 steps into any airport, and you feel yourself sucked into a kind of placelessness, a modular nightmare of function over form that ends only with your subsequent ejection into a different city. So luxury is the air of stylistic enervation that it has overcome the miracle themselves: the hours around the average airport give to nearly a Walker Evans photograph, in the shabby, heroic enervators of those whose experience has taught us to expect nothing.

So when Delta Air Lines, in its bid to launch a low-budget, low-cost cousin subsidiary to compete with smaller carriers like JetBlue and Southwest, hired as creative consultants the designer Kate Spade and her husband, Andy, it might sound — even allowing for the fact that the Spades have built an empire by saying with distance from the cutting edge, cultivating a "downtown" aesthetic for people who never actually go downtown — like a cruel joke. Andy Spade, though, insists that their proposal to create a "boutique hotel in the air" is really a rarefied one. "Whenever I get off a plane," he says, "the first thing I do is I call Kate, and she says, 'How was the flight?' and I say, 'Well, nothing more wrong.' And that's the experience we're all used to. You never say, 'The flight was great.' So we don't expect to revolutionize the entire industry for singular part is like a department store; there's only so much of the overall experience that we can control. We manage everything we can, given what the consumer expects. They don't expect a lot."

The premise of this odd partnership was a kind of happy, synergistic accident, proceeding from the fact that Delta and Kate Spade employ the same public relations firm. When a Delta representative visited the firm for initial brainstorming on how to make Song succeed where

Photographs by Zachary Scott

MAGAZINE SPREAD

DESIGN
Janet Froelich
New York, NY

ART DIRECTION
Janet Froelich

PHOTO EDITOR
Jody Quon

NEWSPAPER
The New York Times
Magazine

PRINCIPAL TYPE
Bits and Cheltenham

DIMENSIONS
9.5 x 11.75 in.
24.1 x 29.8 cm

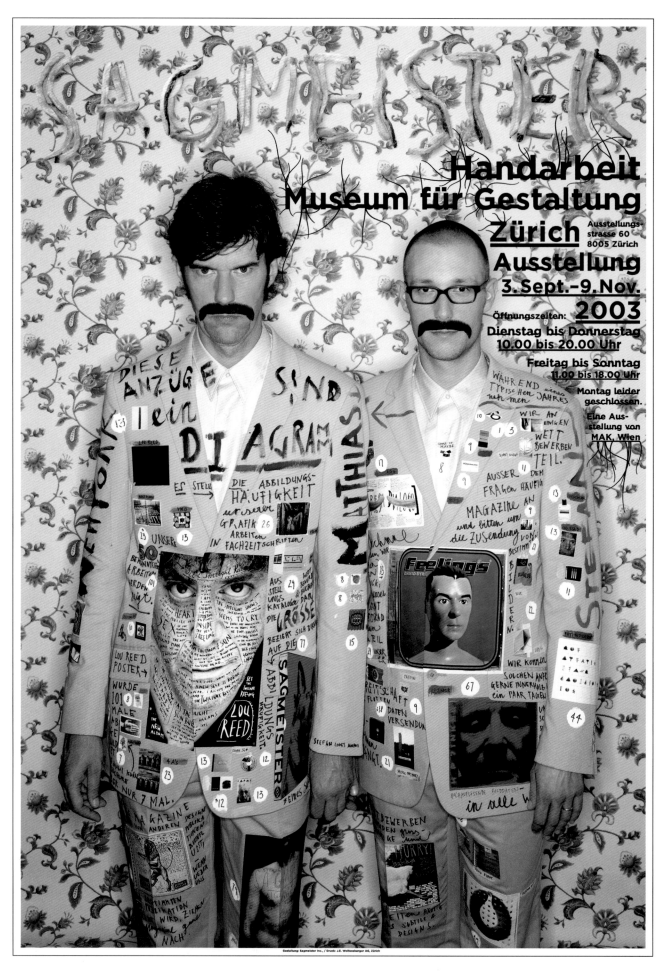

POSTER

DESIGN
Stefan Sagmeister and
Matthias Ernstberger
New York, NY

ART DIRECTION
Stefan Sagmeister

LETTERING
Stefan Sagmeister and
Matthias Ernstberger

PHOTOGRAPHY
Bela Borsodi

DESIGN OFFICE
Sagmeister, Inc.

CLIENT
Museum für Gestaltung,
Zürich

PRINCIPAL TYPE
Handlettering

DIMENSIONS
35.5 x 50.5 in.
90.2 x 128.3 cm

BOOK COVER

DESIGN
Kathleen DiGrado
New York, NY

CREATIVE DIRECTION
Susan Mitchell, Farrar Straus
& Giroux

DESIGN OFFICE
Katheen DiGrado Design

CLIENT
Farrar Straus & Giroux

PRINCIPAL TYPE
ITC Edwardian Script,
Engravers Bold, and
HTF Knockout Middleweight

DIMENSION
5.6 x 8.5 in.
14.2 x 21.6 cm

SIGNAGE

DESIGN
Masayoshi Kodaira,
Shigeki Yamane, and
Sayuri Shoji
Tokyo, Japan

ART DIRECTION
Masayoshi Kodaira

CREATIVE DIRECTION
Hideki Azuma and
Natsumi Morita

COPYWRITERS
Hideki Azuma and
Natsumi Morita

STUDIO
FLAME, Inc.

CLIENT
Mitsubishi Corp. UBS Realty

PRINCIPAL TYPE
Helvetica modified

DIMENSIONS
Various

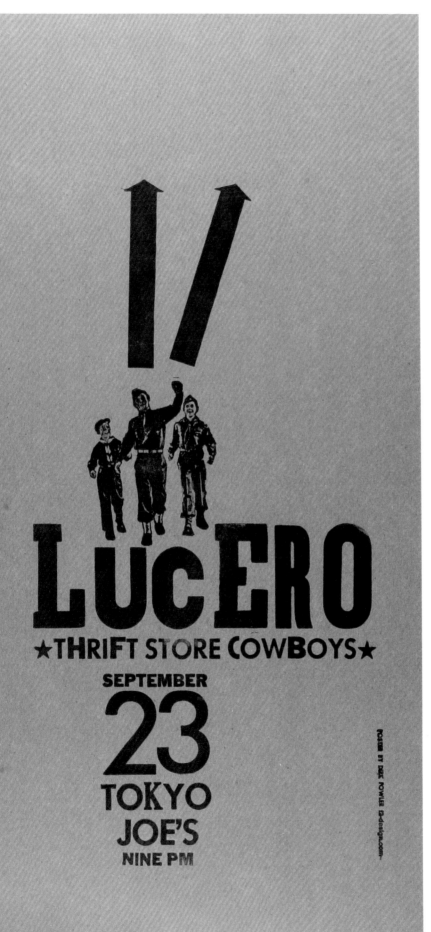

POSTER

DESIGN
Dirk Fowler
Lubbock, TX

DESIGN OFFICE
f2 design

CLIENT
Tokyo Joe's

PRINCIPAL TYPE
Various wood type

DIMENSIONS
12 x 23 in.
30.5 x 58.4 cm

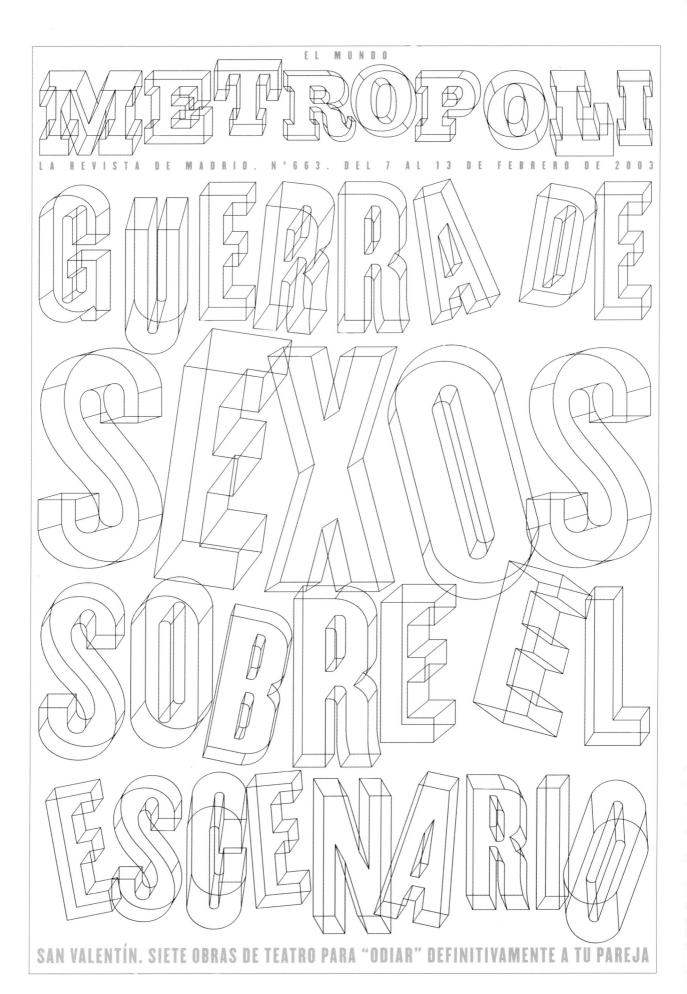

EL MUNDO

METROPOLI

LA REVISTA DE MADRID. Nº663. DEL 7 AL 13 DE FEBRERO DE 2003

GUERRA DE SEXOS SOBRE EL ESCENARIO

SAN VALENTÍN. SIETE OBRAS DE TEATRO PARA "ODIAR" DEFINITIVAMENTE A TU PAREJA

MAGAZINE COVER

DESIGN
Rodrigo Sánchez and
María González
Madrid, Spain

ART DIRECTION
Rodrigo Sánchez

CREATIVE DIRECTION
Carmelo Caderot

MAGAZINE
Unidad Editorial, S.A.
El Mundo

PRINCIPAL TYPE
HTF Champion and Giza

DIMENSIONS
7.9 x 11.2 in.
20 x 28.5 cm

CORPORATE IDENTITY

DESIGN
it'sme marielle enders
Düsseldorf, Germany

PRINCIPAL TYPE
Lucida Sans and
Lucida Typewriter

DIMENSIONS
Various

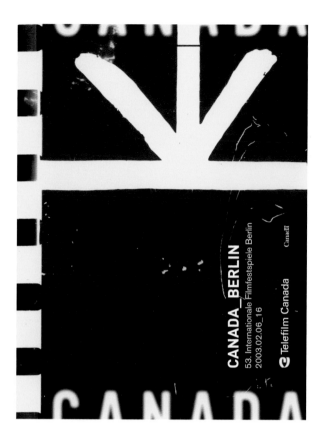

CANADA_BERLIN
53. Internationale Filmfestspiele Berlin
2003.02.06_16

Telefilm Canada

Canadä

04

MEET THE CANADIANS IN BERLIN
RENCONTREZ LES CANADIENS À BERLIN

05

TELEFILM CANADA

BUILDING AUDIENCES
À LA CONQUÊTE DES AUDITOIRES

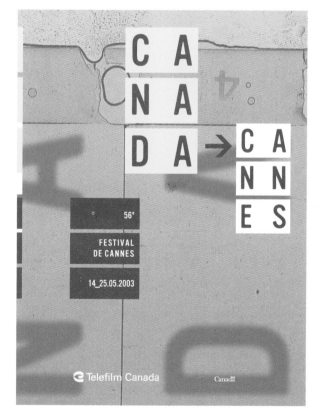

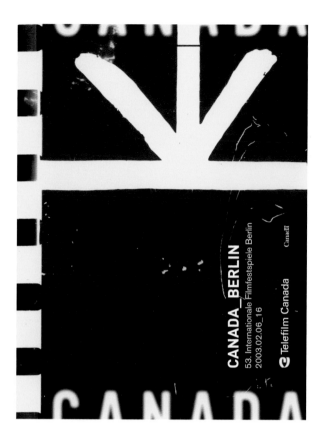

CANADA → CANNES

56e
FESTIVAL
DE CANNES
14_25.05.2003

Telefilm Canada Canadä

Photographs by Matthew Rolston

MAGAZINE SPREAD

DESIGN
Kory Kennedy
New York, NY

ART DIRECTION
Andy Cowles and
Kory Kennedy

MAGAZINE
Rolling Stone

PRINCIPAL TYPE
Housemaid

DIMENSIONS
12 x 19.5 in.
30.5 x 49.5 cm

BROCHURE

DESIGN
Anouk Pennel-Duguay
Montreal, Canada

ART DIRECTION
François Picard

DESIGN OFFICE
Épicentre

CLIENT
Telefilm Canada

PRINCIPAL TYPEFACE
Akzidenz Grotesk and
FF DIN

DIMENSIONS
6.5 x 8.5 in.
16.5 x 21.6 cm

STUDENT PROJECT

DESIGN
Hwa Shin Lee, Ben Kutil, and
Alia Chughtai
Baltimore, MD

ART DIRECTION
Hwa Shin Lee

CREATIVE DIRECTION
Hwa Shin Lee

PRINTER
Advance Printing Inc.

BINDERY
Advantage Book Binding Inc.

INSTRUCTOR
Lew Fifield

SCHOOL
Maryland Institute College of Art

PRINCIPAL TYPE
Bembo and Trade Gothic

DIMENSIONS
4.5 x 5.75 in.
11.4 x 14.6 cm

hide and seek

by deny khoung

The chromatophore system, which consists of specialized pigment cells that, controlled by muscles, mix a variety of colors until a desired effect is achieved. Octopus can change appearance as much as twenty times a minute. Along with colors, octopus can also adjust the texture of its skin. It can change from frilly to smooth to pebbly depending on the texture of the rock or coral background. This ability enables the octopus to avoid predators as well as aiding in capturing prey. The color change used for these reasons but to also reveal its moods; it turns white with fear, displays anger. During mating, a dizzying display of stripes and colors reflects its moods. The chromatophore system, which consists of specialized pigment cells, mix a variety of colors until a desired effect is achieved. Octopus can change

Sea Chameleon

Inkscreen

beat it
flee
split
cloak
blast off
vacate

STUDENT PROJECT

DESIGN
Deny Khoung
San Jose, CA

INSTRUCTOR
Chang Sik Kim

SCHOOL
San Jose State University

PRINCIPAL TYPE
FF Keedy and Meta

MAGAZINE SPREAD

DESIGN
Arem Duplessis
New York, NY

ART DIRECTION
Arem Duplessis

CREATIVE DIRECTION
Arem Duplessis

MAGAZINE
Spin Magazine

PRINCIPAL TYPE
Neue Helvetica

DIMENSIONS
16.25 x 11 in.
41.3 x 27.9 cm

POSTER

DESIGN
Niklaus Troxler
Willisau, Switzerland

ART DIRECTION
Niklaus Troxler

DESIGN OFICE
Niklaus Troxler Design

CLIENT
Jazz in Willisau

PRINCIPAL TYPE
Techno

DIMENSIONS
35.6 x 50.4 in.
90.5 x 128 cm

Jazz in Wil

Freitag 28. mä

20.30

Simon

ab

234, rue **Baronet**, C.P. 580
Sainte-Marie (Québec)
Canada G6E 3B8
T. 418 387-5431
F. 418 386-4427
http://www.baronet.ca

234, rue **Baronet**, C.P. 580
Sainte-Marie (Québec)
Canada G6E 3B8
T. 418 387-5431
F. 418 387-3028
http://www.baronet.ca

234, rue **Baronet**, C.P. 580
Sainte-Marie (Québec)
Canada G6E 3B8
T. 418 387-5431
F. 418 386-4427
http://www.baronet.ca

234, rue **Baronet**, C.P. 580
Sainte-Marie (Québec)
Canada G6E 3B8
T. 418 387-5431
F. 418 386-4427
http://www.baronet.ca

Ivan L. Lacroix
Président
ilacroix@baronet.ca

STATIONERY

DESIGN
Rene Clement
Montreal, Canada

ART DIRECTION
Rene Clement

CREATIVE DIRECTION
Louis Gagnon

DESIGN OFFICE
Paprika Communication

CLIENT
Baronet Inc.

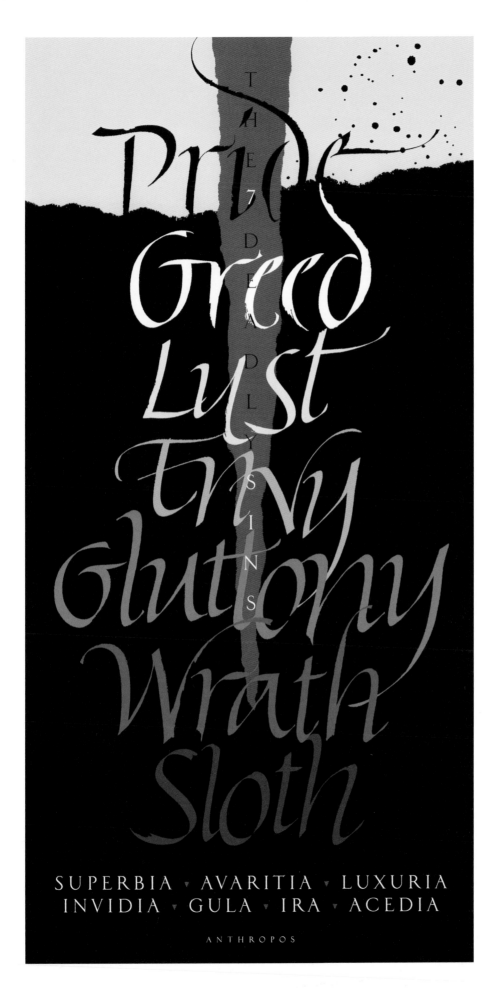

POSTER

DESIGN
Anders Bodebeck
Gothenburg, Sweden

CALLIGRAPHY
Anders Bodebeck

DESIGN OFFICE
Bodebeck Grafiskform AB

CLIENT
Anthropos

PRINCIPAL TYPE
Spartacus

DIMENSIONS
15.4 x 30.7 in.
39 x 78 cm

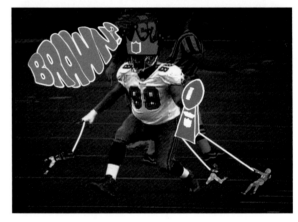

TELEVISION COMMERCIAL

DESIGN
Tom Bradley,
Tom Bruno,
Mathew Cullen,
Jesus DeFrancisco,
Chris De St. Jeor,
Linas Jodwalis,
Mike Steinmann,
and Brad Watanabe
Venice, CA

ART DIRECTION
Jesus DeFrancisco

CREATIVE DIRECTION
Brian Bacino,
Mathew Cullen,
Grady Hall, and
Matt Reinhardt

LETTERING
Carm Goode

STUDIO
Motion Theory

CLIENT
Foote, Cone & Belding,
San Francsico, and Fox

PRINCIPAL TYPE
Handlettering and custom

With or without text, a series of talks about type
presented by Creative Review and sponsored by Agfa Monotype

New type design

POSTER

DESIGN
Angus Hyland and
Sharon Hwang
London, England

ART DIRECTION
Angus Hyland

CREATIVE DIRECTION
Angus Hyland

AGENCY
Pentagram Design Ltd.

CLIENT
Pentagram Design Ltd.,
Creative Review, and
Agfa Monotype

PRINCIPAL TYPE
Minion

DIMENSIONS
26.8 x 38.6 in.
68 x 98 cm

Typography by hand

Type on screen

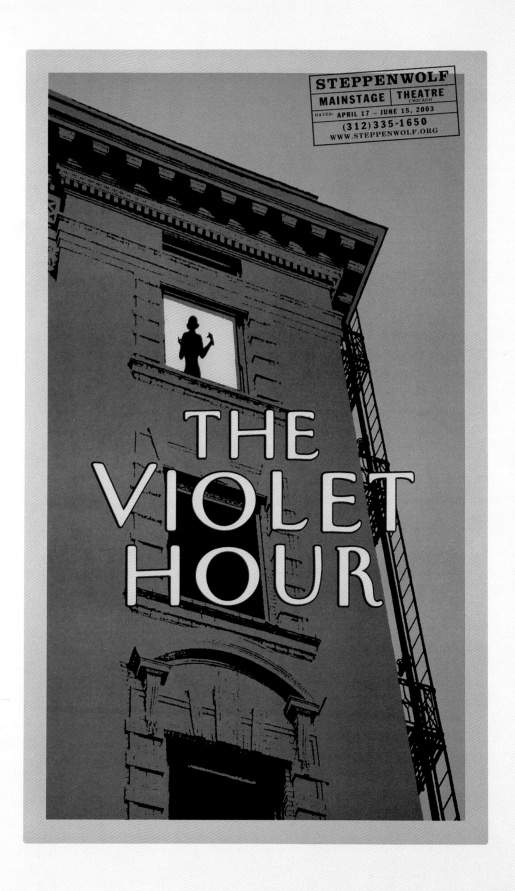

STEPPENWOLF
MAINSTAGE | THEATRE
CHICAGO
DATES: APRIL 17 – JUNE 15, 2003
(312)335-1650
WWW.STEPPENWOLF.ORG

THE
VIOLET
HOUR

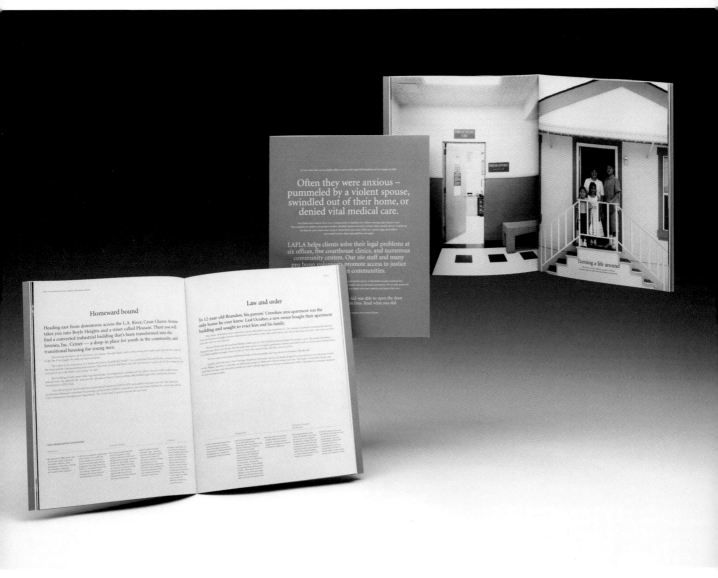

ANNUAL REPORT

DESIGN
Michael Thede
St. Louis, MO

ART DIRECTION
Deanna Kuhlmann-Leavitt

CREATIVE DIRECTION
Deanna Kuhlmann-Leavitt

PHOTOGRAPHY
Everard Williams, Jr.
Altadena, CA

DESIGN OFFICE
Kuhlmann Leavitt, Inc.

CLIENT
The Legal Aid Foundation
of Los Angeles

PRINCIPAL TYPE
Minion, Minion Expert,
and Univers 55

DIMENSIONS
8.25 x 10 in.
21 x 25.4 cm

POSTER

DESIGN
Steve Sandstrom and
David Creech
Portland, OR

ART DIRECTION
Steve Sandstrom

CREATIVE DIRECTION
Joe Sciarrotta, Ogilvy & Mather
Chicago, IL

ILLUSTRATION
Steve Sandstrom and
David Creech

DESIGN OFFICE
Sandstrom Design

CLIENT
Steppenwolf Theatre

PRINCIPAL TYPE
Century Schoolbook,
Clarendon, Franklin Gothic,
and Irvin-New Yorker

DIMENSIONS
24 x 36 in.
61 x 91.4 cm

POSTER

DESIGN
Brady Vest
Kansas City, MO

ART DIRECTION
Brady Vest

STUDIO
Hammerpress

CLIENT
Eleven Productions

PRINCIPAL TYPE
Various lead and wood type
and ornaments

DIMENSIONS
14 x 22 in.
35.6 x 55.9 cm

CORPORATE IDENTITY

DESIGN
Sarah Nelson and
Sharon Werner
Minneapolis, MN

ART DIRECTION
Sharon Werner

LETTERING
Sarah Nelson

DESIGN OFFICE
Werner Design Werks, Inc.

CLIENT
TVbyGirl

PRINCIPAL TYPE
ITC Franklin Gothic

DIMENSIONS
Various

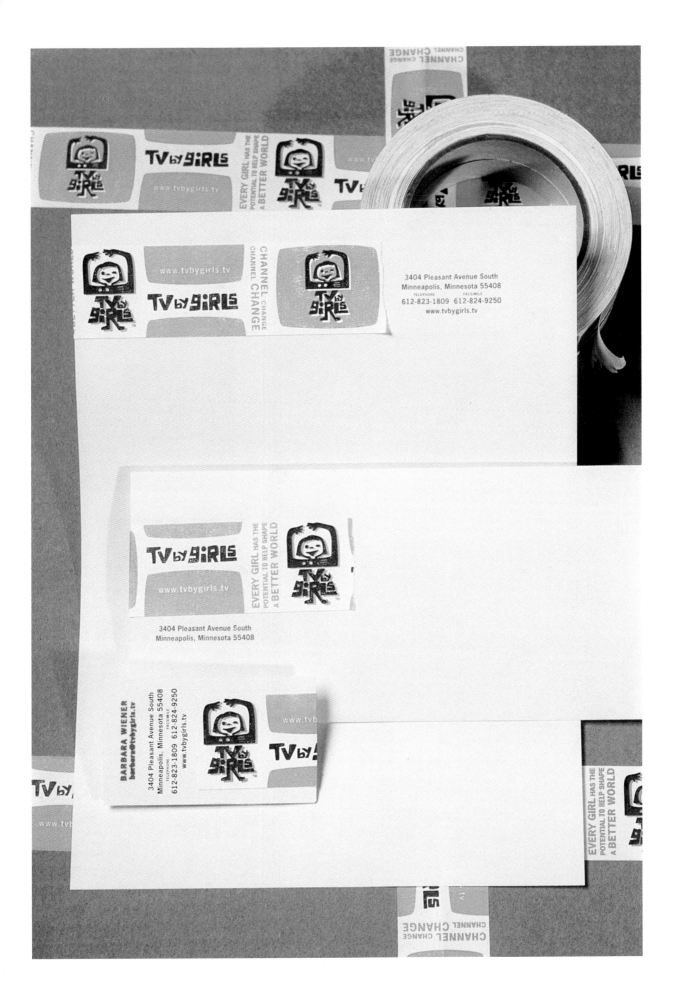

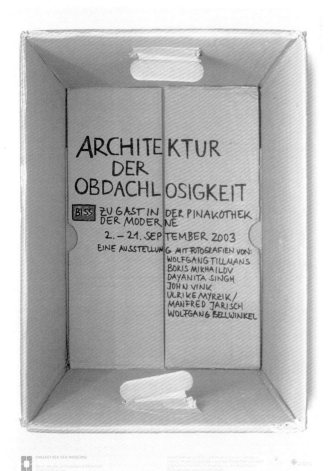

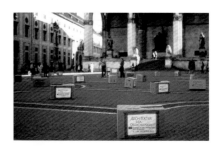

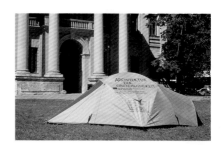

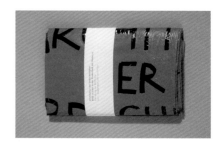

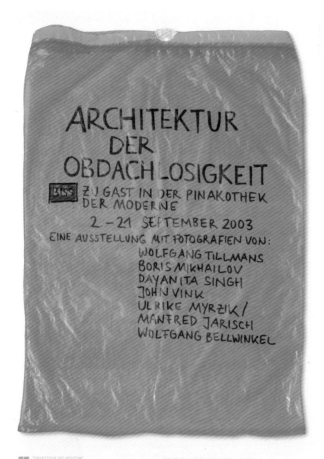

ADVERTISEMENT

DESIGN
Sabine Moll, Päivi Helander,
and José de Ameida
Unterhaching, Germany

ART DIRECTION
Marie-Luise Dorst and
José de Ameida

CREATIVE DIRECTION
Joerg Jahn and
Ralph Taubenberger

PHOTOGRAPHY
Peter Weber

AGENCY
Heye & Partner GmbH

CLIENT
BISS e.V.

PRINCIPAL TYPE
FF DIN Bold, FF DIN
Regular, and
handwriting

DIMENSIONS
Various

CATALOG

DESIGN
Petra Michel and Florian Pfeffer
Bremen, Germany

DESIGN OFFICE
jung und pfeffer: visuelle kommunikation

CLIENT
Ouput Foundation

PRINCIPAL TYPE
Cachet, Dalliance Script Display, and Dolly

DIMENSIONS
9.1 x 13 in.
23 x 33 cm

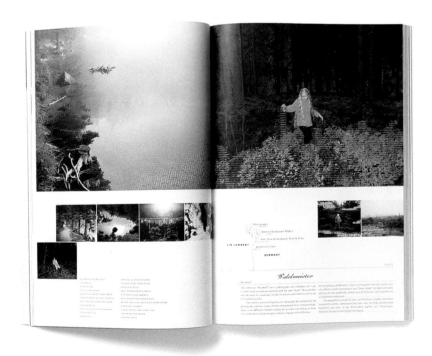

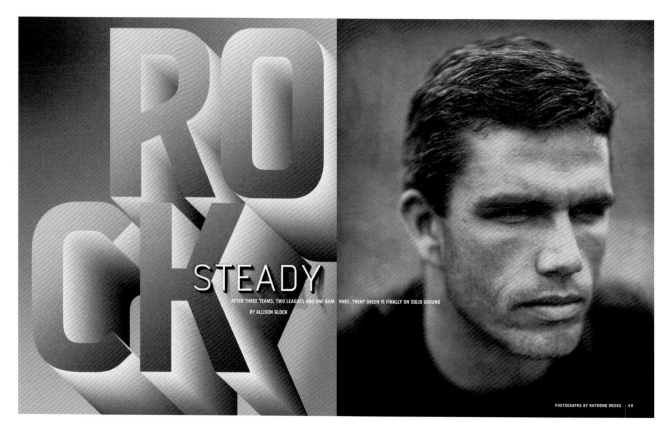

ROCK

STEADY

AFTER THREE TEAMS, TWO LEAGUES AND ONE BUM KNEE, TRENT GREEN IS FINALLY ON SOLID GROUND

BY ALLISON GLOCK

PHOTOGRAPHS BY RAYMOND MEEKS | 49

MAGAZINE SPREAD

DESIGN
Siung Tjia
New York, NY

ART DIRECTION
Siung Tjia

MAGAZINE
ESPN The Magazine

PRINCIPAL TYPE
ESPN Gothic and
Trade Gothic

DIMENSIONS
20 x 12 in.
50.8 x 30.5 cm

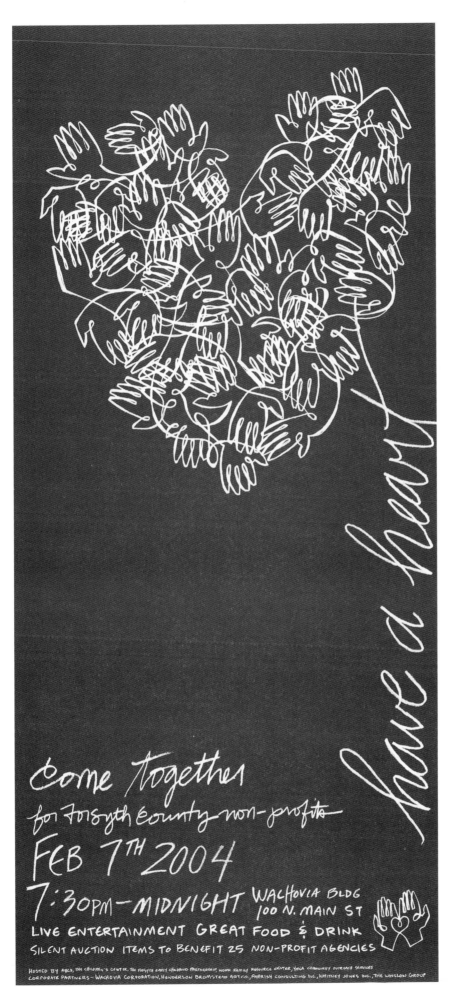

POSTER

DESIGN
Michelle White
Winston-Salem, NC

ART DIRECTION
Hayes Henderson

LETTERING
Michelle White

DESIGN OFFICE
HendersonBromsteadArtCo.

CLIENT
Forsyth County
Non-Profit Organizations

PRINCIPAL TYPE
Handlettering

DIMENSIONS
16 x 35 in.
40.6 x 88.9 cm

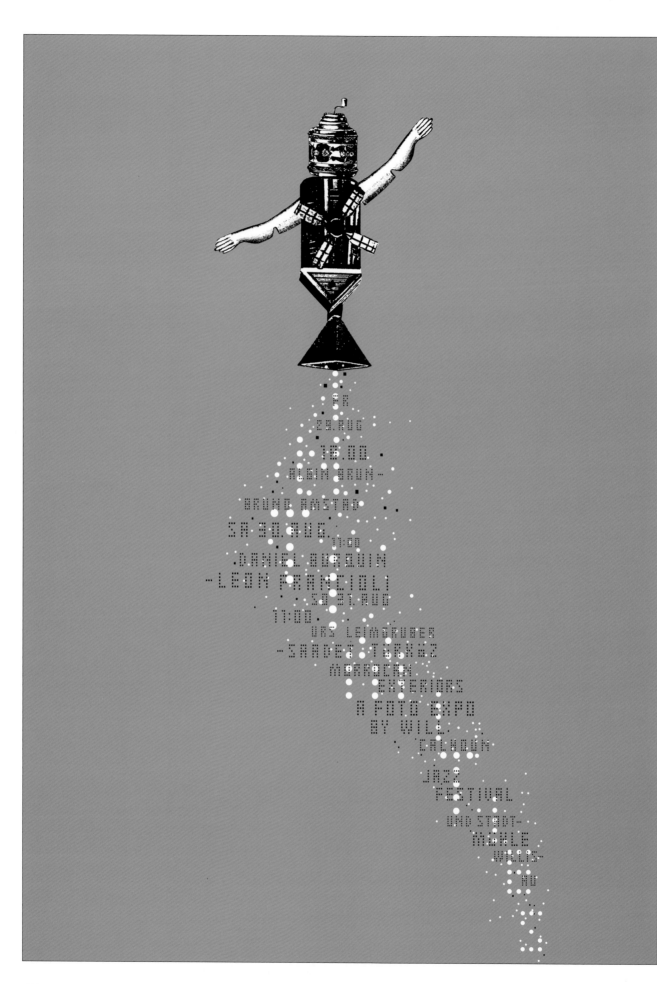

ANNUAL REPORT

DESIGN
Anke von Bremen
Düsseldorf, Germany

ART DIRECTION
Anke von Bremen

LETTERING
Anke von Bremen

PHOTOGRAPHY
Rüdiger Nehmzow and
Robin Merkisch

TEXT
Norbert Herwig, Plan C

DESIGN OFFICE
Gestaltung von Bremen
Düsseldorf

CLIENT
Ströer Out-of-Home Media AG

PRINCIPAL TYPE
Futura, Frutiger, and
Frutiger Condensed

DIMENSIONS
9.5 x 11.9 in.
24 x 30.3 cm

POSTER

DESIGN
Annik Troxler
Lausanne, Switzerland

CREATIVE DIRECTION
Niklaus Troxler
Willisau, Switzerland

CLIENT
Jazz in Willisau

PRINCIPAL TYPE
Jazz03

DIMENSIONS
35.6 x 50.4 in.
90.5 x 128 cm

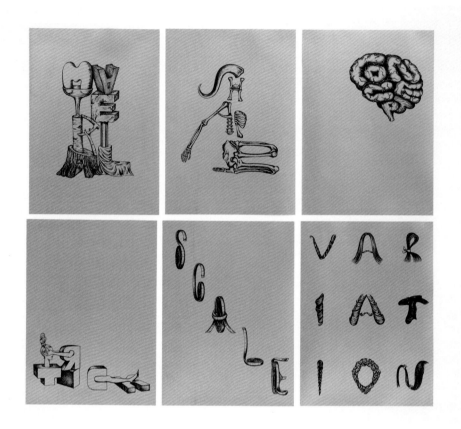

BOOK TITLE PAGES

DESIGN
Masayoshi Kodaira
and Shigeki Yamane
Tokyo, Japan

ART DIRECTION
Masayoshi Kodaira

ILLUSTRATION
Shigeki Yamane
and Yuriko

EDITOR
Kaoru Takahashi

STUDIO
FLAME, Inc.

CLIENT
PIE Co., Ltd.

PRINCIPAL TYPE
Handlettering

DIMENSIONS
11.8 x 8.8 in.
30 x 22.4 cm

EXHIBITION

DESIGN
Clayton Dixon
Christchurch, New Zealand

ART DIRECTION
Guy Pask and
Douglas Maclean

CREATIVE DIRECTION
Guy Pask

AGENCY
Strategy Advertising
and Design

CLIENT
Christchurch Art Gallery
Te Puna o Waiwhetu

PRINCIPAL TYPE
Aspect/Christchurch Bold
and Bliss Light

DIMENSIONS
Various

OVER 80 GARMENTS FROM THE WORLD'S GREATEST FASHION DESIGNERS

JAPONISM IN FASHION

ISSEY MIYAKE YVES ST LAURENT JEAN-PAUL GAULTIER JOHN GALIANO
THE KYOTO COSTUME INSTITUTE CHRISTIAN DIOR COMME DES GARÇONS
YVES ST LAURENT AMY BEER GIVENCHY JUN TAKAHASHI CHRISTIAN DIOR
ISSEY MIYAKE YVES ST LAURENT JOHN GALIANO GIVENCHY
CHRISTIAN DIOR COMME DES GARÇONS DOEUILET YVES ST LAURENT AMY LINKER
GIVENCHY JUN TAKAHASHI CHRISTIAN DIOR ISSEY MIYAKE ROUFF OF PARIS
COCO CHANEL COMME DES GARÇONS CHRISTIAN DIOR DOEUILET
YVES ST LAURENT MADELEINE VIONNET AMY LINKER GIVENCHY
CHRISTIAN DIOR ISSEY MIYAKE RO· ·IS JOHN GALIANO YVES ST LAURENT
THE MISSES TURNER CHRISTI·
·YES ST LAUR·
·YMI

·RICK · ·AUR· ·AMI LINKER BEER CHRISTIAN ·
JUN TAKAHAS ·HANEL IS· ·Y MIYAKE JOHN GIVENCHY THE KYOTO COS·
CHRISTIAN DIOR· ·IE DES· ·RÇONS DOEUILET YVES ST LAURENT AMY LINKE
GIVENCHY JUN TAK· ·RISTIAN DIOR ISSEY MIYAKE
THE MISSES TURNER CH·· ·AN DIOR COMME DES GARÇONS
YVES ST LAURENT AMY LINKER WORTH COCO CHANEL BEER GIVENCHY
ISSEY MIYAKE MADELEINE VIONNET ROUFF OF PARIS JOHN GALIANO GIVENCHY
THE MISSES TURNER CHRISTIAN DIOR COMME DES GARÇONS DOEUILET
AMY LINKER BEER GIVENCHY JUN TAKAHASHI CHRISTIAN DIOR ISSEY MIYAKE
YVES ST LAURENT CHRISTIAN DIOR COMME DES GARÇONS DOEUILET AMY LINKER

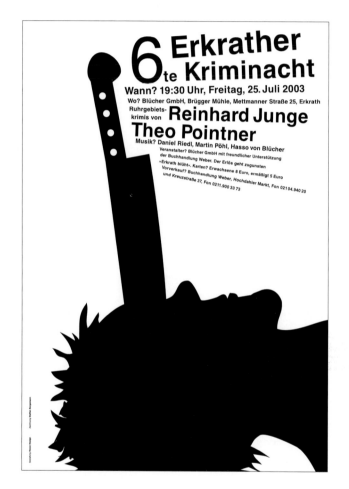

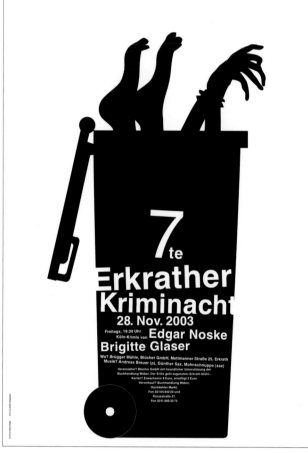

POSTER

DESIGN
Klaus Hesse and
Steffen Bergemann
Erkrath, Germany

DESIGN OFFICE
Hesse Design

CLIENT
Hasso von Blücher

PRINCIPAL TYPE
Helvetica

DIMENSIONS
27.6 x 39.4 in.
70 x 100 cm

BROCHURE

DESIGN
Jan Maier and Joerg Bauer
Stuttgart, Germany

ART DIRECTION
Jan Maier and Joerg Bauer

CREATIVE DIRECTION
Joerg Bauer

DESIGN OFFICE
joergbauerdesign

CLIENT
Undercover

PRINCIPAL TYPE
Helvetica

DIMENSIONS
8.3 x 10.6 in.
21 x 27 cm

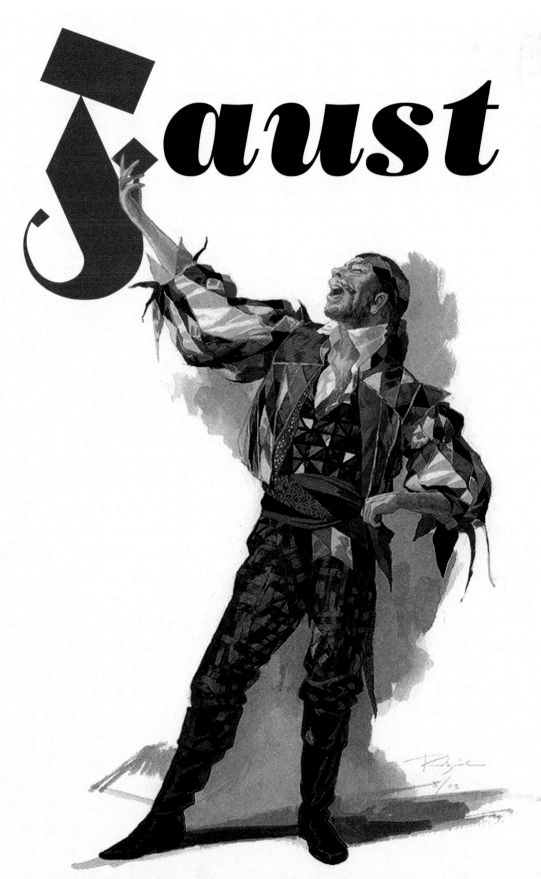

Faust

2003 **LYRIC OPERA OF CHICAGO** 2004

POSTER MADE POSSIBLY BY A GENEROUS GIFT FROM WINSTON & STRAWN

THE ISLANDS OF
THE bahamas

POSTER

DESIGN
Rick Valicenti and
Rob Irrgang
Barrington, IL

ART DIRECTION
Rick Valicenti

ILLUSTRATION
Bob Perdziola
New York, NY

DESIGN OFFICE
Thirst 3ST.com

CLIENT
Lyric Opera of Chicago

PRINCIPAL TYPE
Lyric, Bastard, and
Poster Bodoni

DIMENSIONS
24 x 36 in.
61 x 91.4 cm

LOGOTYPE

DESIGN
David Mashburn
and Jeff Hale
New York, NY

DESIGN DIRECTION
Dan Olson
Minneapolis, MN

CREATIVE DIRECTION
Joe Duffy
Minneapolis, MN

PRODUCTION ARTIST
Aaron Padin

DESIGN OFFICE
Duffy

CLIENT
The Bahamas Ministry
of Tourism

PRINCIPAL TYPE
HTF Gotham Medium
and custom typeface

CORPORATE IDENTITY

DESIGN
Patrick Bittner
Saarbücken, Germany

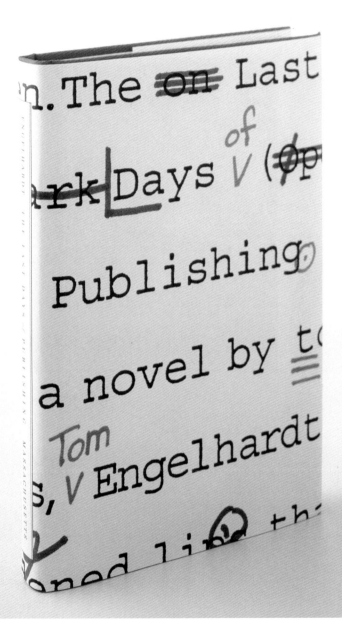

BOOK

DESIGN
Louise Fili and
Chad Roberts
New York, NY

ART DIRECTION
Louise Fili

CREATIVE DIRECTION
Louise Fili

DESIGN OFFICE
Louise Fili Ltd.

CLIENT
University of
Massachusetts Press

PRINCIPAL TYPE
Courier

DIMENSIONS
5.9 x 8.75 in.
15 x 22.2 cm

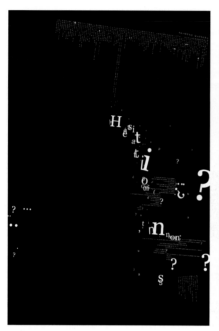

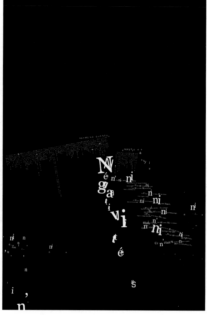

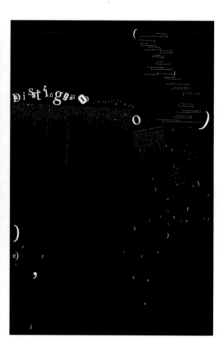

STUDENT PROJECT

DESIGN
Maryse Verreault
Montreal, Canada

SCHOOL
École de design, UQAM

INSTRUCTOR
Judith Poirier

PRINCIPAL TYPE
Eurostile, Euorstile Bold,
and Georgia

DIMENSIONS
20 x 30 in.
50.8 x 76.2 cm

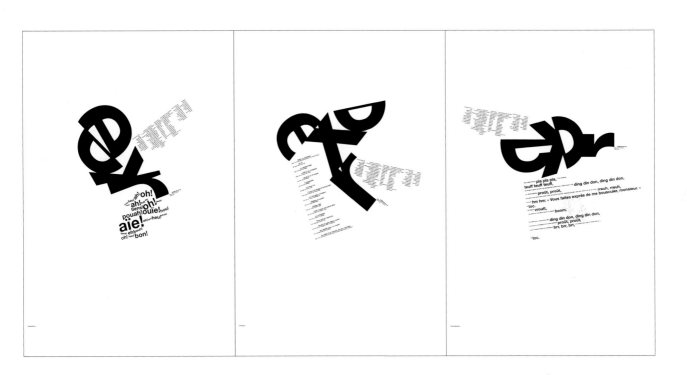

STUDENT PROJECT

DESIGN
Catherine Laporte
Montreal, Canada

SCHOOL
École de design, UQAM

INSTRUCTOR
Judith Poirier

PRINCIPAL TYPE
Neue Helvetica

DIMENSIONS
24 x 36 in.
61 x 91.4 cm

2003. ES GUETS NEUS... UND AUF
DASS ES SICH AUSZAHLEN WIRD!
JANUAR 1 2 3 4 5 6 7 8 9 10 11 12 13 14
15 16 17 18 19 20 21 22 23 24 25 26 27
28 29 30 31 FEBRUAR 1 2 3 4 5 6 7 8
9 10 11 12 13 14 15 16 17 18 19 20 21
22 23 24 25 26 27 28 MÄRZ 1 2 3 4
5 6 7 8 9 10 11 12 13 14 15 16 17 18
19 20 21 22 23 24 25 26 27 28 29 30 31
APRIL 1 2 3 4 5 6 7 8 9 10 11 12 13 14
15 16 17 18 19 20 21 22 23 24 25 26
27 28 29 30 MAI 1 2 3 4 5 6 7 8 9
10 11 12 13 14 15 16 17 18 19 20 21 22
23 24 25 26 27 28 29 30 31 JUNI 1 2
3 4 5 6 7 8 9 10 11 12 13 14 15 16 17 18
19 20 21 22 23 24 25 26 27 28 29 30
JULI 1 2 3 4 5 6 7 8 9 10 11 12 13 14
15 16 17 18 19 20 21 22 23 24 25 26 27
28 29 30 31 AUGUST 1 2 3 4 5 6 7 8
9 10 11 12 13 14 15 16 17 18 19 20 21
22 23 24 25 26 27 28 29 30 31 SEP
TEMBER 1 2 3 4 5 6 7 8 9 10 11 12
13 14 15 16 17 18 19 20 21 22 23 24
25 26 27 28 29 30 OKTOBER 1 2 3 4
5 6 7 8 9 10 11 12 13 14 15 16 17 18
19 20 21 22 23 24 25 26 27 28 29 30 31
NOVEMBER 1 2 3 4 5 6 7 8 9 10 11 12
13 14 15 16 17 18 19 20 21 22 23 24 25
26 27 28 29 30 DEZEMBER 1 2 3 4 5
6 7 8 9 10 11 12 13 14 15 16 17 18 19
20 21 22 23 24 25 26 27 28 29 30 31
BÖSCH SIEBDRUCK AG STANS

POSTER

DESIGN
Niklaus Troxler
Willisau, Switzerland

ART DIRECTION
Niklaus Troxler

LETTERING
Niklaus Troxler

DESIGN OFFICE
Niklaus Troxler Design

CLIENT
Bösch Siebdruck Stans

PRINCIPAL TYPE
Rubber stamp letters

DIMENSIONS
35.4 x 50.4 in.
90 x 128 cm

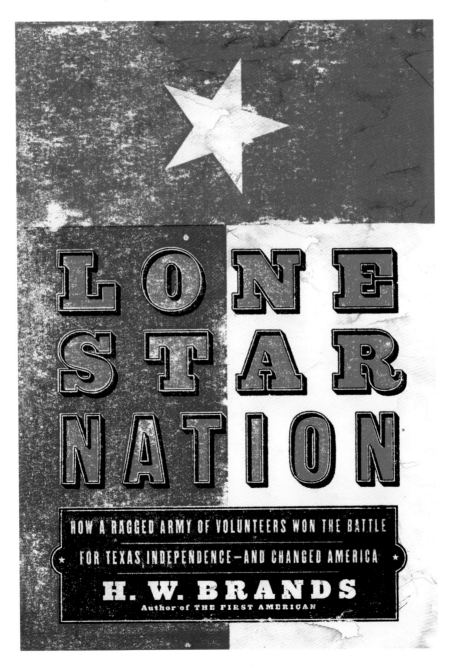

BOOK COVER

DESIGN
Rex Bonomelli
New York, NY

ART DIRECTION
Rex Bonomelli

CREATIVE DIRECTION
John Fontana

PUBLISHER
Doubleday

PRINCIPAL TYPE
Opti Morgan-One
and HTF Ziggurat

DIMENSIONS
6.4 x 9.25 in.
16.3 x 23.5 cm .

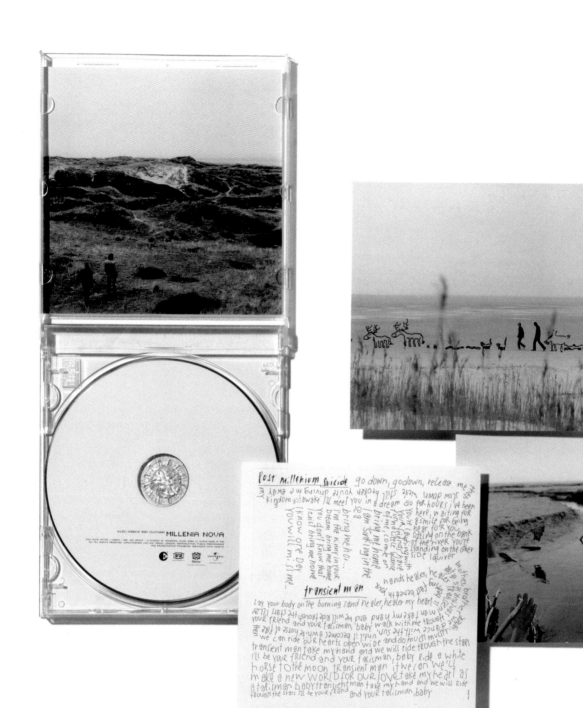

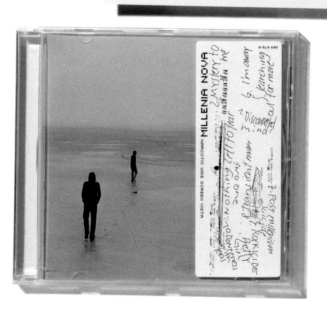

PACKAGING

DESIGN
Stefan Bogner and
Fritz Schneider
Munich, Germany

ART DIRECTION
Stefan Bogner

CREATIVE DIRECTION
Stefan Bogner

LETTERING
Fritz Schneider

AGENCY
Factor Product GmbH

CLIENT
Sony Columbia Germany

PRINCIPAL TYPE
Hi Log In

DIMENSIONS
4.5 x 5.5 in.
11.4 x 14 cm

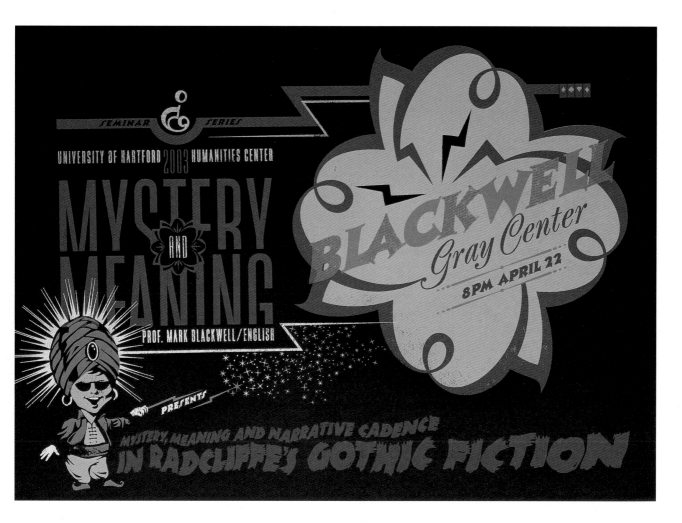

POSTER

DESIGN
John Nordyke
West Hartford, CT

PRINTER
John Nordyke

DESIGN OFFICE
Nordyke Design

CLIENT
UHA Humanities Center

PRINCIPAL TYPE
Exquisit, Jazz Poster,
Zombie, and
Zurich Extra Condensed

DIMENSIONS
28 x 20 in.
71.1 x 50.8 cm

Wishing you a brilliant holiday

CARD

DESIGN
Emily Mitchell
New York, NY

CREATIVE DIRECTION
Billie Harber and
Randall Hensley

DESIGN OFFICE
Industrie Brand Partners, Inc.

CLIENT
IBM Marketing

PRINCIPAL TYPE
Helvetica

DIMENSIONS
4.5 x 5.5 in.
11.4 x 14 cm

BROCHURE

ART DIRECTION
Christian Toensmann
Hamburg, Germany

CREATIVE DIRECTION
Johannes Erler

DESIGN OFFICE
Factor Design AG

PRINCIPAL TYPE
Alternate Gothic
and Dolly

DIMENSIONS
8.5 x 11 in.
21.5 x 28 cm

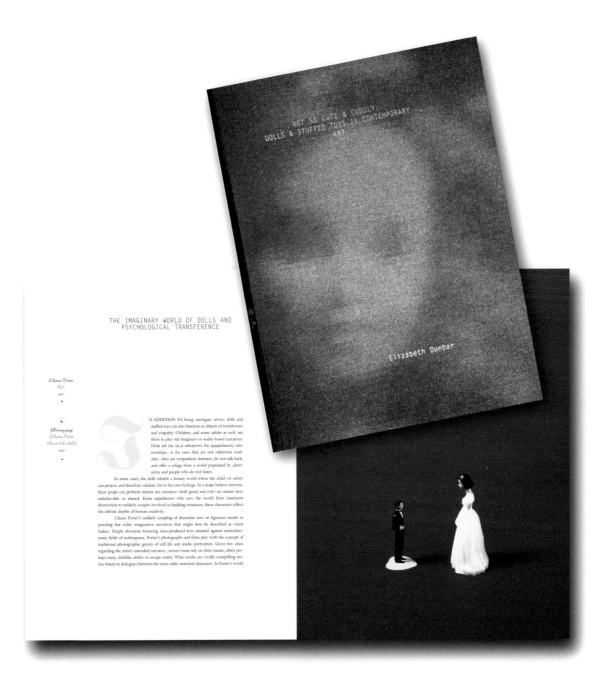

THE IMAGINARY WORLD OF DOLLS AND
PSYCHOLOGICAL TRANSFERENCE

Liliana Porter
No!
2001

•

following page
Liliana Porter
(Dream Self- (still)
2000

•

I N ADDITION TO being surrogate selves, dolls and stuffed toys can also function as objects of transference and empathy. Children, and some adults as well, use them to play out imaginary or reality-based narratives. Dolls are the ideal substitutes for unsatisfactory relationships, or for ones that are not otherwise available—they are sympathetic listeners, do not talk back, and offer a refuge from a world populated by adversaries and people who do not listen.

In some cases, the dolls inhabit a fantasy world where the child (or artist) can project, and therefore validate, his or her own feelings. In a make-believe universe, these props can perform almost any scenario—both good and evil—no matter how unbelievable or absurd. From superheroes who save the world from imminent destruction to unlikely couples involved in budding romances, these characters reflect the infinite depths of human creativity.

Liliana Porter's unlikely coupling of dissimilar toys or figurines results in puzzling but richly imaginative narratives that might best be described as visual haikus. Simple dioramas featuring mass-produced toys situated against monochromatic fields of nothingness, Porter's photographs and films play with the concept of traditional photographic genres of still life and studio portraiture. Given few clues regarding the artist's intended narrative, viewers must rely on their innate, albeit perhaps rusty, childlike ability to escape reality. What results are vividly compelling stories based on dialogues between the most oddly-matched characters. In Porter's world

CATALOG

DESIGN
Dominik D'Angelo
Wichita, KS

ART DIRECTION
Dominik D'Angelo

DESIGN OFFICE
Wichita State University,
Media Resources Center

CLIENT
Ulrich Museum of Art

PRINCIPAL TYPE
Fette Fraktur, ITC Galliard,
and Letter Gothic

DIMENSIONS
8.5 x 11 in.
21.6 x 27.9 cm

POSTER

DESIGN
Mike Joyce
New York, NY

ART DIRECTION
Mike Joyce

CREATIVE DIRECTION
Mike Joyce

DESIGN OFFICE
Stereotype Design

CLIENT
The Juliana Theory

PRINCIPAL TYPE
HTF Champion

DIMENSIONS
18 x 24 in.
45.7 x 61 cm

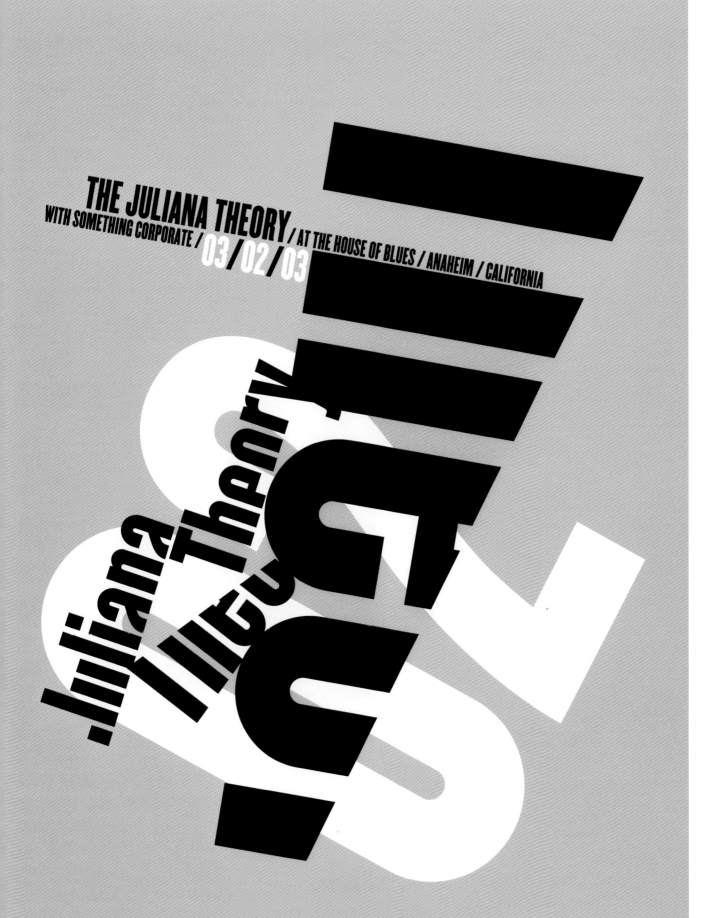

THE JULIANA THEORY
WITH SOMETHING CORPORATE / AT THE HOUSE OF BLUES / ANAHEIM / CALIFORNIA
03 / 02 / 03

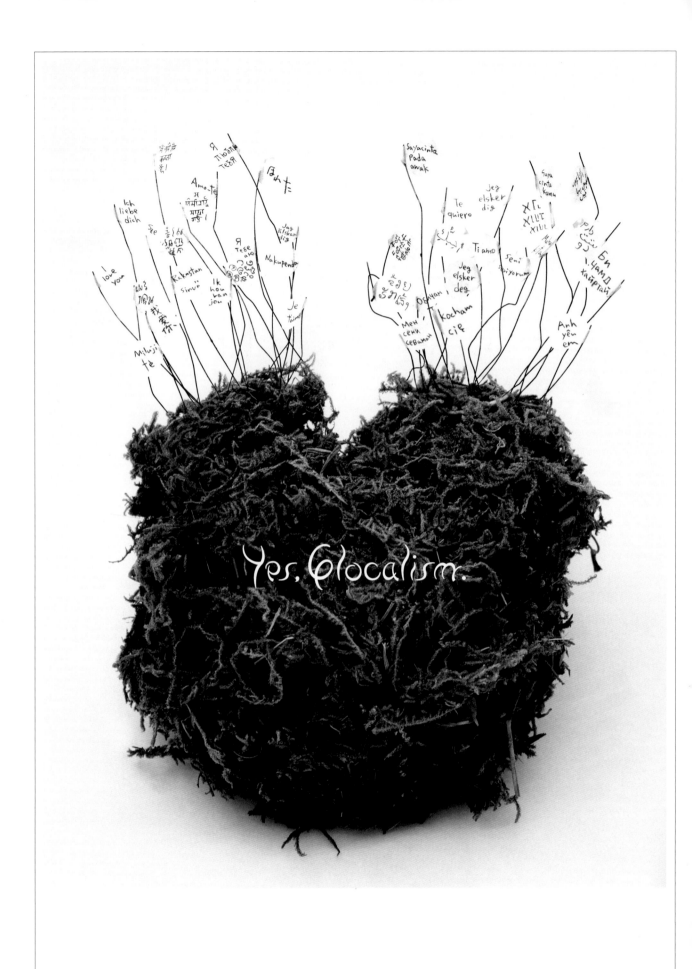

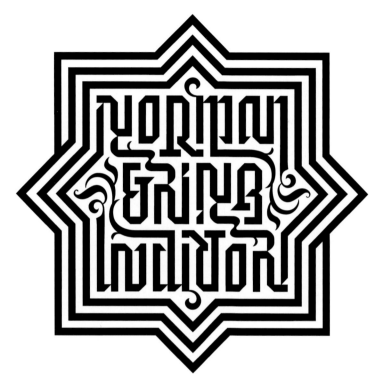

LOGOTYPE

DESIGN
John Langdon
Philadelphia, PA

LETTERING
John Langdon

CLIENT
Norman and
Rina Indictor

PRINCIPAL TYPE
Handlettering

POSTER

DESIGN
Kiyotaka Higuchi
Tokyo, Japan

ART DIRECTION
Kiyotaka Higuchi

CREATIVE DIRECTION
Kiyotaka Higuchi

LETTERING
Kiyotaka Higuchi

AGENCY
Daiko Advertising Creative
& Partners Inc.

CLIENT
Inter Medium Institute
Graduate School

PRINCIPAL TYPE
MossSigh

DIMENSIONS
28.5 x 40.6 in.
72.8 x 103 cm

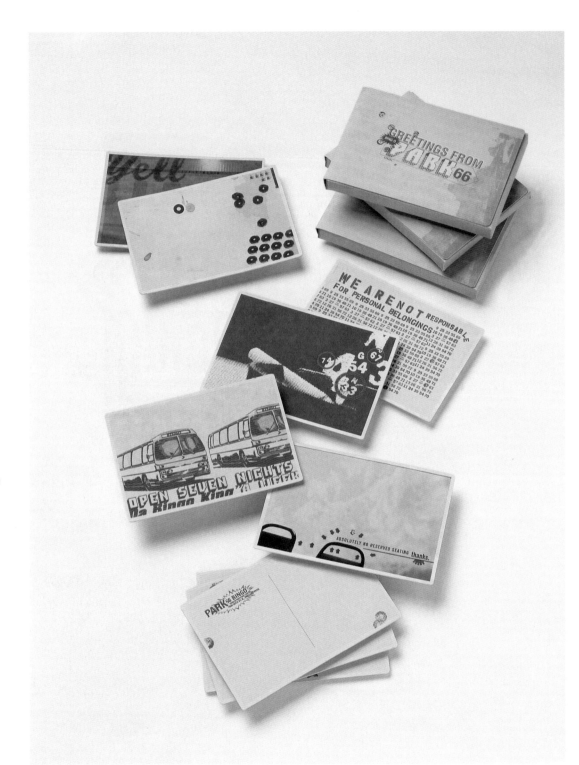

POSTCARDS

DESIGN
Sarah Petti
Holmes Beach, FL

ART DIRECTION
Sarah Petti

CREATIVE DIRECTION
Sarah Petti

LETTERING
Sarah Petti

STUDIO
Sarah Petti

PRINCIPAL TYPE
Univers

DIMENSIONS
6.5 x 4.5 in.
16.5 x 11.4 cm

ADVERTISEMENT

DESIGN
Claire Dawson
Toronto, Canada

ART DIRECTION
Diti Katona and
John Pylypczak

PHOTOGRAPHY
Chris Nicholls

DESIGN OFFICE
Concrete Design
Communications, Inc.

CLIENT
Holt Renfrew

PRINCIPAL TYPE
Trade Gothic

DIMENSIONS
7.9 x 10.8 in.
20 x 27.5 cm

POSTER

DESIGN
Steve Sandstrom and
David Creech
Portland, OR

ART DIRECTION
Steve Sandstrom

CREATIVE DIRECTION
Joe Sciarrotta,
Ogilvy & Mather
Chicago, IL

DESIGN OFFICE
Sandstrom Design

CLIENT
Steppenwolf Theatre

PRINCIPAL TYPE
Century Schoolbook,
Clarendon,
Franklin Gothic,
and Rosewood

DIMENSIONS
24 x 36 in.
61 x 91.4 cm

BROCHURE

DESIGN
Geoff Halber
Madison, WI

CREATIVE DIRECTION
Dana Lytle

DESIGN OFFICE
Planet Propaganda

CLIENT
Ten Chimneys Foundation

PRINCIPAL TYPE
Engravers Gothic BT,
Engravers Gothic Ultra Bold,
and Hightower

DIMENSIONS
6.5 x 9 in.
16.5 x 22.9 cm

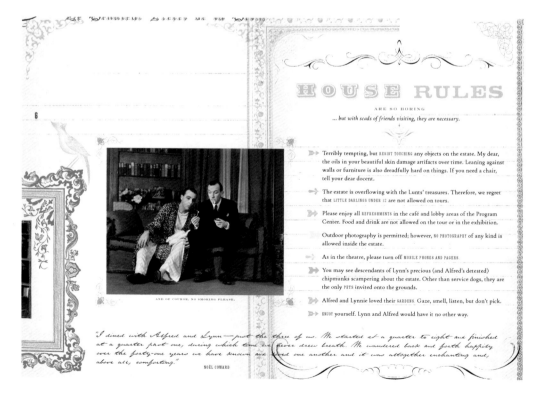

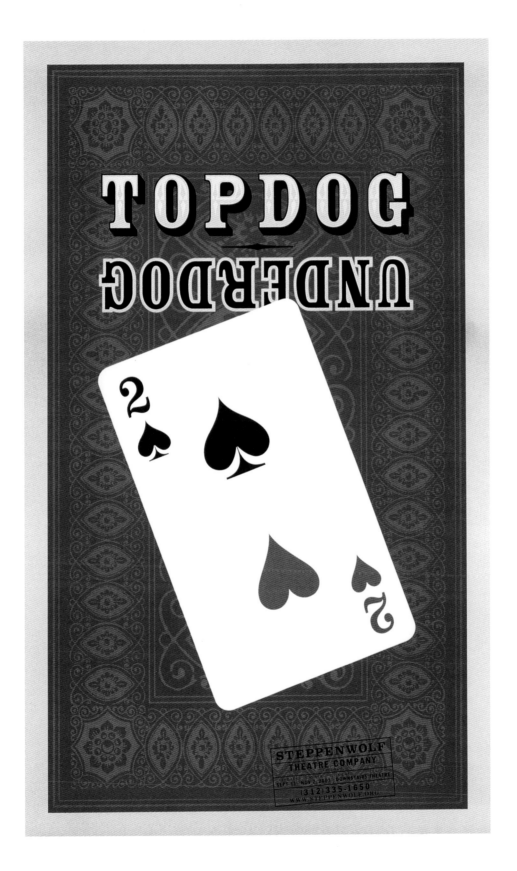

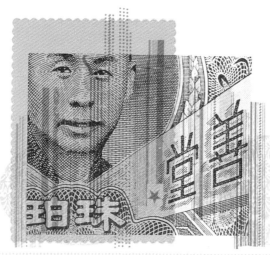

tuesday

NOVEMBER 4th

2003 .. ✳ Belle & Sebastian

✳ *with special guests* *R a s p u t i n a*

✳ ■ ■ ■ ■ ■ ■ ■ ■ ■ Liberty Hall ▣

■ .. 642 massachusetts street ● lawrence, kansas

18 & over doors open at 7 o'clock eleven productions printed & designed at Hammerpress : 816.421.1929

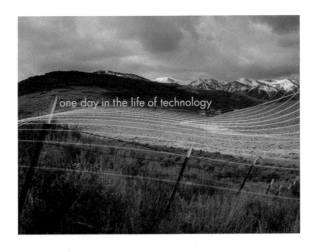

TELEVISION COMMERCIAL

DESIGN
Kaan Atilla, John Clark,
Mathew Cullen,
Paulo De Almada,
Irene Park, Mike Slane,
Mike Steinmann, and
Shihlin Wu
Venice, CA

ART DIRECTION
Kaan Atilla

CREATIVE DIRECTION
Mathew Cullen,
Steve Luker, John Norman,
and Steve Simpson

STUDIO
Motion Theory

CLIENT
Goodby, Silverstein & Partners
and Hewlett Packard

PRINCIPAL TYPE
Futura

POSTER

DESIGN
Brady Vest
Kansas City, MO

ART DIRECTION
Brady Vest

STUDIO
Hammerpress

CLIENT
Eleven Productions

PRINCIPAL TYPE
Craw, Helenic, Spartan,
and various

DIMENSIONS
14 x 22 in.
35.6 x 55.9 cm

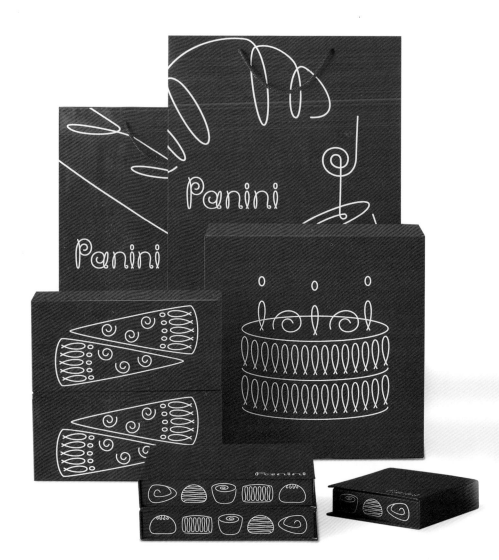

LOGOTYPE

DESIGN
Hideo Akiba and
Fiona Verdon-Smith
London, England

ART DIRECTION
Sonja Frick

CREATIVE DIRECTION
Mary Lewis

ILLUSTRATION
Hideo Akiba and
Fiona Verdon-Smith

TYPOGRAPHER
Hideo Akiba

AGENCY
Lewis Moberly

CLIENT
Grand Hyatt,
Dubai, UAE

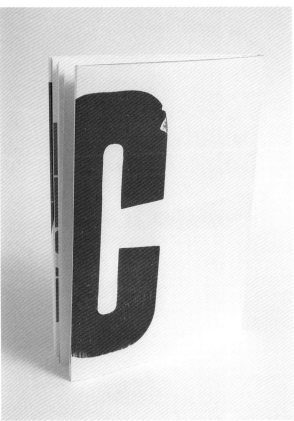

CATALOG

DESIGN
Scott Williams and
Henrik Kubel
London, England

ART DIRECTION
Scott Williams and
Henrik Kubel

CREATIVE DIRECTION
Scott Williams and
Henrik Kubel

LETTERING
Henrik Kubel and
Scott Williams

TYPESETTER
Stan Lane

STUDIO
A2-Graphics/SW/HK

CLIENT
ISTD/International Society of
Typographic Designers

PRINCIPAL TYPE
Caslon 128, wood, metal,
and custom typefaces

DIMENSIONS
8.3 x 11.7 in.
21 x 29.7 cm

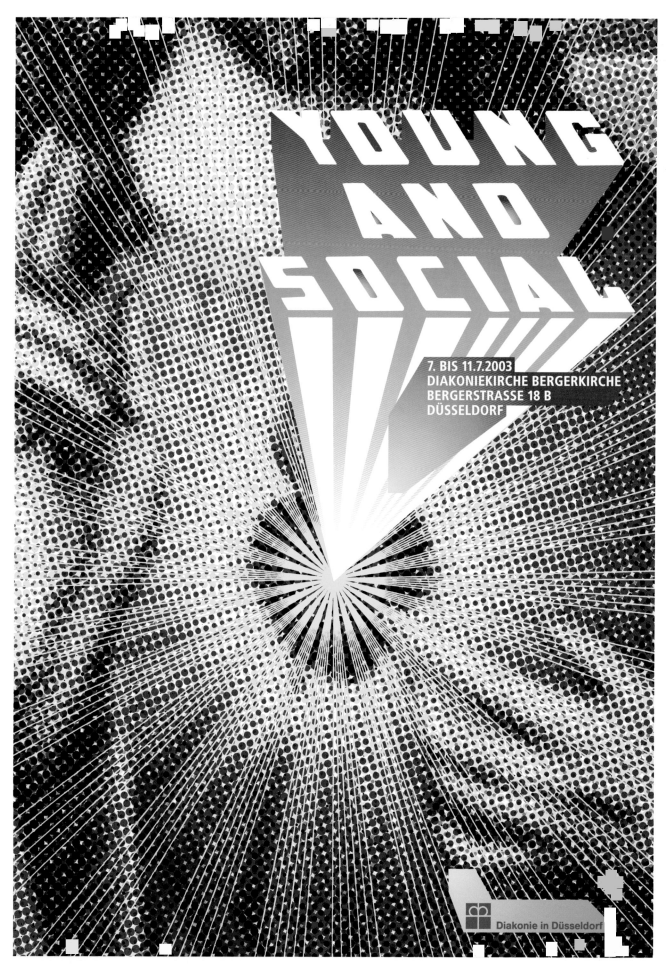

YOUNG AND SOCIAL

7. BIS 11.7.2003
DIAKONIEKIRCHE BERGERKIRCHE
BERGERSTRASSE 18 B
DÜSSELDORF

Diakonie in Düsseldorf

CATALOG

DESIGN
Cheryl Towler Weese,
Garrett Niksch, and
Maia Wright
Chicago, IL

CREATIVE DIRECTION
Kathy Fredrickson and
Cheryl Towler Weese

PROJECT MANAGEMENT AND PRODUCTION
Matt Simpson and
Marty Maxwell

DESIGN OFFICE
studio blue

CLIENT
Otis College of Art and Design

PRINCIPAL TYPE
Bryant and Fig
heavily manipulated

DIMENSIONS
7.25 x 9.9 in.
18.4 x 25.2 cm

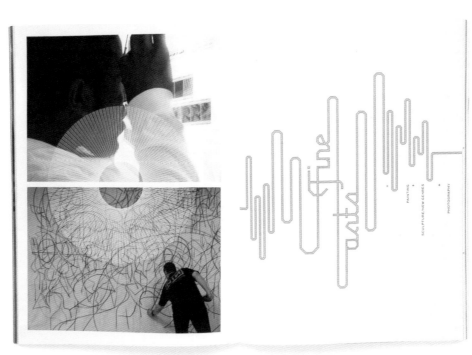

POSTER

DESIGN
Barbara Baettig and
Fons Hickmann
Berlin, Germany

ART DIRECTION
Fons Hickmann

PRINTER
b2 Bellers Siebdruck
Langenfeld. Germany

STUDIO
Fons Hickmann m23

CLIENT
Diakonie Düsseldorf

PRINCIPAL TYPE
m23-bb and Motorcade

DIMENSIONS
33.1 x 46.8 in.
84 x 118.9 cm

POSTER

DESIGN
Charles S. Anderson
and Sheraton Green
Minneapolis, MN

ART DIRECTION
Charles S. Anderson

DESIGN OFFICE
Charles S. Anderson Design Compa

CLIENT
American Institute of Graphic Arts,
Minnesota

PRINCIPAL TYPE
News Gothic

DIMENSIONS
23 x 30 in.
58.4 x 76.2 cm

BROCHURE

DESIGN
Sharon Werner and
Sarah Nelson
Minneapolis, MN

ART DIRECTION
Sharon Werner

ILLUSTRATION
Sharon Werner and
Sarah Nelson

DESIGN OFFICE
Werner Design Werks, Inc.

CLIENT
American Institute of Graphic Arts,
Minnesota

PRINCIPAL TYPE
Clarendon and Gothic

DIMENSIONS
4.25 x 5.75 in.
10.8 x 14.6 cm

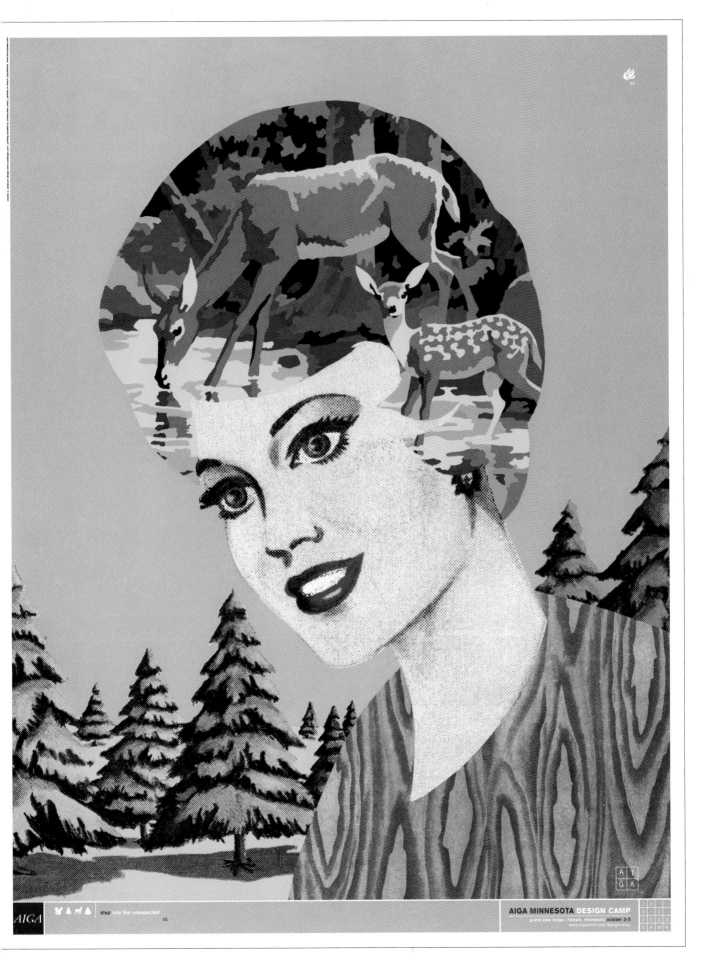

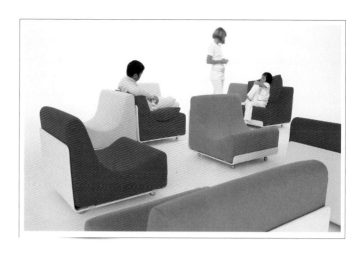

BOOK

Design
Verena Baumhögger and
Lin Lambert
Hamburg, Germany

Art Direction
Jan Kruse

Creative Direction
Olaf Stein

Design Office
Factor Design AG

Client
COR Sitzmöbel

Principal Type
FF Celeste Small Text
and COR corporate type

Dimensions
7.9 x 10.2 in.
20 x 26 cm

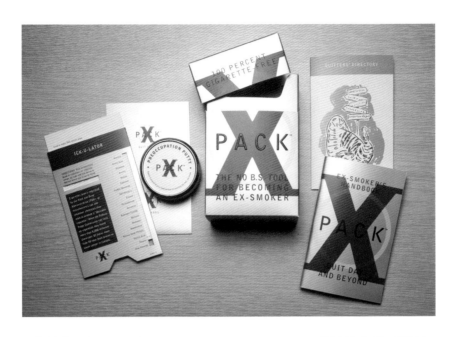

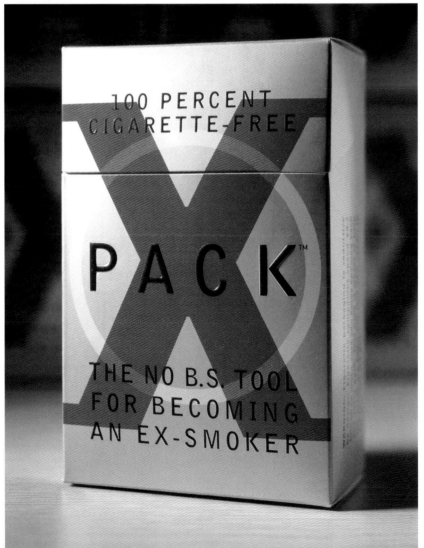

PACKAGING

DESIGN
Jon Olsen and
Shanin Andrew
Portland, OR

ART DIRECTION
Jon Olsen

CREATIVE DIRECTION
Steve Sandstrom
and Jon Olsen

ILLUSTRATION
Ward Schumaker

DESIGN OFFICE
Sandstrom Design

CLIENT
Population Services
International

PRINCIPAL TYPE
Bell Gothic, Brothers,
and FF DIN

DIMENSIONS
Various

For mmmillions of years flowers have been producing thorns. For millions of years sheep have been stealing them all the same. And it's not serious, trying to understand

THE WAR BETWEEN SHEEP AND FLOWERS

produce thorns that are good for nothing? It's not serious and more important why flowers go to trouble to produce them that are good important

A gentleMAN realizES loves REPAIRS

Suppose I happen to know a flower that a little sheep can wipe out in a single bite

a flower of which just one example exists among the millions and

And that isn't important?"

STUDENT PROJECT

DESIGN
Omid Rashidi
San Francisco, CA

SCHOOL
California College of the Arts

INSTRUCTOR
Jeremy Mende

PRINCIPAL TYPE
Goudy and
Goudy Handtooled

DIMENSIONS
28 x 42 in.
71.1 x 106.7 cm

STUDENT PROJECT

DESIGN
Jae-Hyouk Sung
Valencia, CA

SCHOOL
California Institute of the Arts

INSTRUCTORS
Anne Burdick, Ed Fella,
Lorraine Wild, and
Michael Worthington

PRINCIPAL TYPE
SMS-Nega-Unigature,
SMS-Emoticonabet,
and SMS-Unigature

DIMENSIONS
8.5 x 10.5 in.
21.6 x 26.7 cm

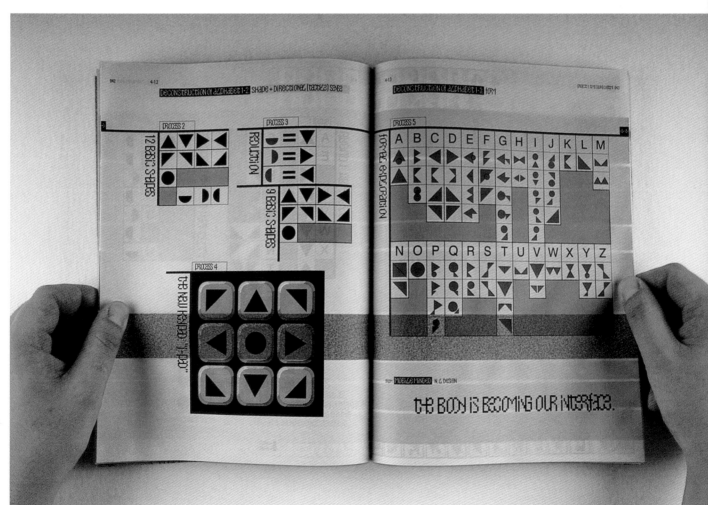

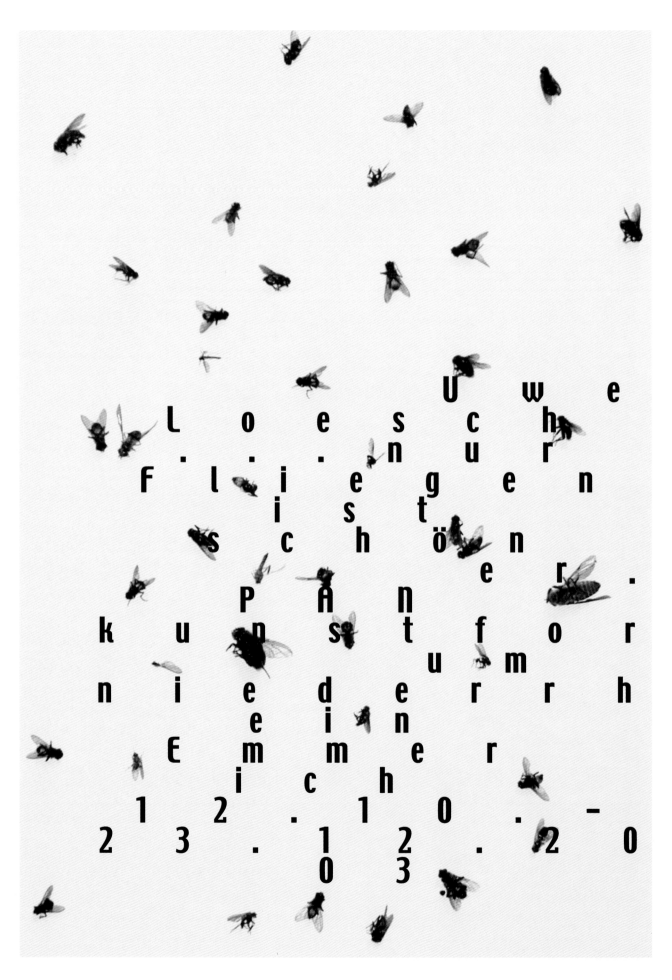

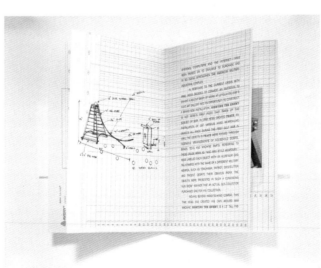

DIE SEIDENSTRASSEN

HANDELSROUTEN KULTURWEGE

ZITTA SULTANBAEVA
ABLIKIM AKMULLAEV
MARITA DAMKRÖGER
H.-KLAUS KÜHN
NASRIN TABATABAI
QIN YUFEN

18. JUNI – 10. AUGUST 2003
DIENSTAG – FREITAG 12 – 18 UHR
SAMSTAG UND SONNTAG 12 – 17 UHR
EINTRITT FREI

IFA-GALERIE BONN
MUSEUMSMEILE
WILLY-BRANDT-ALLEE 9
53113 BONN
TEL 0228/224450

WWW.IFA.DE

BROCHURE

DESIGN
Akihiko Tsukamoto
Tokyo, Japan

ART DIRECTION
Akihiko Tsukamoto

ILLUSTRATION
Frank Viva
Toronto, Canada

COPYWRITER
Masayuki Minoda

PRINTER
Taiyo Printing Co., Ltd.

DESIGN OFFICE
Zuan Club

CLIENT
Arjo Wiggins Canson KK

PRINCIPAL TYPE
Shinbun Extra Bold Minchyotai

DIMENSIONS
5.8 x 9.5 in.
14.8 x 24 cm

POSTER

DESIGN
Barbara Baettig
and Fons Hickmann
Berlin, Germany

ART DIRECTION
Fons Hickmann

EDITOR
Beate Eckstein

STUDIO
Fons Hickmann m23

CLIENT
IFA Gallery

PRINCIPAL TYPE
m23-silkroad

DIMENSIONS
23.6 x 33.1 in.
60 x 84 cm

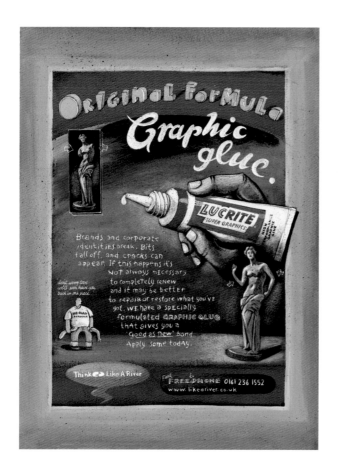

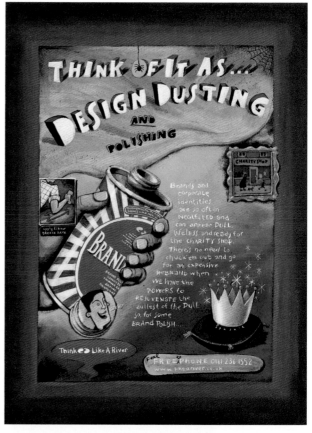

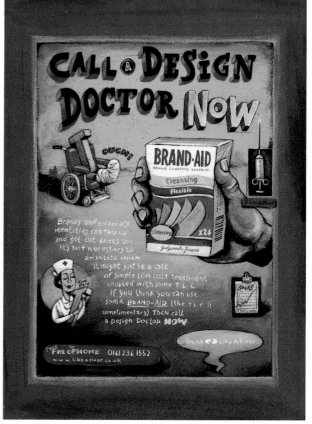

ADVERTISEMENT

ART DIRECTION
Rob Taylor
Manchester, England

CREATIVE DIRECTION
Rob Taylor and
Peter Rogers

LETTERING
Rob Taylor

ILLUSTRATION
Simon Henshaw and
Andy O'Shaughnessy

AGENCY
Like A River Brand
Communications

PRINCIPAL TYPE
Handlettering

DIMENSIONS
9.5 x 13 in.
24 x 33 cm

26 is a not-for-profit association of writers and language specialists.

We're here to raise the profile of writing in business and demonstrate the contribution it can make to working life.

We want to help individuals, businesses, brands, charities and government bodies tell their stories and discover compelling ways to engage their audience.

We believe the sheer power of words is hugely underestimated, and that experienced and imaginative writers can offer the business community (and the wider community) wonderful opportunities and benefits.

We're creating an inspirational network of talented people who can help individuals and organisations develop their communication skills. Our network will include all sorts of writers and consultants, from poets to brand language experts.

But most of all, we're here to have some fun with language. We want to show how words can entertain, inspire and inform - starting right here...

BROCHURE

DESIGN
Harry Pearce
London, England

ART DIRECTION
Harry Pearce

CREATIVE DIRECTION
Harry Pearce

COPY CONCEPT
Harry Pearce

DESIGN STUDIO
Lippa Pearce Design

CLIENT
'26'

PRINCIPAL TYPE
Didot, AG Old Face,
and Times

DIMENSIONS
15.6 x 23.8 in.
39.5 x 60.5 cm

BROCHURE

DESIGN
Pierre Vermeir
London, England

ART DIRECTION
Roger Felton and
Pierre Vermeir

CREATIVE DIRECTION
Pierre Vermeir

DESIGN AGENCY
HGV Felton

CLIENT
Bailhache Labesse

PRINCIPAL TYPE
Akzidenz Grotesk

DIMENSIONS
8.9 x 10.6 in.
22.5 x 27 cm

POSTER

DESIGN
Niklaus Troxler
Willisau, Switzerland

ART DIRECTION
Niklaus Troxler

LETTERING
Niklaus Troxler

DESIGN OFFICE
Niklaus Troxler Design

CLIENT
Jazz in Willisau

PRINCIPAL TYPE
VAG

DIMENSIONS
35.4 x 50.4 in.
90 x 128 cm

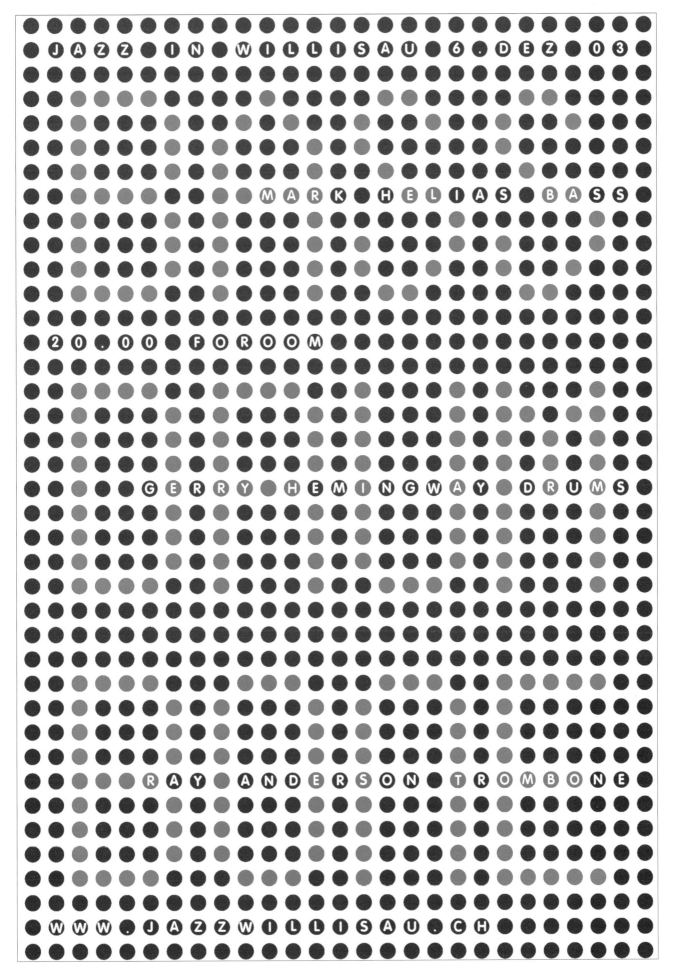

JAZZ IN WILLISAU 6. DEZ 03

MARK HELIAS BASS

20.00 FOROOM

GERRY HEMINGWAY DRUMS

RAY ANDERSON TROMBONE

WWW.JAZZWILLISAU.CH

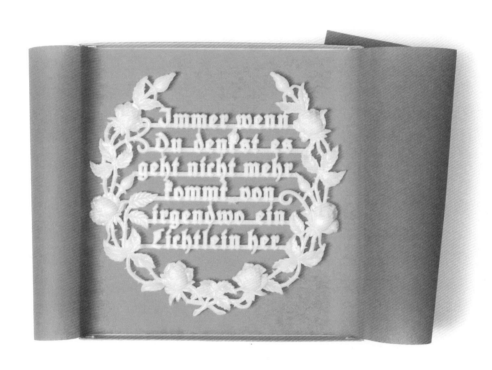

GREETING CARD

DESIGN
Heine/Lenz/Zizka
Frankfurt, Germany

CREATIVE DIRECTION
Achim Heine, Michael Lenz,
and Peter Zizka

LETTERING
Koziol
Erbach, Germany

DESIGN OFFICE
Heine/Lenz/Zizka

PRINCIPAL TYPE
Fraktur

DIMENSIONS
5.9 x 5.5 in.
15 x 14 cm

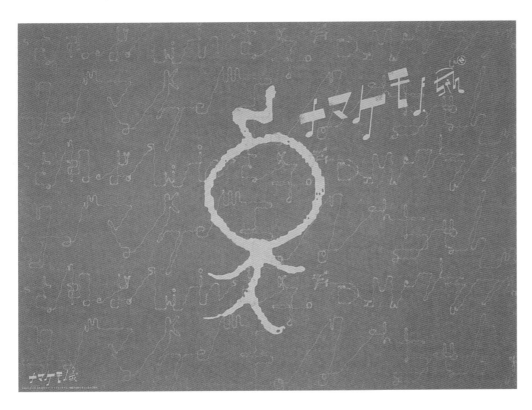

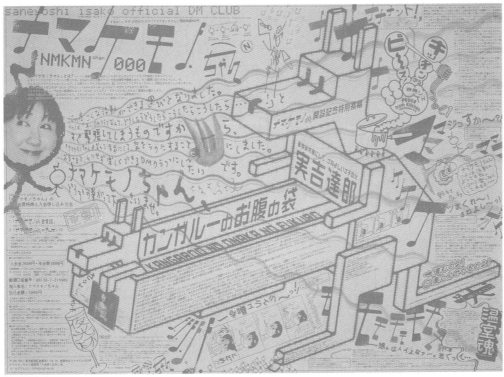

HANDBILL

DESIGN
Jun Takechi
Tokyo, Japan

ART DIRECTION
Jun Takechi

CREATIVE DIRECTION
Sachiko Ichihara

LETTERING
Isako Saneyoshi

ILLUSTRATION
Tatsutoshi Nomura and
Kotobuki Shiriagari

CLIENT
NaMaKeMoNo chan

PRINCIPAL TYPE
Handlettering

DIMENSIONS
27.6 x 19.7 in.
70 x 50 cm

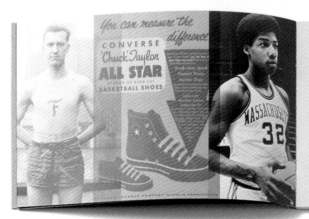

CHUCK TAYLOR: The Ambassador of Basketball put his knowledge and love of the game into the All Star® shoe which he helped design. The famous All Star patch was not merely aesthetic but designed to protect the ankle as a player would run the floor; a new concept in the sport. As an athlete, he understood how simple innovations could improve his shoe and in turn improve the game. And that was his ultimate motivation. Chuck traveled the country for 35 years running basketball clinics and spreading the excitement of the game everywhere he went. His influence is still felt in basketball and beyond, reaching into the realm of popular culture. JULIUS ERVING: "Dr. J" changed the game with never before performed feats of athleticism and self-expression. Above-the-rim basketball owes itself to the "Doctor" who paved the way for the stars and electricity of the game today.

SPORTS CLASSICS
CONVERSE® RE-ISSUE™
★

For those who weren't there the first time around, it worked like this: You opened the box and the room filled with the crinkling of the paper and the smell of fresh rubber. Instantly you felt like you could run faster, jump higher, kick a little harder. But most of all, you felt a knowing glance from others, who like you, knew the secret of Converse. Many still do. Converse Re-Issues are authentic athletic shoes that recall the purity of sports from yesteryear.

RE-ISSUE

BROCHURE

DESIGN
Steve Sandstrom and
Starlee Matz
Portland, OR

ART DIRECTION
Steve Sandstrom

CREATIVE DIRECTION
Steve Sandstrom

DESIGN OFFICE
Sandstrom Design

CLIENT
Converse

PRINCIPAL TYPE
HTF Acropolis, Code, FF DIN,
and News Gothic

DIMENSIONS
8 x 5 in.
20.3 x 12.7 cm

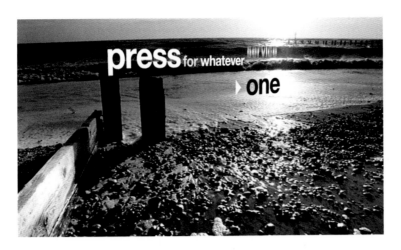

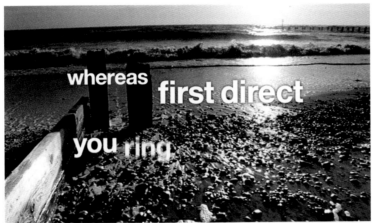

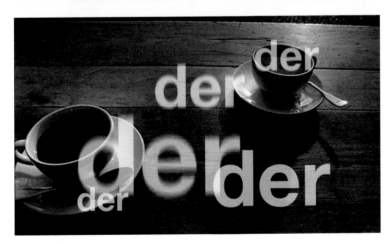

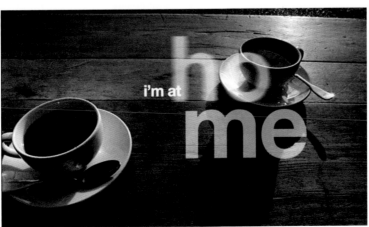

ADVERTISEMENT

DESIGN
Why Not Associates
London, England

ART DIRECTION
Why Not Associates

CREATIVE DIRECTION
Why Not Associates

DIRECTOR
Lucy Blakstad,
The Brave Film Company

STUDIO
Why Not Associates

CLIENT
WCRS/First Direct

PRINCIPAL TYPE
Helvetica

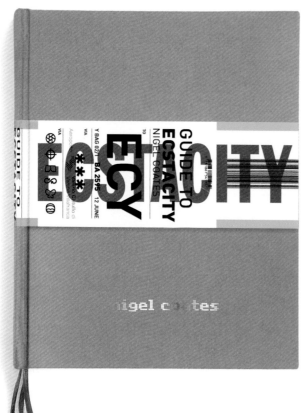

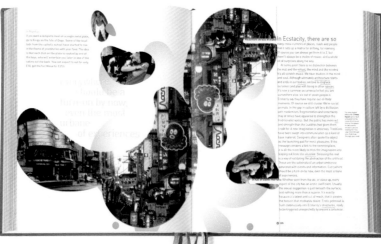

POSTER

DESIGN
Steve Sandstrom
and David Creech
Portland, OR

ART DIRECTION
Steve Sandstrom

CREATIVE DIRECTION
Joe Sciarrotta,
Ogilvy & Mather
Chicago, IL

ILLUSTRATION
Steve Sandstrom

DESIGN OFFICE
Sandstrom Design

CLIENT
Steppenwolf Theatre

PRINCIPAL TYPE
Alternate Gothic,
Century Schoolbook,
Clarendon,
Franklin Gothic,
and Gazz Stencil

DIMENSIONS
24 x 36 in.
61 x 91.4 cm

BOOK

DESIGN
Why Not Associates
London, England

ART DIRECTION
Why Not Associates

CREATIVE DIRECTION
Why Not Associates

STUDIO
Why Not Associates

CLIENT
Laurence King Publishing &
Nigel Coates

PRINCIPAL TYPE
FF DIN

DIMENSIONS
8 x 9.75 in.
20.3 x 24.8 cm

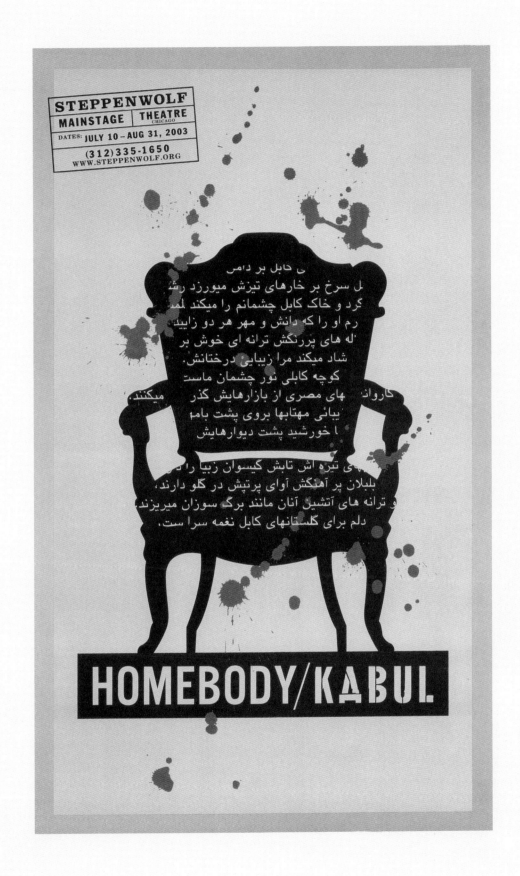

STATIONERY

DESIGN
Graham Clifford
New York, NY

COPYWRITER
David Metcalf

DESIGN OFFICE
Graham Clifford Design

CLIENT

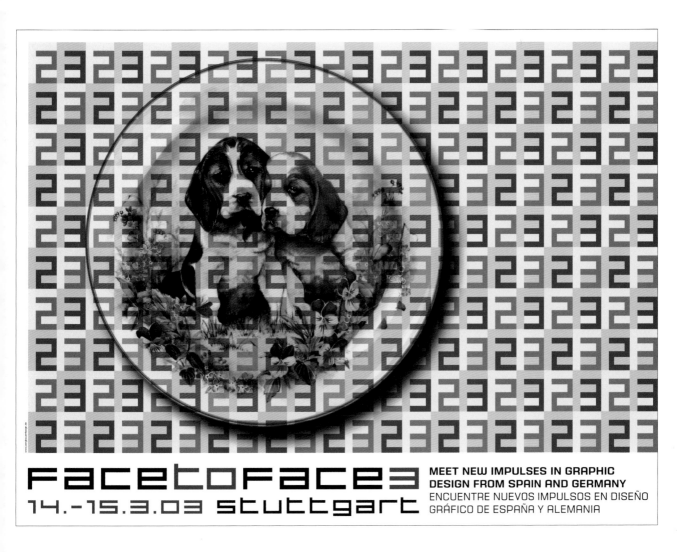

facetoface3
14.-15.3.03 stuttgart

**MEET NEW IMPULSES IN GRAPHIC
DESIGN FROM SPAIN AND GERMANY**
ENCUENTRE NUEVOS IMPULSOS EN DISEÑO
GRÁFICO DE ESPAÑA Y ALEMANIA

POSTER

DESIGN
Joerg Bauer
Stuttgart, Germany

ART DIRECTION
Joerg Bauer

CREATIVE DIRECTION
Joerg Bauer

DESIGN OFFICE
joergbauerdesign

CLIENT
Design Center Stuttgart

PRINCIPAL TYPE
Hi-Score and
House Gothic 23

DIMENSIONS
33.4 x 23.4 in.
84.7 x 59.4 cm

BOOK

DESIGN
Alethea Morrison
San Francisco, CA

PUBLISHER
Chronicle Books

PRINCIPAL TYPE
Historical typefaces

DIMENSIONS
6.5 x 6.5 in.
16.5 x 16.5 cm

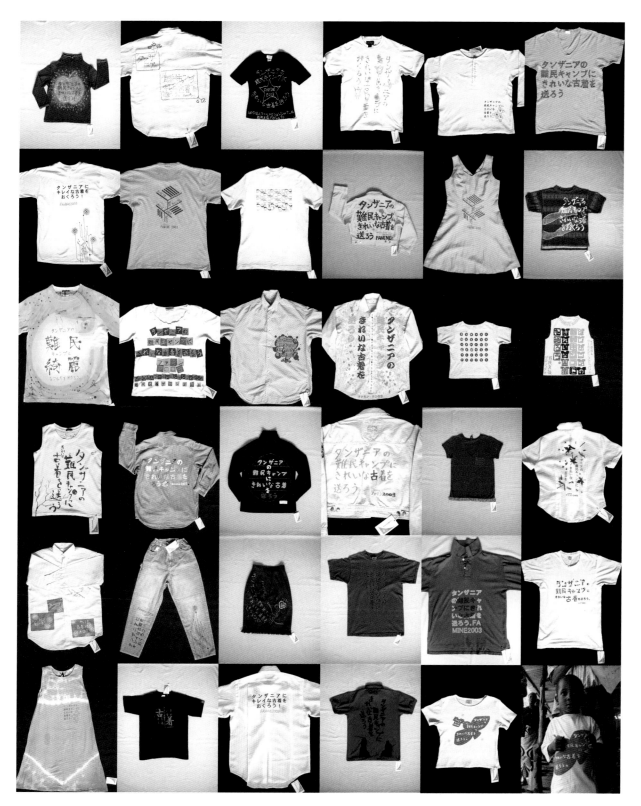

T-SHIRT

DESIGN
Hitomi Akasaka
Tokyo, Japan

ART DIRECTION
Takashi Fukui

CREATIVE DIRECTION
Takashi Fukui and
Motomu Ishida

LETTERING
Motomu Ishida

AGENCY
Dentsu Inc.

CLIENT
World Vision Japan

PRINCIPAL TYPE
Gothic and handlettering

DIMENSIONS
15.8 x 19.7 in.
40 x 50 cm

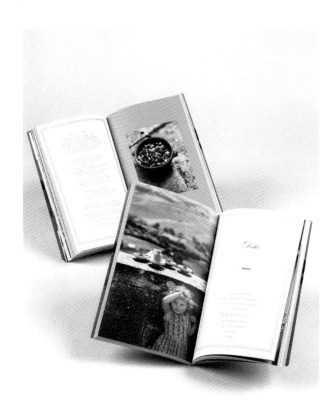

BOOK

DESIGN
Pamela Zuccker
and Katja Burkett
*Houston, TX, and
Atlanta, GA*

ART DIRECTION
Pamela Zuccker
and Katja Burkett

CREATIVE DIRECTION
Smith Hanes
Atlanta, GA

LETTERING
Louise Fili
New York, NY

PHOTOGRAPHY
Rob Brinson

BOOK JACKET DESIGN
Louise Fili

DESIGN OFFICE
Pomme Studio

CLIENT
Bella Cucina Artful Food

PRINCIPAL TYPE
Kuenstler Script, Mrs. Eaves,
and various ornaments

DIMENSIONS
7.25 x 12 in.
18.4 x 30.5 cm

POSTER

DESIGN
Fernando Gutiérrez
and Chris Duggan
London, England

ART DIRECTION
Fernando Gutiérrez

CREATIVE DIRECTION
Fernando Gutiérrez

LETTERING
Chris Duggan

AGENCY
Pentagram Design Ltd.

CLIENT
Didac Films/
Warner Sogecine

PRINCIPAL TYPE
Bureau Grotesque
and wood type

DIMENSIONS
27.6 x 39.4 in.
70 x 100 cm

LA HISTORIA REAL DE DOS ESPAÑOLES
QUE VIAJARON A OTRO PLANETA

PLATILLOS VOLANTES

DIRECTOR ÓSCAR AIBAR

ÁNGEL DE ANDRÉS LÓPEZ · JORDI VILCHES

UNA PRODUCCIÓN DE DIDAC FILMS · ENRIQUE CEREZO P.C.S.A DIRECTORA DE ARTE ION ARRETXE
DISEÑO DE VESTUARIO NEREIDA BONMATÍ MAQUILLAJE RAQUEL RODRÍGUEZ SONIDO DANIEL FONTRODONA
MONTAJE FERNANDO PARDO DIRECTOR DE PRODUCCIÓN MARTÍN CABAÑAS DIRECTOR DE FOTOGRAFÍA MARIO MONTERO
MÚSICA JAVIER NAVARRETE GUIÓN ÓSCAR AIBAR · JORGE GUERRICAECHEVARRÍA
PRODUCTORES EJECUTIVOS PEDRO COSTA · ENRIQUE CEREZO

www.plus.es/platillosvolantes

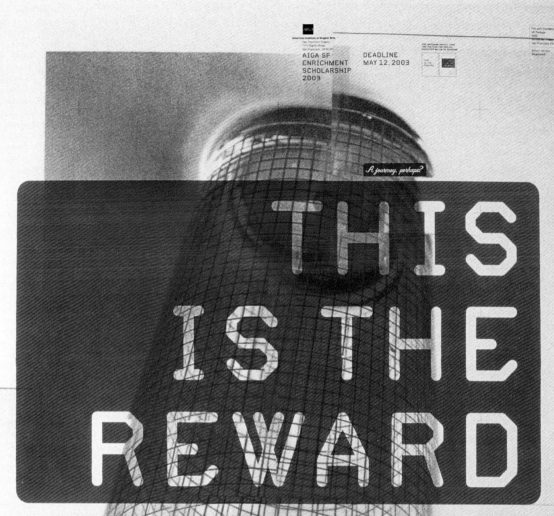

A journey, perhaps?

THIS IS THE REWARD

THE SAN FRANCISCO CHAPTER OF THE AMERICAN INSTITUTE OF GRAPHIC ARTS ENRICHMENT SCHOLARSHIP SUPPORTS AND ENCOURAGES DIVERSITY IN GRAPHIC DESIGN EDUCATION BY PROVIDING STUDENTS WITH THE OPPORTUNITY TO EXPAND THEIR EDUCATIONAL EXPERIENCE THROUGH SPECIAL PROGRAMS OFFERED BY ACCREDITED INSTITUTIONS IN THE U.S. AND ABROAD. THIS OPPORTUNITY IS ONE OF THE MOST IMPORTANT SERVICES THE AIGA CAN PROVIDE FOR THE ADVANCEMENT OF THE GRAPHIC DESIGN PROFESSION.

AIGA SF ENRICHMENT SCHOLARSHIP 2003

DEADLINE MAY 12, 2003

American Institute of Graphic Arts
San Francisco Chapter

Judges

Sharrie Brooks *Erik Cox* *Patricia Evangelista* *Todd Bouman* *April Greiman*

PROGRAMS/CONFERENCES

ELIGIBILITY

CHECKLIST

CRITERIA/REQUIREMENTS

APPLICATION FORM

SPONSOR FORM

QUESTIONS?

Black PANTONE 485 CV

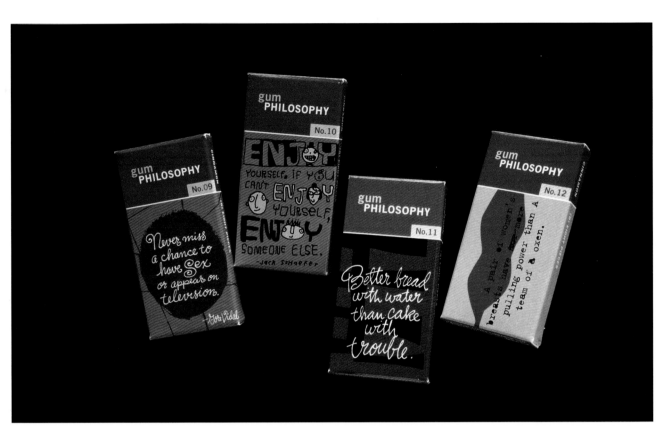

PACKAGING

DESIGN
Michelle Sonderegger
and Ingred Sidie
Kansas City, MO

ART DIRECTION
Michelle Sonderegger
and Ingred Sidie

LETTERING
Tom Patrick, Meg Cundiff,
and Michelle Sonderegger

DESIGN OFFICE
Design Ranch

CLIENT
Blue Q

PRINCIPAL TYPE
Handlettering

DIMENSIONS
1.4 x 2.6 x .3 in.
3.6 x 6.6 x .8 cm

POSTER

DESIGN
Eric Heiman and
Adam Brodsley
San Francisco, CA

CREATIVE DIRECTION
Eric Heiman and
Adam Brodsley

STUDIO
Volume Design, Inc.

CLIENT
American Institute of Graphic Arts,
San Francisco

PRINCIPAL TYPE
FF DIN, Punctual, and Vitrina

DIMENSIONS
25 x 28 in.
63.5 x 71.1 cm

watching words move

BOOK RE-ISSUED

DESIGN
Brownjohn, Chermayeff & Geismar 1959
New York, NY

DESIGN OFFICE
Chermayeff & Geismar, Inc.

CLIENT
Typographica Magazine

PRINCIPAL TYPE
Standard

DIMENSIONS
5 x 6 in.
12.7 x 15.2 cm

addding

subtrcting

nippea

multimultiplying

div id ing

tophalf

blo↓↑o ⊿s∠c⊏oana—∠s.—s

inflatio^n telesoapvisbeerion

ero
1ne
2wo 6ix
3hree 7even
4our 8ight
5ive 9ine
 10en rreeppeeaatt

sexxx surpr!se

TΛNNEL

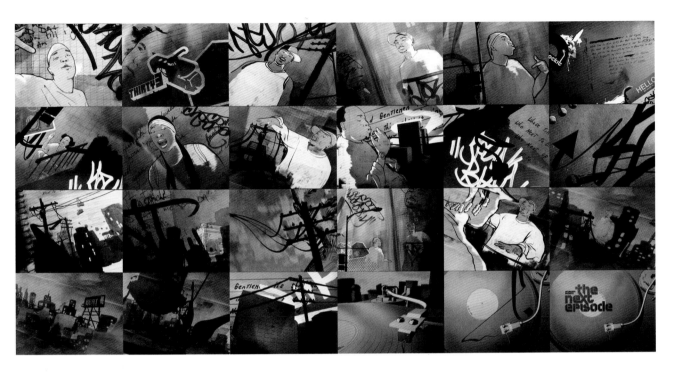

OPENING FILM SEQUENCE

DESIGN
Jason Cook
Santa Monica, CA

EXECUTIVE PRODUCER
Elizabeth Hummer

ART DIRECTION
Tom Koh

CREATIVE DIRECTION
Chris Do

ILLUSTRATION
Steve Harrington,
Justin Krietemeyer,
Steve Pacheco, and
Bill Sneed

ANIMATION
Atsushi Ishizuka,
Jason Lowe, and
Maithy Tran

AGENCY
Blind, Inc.

CLIENT
Interscope Records for
Showtime Networks
Moses Edinborough, director
Randy Sosin, executive producer
Jillian Fleer, executive producer

SOFTWARE
After Effects, Cinema 4D, Flame,
Illustrator, Maya, Mixed Media,
Photoshop, and 3D StudioMax

Hiver ██ Le temps

Çpropos

«Le temps, image
mobile de l'éternité»
Platon

STUDENT PROJECT

DESIGN
Patricia Pérez Vélez
Montreal, Canada

SCHOOL
École de design, UQAM

INSTRUCTOR
Judith Poirier

PRINCIPAL TYPE
Food Show, Gill Sans Light,
and Neue Helvetica 75

DIMENSIONS
3.75 x 5.5 in.
9.5 x 14 cm

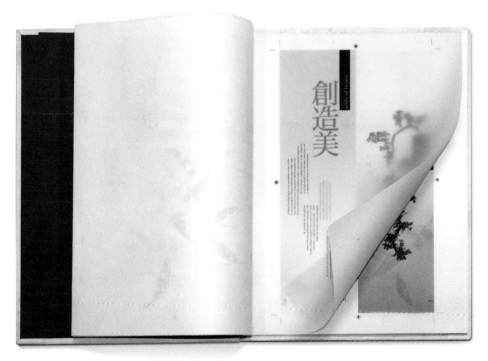

STUDENT PROJECT

DESIGN
Aki Yasukawa
San Francisco, CA

SCHOOL
San Jose State University

INSTRUCTOR
Chang Kim

PRINCIPAL TYPE
Baskerville, Hiragino
Mincho Pro, and Optima

DIMENSIONS
10 x 13.5 in.
25.4 x 34.30 cm

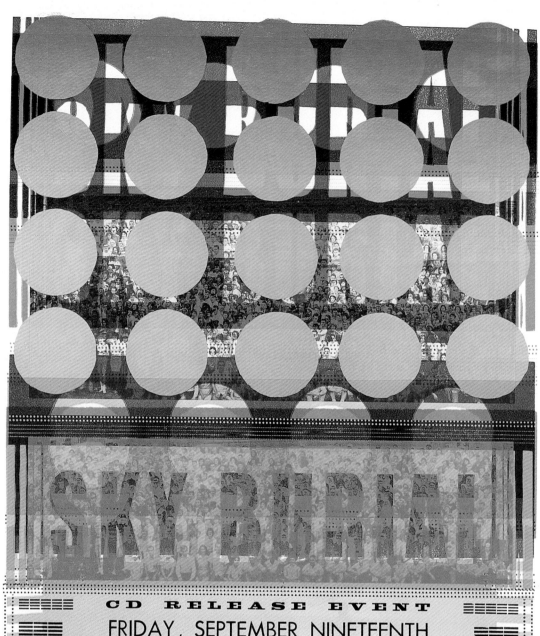

CD RELEASE EVENT
FRIDAY, SEPTEMBER NINETEENTH
NINE O'CLOCK TO MIDNIGHT
THE CUP & SAUCER
412 DELAWARE . KCMO

seven layers in two days at Hammerpress Letterpress Studio 816.421.1929

SKY BURIAL

LOGOTYPE

DESIGN
Slavimir Stojanović
Ljubljana, Slovenia

ART DIRECTION
Slavimir Stojanović

CREATIVE DIRECTION
Igor Arih

AGENCY
Arih Agency

CLIENT
Lisac & Lisac
and Fox & Fox

DIMENSIONS
7.9 x 7.9 in.
20 x 20 cm

POSTER

DESIGN
Brady Vest
Kansas City, MO

ART DIRECTION
Brady Vest

STUDIO
Hammerpress

CLIENT
Sky Burial

PRINCIPAL TYPE
Egyptian, Spartan,
Twentieth Century,
and handcarving

DIMENSIONS
14 x 22 in.
35.6 x 55.9 cm

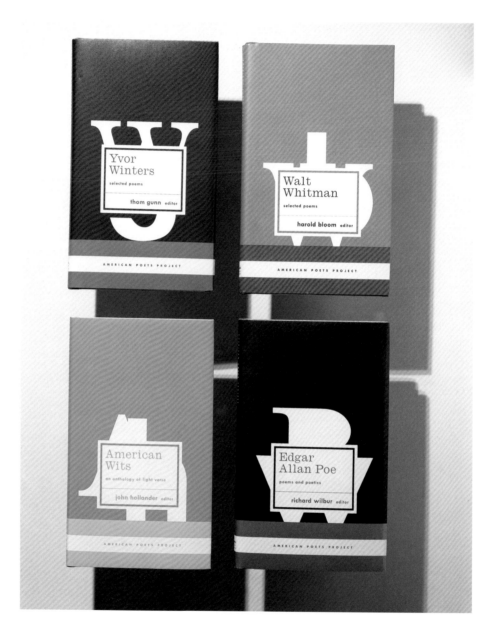

BOOK COVERS

DESIGN
Mark Melnick
New York, NY

CREATIVE DIRECTION
Chip Kidd

CLIENT
Library of America

PRINCIPAL TYPE
Ionic MT and
Twentieth Century MT

DIMENSIONS
4.75 x 7.75 in.
12.1 x 19.7 cm

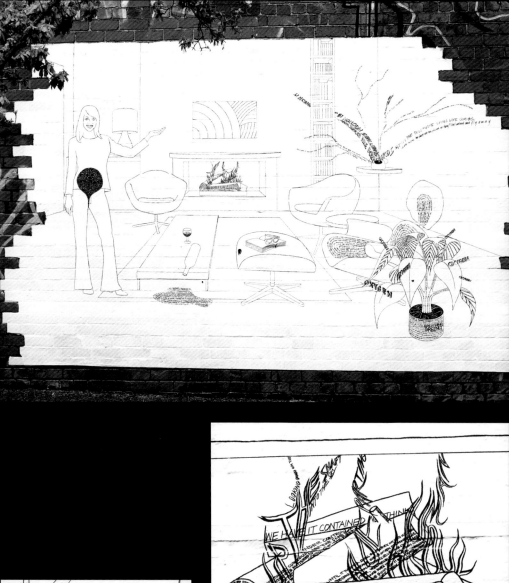

INSTALLATION

DESIGN
Jessie Fairweather
Melbourne, Australia

LETTERING
Jessie Fairweather

WRITERS
Joel Catchlove,
Sean Whelan,
and Lee Tan Lam

DESIGN OFFICE
Foundry: Typography, Design &
Visual Dialogue

CLIENT
SBS New Media and
Film Victoria: Cornerfold Issue 9 - Street Art

less Than Jake

Autopilot Off

New York City

Fall Out

Jazze Pha

Navy Pier

November 30

POSTER

DESIGN
Mike Joyce
New York, NY

ART DIRECTION
Mike Joyce

CREATIVE DIRECTION
Mike Joyce

DESIGN OFFICE
Stereotype Design

CLIENT
Less Than Jake

PRINCIPAL TYPE
Helvetica

DIMENSIONS
18 x 24 in.
45.7 x 61 cm

MAGAZINE

DESIGN
Ben Parker, Paul Austin,
and Nick Tweedie
London, England

ART DIRECTION
Ben Parker, Paul Austin,
and Nick Tweedie

CREATIVE DIRECTION
Ben Parker, Paul Austin,
and Nick Tweedie

AGENCY
Made Thought

CLIENT
Grafik

PRINCIPAL TYPE
Avant Garde and
Lubalin Graph

DIMENSION
8.9 x 12.2 in.
22.5 x 31 cm

POSTER

DESIGN
Dirk Fowler
Lubbock, TX

DESIGN OFFICE
f2 design

CLIENT
KTXT 88.1 FM

PRINCIPAL TYPE
Handcut and
metal type

DIMENSIONS
15.5 x 23 in.
39.4 x 58.4 cm

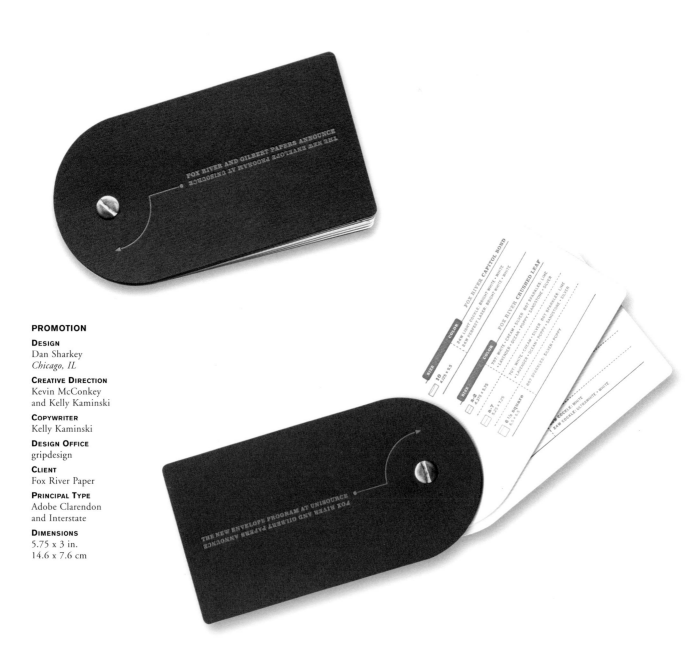

PROMOTION

DESIGN
Dan Sharkey
Chicago, IL

CREATIVE DIRECTION
Kevin McConkey
and Kelly Kaminski

COPYWRITER
Kelly Kaminski

DESIGN OFFICE
gripdesign

CLIENT
Fox River Paper

PRINCIPAL TYPE
Adobe Clarendon
and Interstate

DIMENSIONS
5.75 x 3 in.
14.6 x 7.6 cm

LIGHTNING BOLT

18
OCTOBER
JAPAN KARATE ATTACK
AGENTS OF VIRTUCON
THE PAVILION
602 E. 19TH ST.
POSTER BY DIRK FOWLER f2-design.com

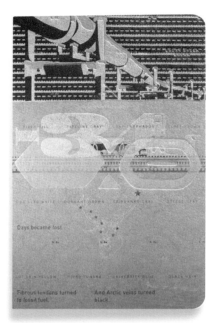

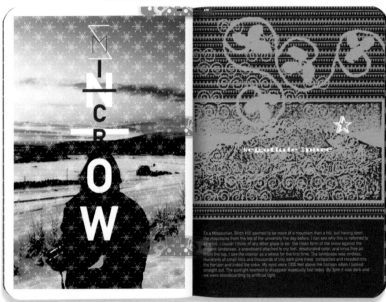

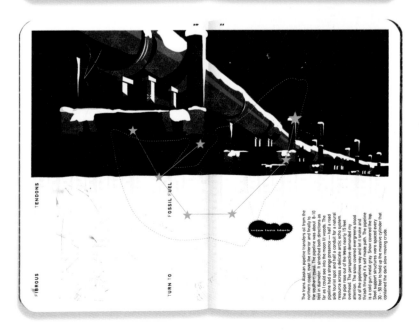

BOOK

DESIGN
Jeff Miller
Kansas City, MO

ART DIRECTION
Jeff Miller

AGENCY
Slow-motion

PRINCIPAL TYPE
Detroit and Madrone

DIMENSIONS
4.7 x 7 in.
11.9 x 17.8 cm

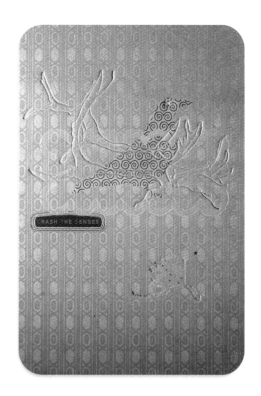

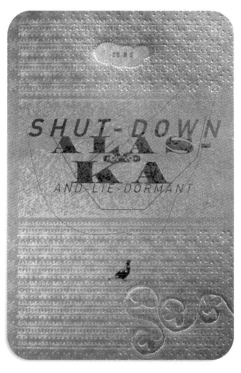

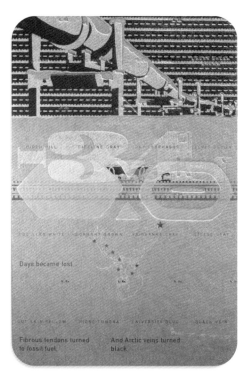

POSTCARDS

DESIGN
Jeff Miller
Kansas City, MO

ART DIRECTION
Jeff Miller

AGENCY
Slow-motion

PRINCIPAL TYPE
Detroit and Madrone

DIMENSIONS
4.6 x 7 in.
11.7 x 17.8 cm

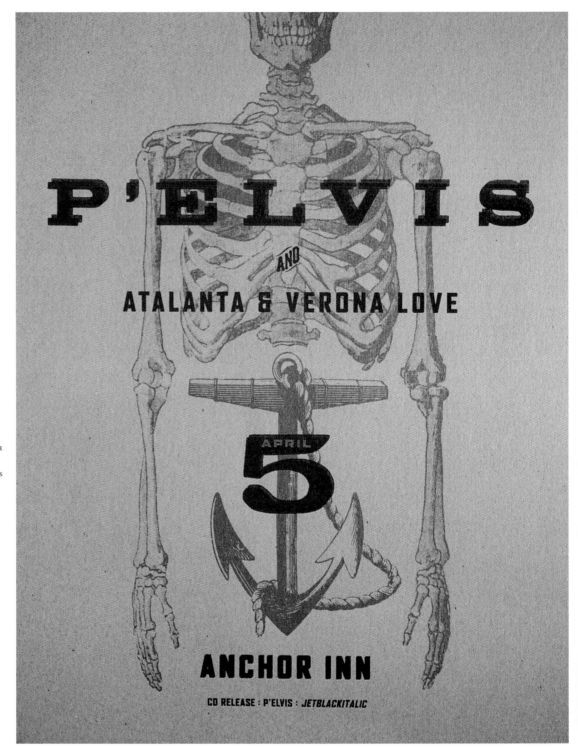

POSTER

DESIGN
Kevin Wade
Madison, WI

DESIGN OFFICE
Planet Propaganda

CLIENT
Purgatone Records

PRINCIPAL TYPE
Agency FB

DIMENSIONS
26 x 38 in.
66 x 96.5 cm

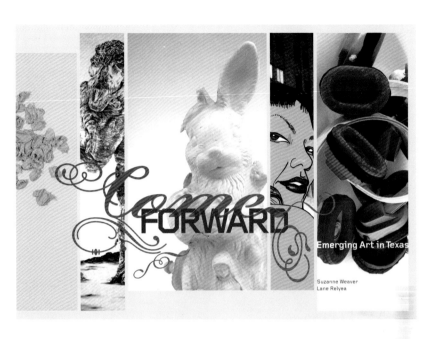

CATALOG

DESIGN
Sibylle Hagmann
Houston, TX

ART DIRECTION
Sibylle Hagmann

CREATIVE DIRECTION
Sibylle Hagmann

STUDIO
Kontour

CLIENT
Dallas Museum of Art

PRINCIPAL TYPE
Dalliance and
Foundry Gridnik

DIMENSIONS
12 x 8.5 in.
30.5 x 21.6 cm

200

PACKAGING

DESIGN
Kevin Wade
Madison, WI

DESIGN OFFICE
Planet Propaganda

CLIENT
Purgatone Records

PRINCIPAL TYPE
HTF Gotham Bold,
HTF Gotham Bold Italic,
and HTF Gotham Light

DIMENSIONS
5.5 x 4.9 in.
14 x 12.5 cm

POSTER

DESIGN
Studio Boot
's-Hertogenbosch, The Netherlands

ART DIRECTION
Edwin Vollebergh and Petra Janssen

CREATIVE DIRECTION
Edwin Vollebergh and Petra Janssen

LETTERING
Edwin Vollebergh

ILLUSTRATION
Studio Boot

DESIGN OFFICE
Studio Boot

CLIENT
Kerlensky Silkscreen Printing, Boxtel

PRINCIPAL TYPE
bootie bold

DIMENSIONS
23.6 x 32.7 in.
60 x 83 cm

POSTER

DESIGN
Nancy Bond Carle
Boston, MA

ART DIRECTION
Nancy Bond Carle

CREATIVE DIRECTION
Tom Simons

LETTERING
John Burgoyne
Belmont, MA

ILLUSTRATION
John Burgoyne

PRODUCTION MANAGER
Deb Olson

AGENCY
Partners + Simons

CLIENT
Applied Biosystems

PRINCIPAL TYPE
Adobe Garamond and
Univers

DIMENSIONS
38 x 16 in.
96.5 x 40.6 cm

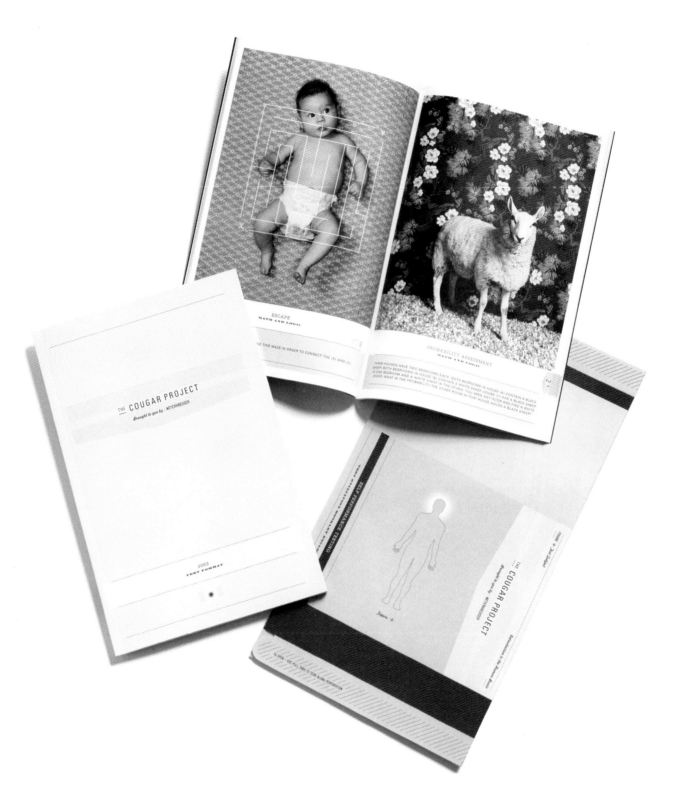

BROCHURE

DESIGN
Steven Tolleson and
Jaime Calderon
San Francisco, CA

ART DIRECTION
Steven Tolleson

CREATIVE DIRECTION
Steven Tolleson

PHOTOGRAPHY
Kyoko Hamada,
Catherine Ledner,
and Alan Powdrill

DESIGN OFFICE
Tolleson Design

CLIENT
Weyerhaeuser

PRINCIPAL TYPE
Black Oak, FF Freehand,
and Trade Gothic

DIMENSIONS
5.5 x 8.5 in.
14 x 21.6 cm

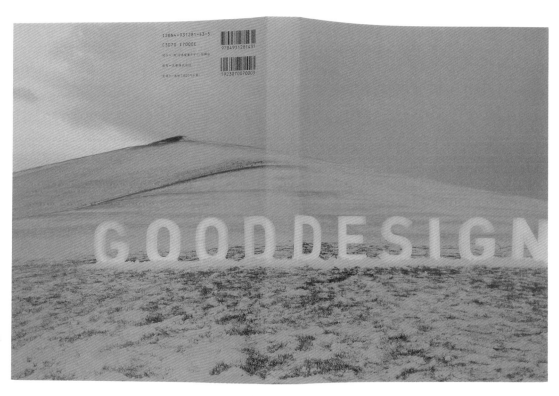

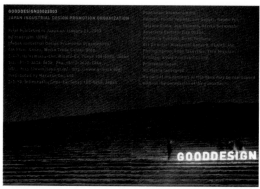

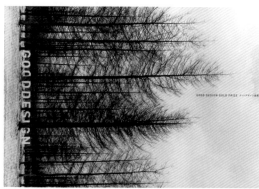

BOOK

DESIGN
Masayoshi Kodaira
Tokyo, Japan

ART DIRECTION
Masayoshi Kodaira

PHOTOGRAPHY
Kozo Takayama

STUDIO
FLAME, Inc.

CLIENT
Japan Industrial Design
Promotion Organization

PRINCIPAL TYPE
FF DIN

DIMENSIONS
8.9 x 11.7 in.
22.5 x 29.7 cm

POSTER

DESIGN
Ohsugi Gaku and
Takaba Yuko
Tokyo, Japan

ART DIRECTION
Ohsugi Gaku

CREATIVE DIRECTION
Ohsugi Gaku

DESIGN OFFICE
702 Design Works Co., Ltd.

CLIENT
Futaki Interior Co., Ltd.

PRINCIPAL TYPE
Futura

DIMENSION
28.7 x 40.6 in.
72.9 x 103.2 cm

Broom Street Theater

1119 WILLIAMSON STREET | TICKETS $7
FRIDAYS, SATURDAYS, SUNDAYS | 8PM
WWW.BROOMSTREET.ORG

THE ALABASTER COUNTY

LITTLE LEAGUE

& beauty pageant

WRITTEN & DIRECTED BY SCOTT FEINER
PERFORMANCES JUNE 6TH – JULY 13TH

PLANET PROPAGANDA

NEWSLETTER

DESIGN
Matt Willey
London, England

ART DIRECTION
Matt Willey

CREATIVE DIRECTION
Matt Willey

DESIGN STUDIO
Frost Design London

CLIENT
British Design &
Art Direction/D&AD

PRINCIPAL TYPE
Clarendon

DIMENSIONS
7.7 x 10 in.
19.5 x 25.5 cm

POSTER

DESIGN
Kevin Wade
Madison, WI

DESIGN OFFICE
Planet Propaganda

CLIENT
Broom Street Theatre

PRINCIPAL TYPE
Clarendon Extended,
HTF Gotham Bold,
and Ribbonette

DIMENSIONS
19 x 25 in.
48.3 x 63.5 cm

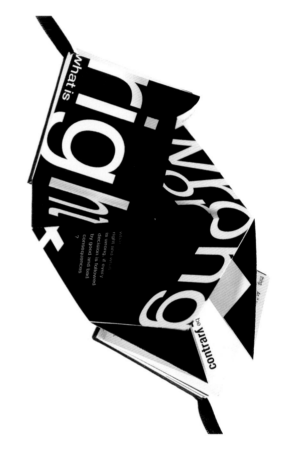

STUDENT PROJECT

DESIGN
Brigitta Bungard
New York, NY

SCHOOL
School of Visual Arts

INSTRUCTOR
Mike Joyce

PRINCIPAL TYPE
Neue Helvetica

DIMENSIONS
2.4 x 2.4 in.
6.1 x 6.1 cm

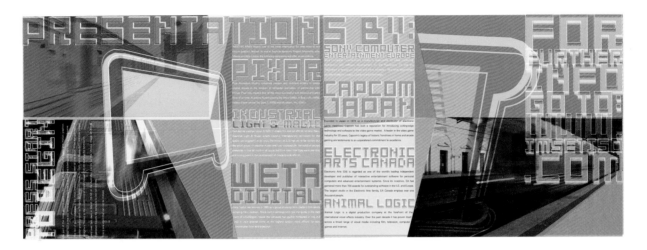

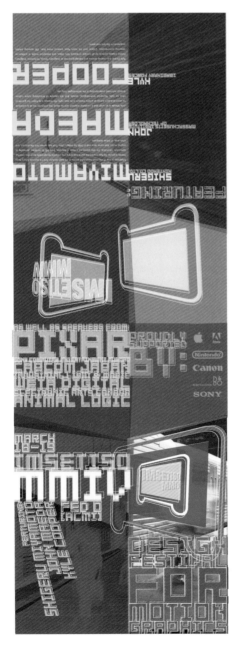

STUDENT PROJECT

DESIGN
Chris Stephen
Ballarat, Australia

SCHOOL
University of Ballarat

INSTRUCTOR
Helmut Stenzel

FOR IMPACT,
POSTERS ARE
INVINCIBLE...

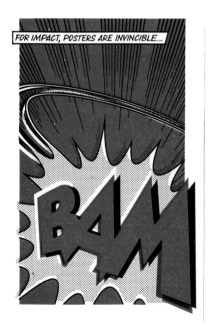

FOR IMPACT, POSTERS ARE INVINCIBLE...

RED 50% BLACK

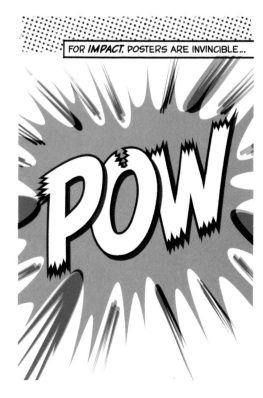

FOR *IMPACT*, POSTERS ARE INVINCIBLE...

POSTER

DESIGN
Paul Belford and John Tisdall
London, England

ART DIRECTION
Paul Belford

CREATIVE DIRECTION
Paul Belford and Nigel Roberts

LETTERING
John Tisdall and Paul Belford

COPYWRITER
Nigel Roberts

AGENCY
AMV.BBDO

CLIENT
The Outdoor Advertisers Association

PRINCIPAL TYPE
Handlettering

DIMENSIONS
Various

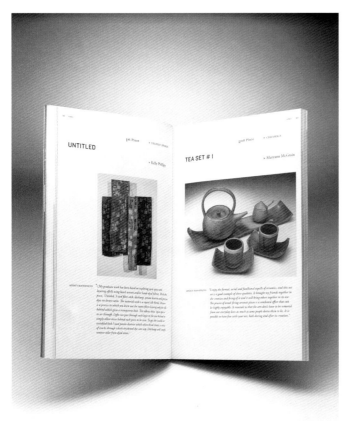

MAGAZINE

Design
Matthew Muñoz, Laurie Jarzemsky, and
Rachel Hoffman
Greenville, NC

Creative Direction
Matthew Muñoz and Laurie Jarzemsky

Photography
Henry Stindt

Editor
Matthew Muñoz

Faculty Advisor
Craig Malmrose

School
East Carolina University

Principal Type
Adobe Clarendon,
Adobe Garamond Pro, HTF Knockout,
Adobe Minion, and Adobe Wood Type
Ornaments 1

Dimensions
5.9 x 9 in.
15 x 22.9 cm

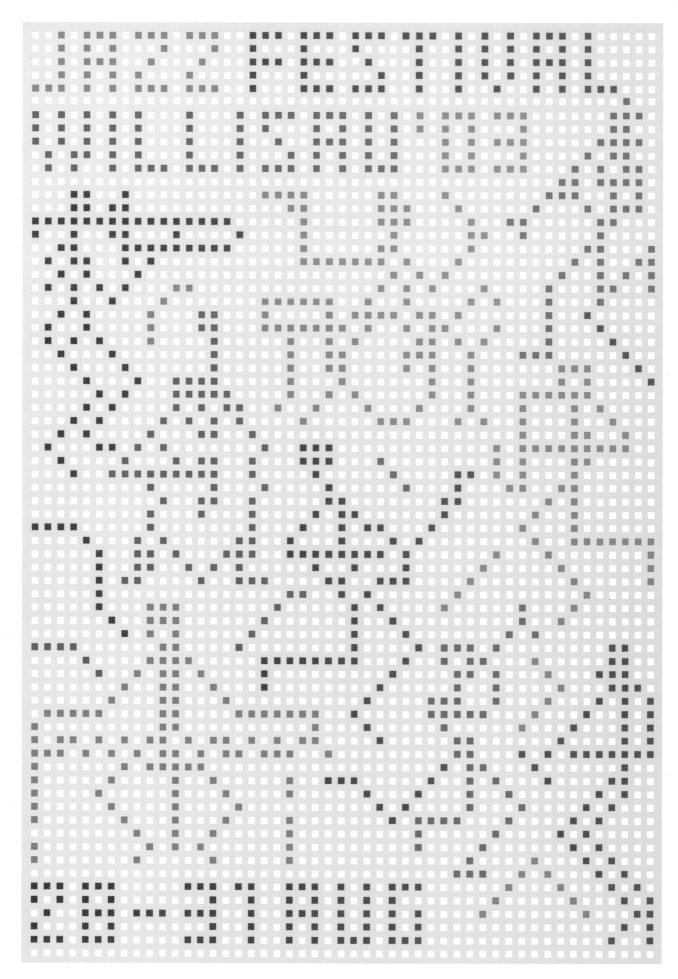

214

POSTER

DESIGN
Niklaus Troxler
Willisau, Switzerland

ART DIRECTION
Niklaus Troxler

LETTERING
Niklaus Troxler

DESIGN OFFICE
Niklaus Troxler Design

CLIENT
Jazz in Willisau

PRINCIPAL TYPE
Custom typeface

DIMENSIONS
35.4 x 50.4 in.
90 x 128 cm

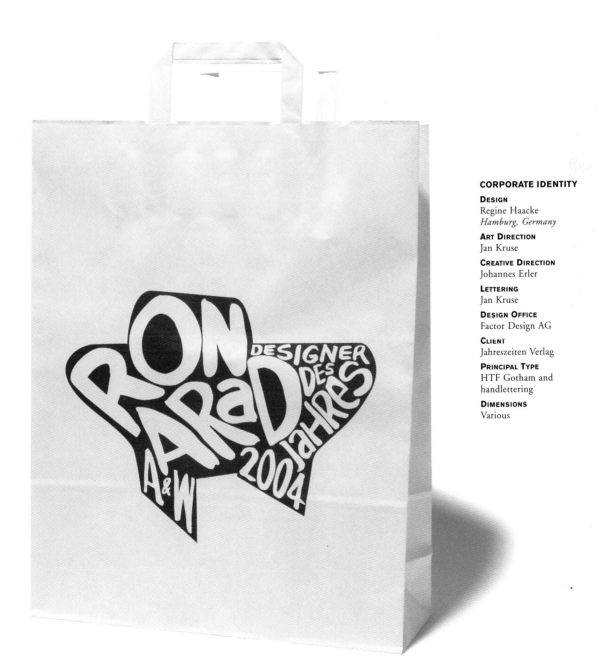

CORPORATE IDENTITY

DESIGN
Regine Haacke
Hamburg, Germany

ART DIRECTION
Jan Kruse

CREATIVE DIRECTION
Johannes Erler

LETTERING
Jan Kruse

DESIGN OFFICE
Factor Design AG

CLIENT
Jahreszeiten Verlag

PRINCIPAL TYPE
HTF Gotham and
handlettering

DIMENSIONS
Various

MAGAZINE

DESIGN
Domenic Lippa
London, England

ART DIRECTION
Domenic Lippa

CREATIVE DIRECTION
Domenic Lippa

COPYWRITERS
Domenic Lippa,
Ian Chilvers, and
Patrick Baglee

EDITORS
James Alexander,
Patrick Baglee, and
Domenic Lippa

DESIGN STUDIO
Lippa Pearce Design

CLIENT
The Typographic Circle

PRINCIPAL TYPE
Enigma, Franklin Gothic,
and Gothic 13

DIMENSIONS
9.25 x 11 in.
23.5 x 28 cm

POSTER

DESIGN
Michael Strassburger
Seattle, WA

ART DIRECTION
Michael Strassburger

CREATIVE DIRECTION
Adam Zacks
Bellevue, WA

LETTERING
Michael Strassburger

STUDIO
Modern Dog Design 'n Thing

CLIENT
House of Blues

PRINCIPAL TYPE
Handlettering

DIMENSIONS
16.5 x 24 in.
41.9 x 61 cm

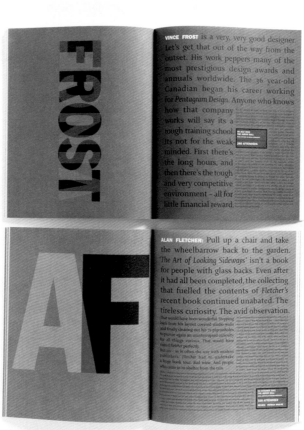

BEN HARPER & The Innocent criminals
JACK JOHNSON
A HOUSE OF BLUES SHOW
....With....
DJ LOGIC
At The GORGE Amphitheatre
Sat. Aug. 23 6:30

Tickets are available
at all Ticketmaster outlets,
online at ticketmaster.com or hob.com
or charge by phone at
(206) 628-0888

POSTER

DESIGN
Motoya Sugisaki
Tokyo, Japan

ART DIRECTION
Motoya Sugisaki

CREATIVE DIRECTION
Masayoshi Suzuki
Aichi, Japan

LETTERING
Motoya Sugisaki

DESIGN OFFICE
Sugisaki Motoya Design Office

CLIENT
Wise Corporation

PRINCIPAL TYPE
Handlettering

DIMENSIONS
28.7 x 40.6 in.
72.8 x 103 cm

Kavesom.

Jens Martin Skibsted

Kirketårnet søndervejet
Atten tons
Verden er min famlen
Ene gulerødder
Skarpe blomster, mælkeveje under dine supper
O for negerkysset
Merz til venstre dingler

Simon Grotrian har udplukket & arrangeret Jens Martin Skibsteds tidlige
digte. De kommer fra en tid hvor frustration, underbevidsthed &
metafysik var sammenfaldende. Tilsammen er digtene en søgen efter
udtryk, en skaben af udtryk & en kaven sig frem gennem poesiens
ulgennemsigtige rum.

ATTIKA

ISBN 87 7528 530 4

9 788775 285303

brain

Kavesom

metaphysic

heart

gut

genital

Forfatterforlaget Attika

*Baby universets uhåndgribeligesmile. Afførende hylstre vegeterer hopla
hopsisa, while a hunde livs freezing klare øjnearedecestot tilraner
themselves råstof – desintegrerer by a vissen værensbon to lob. Only meat
flæsk & idioty from no.*

Babyuniversets uhåndgribelige smil.

Afførende hylstre vegeterer hopla hopsasa, mens et hundelivs
frostklare øjne forgæves tilraner sig råstof – desintegrerer med en
vissen værensbon i røven.
Kun kød, flæsk & idioti fra intet.

*Fx. sell. ninetypisk cheers by coffee & cake to a scandinavian nik from
implicit informed. Reflection to øjnenes nedadbøjethed. Heartfelt bondage
from that gryende ragnarok jantepastiche, to todays loudly by they
long-winded shadows out of bravado. A to the border meaningful "Hello"
to the door jolly.*

Fx. Venskab.

Arketypisk tak for kaffe & kage til et nordisk nik
af stiltiende indforståethed. Genskin i øjnenes
nedadbøjethed. Inderlig trælle af det gryende ragnarok
& jantepastiche, i dagens højlys med de
langstrakte skygger på trods. Et til randen meningsfuldt
»Hej« til dørens knagen.

BOOK

DESIGN
Rick Valicenti and
Tracy Jenkins
Barrington, IL

ART DIRECTION
Rick Valicenti

PHOTOGRAPHY
Rick Valicenti

DESIGN OFFICE
Thirst 3ST.com

CLIENT
Jens Martin Skibsted
Denmark

PRINCIPAL TYPE
Apex Sans and Pixella

DIMENSIONS
4.5 x 6.5 in.
11.4 x 16.3 cm

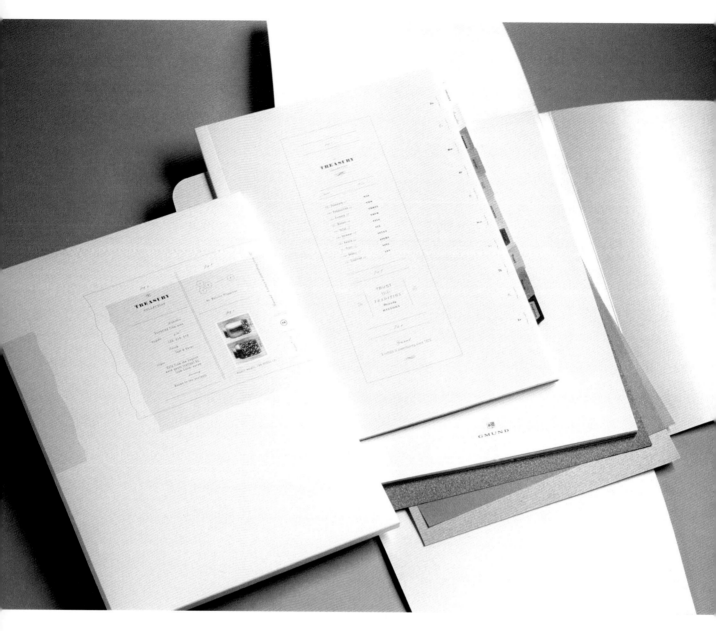

CATALOG

DESIGN
Steven Tolleson and
Craig Clark
San Francisco, CA

ART DIRECTION
Steven Tolleson

CREATIVE DIRECTION
Steven Tolleson

PHOTOGRAPHY
Mark Hooper and various

DESIGN OFFICE
Tolleson Design

CLIENT
Gmund Paper

PRINCIPAL TYPE
Various

DIMENSIONS
8.75 x 12 in.
22.2 x 30.5 cm

CATALOG

DESIGN
Dave Taylor
Madison, WI

CREATIVE DIRECTION
Dana Lytle

DESIGN OFFICE
Planet Propaganda

CLIENT
Gary Fisher Bikes

PRINCIPAL TYPE
Belizio and CIA

DIMENSIONS
10.9 x 8.5 in.
27.7 x 21.6 cm

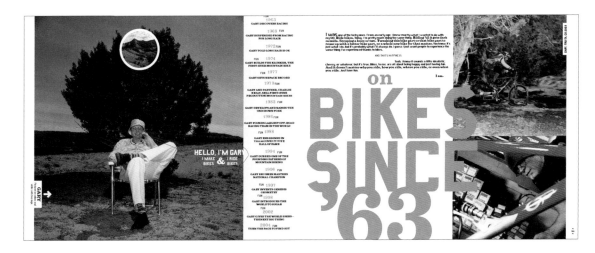

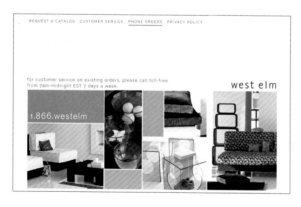

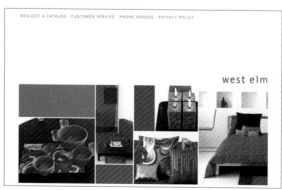

WEB SITE

DESIGN
Abby Clawson Low
New York, NY

CREATIVE DIRECTION
Allison Williams and
J.P. Williams

DESIGN OFFICE
Design: MW

CLIENT
West Elm

PRINCIPAL TYPE
Akzidenz Grotesk

POSTER

DESIGN
Troy Tyner,
Elliot Strunk,
Kevin Pojman,
and John Foust
Winston-Salem, NC

CREATIVE DIRECTION
Troy Tyner

LETTERING
Kevin Pojman

COPYWRITER
Julie Curtis
Hermosa Beach, CA

DESIGN OFFICE
Mitre Design

CLIENT
MakeaScene.org

PRINCIPAL TYPE
Various

DIMENSIONS
24 x 32 in.
61 x 81.3 cm

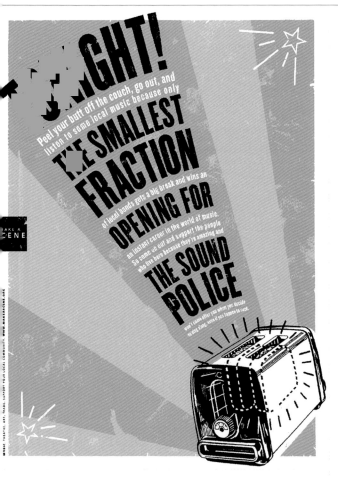

...GHT!

Peel your butt off the couch, go out, and listen to some local music because only

THE SMALLEST FRACTION of local bands gets a big break and wins an **OPENING FOR** an instant career in the world of music. So come on out and support the people who live here because they're amazing and **THE SOUND POLICE** won't come after you when you decide to stay home, here'd out, begin to care.

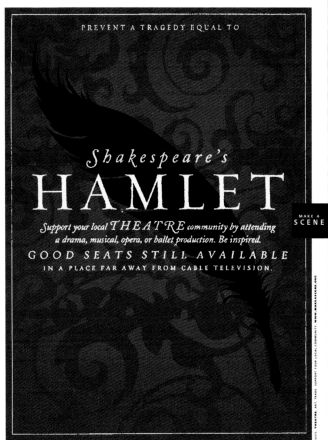

PREVENT A TRAGEDY EQUAL TO

Shakespeare's

HAMLET

Support your local THEATRE *community by attending a drama, musical, opera, or ballet production. Be inspired.*

GOOD SEATS STILL AVAILABLE
IN A PLACE FAR AWAY FROM CABLE TELEVISION.

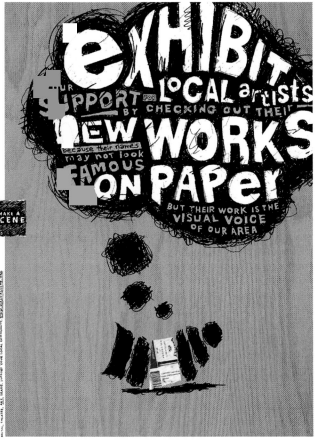

EXHIBIT support for **LOCAL** artists by checking out their **NEW WORKS** because their names may not look **FAMOUS ON PAPER** but their work is the **VISUAL VOICE OF OUR AREA**

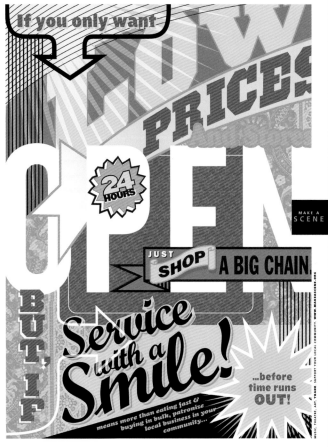

If you only want **LOW PRICES OPEN** 24 HOURS JUST SHOP A BIG CHAIN. BUT IF *Service with a Smile!* means more than eating fast & buying in bulk, patronize your local business in your community... ...before time runs OUT!

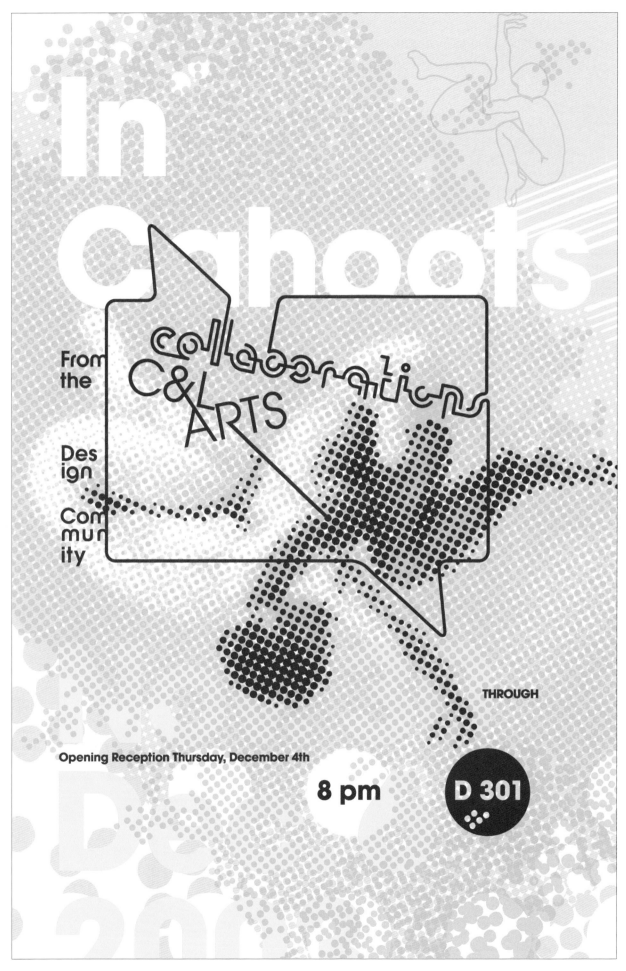

In Cahoots

collaborations

C&L
ARTS

From
the

Des
ign

Com
mun
ity

THROUGH

Opening Reception Thursday, December 4th

8 pm

D 301

BOOK

Design
Yael Eisele
New York, NY

Creative Direction
Allison Williams and
J.P. Williams

Design Office
Design: MW

Client
Melcher Media

Principal Type
Vendetta

Dimensions
6.5 x 9.5 in.
16.5 x 24.1 cm

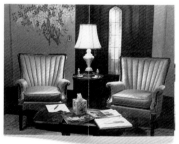

POSTER

Design
Weston Bingham and
Helena Fruehauf
New York, NY

Creative Direction
Weston Bingham and
Helena Fruehauf

Lettering
Weston Bingham

Client
California Institute of the Arts

Principal Type
Avant Garde and Gothic

Dimensions
22 x 34 in.
55.9 x 86.4 cm

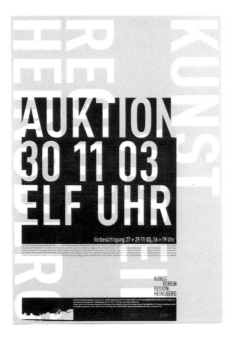

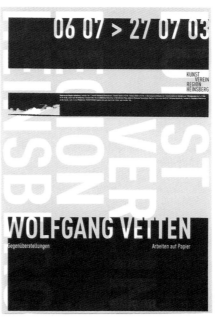

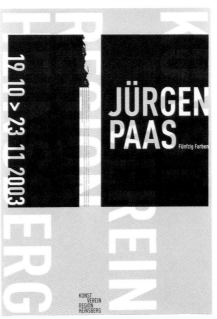

POSTER

DESIGN
Helen Hacker
Düsseldorf, Germany

LETTERING
Helen Hacker

DESIGN OFFICE
Büro Grotesk

CLIENT
Kunstverein Region Heinsberg

PRINCIPAL TYPE
FF DIN Condensed

DIMENSIONS
16.5 x 23.4 in.
42 x 59.4 cm

POSTER

DESIGN
Sean Carmody
New York, NY

ART DIRECTION
Paula Scher

LETTERING
Paula Scher

DESIGN OFFICE
Pentagram Design, Inc

CLIENT
The Public Theater

PRINCIPAL TYPE
Handlettering

DIMENSIONS
30 x 46 in.
76.2 x 116.8 cm

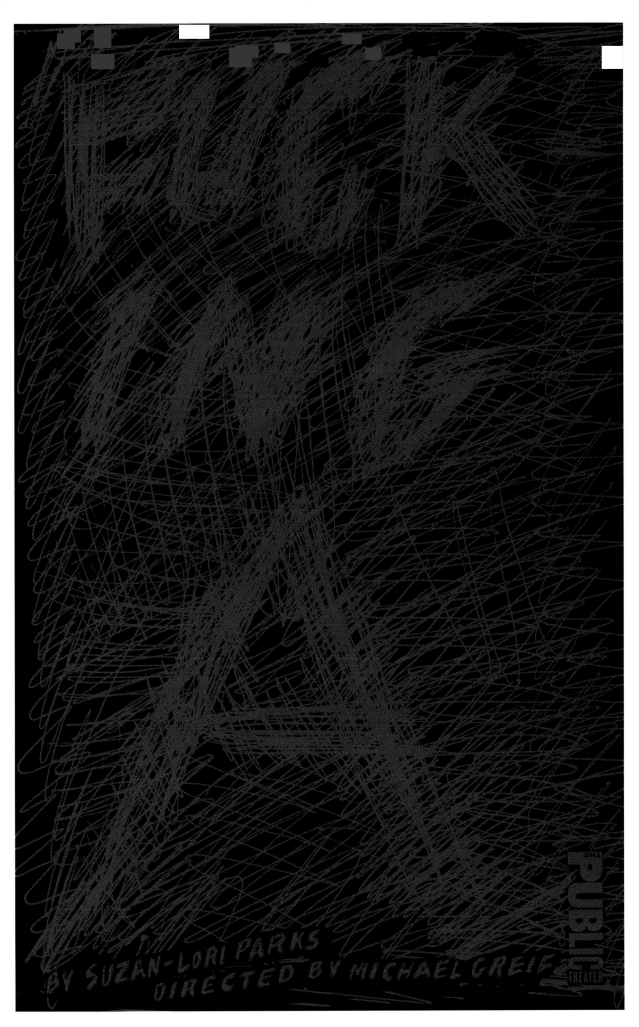

FALL
OUT
BOY

AUGUST2ND2003
WICKERPARKFEST
CHICAGOILLINOIS

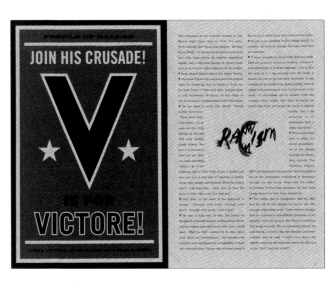

MAGAZINE

DESIGN
David Beck and Craig Skinner
Dallas, TX

ART DIRECTION
David Beck and Craig Skinner

CREATIVE DIRECTION
David Beck

LETTERING
David Parsons and Casey McGarr

PHOTOGRAPHY
Phil Hollenbeck and John Wong

WRITERS
Phil Hollenbeck and Aaron Barker

STUDIO
David Back Design

CLIENT
Dallas Society of Visual Communications

PRINCIPAL TYPE
Benguiat Frisky, Garamond, Serifa,
tombstone rubbings, and handlettering

DIMENSIONS
6 x 9 in.
15.2 x 22.9 cm

POSTER

DESIGN
Mike Joyce
New York, NY

ART DIRECTION
Mike Joyce

CREATIVE DIRECTION
Mike Joyce

DESIGN OFFICE
Stereotype Design

CLIENT
Fall Out Boy

PRINCIPAL TYPE
Helenic

DIMENSIONS
18 x 24 in.
45.7 x 61 cm

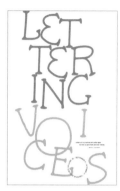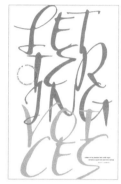
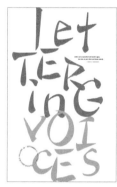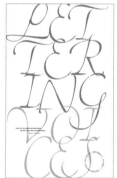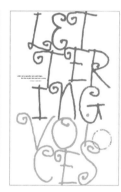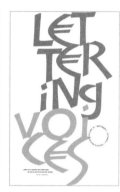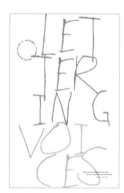

POSTER

DESIGN
Rick Cusick
Kansas City, MO

ART DIRECTION
Rick Cusick and
Ann Montgomery

STUDIO
Hallmark Lettering Studio

PRINCIPAL TYPE
Hallmark proprietary fonts,
Arial Narrow Bold,
and Arial Bold Italic

DIMENSIONS
11 x 16.9 in.
27.9 x 42.9 cm

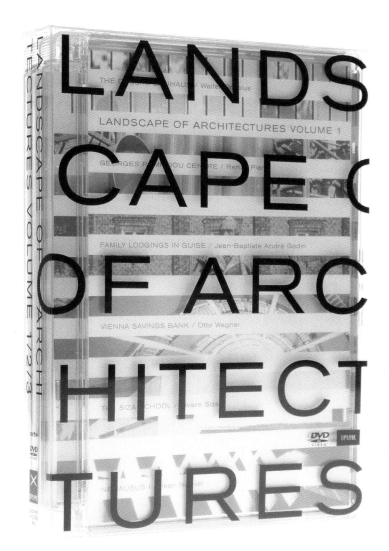

LANDS
CAPE O
OF ARC
HITECT
TURES

PACKAGING

DESIGN
Masayoshi Kodaira
Tokyo, Japan

ART DIRECTION
Masayoshi Kodaira

STUDIO
FLAME, Inc.

CLIENT
UPLINK Co.

PRINCIPAL TYPE
Berthold Akzidenz Grotesk

DIMENSIONS
5.6 x 7.6 x 1.25 in.
14.3 x 19.2 x 3.2 cm

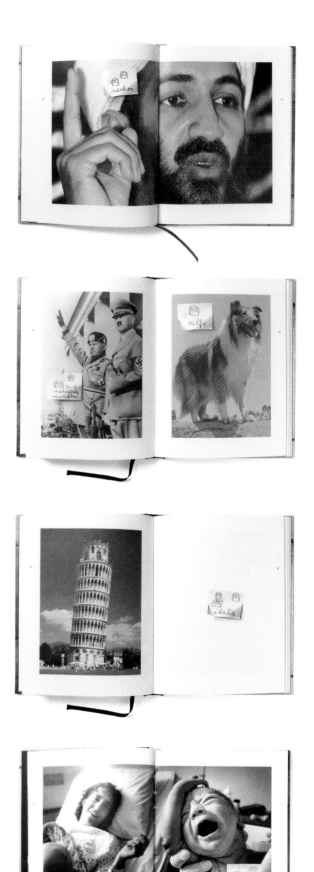

BOOK

ART DIRECTION
Till Schaffarczyk
Frankfurt, Germany

CREATIVE DIRECTION
Helmut Himmler

PUBLISHER
Hermann Schmidt Verlag

AGENCY
Ogilvy & Mather Frankfurt

PRINCIPAL TYPE
Handlettering

DIMENSIONS
6.8 x 8.8 in.
17.3 x 22.3 cm

BOOK COVER

DESIGN
Gerry Greaney
Baltimore, MD

DESIGN OFFICE
Greaney Design

CLIENT
Maryland Institute College of Art

PRINCIPAL TYPE
Lo-Res

DIMENSIONS
6 x 9 in.
15.2 x 22.9 cm

PACKAGING

DESIGN
Yoshimaru Takahashi
Osaka, Japan

ART DIRECTION
Yoshimaru Takahashi

LETTERING
Yoshimaru Takahashi

DESIGN OFFICE
Kokokumaru Co. Ltd.

CLIENT
Japan Match Industry Org.
and MatchNet.Project

PRINCIPAL TYPE
Univers

DIMENSIONS
2.2 x 1.4 x .6 in.
5.6 x 3.6 x 1.6 cm

BOOK

DESIGN
Matteo Bologna
and Victor Mingovits
New York, NY

ART DIRECTION
Matteo Bologna

CREATIVE DIRECTION
Matteo Bologna

STUDIO
Mucca Design Corporation

CLIENT
Balthazar Restaurant

PRINCIPAL TYPE
Americana,
Bureau Grotesque customized,
and Jenson Bold Condensed

DIMENSIONS
7.75 x 10.5 in.
19.7 x 26.7 cm

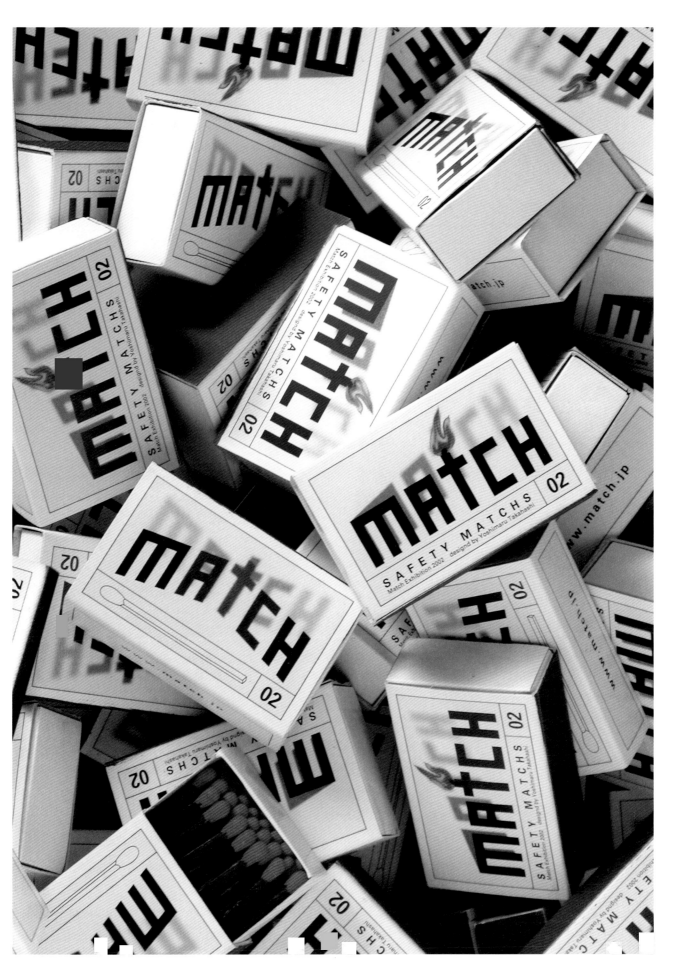

o Metropolis

We strive for a "fusion" practice that moves well beyond a multidisciplinary approach. Integrated, project-specific teams focus on shared and mutually creative ways of working. Typically client teams take part in the process in forums such as roundtables and advisory groups that critique projects and the firm as a whole. EDAW supports powerful communications technology and an open firm culture to tear down old walls—between this and that office, this and that specialist, this and that time zone..., and between our goals and yours.

Fusion is more than collaboration; it propels the search for the best idea.

Planners team with archaeologists, historians with engineers, designers with biologists. We listen, learn, debate. We harness the power of disagreement— push and pull, merge ideas, shape realities. This is the best of EDAW.

Another asset we share is a global store of experience. EDAW professionals on different coasts—and continents—regularly convene practice circles by videoconference to exchange ideas within their specialties, while in-house symposiums on interdisciplinary topics explore convergent trends among fields.

The U.S. Navy wanted to do the right thing with the vernal pools along the Pacific coast at Marine Corps Air Station Miramar, California. But were these bloom-t really irreplaceable homes to hundreds of fragile life forms? (They were.) What about military, economic and community uses for the land around them? The Navy turned to EDAW.

Tiny as they are, Miramar Air Station's vernal pools raise a major issue: the meeting of military mission on federal land with an ecological imperative to save fragile habitat.

The big job of designing Atlanta's Centennial Olympic Park proved even bigger when we realized it would become a regional economic catalyst. "Atlanta's waterfront," in the words of this non-waterfront city's mayor.

"When you need to deal with a million acres there's only one firm you call," says the chairman of the St. Joe Land Company. Today a wood products reserve spanning 14 counties, St. Joe's slice of Florida's panhandle is tomorrow's metropolitan region, an ecological treasure, and a magnet for recreation and tourism—all that and more.

Understanding it involved more than 20 and creative disciplines, as well as pow for collaborating, mapping and comm (We had them.)

From Vernal Pool to Metropolis

EDAW

Gateway Science School Courtyard
St. Louis, Missouri
Client: St. Louis Public Schools

L04

An award-winning educational landscape helps erase the memory of the Pruitt-Igoe public housing debacle

Two acres of science and math disguised as play. Where 33 public housing towers once stood in shambles, children in the inner city now learn about Missouri's natural ecosystems by playing tag in an Ozark forest or watching a mid- and tall-grass prairie change color during the year. A weather station and windmill beat tether-ball and four-square hands down.

Transforming a brownfields site into Olympic housing, an ecologically sustainable village—an Australian model in green

The "Green Olympics" have given way to a green community. From an athlete's village to a 5,000-resident neighborhood that features 850 solar-powered homes. Ninety percent of construction hard waste and sixty percent of soft waste recycled. Carbon-dioxide emissions are being reduced by 2,000 tons a year. And, by it functions as a vibrant urban center.

Designing a Chinese city while maintaining environmental standards

The centerpiece of a 70 km² new town development with a future population of 600,000 residents, Lake's 513 hectares are designed to house 500 companies with eight waterfront around a healthy lake. A large ceremon waterfront promenade complement the

Jinji Lake Landscape Master Plan
Suzhou, China
Client: Suzhou Industrial Park Administrative Committee

Newington Olympic Village Plan and Landscape
Homebush Bay, New South Wales, Australia
Client: Mirvac Lend Lease Village Consortium / OCA

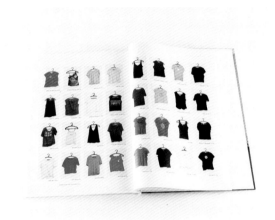

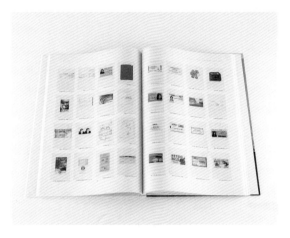

BROCHURE

DESIGN
Gaby Brink and
Marius Gedgaudas
San Francisco, CA

ART DIRECTION
Gaby Brink

CREATIVE DIRECTION
Gaby Brink

DESIGN OFFICE
Templin Brink Design

CLIENT
EDAW

PRINCIPAL TYPE
Univers

DIMENSIONS
7 x 9 in.
17.8 x 22.9 cm

STUDENT PROJECT

DESIGN
Navi Katzman
Jerusalem, Israel

SCHOOL
Bezalel Academy of Art and Design

INSTRUCTOR
Avi Aisenstein

PRINCIPAL TYPE
Frank-Rehil

DIMENSIONS
12 x 17 in.
30.5 x 43.2 cm

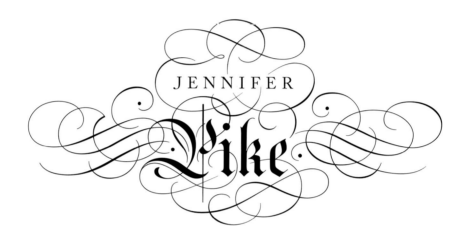

JENNIFER Pike

THE BBC YOUNG MUSICIAN OF THE YEAR 2002

LOGOTYPE

DESIGN
Tony Forster
Tyldesley, England

ART DIRECTION
Tony Forster

LETTERING
Tony Forster

DIGITIZER
Alan Meeks
*Little Chalfont,
England*

STUDIO
Tony Forster Typographics

CLIENT
Jennifer Pike

PRINCIPAL TYPE
Adobe Caslon

POSTER

DESIGN
Niklaus Troxler
Willisau, Switzerland

ART DIRECTION
Niklaus Troxler

LETTERING
Niklaus Troxler

DESIGN OFFICE
Niklaus Troxler Design

CLIENT
Jazz in Willisau

PRINCIPAL TYPE
Custom

DIMENSIONS
35.6 x 50.4 in.
90.5 x 128 cm

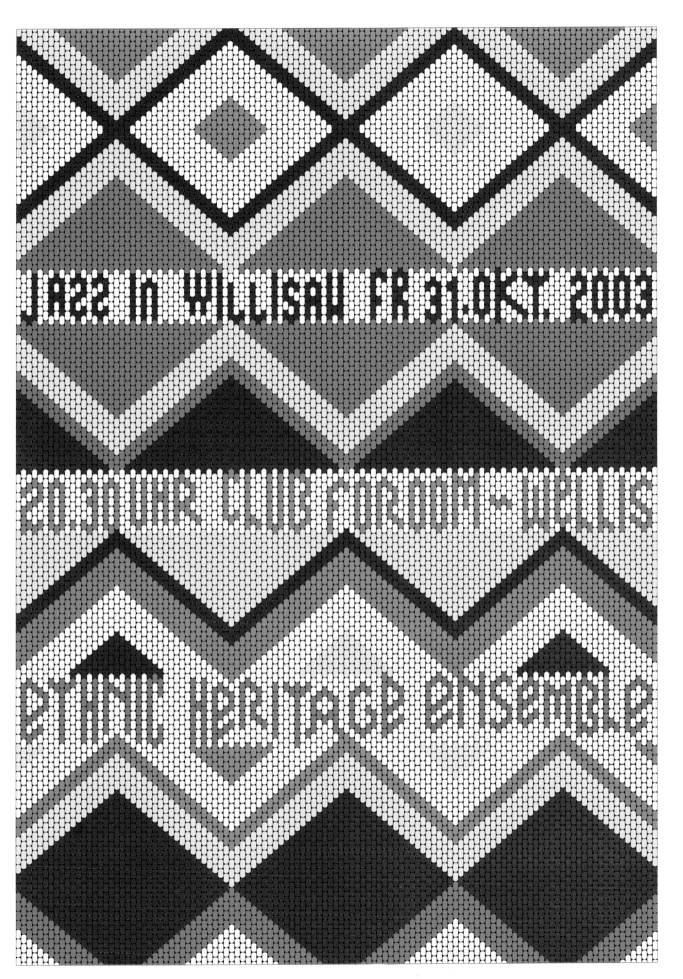

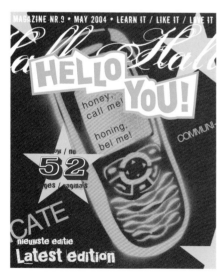

MAGAZINE COVERS

DESIGN
Petra Janssen and
Edwin Vollebergh
's-Hertogenbosch,
The Netherlands

ART DIRECTION
Petra Janssen and
Edwin Vollebergh

CREATIVE DIRECTION
Petra Janssen and
Edwin Vollebergh

LETTERING
Edwin Vollebergh

DESIGN OFFICE
Studio Boot

CLIENT
Malmberg Publishers

PRINCIPAL TYPE
Author and Typewriter

DIMENSIONS
6.4 x 7.6 in.
16.2 x 19.3 cm

POSTER

DESIGN
Till Schaffarczyk
Frankfurt, Germany

ART DIRECTION
Till Schaffarczyk

PHOTOGRAPHY
Joachim Bacherl

AGENCY
Ogilvy & Mather Frankf

CLIENT
Café Lesecafé Frankfurt

PRINCIPAL TYPE
Sabon Bold

DIMENSIONS
23.4 x 33.1 in.
59.4 x 84.1 cm

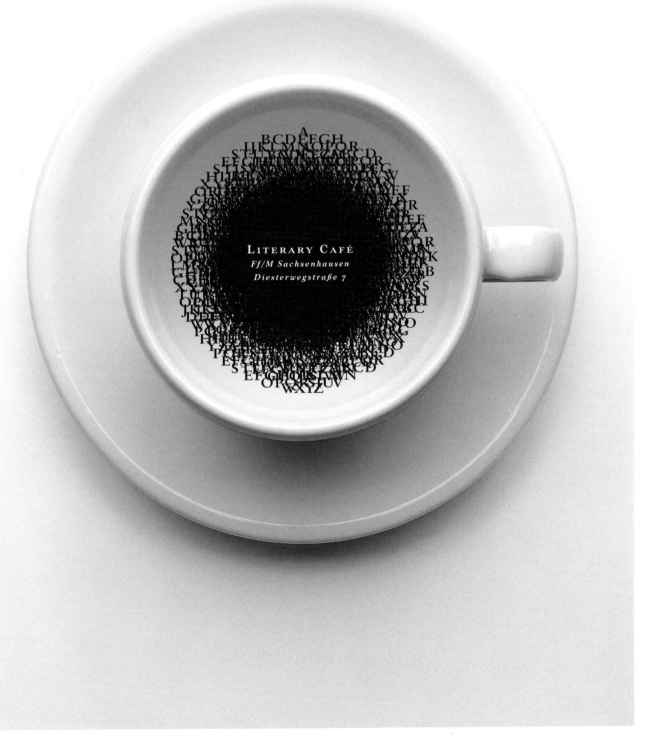

LITERARY CAFÉ
Ff/M Sachsenhausen
Diesterwegstraße 7

wednesday & thursday

NOVEMBER 12th & 13th

2003 *the Polyphonic Spree

TWO NIGHTS

THE GRANADA

644 massachusetts street ● lawrence, kansas

printed & designed at Hammerpress : 816.421.1929

POSTER

DESIGN
Brady Vest
Kansas City, MO

ART DIRECTION
Brady Vest

STUDIO
Hammerpress

CLIENT
The Granada

PRINCIPAL TYPE
Craw, Helenic,
Spartan, and various

DIMENSIONS
14 x 22 in.
35.6 x 55.9 cm

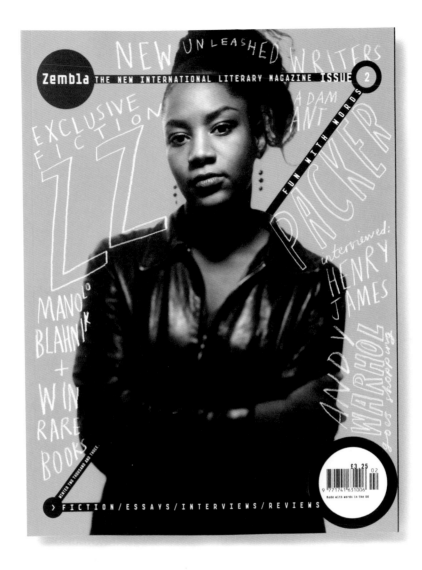

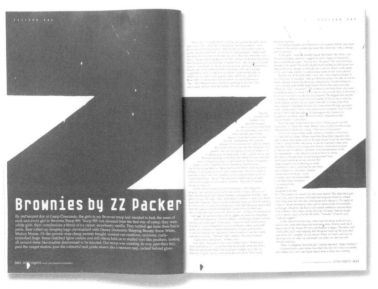

MAGAZINE

DESIGN
Vince Frost and
Matt Willey
London, England

ART DIRECTION
Vince Frost and
Matt Willey

CREATIVE DIRECTION
Vince Frost and
Matt Willey

DESIGN STUDIO
Frost Design London

CLIENT
Zembla Magazine

PRINCIPAL TYPE
Arete Mono and
Palatino

DIMENSIONS
9.1 x 11.8 in.
23 x 30 cm

BROCHURE

DESIGN
Susan Dann,
Laurence Pasteels,
Marie-Elaine Benoit,
and Yann Mooney
Montreal, Canada

CREATIVE DIRECTION
Hélène Godin

TYPOGRAPHER
Graphiques M & H

AGENCY
DIESEL

CLIENT
Graphiques M & H

PRINCIPAL TYPE
Johndvl, HTF Knockout,
and Kolo

DIMENSIONS
9 x 9 in.
22.9 x 22.9 cm

Give 'em Helvetica

BOOK

DESIGN
Michael Skjei
Minneapolis, MN

DESIGN OFFICE
M. Skjei (Shay) Design Co

PUBLISHER
Shay, Shea, Hsieh & Skjei,
Publishers

DIMENSIONS
5.9 x 8.5 in.
15 x 21.6 cm

PRINCIPAL TYPE
Helvetica

Even a cursory glance through a type house manual or popular magazine from the last 30 years should dash the idea that the world ever tottered on the brink of global Helvetican domination. *Michael Rock, 1992* When I first entered the business, we had just come out of the dullsville fifties. Too much Helvetica. *Dan Solo, 1998* Helvetica is the most grotesque of all the Grotesks. *Paul Shaw, 1998* Swiss Family Helvetica. *Will Powers, 1998* The invisible typeface. *John Cleveland, 1998* Of all the typefaces, Helvetica is the most ubiquitous. *Carol Newsom, 1999* You know the old adage, "you can't say anything nice don't say anything at all." I don't think I have anything either interesting or insightful to say about Helvetica. It's so neutral, which I suppose is it's principal virtue. *Lou Danziger, 1999* The European Committee for Uniformity of Type Design and type Safety decided to abolish Helvetica for the 21 century as absolutely nonfunctional and dangerous. *Eugene Bugleicherhaus, 1999* Helvetica, a design that died in the seventies and has lingered since then as a sad result of its having been bundled with most every operating system and laser printer made since the invention of Postscript. *John Butler, 1999* Much of the the design of the [sixties] era, was not only ugly but inefficient. After trying to read those Fillmore posters, Helvetica medium might never have looked so good. *David Bonetti, 1999* Helvetica was undeniably the typeface for almost 30 years, and we were linked to it. It was a friend we could count on to give the appearance of design when the idea was weak but not get in the way of that rare stroke of brilliance. Helvetica had the unique quality of being either commanding or benign. *Jack Summerford, 1999* Helvetica by any other name is still Helvetica. *Bill Thorburn, 2000* I'm sticking with Helvetica. [So just] leave me alone you bastards! *Steve Mehallo, 2000*

VIDEO

DESIGN
Sagi Haviv
New York, NY

DESIGN OFFICE
Chermayeff & Geismar Inc.

CLIENT
American Institute of Graphic Arts

PRINCIPAL TYPE
Franklin Gothic No. 2

POSTER

DESIGN
Keiko Itakura and
Go Takahashi
Tokyo, Japan

ART DIRECTION
Manabu Mizuno

CREATIVE DIRECTION
Manabu Mizuno

LETTERING
Keiko Itakura

ILLUSTRATION
Keiko Itakura

DESIGN OFFICE
good design company

CLIENT
Twincle Corporation Inc.

PRINCIPAL TYPE
Handlettering

DIMENSIONS
20.2 x 29 in.
51.4 x 73.7 cm

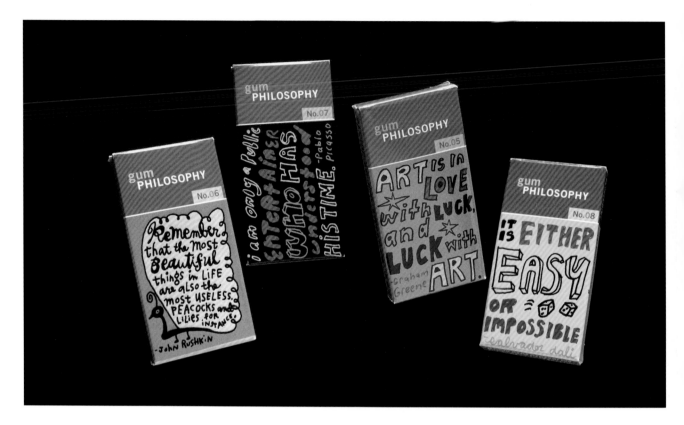

PACKAGING

DESIGN
Michelle Sonderegger
and Ingred Sidie
Kansas City, MO

ART DIRECTION
Michelle Sonderegger
and Ingred Sidie

LETTERING
Martha Rich and
Meg Cundiff
*Pasadena, CA, and
Kansas City, MO*

DESIGN OFFICE
Design Ranch

CLIENT
Blue Q

PRINCIPAL TYPE
Handlettering

DIMENSIONS
1.4 x 2.6 x .3 in.
3.6 x 6.6 x .8 cm

POSTER

DESIGN
Mike Joyce
New York, NY

ART DIRECTION
Mike Joyce

CREATIVE DIRECTION
Mike Joyce

DESIGN OFFICE
Stereotype Design

CLIENT
Agent Orange

PRINCIPAL TYPE
Helvetica Compressed
and Rosewood

DIMENSIONS
18 x 24 in.
45.7 x 61 cm

POSTER

DESIGN
Kevin Wade
Madison, WI

DESIGN OFFICE
Planet Propaganda

CLIENT
Purgatone Records

PRINCIPAL TYPE
Futura

DIMENSIONS
19 x 25 in.
48.3 x 63.5 cm

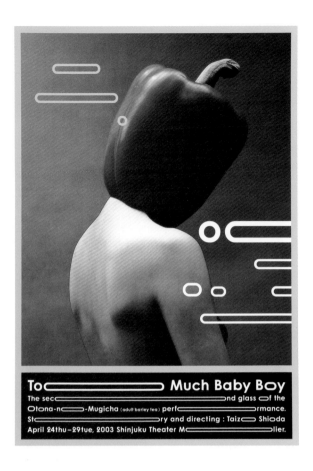

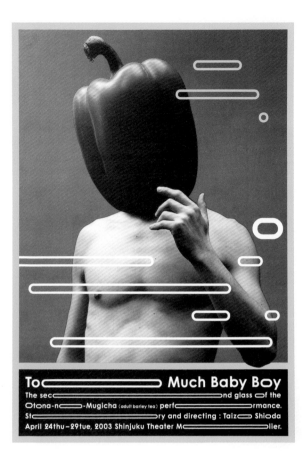

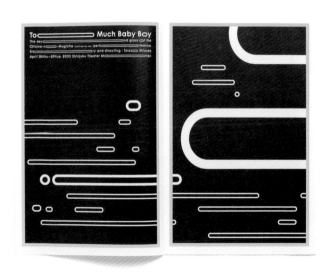

**POSTER AND
BROCHURE**

DESIGN
Kota Sagae
Tokyo, Japan

ART DIRECTION
Kota Sagae

PHOTOGRAPHY
Junmaru Sayama

DESIGN OFFICE
Chou Design Co., Ltd.

CLIENT
Otona-No-Mugicha

PRINCIPAL TYPE
Century Gothic Bold

DIMENSIONS
Various

TELEVISION COMMERCIAL

DESIGN
Tom Bradley, Tom Bruno,
Mathew Cullen, Jesus DeFrancisco,
Chris De St. Jeor, Linas Jodwalis,
Mike Steinmann, and Brad Watanabe
Venice, CA

ART DIRECTION:
Jesus DeFrancisco

CREATIVE DIRECTION
Brian Bacino, Mathew Cullen,
Grady Hall, and Matt Reinhardt

LETTERING
Jesus DeFrancisco and Irene Park

STUDIO
Motion Theory

CLIENT
Foote, Cone & Belding,
San Francisco, and Fox

PRINCIPAL TYPE
Handlettering and custom

PACKAGING

DESIGN
Andreas Wesle
Munich, Germany

ART DIRECTION
Andreas Wesle and
Thomas Markl

CREATIVE DIRECTION
Stefan Bogner

AGENCY
Factor Product GmbH

CLIENT
Compost Records Germa

PRINCIPAL TYPE
Helvetica

DIMENSIONS
5.5 x 5 in.
14 x 12.7 cm

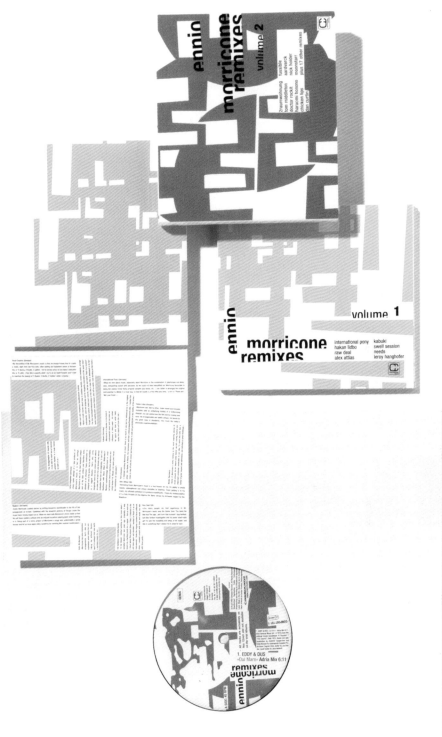

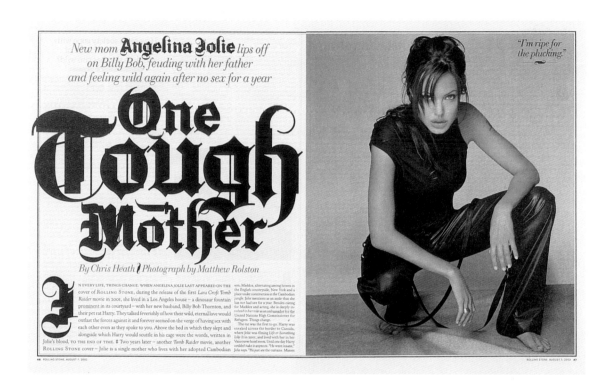

New mom **Angelina Jolie** *lips off on Billy Bob, feuding with her father and feeling wild again after no sex for a year*

One Tough Mother

By Chris Heath / Photograph by Matthew Rolston

IN EVERY LIFE, THINGS CHANGE. WHEN ANGELINA JOLIE LAST APPEARED ON THE cover of ROLLING STONE, during the release of the first *Lara Croft: Tomb Raider* movie in 2001, she lived in a Los Angeles house – a dinosaur fountain prominent in its courtyard – with her new husband, Billy Bob Thornton, and their pet rat Harry. They talked feverishly of how their wild, eternal love would outlast the forces against it and forever seemed on the verge of having sex with each other even as they spoke to you. Above the bed in which they slept and alongside which Harry would scuttle in his cage were the words, written in Jolie's blood, TO THE END OF TIME. ‡ Two years later – another *Tomb Raider* movie, another ROLLING STONE cover – Jolie is a single mother who lives with her adopted Cambodian

son, Maddox, alternating among homes in the English countryside, New York and a place under construction in the Cambodian jungle. Jolie mentions as an aside that she has not had sex for a year. Besides caring for Maddox and acting, she is deeply involved in her role as an ambassador for the United Nations High Commissioner for Refugees. Things change.

The rat was the first to go. Harry was sneaked across the border to Canada, where Jolie was filming *Life or Something Like It* in 2001, and lived with her in her Vancouver hotel room. Until one day Harry couldn't take it anymore. "He went insane," Jolie says. "He just ate the curtains. Maddox

"I'm ripe for the plucking."

MAGAZINE SPREAD

DESIGN
Kory Kennedy
New York, NY

ART DIRECTION
Andy Cowles and
Kory Kennedy

MAGAZINE
Rolling Stone

PRINCIPAL TYPE
Hellvettika

DIMENSIONS
12 x 19.5 in.
30.5 x 49.5 cm

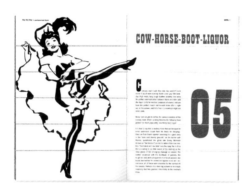

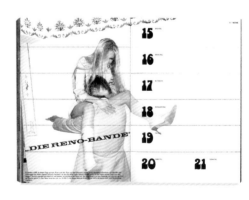

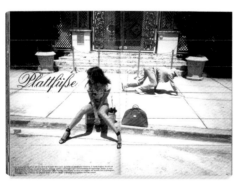

CALENDAR

DESIGN
Fotografie Frank M. Orel
Stuttgart, Germany

ART DIRECTION
Dennis Orel

CREATIVE DIRECTION
Frank M. Orel

AGENCY
Fotografie Frank M. Orel

PRINCIPAL TYPE
Bottleneck, Franklin Gothic
Book Condensed, Playbill,
and various

DIMENSIONS
4.9 x 6.9 in.
12.5 x 17.5 cm

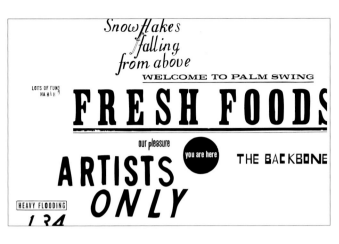

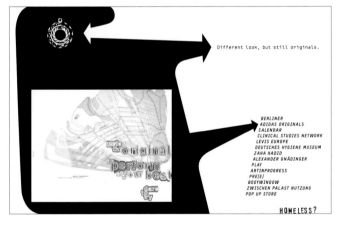

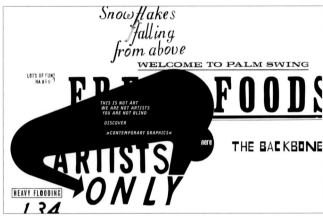

WEB SITE

DESIGN
Thees Dohrn and
Philipp von Rohden
Berlin, Germany

ART DIRECTION
Thees Dohrn and
Philipp von Rohden

CREATIVE DIRECTION
Thees Dohrn and
Philipp von Rohden

DESIGN OFFICE
Zitromat

PRINCIPAL TYPE
Typestar Black Italic,
Typestar OCR, and various

POSTER

DESIGN
Uwe Loesch
Düsseldorf, Germany

ART DIRECTION
Uwe Loesch

STUDIO
Uwe Loesch

CLIENT
Museum of Arts & Design, New Yo
Museum für Angewandte Kunst
Frankfurt am Main; and Klingspor
Museum Offenbach

PRINCIPAL TYPE
Techno

DIMENSIONS
33.1 x 46.9 in.
84 x 119 cm

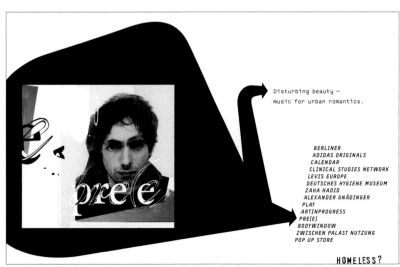

Corporate

Identity

Körpersprache

9. Triennale

für Form und Inhalte

USA und Deutschland

19. Juni bis 31. August 2003

Museum für

Angewandte Kunst

Frankfurt am Main

Klingspor Museum

Offenbach am Main

Body Language

Form and Content

Germany

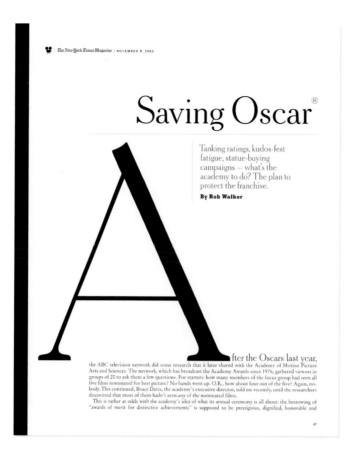

The New York Times Magazine / NOVEMBER 9, 2002

Saving Oscar®

Tanking ratings, kudos-fest
fatigue, statue-buying
campaigns — what's the
academy to do? The plan to
protect the franchise.
By Rob Walker

After the Oscars last year,
the ABC television network did some research that it later shared with the Academy of Motion Picture
Arts and Sciences. The network, which has broadcast the Academy Awards since 1976, gathered viewers in
groups of 20 to ask them a few questions. For starters: how many members of the focus group had seen all
five films nominated for best picture? No hands went up. O.K., how about four out of the five? Again, no-
body. This continued, Bruce Davis, the academy's executive director, told me recently, until the researchers
discovered that most of them hadn't seen *any* of the nominated films.
This is rather at odds with the academy's idea of what its annual ceremony is all about: the bestowing of
"awards of merit for distinctive achievements" is supposed to be prestigious, dignified, honorable and

47

CORPORATE IDENTITY

DESIGN
Jennifer Muller
Brooklyn, NY

ART DIRECTION
Jennifer Muller

CREATIVE DIRECTION
Jennifer Muller

STUDIO
Lucky Tangerine

CLIENT
Lollie

PRINCIPAL TYPE
Futura Book and
Futura Demi Bold

DIMENSIONS
Various

MAGAZINE

DESIGN
Cathy Gilmore-Barnes
and Kristina DiMatteo
New York, NY

ART DIRECTION
Janet Froelich

PHOTO EDITOR
Kathy Ryan

MAGAZINE
The New York Times Magazine

PRINCIPAL TYPE
Cheltenham

DIMENSIONS
9.5 x 11.75 in.
24.1 x 29.8 cm

What the Camera Sees in Her

Assessing Cate Blanchett. By Daphne Merkin

Cate Blanchett is not, at first glance, outrageously
beautiful indeed her strong face can, from certain
angles, seem almost plain. Her cheekbones have

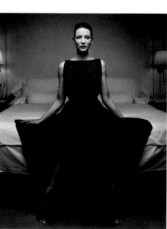

Photograph by Robert Maxwell

Drawn to Narrative

For Tim Burton, moviemaking has always been
about the visuals, but in making a film about a dying
father he has discovered the allure of storytelling. By Lynn Hirschberg

Nearly everywhere he goes, Tim Burton carries a
pocket-size sketchbook and a small watercolor
kit. Even when he's shooting movies like
"Beetlejuice," "Batman" and "Big Fish," his lat-
est film, which opens in New York on Dec. 10.

Photographs by Dan Winters

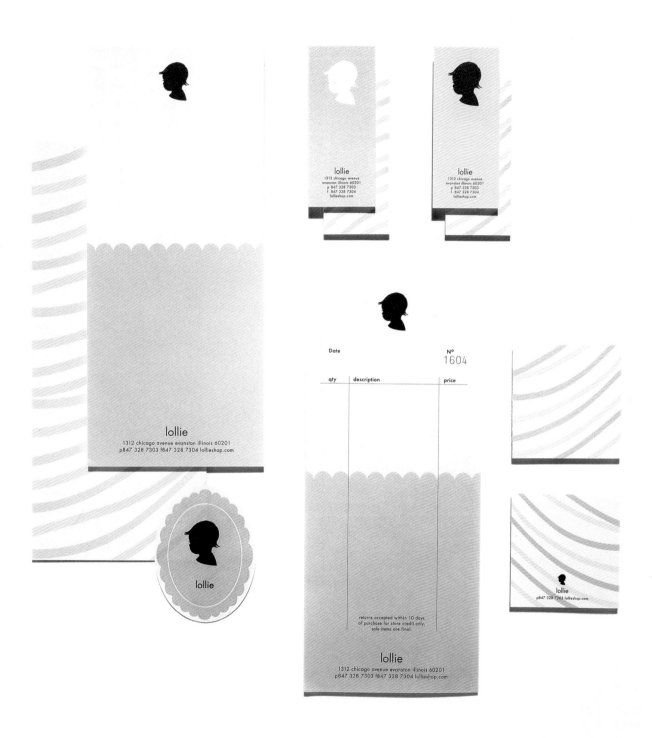

lollie

1312 chicago avenue evanston illinois 60201
p847 328 7303 f847 328 7304 lollieshop.com

lollie

1312 chicago avenue
evanston illinois 60201
p 847 328 7303
f 847 328 7304
lollieshop.com

lollie

1312 chicago avenue
evanston illinois 60201
p 847 328 7303
f 847 328 7304
lollieshop.com

lollie

Date

N°
1604

qty description price

returns accepted within 10 days
of purchase for store credit only.
sale items are final.

lollie

1312 chicago avenue evanston illinois 60201
p847 328 7303 f847 328 7304 lollieshop.com

lollie
p847 328 7303 lollieshop.com

BOOK

DESIGN
David Schrimpf
Minneapolis, MN

CREATIVE DIRECTION
Bill Thorburn

DESIGN OFFICE
Carmichael Lynch Thorburn

CLIENT
Wabedo Lakes Association

PRINCIPAL TYPE
Cheltenham, Quorum, typewriter,
and handlettering

DIMENSIONS
6.5 x 8.25 in.
16.5 x 21 cm

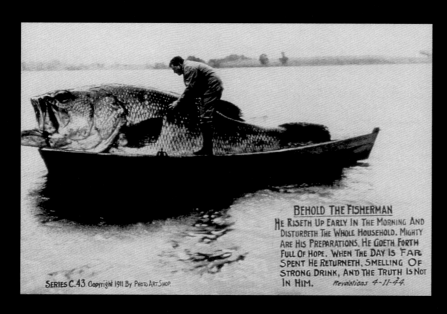

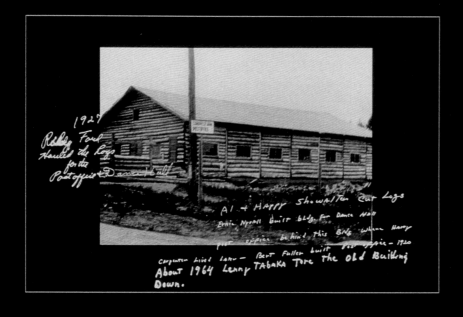

CORPORATE IDENTITY

DESIGN
Christopher Wiehl
Düsseldorf, Germany

ART DIRECTION
Christopher Wiehl

STUDIO
paarpiloten

CLIENT
Ungershooting/Richard Unger

PRINCIPAL TYPE
Franklin Gothic

DIMENSIONS
Various

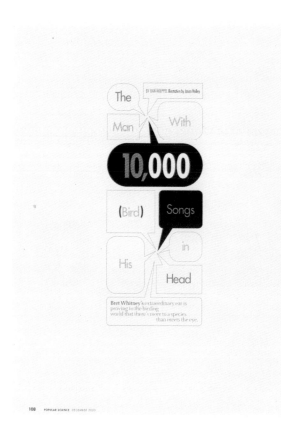

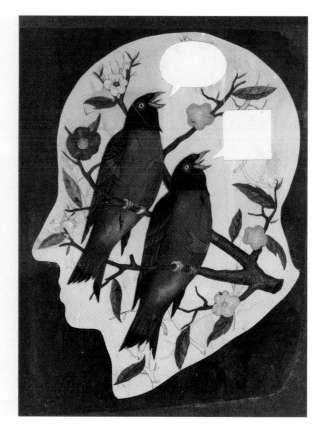

MAGAZINE SPREAD

DESIGN
Dirk Barnett
New York, NY

ART DIRECTION
Dirk Barnett

CREATIVE DIRECTION
Dirk Barnett

ILLUSTRATION
Jason Holley

MAGAZINE
Popular Science

PRINCIPAL TYPE
Futura

DIMENSIONS
10.5 x 15.75 in.
26.7 x 40 cm

MAGAZINE COVER

DESIGN
Rodrigo Sánchez
and María González
Madrid, Spain

ART DIRECTION
Rodrigo Sánchez

CREATIVE DIRECTION
Carmelo Caderot

LETTERING
Rodrigo Sánchez

MAGAZINE
Unidad Editorial, S.A.
El Mundo

PRINCIPAL TYPE
Handlettering

DIMENSIONS
7.9 x 11.2 in.
20 x 28.5 cm

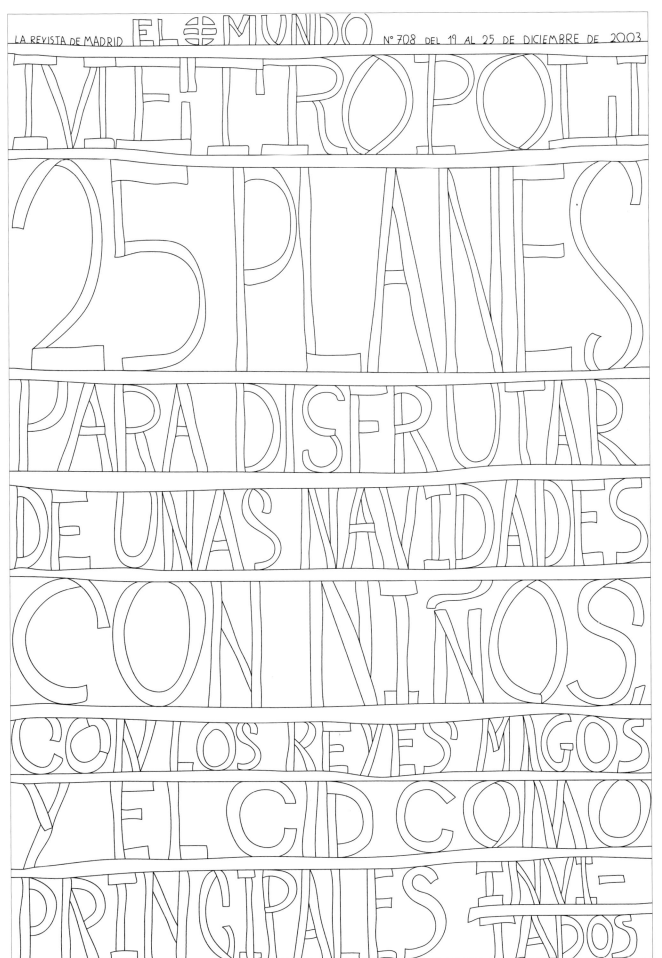

METROPOLI

25 PLANES PARA DISFRUTAR DE UNAS NAVIDADES CON NIÑOS. CON LOS REYES MAGOS Y EL CID COMO PRINCIPALES INVI-TADOS

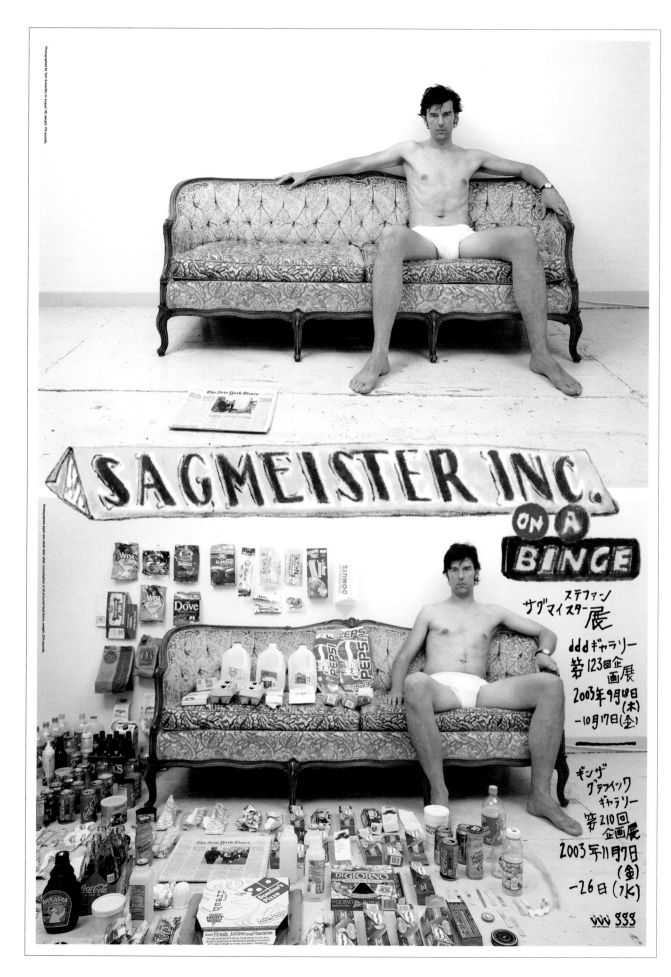

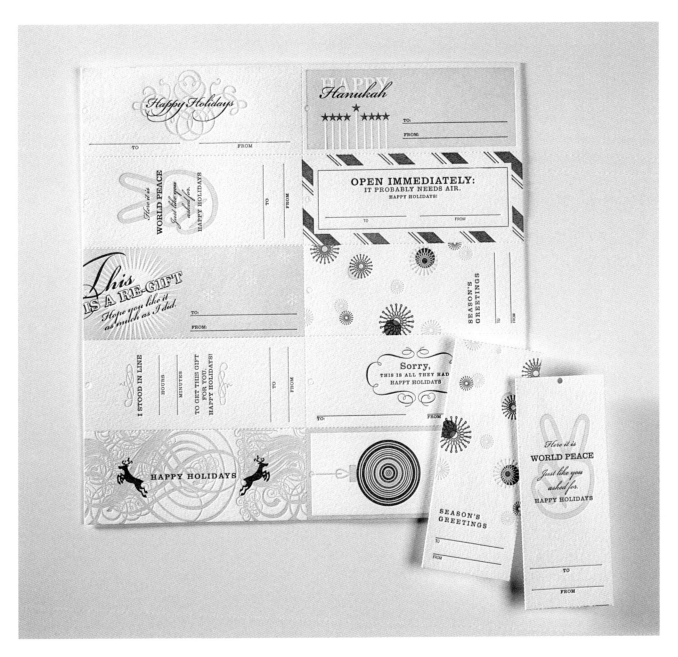

POSTER

DESIGN
Stefan Sagmeister and
Matthias Ernstberger
New York, NY

ART DIRECTION
Stefan Sagmeister

LETTERING
Stefan Sagmeister

PHOTOGRAPHY
Tom Schierlitz

DESIGN OFFICE
Sagmeister, Inc.

CLIENT
GGG gallery and
DDD gallery

PRINCIPAL TYPE
Handlettering

DIMENSIONS
28.5 x 40.5 in.
72.4 x 102.9 cm

GIFT TAGS

DESIGN
Marian Williams
Chicago, IL

WRITERS
Pam Mufson and Nic Fantl

AGENCY
LBWorks, A Leo Burnett Company

PRINCIPAL TYPE
Bickham Script, Clarendon,
and News Gothic

DIMENSIONS
10 x 10 in.
25.4 x 25.4 cm

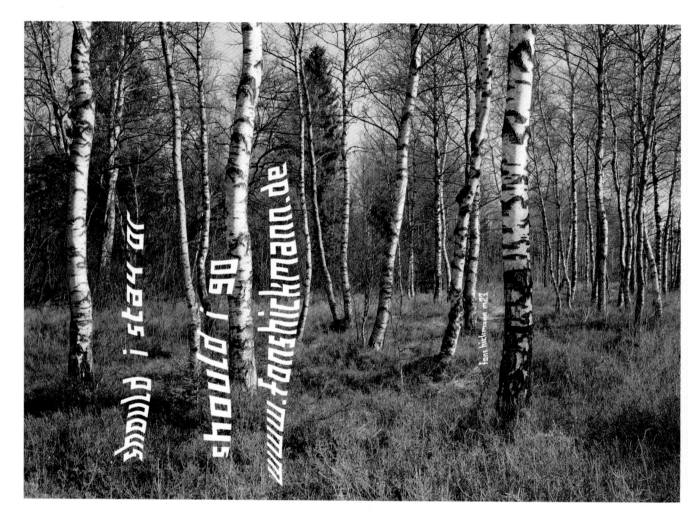

POSTER

Design
Fons Hickmann
and Simon Gallus
Berlin, Germany

Art Direction
Fons Hickmann

Photography
Simon Gallus

Studio
Fons Hickmann m23

Client
www.fonshickmann.com

Principal Type
FF Pop

Dimensions
47.2 x 33.1 in.
120 x 84 cm

LOGOTYPE

DESIGN
John Langdon
Philadelphia, PA

LETTERING
John Langdon

DESIGN
John Langdon Design

CLIENT
The Faithfull

PRINCIPAL TYPE
Handlettering

FILM TITLE

DESIGN
Jasmine Jodry
New York, NY

CREATIVE DIRECTION
Antoine Tinguely,
Laurent Fauchere,
and Jakob Trollbäck

PRODUCER
Sarah Cole

DESIGN OFFICE
Trollbäck & Company

CLIENT
HBO Films

POSTER

DESIGN
Dmitri Lavrow
Berlin, Germany

CREATIVE DIRECTION
Dmitri Lavrow

PHOTOGRAPHY
Britta Henrici and
Dmitri Lavrow

DESIGN OFFICE
Hard Case Design

CLIENT
M.A.I.S.

PRINCIPAL TYPE
Berthold Clarendon,
FF SubMono,
FF SubVario, and
handlettering

DIMENSIONS
26.8 x 40.2 in.
68 x 102 cm

CORPORATE IDENTITY

DESIGN
Christopher Wiehl
Düsseldorf, Germany

ART DIRECTION
Christopher Wiehl

STUDIO
paarpiloten

CLIENT
LOLLEKUNDBOLLEK.DE

PRINCIPAL TYPE
URW Unitus

DIMENSIONS
Various

TDC² 2004

The chair and the jury of a type competition are a fortunate lot. The company is good. Josh Darden, Veronika Elsner, Dmitry Krasny, and Pablo Medina are each talented typographers who bring a wealth and variety of experiences to the table. The task is enviable: a day of analyzing text and display faces, non-Latin fonts, and ornaments. Though nontypographers might scoff at the thought, for the initiated it is one of life's great pleasures to be sequestered for ten hours with a selection of the best typefaces of a given year and to discuss their relative merits with a group of practiced peers.

The TDC² 2004 competition (the seventh type design competition held by the Type Directors Club) received 112 entries from 16 countries. The entries were arrayed by category in successive waves, and the judges allowed to quietly walk through, making mental notes. All indications of authorship were hidden. After silent observation, deliberations began. As a group, the jury pondered each entry, discussing its individual merits. Some were saved for later; others were appreciated and released back into the wild.

First cuts were easy. Some designs need more time to develop, or they are short creative paths with no apparent destination, or they are longer creative paths though a tangle. The ensuing conversations about the entries that made it through the first round were more consuming. Subsequent rounds brought more careful analysis, more critical observation, and an exacting articulation that revealed still more of the intelligence and seriousness of the judges.

The procession to the 17 winning entries was an education and affirmation of what we each consider to be the essentials of excellence in type design. Behind the broad categories—creativity, novelty, consistency, suitability, and technique—are their relative definitions and their importance to each of the judges, as noted in the Judges' Choices. Four heads are better than one—especially when they're on the shoulders of uniquely talented individuals.

The type specimens that follow are a testimony to the efforts of the best practitioners of our quiet craft for 2003. We congratulate the winners and offer every encouragement for continued excellence.

Charles Nix

ABCDEFGHIJKLM
NOPQRSTUVWXY&Z
1234567890 abcde
fghijklmnopqrstuv
wxyz ABCDEFGH
IJKLMNOPQRST
UVWXY&Z 1234
567890 abcdefg
hijklmnopqrst
uvwxyz

ABCDEFGH
IJKLMNOP
QRSTUVW
XY&Z 12345
67890 abc
defghijklm
nopqrstuv
wxyz

ABCDEF
GHIJKLM
NOPQRS
TUVWXY
Z abcdef
ghijklmno
pqrstuvw
xyz

ABCDEFGHIJKL
MNOPQRSTUVW
XY&Z 12345678
90 abcdefghijkl
mnopqrstuvwx
yz ABCDEFGHIJ
KLMNOPQRSTU
VWXY&Z 123456
7890 abcdefgh
ijklmnopqrstuv
wxyz

ABCDEFGH
IJKLMNOP
QRSTUVWX
Y&Z 1234
567890 abc
defghijkl
mnopqrstu
vwxyz

ABCDEFGHIJKL
MNOPQRSTUV
WXY&Z1234567890
abcdefghijklmnopq
rstuvwxyz ABCDEF
GHIJKLMNOP
QRSTUVWXY&Z
1234567890 abcdefg
hijklmnopqrstuvwxyz
ABCDEFGHIJKLM
NOPQRSTUVWXY&Z
1234567890
1234567890

ABCDEFGHI
JKLMNOPQ
RSTUVWX
Y&Z 123456
7890 ABCD
EFGHIJKLM
NOPQRSTU
VWXYZ

ABCDEF
GHIJK
LMNOPQ
RSTUV
WXY&Z
123456
7890

Joshua Darden

Dmitri Krasny

Charles Nix
Chairman

Veronika Elsner

Pablo Medina

TDC² Judges

Joshua Darden designs typefaces and
develops tools for producing typefaces.
He works for Jonathan Hoefler and
Tobias Frere-Jones in New York.

stand van zaken in Engeland, die menschen het
schadelijkst, die meest goed trachten te doen, en
ten slotte hebben wij beleefd dat mannen die in de
werkelijkheid het vraagstuk hebben bestudeerd en
op de hoogte zijn van zijn levensverschijnselen—
academisch gevormde mannen die in Oost-Londen
leven—de gemeenschap met klem van rede hebben
aangezocht, haar altruistische aandriften van welda-
digheid, welwillendheid en dergelijke te beteugelen.
Zij doen dit op grond dat weldadigheid van dien
aard verlaagt en veronzedelijkt. Zij hebben
volkomen gelijk. Weldadigheid schept een sleep
van zonden. Men kan ook nog hierop wijzen,
dat het onzedelijk is om den bijzonderen eigendom
te gebruiken met de bedoeling om de euvels die van
de instelling van den bijzonderen eigendom gevolg
zijn, te verlichten. Het is evenzeer onzedelijk
als valsch.

Onder het socialisme zal dit alles natuurlijk
gewijzigd worden. Er zullen dan geen menschen zijn,
die leven in vunze krotten en vunze vodden, en die
ongezonde, hongergekwelde kinderen trachten
groot te brengen te midden van onmogelijke
allerterugstootendste omgevingen. De veiligheid
der samenleving zal niet, als nu, afhankelijk zijn van
den staat van het weder. Als de vorst invalt, zullen
wij niet een honderdduizend werkloozen hebben,
die in een toestand van walgelijke ellende de straten
afloopen of kermen tot hun buren om een aalmoes,

hongersnood. Onvermijdelijk moeten zij door dit
alles diep worden aangedaan. De gevoels-
aandoeningen van den mensch worden schielijker
in beweging gezet dan zijn verstandswerkingen,
en zooals ik voor eenigen tijd betoogde in een
artikel over de werking der critiek: het is veel
gemakkelijker eensgevoelig te zijn met lijden dan
met de gedachte. Dienovereenkomstig nemen zij,
met bewonderenswaardige, of al verkeerd Velijk
gerichte bedoelingen, met grooten ernst en
overdreven sentimentaliteit, de taak ter hand
om de euvelen die zij voor oogen hebben,
te verhelpen. Maar hunne middelen genezen
de kwaal niet, zij verlengen alleen het proces.
Eigenlijk zijn hun middelen een onderdeel
van de kwaal.

Zij beproeven, bijvoorbeeld, het vraagstuk der
armoede op te lossen door de armen in het leven
te houden, of door, volgens de allernieuwste
richting, de armen te vermaken. Maar dit is geen
oplossing: het is een verzwaring der moeilijkheid.
Het eigenlijke doel moet het pogen zijn de
maatschappij herop te bouwen op zulke grondsla-
gen, dat armoede onmogelijk zal wezen. De deug-
den van het altruisme hebben de uitvoering van
dit streven aanmerkelijk belemmerd. Evenals
indertijd die slaveneigenaars het grootste kwaad
stichtten, die welwillend voor hun slaven waren,
omdat zij voorkwamen dat de afschuwelijkheid

Veronika Elsner had contact with the type industry for the first time in 1975 during the ATypI in Warsaw. Before she founded her own studios in 1986 in Hamburg, Germany, together with her business partner Günther Flake, she was a consultant to URW GmbH while the IKARUS system was developed. Between 1978 and 1984 she aided and trained many teams of designers, moving from pencil drawing and stencil cutting to digitizer, keyboard, and computer mouse. Meanwhile the Elsner+Flake Digital Library grew to about 2,500 fonts in all font formats, including OpenType which is marketed worldwide through major font vendors. Veronika's specialty is consulting nationwide and worldwide with corporations about corporate type design. Her clients include major German publishers and advertising agencies.

he was one of the older

El dibujo de los tipos ofrece mucipa

Some Like it Hot and Spicy

`I know a guy with a`

You will see beautiful draw

une grossière négligence

qui découleraient d'une telle ente

Rotkäppchen und der böse

Knowing and abiding by the

Buntpapierindustrie unterric

I think he may be an acto

Ben Franklin was inventing

Dmitry Krasny is the founder and creative director of Deka Design, an award-winning visual communications firm in New York City. Born in Kiev, Ukraine, he emigrated from the Soviet Union in 1979 and earned a BA from Cooper Union, studied at the Gerrit Rietveld Academie in Amsterdam, and received an MFA from Yale University. He has been teaching courses in typography, information design, and book design at Parsons School of Design in New York since 1994 and served as chair of the Communication Design Department of Kanazawa International Design Institute (KIDI) in Japan.

Q
qwert
WERTYUI
yuiopasd
OPASDFGHJK
cfghjklzx
LZXCVBN
nvbm
¿£!M¡$?
{ ¼ ½ ¾ ⅛ ⅜ ⅝ ⅞ ⅓ ⅔ }
‹ (ff fi fl ffi ffl) ›
&§¢1234567890$ß
£%1234567890‰¥
œåáéëôöûüøøçñæ
ŒÎÍÏÓÔØÇÅÂÁÑ

Q
qwert
WERTYUI
yuiopasd
OPASDFGHJK
cfghjklzx
LZXCVBN
nvbm
¿£!M¡$?
&§fi1234567890ß¢
QWERTYUIOPASDF
GHJKLZXCVBNM
&1234567890
‹fi1234567890fl›?
ŒÞÐËÕØÔÎÍÙÛÁ

MoMA BUILDS
A NEW ART CENTER

An essential component of the building project is MoMA QNS, a new multiuse facility in Long Island City, Queens, housed in a redesigned building that was once a Swingline staple factory. Located near P.S.1 Contemporary Art Center, MoMA's affiliate, MoMA QNS will provide The Museum of Modern Art with much-needed space for galleries, offices, study centers, workshops, and storage.

Serving as the base of the Museum's operations and exhibition program from summer 2002 through late 2004, MoMA QNS will offer a wide range of exhibitions and programs. Once the new Museum opens, this facility will remain a permanent and important part of MoMA's resources, performing crucial functions related to storage, research, conservation, and more.

MoMA QNS is designed by Cooper, Robertson and Partners of New York. The public spaces are designed in collaboration with Michael Maltzan Architecture, of Los Angeles.

Pablo Medina is a graphic designer, design educator, and artist who currently runs Cubanica, a font foundry and design studio where he works with The Cooper-Hewitt National Design Museum, The Museum of Modern Art, Nat Nast Apparel, and *Teen People* Magazine. His work has been included in such exhibitions as The Art Directors Club's Young Guns III, the Face Off of the American Institute of Graphic Arts, and the National Design Triennial at the Cooper-Hewitt/Smithsonian Museum. Pablo's book design for Coisa Linda is in the permanent collection of The Museum of Modern Art. His work has been featured in a number of publications, and he is a full-time faculty member at Parsons School of Design. Pablo has taught at Maryland Institute College of Art and lectured at Pratt Institute and Altos de Chavon in the Dominican Republic.

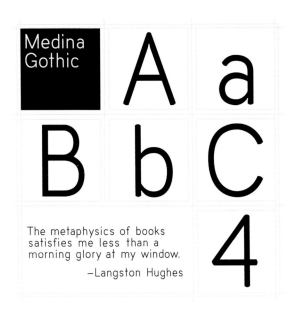

Medina
Gothic

A a
B b C
4

The metaphysics of books
satisfies me less than a
morning glory at my window.
—Langston Hughes

Joshua Darden The cross between calligraphy and sans serif is rare, inhabiting territory between Hermann Zapf's Optima, which has a classical sans structure with a calligraphic spirit, and Warren Chapell's Lydian, which is classical calligraphy without serifs. Cyrus Highsmith claims adventurous new ground with Amira, a letterform that pops from the page with an angled vitality that both welcomes and surprises readers with bright new rhythms and texture.

Designer This typeface is disarming. Careful attention to drafting tempers the shapes that would seem anarchic in another context; each twist and taper is in its correct place. The measured pitch in the horizontal strokes binds the textblock together, creating a stable and very pleasant system of shapes en masse. If Optima conjures an image of the solitary scribe or the contemplative stonecutter, this design evokes a lunchroom full of schoolchildren agitating for their granola.

Cyrus Highsmith

LUNAR ECLIPSE PREDICTED

Missions to Mars & further beyond this tiny nebula

Boötes

Unsettling New Gravitational Push

Real sci-fi buffs

156 Neighborly Venusians Offered Us a Lift

FROZEN SUN

Commander, it appears that we are orbiting in circles

Exiled!

New Volatile Alien Quasar Real Estate Scam Discovered

PITCH BLACK YONDER

Launched

GRUMPY WIZARDS MAKE A *TOXIC BREW FOR EVIL QUEENS* & jealous jacks. Lazy mover quit hard packing the papier-mâché jewelry boxes. Back at my quaint garden: jaunty zinnias often vie with flaunting phlox. *Hark! 4,872 toxic jungle water vipers quietly drop upon the zebras for meals. For only about $65, jolly housewives made inexpensive meal plans using new quick-frozen jaded vegetables.* Zombies acted so quaintly while they kept on driving their 31 oxen fast-forward. At my grand prix, J. Blatz was equally villified for his funky way. **My old grandfather spent his day quickly carving wax buzzards, mostly with junk.** When we go back to our Juarez, Mexico, won't we fly over some

GRUMPY WIZARDS MAKE A *TOXIC BREW FOR EVIL QUEENS* Pack my bandbox with five more dozen lime liquor jugs. Will Major Douglas be expected to take his true/false pop quiz very soon? *A mad-as-heck boxer shot three quick, gloved jabs to the bony jaw of his dizzy opponent.* Just work for improving basic techniques. **Jimmy & Zack, the able police explaining, were seen.** Diving into a field of buttered quahogs. Monique, the buxom coed likes

GRUMPY WIZARDS MAKE A *TOXIC BREW FOR EVIL QUEEN* **The jukebox music puzzled a gentle visitor from the quaint valley town. Nancy Bizaldanti exchanged vows with a Harvey** *The quick brown fox jumps over the lazy dog.* **Pickled, Gorby does jump raw fax. Sympathy would fix all Quaker objects in theater. Doxy with charm & buzz quaffs vodka julep. Oozy an quivering**

TYPEFACE NAME
Amira

TYPEFACE DESIGNER
Cyrus Highsmith
Boston, MA

FOUNDRY
The Font Bureau, Inc.

MEMBERS OF TYPEFACE FAMILY/SYSTEM
Regular, Regular Italic, Light, Light Italic, Black, Black Italic, Bold, Bold Italic, Semibold, and Semibold Italic

Veronika Elsner Since the minute I discovered the type industry for the first time in 1975, I have studied letterforms. Having a digital type library of about 2,500 fonts by now, I have seen so many letter shapes, custom fonts, designers' entries, but now for the first time I was asked by the TDC[2] committee to do this officially. From 150 entries we had to choose about 20 fonts. We spent several rounds looking at the designs and comparing them. The first type design I found outstanding was a very fine representation of a body type font in only one weight: book and the corresponding italic with a huge character layout, including a large character set. The serif style with a humanistic influence showed the great professional skill of an experienced type designer with a fundamental knowledge of type design over the centuries. I was impressed by the fine letter spacing, well-positioned accents, and kerning of such a huge font. The elegant typeface showed such a vivid personality through slight irregular shapes that I guessed this entry had been drawn by hand and digitized afterwards. Impressive as well was the corresponding set of Cyrillics which harmonized with the Latin, but still had its own character. I was sure that a great name stood behind this wonderful font, one of the best-known designers in the industry. I was thrilled when the chairman uncovered the lid and announced, "You will be surprised: Veronika has designed your choice!" Veronika Burian from the University of Reading created Maiola. I am sure we will hear more from her in the future.

Designer The sources of inspiration for Maiola were in particular the work of the Czech type designers Oldrich Menhart and Vojtech Preissig. The vigor and elegance of their work married to their expressive and personal character fascinated me. The intention, however, was not to follow this same path but to define my own interpretation. Indeed Maiola handles its idiosyncrasies with care and imparts the concepts of irregularity and angularity in a rather discrete way. For instance, the strokes and serifs vary slightly in weight and shape, and the foot serifs are asymmetrical in length and diagonally cut. The dynamic spirit is further enhanced by calligraphic reminiscence, clearly shown in features such as the dot on the "i," stroke modulation, and pen-formed terminals. The typeface also includes a Cyrillic that is supposed to harmonize well with the Latin in bilingual text setting. Despite the many similarities of both scripts, great differences do exist, and I sought to introduce more esprit and liveliness while being careful not to step beyond the threshold of acceptance. Furthermore, the use of Opentype technology allowed for the implementation of typographical particularities such as lining and old-style figures, both tabular and proportional ligatures, alternate characters, and case-sensitive variants.

Veronika Burian

áâàäãąåắằāǽæbćčçċďđéêèëęěéēfğģġħíîìïıĩįïjķŧĺĹļŀľmńń
ñņóôòöõőōøǿœpqŕřŗśšşťţúûùüũųůűūvwxýŷỳÿźžżßþð
ŋﬁﬂﬀﬃﬄ & ÁÂÀÄÃĄÅẮẰĀ ÆÆ BĆČÇĊDĐÉÊÈËĘĚÉĒ
FĞĢĠĦ ÍÎÌÏĨĮĪJ ĶŁĹĻĿĽMNŃÑŅÓ
ÔÒÖÕŐ ŌØǾŒPQŔŘŖŚŠŞŤŢÚÛÙ
ÜŨŲŮŰ ŪVWXÝŶỲŸŹŽŻÞĐŊ абвг
дежзийк лмнопрстуфхцчшщъыьэю
я АБВГД ЕЖЗИЙКЛМНОПРСТУФХ
ЦЧШЩ ЪЫЬЭЮЯёѓѕћіїјќѕўџђєљњ
ЁГЃЋІЇЈ ЌЅЎЏЂЄЉЊ!¡?¿.,:;...--•·„
"" «»()[]{ }|†‡¶§ *❦"°%‰@©®™/|\012
3456789 € $¢¥£ƒ№#¤0123456789€$¢¥£ƒ
№ áâàäã ạåắằāǽæbćčçċďđéêèëęěéēfğģġħ
íîìïıĩįïjķł ĺl·l'ľmńňñņóôòöõőōøǿœpqŕřŗśš
şťţúûùüũ ųůűūvwxýŷỳÿźžżßþðŋﬁﬂﬀﬃﬄ
& ÁÂÀÄ ÃĄÅẮẰĀ ÆÆ BĆČÇĊDĐÉÊÈËĘ
ĚÉĒFĞĢĠ ĦÍÎÌÏĨĮĪJ ĶŁĹĻĿĽMNŃÑŅÓ
ÔÒÖÕŐ Ō ØǾŒPQŔŘŖŚŠŞŤŢÚÛÙÜŨ
ŲŮŰĪ V WXÝŶỲŸŹŽŻÞĐŊ абвгдежз
ийклмно прстуфхцчшщъыьэюяАБВГ
ДЕЖЗИЙКЛМНОПРСТУФХЦЧШЩЪЫЬЭЮЯёѓћіїјќѕў
џђєљњЁГЃЋІЇЈЌЅЎЏЂЄЉЊ!¡?¿.,:;...--•·„""«»()[]{}|†‡¶§
*"°%‰@©®™/|\0123456789€$¥£ƒ№#¤0123456789€$¢¥£ƒ№

It is a contemporary typeface designed in the spirit of our time but bearing in mind historical heritage. Although envisioned mainly for text setting, Maiola remains attractive in display size by revealing its distinctive and complex character. The slight irregularities of the letterforms, as they appear on the printed page, are another characteristic of historical typefaces that wanted to be preserved. This effect of randomness lends charm and vitality to the printed matter. However, the typeface does not endeavour to copy old methods of type-making and printing. On the contrary, it was created using modern Opentype technology. The idea of imperfections is implied in a rather discrete way. For instance, the strokes and serifs vary slightly in weight and shape. The foot serifs are asymmetrical in length and diagonally cut. Furthermore, the dynamic spirit is enhanced by the

TYPEFACE NAME
Maiola

TYPEFACE DESIGNER
Veronika Burian
London, England

LANGUAGE
Cyrillic and Latin

MEMBERS OF TYPEFACE FAMILY/SYSTEM
Regular, Italic, Cyrillic, and Cyrillic Italic

Dmitry Krasny Buttress-EX is a self-supported, three-dimensional, constructed typeface originally made for a particular installation. There is something really wonderful about seeing type outside the boundaries of two dimensions. This is very difficult to do well. Think of most signage and one gets a glazed-over look in their eyes. This design, however, is anything but boring; it is bold and inviting. It possesses an intriguing mixture of certain architectural sophistication and the simplicity of an old erector set.

Of course, Buttress-EX can also function as a 2D font, since it was generated as a Truetype file, but that's no fun. The circular installation physically draws spectators in to become participants, surrounded by type. I especially appreciate the experimentation in the three dimensions and was absorbed by the constructed installation. Having taught classes in 3D typography, I find the issues of light and shadow over and through the letterforms are of constant investigative concern for students. Mr. Oswick uses these techniques for the fullest effect in this project. The proportions and scale of the extruded support structure are worked out so as not to overpower the letters and consequently the message. The supports create a lattice, suspending the letterforms in a rhythmic pattern.

This is a brave submission. I applaud the designer for sending it in and acknowledge his ambition to explore what type can do outside obvious printed uses.

Designer Born out of frustration, "This is an Open Book" began as an undertaking disregarding the constraints of printed typography. It searches for an alternative vehicle to escape from the book and interact with the audience in real space. The project represents a process of ideas determined to give typography the ability to grow legs and literally march around. It was developed as a series of provocative text-based installations questioning the globalization of 21st-century culture, the climax of which was expressed in the installation. Having stepped beyond the page into something entirely tangible, it was then systematically captured in medium format, drawing back the active experience into printed format.

Buttress-EX is a self-supporting structural typeface when constructed that maintains full legibility. It has since been generated as a full character Latin Truetype file, incorporating italic case and multilingual subsets.

Samuel Oswick

Buttress~EX / Regular, Italic
Regular~Stack, Italic~Stack

TYPEFACE NAME
Buttress-EX

TYPEFACE DESIGNER
Samuel Oswick
London, England

FOUNDRY
realistic-situation

MEMBERS OF TYPEFACE FAMILY/SYSTEM
Regular, Italic, Regular Stack, and Italic Stack

Pablo Medina Albert Loos, Brunn's designer, celebrates form and embraces typographic visibility. He's of a generations of designers who love to appreciate the aesthetics of typography and letterforms.

Along with its base alphabet, Brunn utilizes a series of alternate characters with varying stress direction and ornamental swashes. These alternates allow Brunn to morph from relative restraint to unbridled excess within one word. The alternates bring to mind Herb Lubalin's Avant Garde ligatures, which also allow the designer to replace characters to respond to spatial relationships and composition. Brunn's alternates give the typeface a dynamic, improvisational quality.

Brunn also distinguishes itself with hand-crafted, unrefined contours. In looking closely at Brunn's outlines, it seems that no two lines are the same. These slightly varying contours make the letterforms dance and invite the viewer to see the typography and celebrate its form. Vive le maximalisme!

Designers "The use of ornament in whatever style or quality comes from an attitude of childish naïvité," said Albert Loos, who was one of the first champions of pure form. Strange Attractors Design thinks differently and is therefore proud to present Brunn, a formal alternative to many other typefaces that did not grow out of pure love for the Swedish Aring.

This typeface, although constructed on the computer, does not lack any flaws of the hand. While seriously playful in its appearance, with a twist of the Von Trapp's, Strange Attractors Design wishes Brunn well in a world of neomodernist conservatism and preoccupied minds. Let the games begin! Catelijne van Middelkoop and Ryan Pescatore Frisk

THE USE OF ORNAMENT IN WHATEVER STYLE OR QUALITY COMES FROM AN ATTITUDE OF CHILDISH NAÏVITÉ.

ALBERT LOOS

STRANGE ATTRACTORS DESIGN PROUDLY PRESENTS A FORMAL ALTERNATIVE: BRUNN ONE OF THE FIRST CHAMPIONS OF PURE FORM

THE USE OF ORNAMENT IN WHATEVER STYLE OR QUALITY COMES FROM AN ATTITUDE OF CHILDISH NAÏVITÉ.

ALBERT LOOS ONE OF THE FIRST CHAMPIONS OF PURE FORM

TYPEFACE NAME
Brunn

TYPEFACE DESIGNER
Catelijne van Middelkoop and Ryan Pescatore Frisk
Amsterdam, The Netherlands

FOUNDRY
Dialog Nouveau

MEMBERS OF TYPEFACE FAMILY/SYSTEM
Caps and Caps Bold

**TDC² Entries Selected for
Excellence in Type Design**

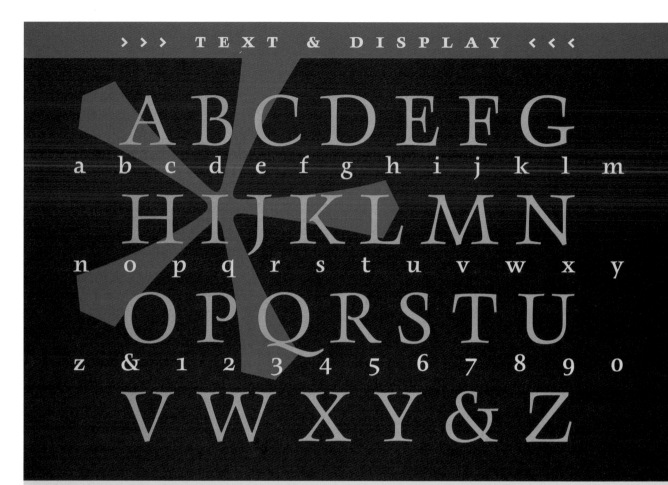

A B C D E F G
a b c d e f g h i j k l m
H I J K L M N
n o p q r s t u v w x y
O P Q R S T U
z & 1 2 3 4 5 6 7 8 9 0
V W X Y & Z

light | CAPS | *italic* | *ITALIC CAPS* | >>> <<< | regular | CAPS | *italic* | *ITALIC CAPS*
medium | **CAPS** | *italic* | *ITALIC CAPS* | >>> <<< | **bold** | **CAPS** | *italic* | *ITALIC CAPS*

>>> FF Angkoon™ <<<

TYPEFACE NAME
FF Angkoon

TYPEFACE DESIGNER
Xavier Dupré
Privat, France

FOUNDRY
FontShop International

HUMEDAD
Heat Index Peaks Above 105
Está Derritiendo
SOLAR FLARES & MAGNETIC FIELDS
Punto del sol
FEET COOKING INSIDE MY SHOES
UN HERVIDOR
Machine Cooled Engines Often Hum
FUEGOS
Delicious Sherbert
MORIRÉ SIN HELADO Y LIMONADA DULCE
Pan Fried

GRUMPY WIZARDS MAKE TOXIC BREW FOR THE EVIL QUEEN & JACK. LAZY MOVE QUIT HARD PACKING OF TO of the papier-mâché jewel boxes. Back at my quiet garden: jaunty zinnias often vie with flaunting phlox. Hark! 4,872 toxic jungle water vipers quietly drop on zebras for one meal! New farm hand (picking just six quinces) proves strong but lazy. For only about $65, jolly housewives made some "inexpensive" meals using quick-frozen vegetables. No jaded zombies acted quaintly but kept driving their 31 oxen for kicks. At my grand prix, J. I. Blatz was equally villified for funky ways. My grandfather spent his days carving 4 wax buzzards, mostly from junk. WHEN WE GO BACK TO JUAREZ, MEXICO, WILL WE GO BY PICTURESQUE ARIZONA? Murky hazing has enveloped a major city as big jarring quakes

MAGOS GRUNONES SE HIZO BREW TOXICO PARA LAS REINAS MALVADAS Y JACKS MOVER FLOJOS DEJA DE LA bastaron para que las cuatro piezas coreográficas pudieran desarrollarse frente a un público expectante. Versátil Uno de los componentes más interesantes de este programa bonita fue la versatilidad. El Ballet Concierto presentó cuatro números, muy distintos entre sí, haciendo gala dominio conceptual y estilístico Alejandra Baldoni y Federico Fernández. Un montaje limpio y el técnicamente fuerte. "Don Quijote, grand pas", de León interpretativo. EN ESTA PIEZA, LOS DUETOS Y LOS SOLOS DE LOS PROTAGÓNICOS SE ALTERNABAN ENTRE PARTIC PACIONES DE UN BAILARINES MÁS. Por 15 minutos de receso, durante los cuales el escenario

TYPEFACE NAME
Zocalo

TYPEFACE DESIGNER
Cyrus Highsmith
Boston, MA

FOUNDRY
The Font Bureau, Inc.

MEMBERS OF TYPEFACE FAMILY/SYSTEM
Display: Roman, Semibold, and Ultra
Text: Regular and Small Caps

WEALTHY SOCIALITES

Greenwich Village

Brick

VERY UNUSUAL NEIGHBORS

For the location, $8,529/month is almost worth it

Cocktail Hour

TONIC SPILLED ALL OVER THE SOFABED

Noticeable

FABULOUS SKYLINE VIEW

FIREPLACE

Turns on with a switch

GRUMPY WIZARD MAKES A *TOXIC BREW, EVIL QUEEN &* jack. Lazy move quit hard pack ing of the jewelry boxes. Back at my quaint garden: jaunty zinn nias vie with flaunting phlox. Hark, may 87,346 toxic jungle water vipers quietly drop on ze bras for meals? New farm hand (picking just sixteen quinces) proves strong but lazy. *For just $65, jolly house wives made "inex-pensive" meals using some quick frozen vegetables.* Jaded zombies acted quaintly but kept driving their 318 oxen forward. At the grand prix, J. Blatz was equally villified for his funky ways. **My grandfather spends his days quickly carving wax buzzards, mostly from junk.** When we go back to San Juarez, Mexico, might we fly there over pictur esque Arizona? SOME MURKY HAZE ENVELOPED A CITY, BUT JARRING QUAKES BROKE THE SEVENTY WINDOWS. So, please pack my box with around fifty dozen liquor jugs. Will Major P. Douglas be expected to take this true/false quiz very soon? A mad boxer shot yet another a

GRUMPY WIZARD MADE A ***TOXIC BREW, EVIL QUEEN &*** **jack. Lazy movers quit hard packing of the papier-mâché jewelry boxes? Back there at my quaintest garden: jaunty zinnnias vied without flaunt ing phlox.** ***Hark! 87,346 toxic jungle water vipers will quietly drop on zebras for meals?*** **New farm hand (picking just sixty tender quinces) proves strong but lazy. For just $65, my jolly**

TYPEFACE NAME
Farnham

TYPEFACE DESIGNER
Christian Schwartz
New York, NY

FOUNDRY
The Font Bureau, Inc.

MEMBERS OF TYPEFACE FAMILY/SYSTEM
Display: Regular, Medium, Light, Bold, Black
and Italic and Small Caps for all
Text: Regular, Bold, Semibold and Italic
and Small Caps for all

ኒያላ ◈ Nyala

፲፱ኛው መቶ ዘመን ኢትዮጵያ ተቄራርጣ ወድቃ ከነበረችበት ጥቃቅን የመሳፍንቶች ግዛትና ድንግርግር ካሉ እኔ ልግዛ ከማለት ጦርነቶች ልትወጣ የጀመረችበት ዘመን ነው። ከነዚህ የዘወትር ጦርነቶች ውስጥ ሊያወጧት የታገሉትና ያወጧትም ፫ ተራውን የነገሡ ነገሥታቶች በዚሁ መቶ ዘመን ውስጥ የተወለዱ ነፉ። ከዚህም ነገሥታት ወደፊት ታሪካቸውን ለመዘርዘር የተዘጋጀነው አጤ ምኔልክ በፊ.፲፯፻፴፮ ነሐሴ ፲፱ ቀን ተወለዱ። ወደ እርሳቸው ታሪካንደርስ ግን ኢትዮጵያን ከዚህ ካልነው የመሳፍንቶች ግዛት ውስጥ አውጥተው አንድነት ያለው የንጉሥ ነገሥት ግዛትና ስፋት እንድታገኝ የሞከሩና የያዙም በቄራጥነታቸውና በጀግንነታቸው የታወቁት አጤ ቴዎድሮስ ናቸው። እርሳቸውም በዚሁ መቶ ዓመት መጀመሪያ ዐሥር ዓመቶች ውስጥ በፊ.፲፯፻፺ ዓ.ም ተወለዱ። የቁራው ባላባት የየጃዝማች ኃይሉ ልጅኳ ቴዎድሮስ በተባለው ስም የኢትዮጵያ ንጉሥ ነገሥት ሳይሆኑ ለራስ ዓሊ እናት ለእቴጌ መነን አሽከርነት አድረው ነበር። በጀግንነታቸውና በደፋርነታቸው የተመሰገኑ ስለነበሩ በእቴጌ መነን እርዳታ የራስ ዓሊን ልጅ (፲፯፻፶፮ ዓ.ም) ዳሩላቸው። ቄየተው ግን ከእቴጌ መነን ጋራ ተጣልተው ሸፍተው መጀመሪያ እቴጌ መነንን ቀጥለውም የጎጃሙን ገዢና ባላባት ደጃች ጎሹን በመጨረሻውም ራስ ዓሊን ተዋግተው ድል አድርገው የጎንደሩን ዐልጋ ያዙ። በጎንደርና በጎጃም የበረውን ደጃዝማች ካሣ አገዛዝም የሚለውን የጦር ኃይል ሰበሩው ድል አድርገው ግዛታቸውን አረጋገጡ። ወዲያውም 'ነይላቸው እታወቀና እበረታ ሔዱ። ካሣበገጠሙት ጦርነት ሁሉ ድል ያገኙ ነበር። በጎንደርና በጎጃም ገዢ የነበረውን ደጃዝማች ካሣ አገዘንም የሚለውን የጦር ኃይል ሰበሩ ድል አድርገው ግዛታቸውን አረጋገጡ። ወዲያውም 'ነይላቸው እታወቀና እበረታ ሔዱ። ካሣበገጠሙት ጦርነት ሁሉ ድል ያገኙ ነበር። በጎንደርና በጎጃም ገብረዎች የነበሩትን መሳፍንት ካሽኑፋና ግዛታቸውን በእጃቸው ካረ በኍላ የካሣ ጦር ራሱን የቻለና የሚፈራ ሆነ። በፊ.፲፯፻፶ፗ ዓ.ም የትግሬው ግዛት ተነጥሎ

Nyala is a new Ethiopic typeface with harmonised Latin companion design, making it ideal for bilingual texts. The Ethiopic character set supports Amharic, Tigrinya, Tigre and many other modern tongues of Ethiopia and Eritrea, and the ancient scriptural language Ge'ez. The Latin character set supports all the major European languages, and also includes diacritics needed for the transliteration of Ethiopian and Eritrean languages, making the font useful for scholarship in many countries.

The Ethiopic design is based on initial outlines prepared by Geraldine Wade, in 1998, as part of a Microsoft project to document typographic requirements for different scripts and languages. During 2003, John Hudson redrew all the Ethiopic characters, making them more formal but keeping the weight and proportions of the earlier design. John designed the Latin companion alongside the new Ethiopic forms, and carefully tested them in bilingual settings.

The OpenType format font contains layout features for both scripts that automatically substitute an extensive set of Latin ligatures, including diacritic combinations for transliterated text, e.g. ch→ch, and contextual grouping of Ethiopic numerals: ፲፪፻፶፮→፲፪፻፶፮.

The Nyala typeface is named for the mountain nyala ‹tragelaphus buxtoni›, a species of great African antelope native to the highlands of Ethiopia, and for the Nyala Ethiopian restaurant in Vancouver, where the ostrich special is particularly recommended.

TYPEFACE NAME
Nyala

TYPEFACE DESIGNER
John Hudson
Vancouver, Canada

FOUNDRY
Tiro Typeworks

LANGUAGE
Ethopic and Latin

MEMBERS OF TYPEFACE FAMILY/SYSTEM
Regular

ئا ئىا ا ا اب ببب پ پىپ پ تتت ت جج جججج ج چچچ
خ خخخخ د دد ر رز زز ژژ س سسس ش ششش
غ غغغغ ف ففف ق ققق ك ككك گ گگگگ گ گگگگ
ل للل م ممم ن ننن ه ههه ه ه و وۇ وۇ وۇ وۇ
ۆئۆئۆ ئۆ ئۆئۇئۆئۇ ى سى ى ئ ئئئ ي يىي ي لا لالا () ✸ ✸
«» ، ، ؛ : ! ؟ <> 1234567890 456١٢٣٤٥٦٧٨٩٠

<div dir="rtl">

تۆز خەت نۇسخىسى

تۆز خەت نۇسخىسىدا يېزىلغان ھۆسنخەتلەر جەددىي ، سالماق ، ھەيۋەتلىك بولۇپ ،ئاساسەن ھۆكۈمەت ھۆججەتلىرى ، سىياسىي
كىتاب – ژۇرناللارنىڭ ماۋزۇلىرى ، بېغىننىڭ ۋۇسكا ، شوئار لىرى ، ھەرخىل ئېلان ۋە ئىدارە جەمئىيەت ، مەكتەپ ، سودا
سارايلىرىنىڭ ۋۇسكىلىرى قاتار لىقلارنى يازسا ئېنىق ، چىرايلىق ھەم ھەيۋەتلىك بو لىدۇ. بۇخىل ئېلان ، ۋۇسكىلارنىڭ
ئېنىقلىق دەرىجىسى باشقا خەت نۇسخىلىرىغا قارىغاندا يۇقىرى بولۇپ ، ئۇنى كۆرگەن ھەرقانداق كىشى بىرقاراپلا ئۇنىڭ
مەزمۇننى بىلىۋالالايدۇ. شۇڭا ئادەتتە ھەرخىل ئېلان ، ۋۇسكىلارنىڭ كۆپ قىسمى تۆز خەت نۇسخىسىدا يېزىلىدۇ.

</div>

TYPEFACE NAME
Microsoft Uighur

TYPEFACE DESIGNER
Mamoun Sakkal
Bothell, Washington

LANGUAGE
Uighur and Arabic Script

ARGOT DISPLAY & *Eduardo Manso*

* * * * * *

Legibility in magazines

DICTIONARIES, NEWSLETTERS, AND BROCHURES

Newburgh & Typography

THE CENTURY (November, 1870). *Theodore Low De Vinne*

* * * * * *

Sphinx of black quartz, judge my vow. Thief, give back my prized wax jonquils. The quick brown fox jumps over the lazy dog. Sixty zippers were quickly picked from the woven jute bag. Jaded zombies acted quaintly but kept driving their oxen forward. *In a formula deus, qualem paulus creavit, dei negatio. Such a religion as Christianity, which does not touch reality at a single point and which goes to pieces the moment reality asserts its rights at any point must be inevitably the* DEADLY ENEMY OF THE WISDOM OF THIS WORLD WHICH IS TO SAY OF SCIENCE AND IT WILL GIVE THE NAME OF GOOD TO WHATEVER MEANS SERVE TO POISON, CALUMNIATE AND CRY DOWN ALL INTELLECTUAL DISCIPLINE. **That is to say, as a philologian a man sees behind the "holy books" and as a physician he sees behind the physiological degeneration of the typical Christian. The physician says "incurable" the philologian says fraud.**

* * * * * *

Regular, *Italic*, SMALL CAPS & **Bold**

TYPEFACE NAME
Argot Display

TYPEFACE DESIGNER
Eduardo Manso
Barcelona, Spain

MEMBERS OF TYPEFACE FAMILY/SYSTEM
Regular, Bold, Italic, and Small Caps

BACKYARD OIL WELLS

Black Gold

TEXAS TEA, IF YOU WANT TO BE MORE OBSCURE

RANCH FOR SALE

I want to move to California, but it seems a little unoriginal

Farewell bash

We ordered 250 gallons of slaw

Midland

Ketchup and mayonnaise helicoptered in from the next county

Mustard Shortage

1,285 EMPTY KEGS OF SASPARILLA AND GINGER BEER

Hot relish

AREN'T CONDIMENTS A FOOD GROUP?

GRUMPY WIZARDS MADE TOXIC BREW FOR THE EVIL QUEEN AND JACKS. LAZIEST MOVERS QUIT SUCH HARD PACKING OF THAT PAPIER-MÂCHÉ JEWELRY BOX. Back at my quaint garden: jaunty zinnias vie with the flaunting phlox. Hark! 4,872 toxic jungle water and vipers quietly drop onto zebras for meals! *New farm hand (picking just six quinces) proves strong but very lazy. For only about $465, these jolly housewives made a very "inexpensive" meal using my quick-frozen vegetable.* Jaded zombies acted quaintly but kept driving their 31 oxen forward. At my grand prix, Judith Blatz was equally villified for her funky ways. MY GRANDFATHER SPENT HIS DAYS QUICKLY CARVING WAX BUZZARDS, MOSTLY OUT OF JUNK. When we go back to Juarez, Mexico, may we fly over picturesque Arizona? Murky haze enveloped a city as the jarring quakes broke the forty-six windows. Pack my box with five dozen liquor jugs. **Would Major Douglas be ex pected to take that big true/false quiz very soon?** A mad boxer shot another quick, gloved jab to the jaw of his dizzy opponent. Just work for an improved basic technique to max imize your typing skills. That's juke box music, puzzling to gentle visitor from a quaint valley town. Nancy Jo Bezal exchanged vows with Robert J.

GRUMPY WIZARDS MADE TOX IC BREW FOR THE EVIL QUEEN AND JACKS. LAZY MOVER QUIT **SUCH HARD PACKING OF THE PAPIER-MÂCHÉ JEWELRY BOX.** Back at my quaint garden: jaunty zinnias vie with flaunting phlox. *Hark! 4,872 toxic jungle water and vipers quietly drop onto zebras for meals!* **New farm hands (picking just sixty quinces) proven strong but lazy.** FOR $65, JOLLIER HOUSE WIVES MADE "INEXPENSIVE" MEALS USING QUICK-FROZEN VEGETABLES.

TYPEFACE NAME
Houston

TYPEFACE DESIGNER
Christian Schwartz
New York, NY

FOUNDRY
The Font Bureau, Inc.

MEMBERS OF TYPEFACE FAMILY/SYSTEM
Text: Roman and Bold with Italics and Small Caps
Deck: Roman and Bold with Italics and Small Caps
Headline: Roman and Bold with Italics and Small Caps

TYPEFACE NAME
FF Unit

TYPEFACE DESIGNER
Erik Spiekermann and Christian Schwartz
Berlin, Germany, and New York, NY

FOUNDRY
FSI Font Shop International

MEMBERS OF TYPEFACE FAMILY/SYSTEM
Regular, Regular Italic, Medium, Light, Thin, Bold, Black, and Ultra

1 The world is everything that is the case

1.1 The world is the totality of facts, not of things

2.141 A picture is a fact

2.1512 It is laid against reality like measure

4 A thought is a proposition with sense

4.001 The totality of propositions is language

4.116 Everything that can be thought at all can be thought clearly. Everything that can be put into words can be put clearly.

4.1212 What can be shown cannot be said.

7 What we cannot speak about we must pass over in silence.

Ardbeg
REGULAR

TYPEFACE NAME
Ardbeg

TYPEFACE DESIGNER
Nathan Matteson
Chicago, IL

MEMBERS OF TYPEFACE FAMILY / SYSTEM
Regular

SAVA

SAVA PRO LIGHT ❀ SAVA PRO REGULAR
SAVA PRO MEDIUM ❀ **SAVA PRO SEMIBOLD**
SAVA PRO BOLD ❀ **SAVA PRO BLACK**

¶ ADOBE INTRODUCES SAVA PRO, A NEW CALLIGRAPHIC TYPE FAMILY FROM CALLIGRAPHER AND TYPE DESIGNER, JOVICA VELJOVIĆ. THESE VERSATILE ALL-CAPITAL ALPHABETS ARE BOTH EXPRESSIVE AND ELEGANT, DERIVING THEIR CHARACTER FROM THE DISCIPLINED STROKES OF THE BROAD-EDGED PEN. INSPIRED BY 4TH-CENTURY GREEK UNCIAL LETTERFORMS, SAVA EVOKES A TIMELESS FEEL. WHILE THE INSPIRATION FOR SAVA COMES FROM ANTIQUITY, IT PROJECTS A DISTINCT MODERN FLAVOR DERIVED FROM VELJOVIĆ'S CONFIDENT PERSONAL DESIGN APPROACH, AND HIS MASTERY OF DIGITAL ALPHABET DESIGN. THESE TENSE YET REFINED FORMS GIVE PASSAGES OF TEXT A MONUMENTAL FEEL, PROVIDING DESIGNERS A PROGRESSIVE ALTERNATIVE TO TRADITIONAL SERIFED ROMAN CAPITALS. THE SAVA PRO FAMILY CONSISTS OF SIX INTEGRATED WEIGHTS THAT CAN BE USED EFFECTIVELY FOR A VARIETY OF DISPLAY AND SPECIALIZED TEXT APPLICATIONS.

KEQTPRFZ **KEQTPRFZ**

NN TT ME THE OO EA HE KA LA ST TI

LATIN

FOR 6,000 YEARS, MAN HAS COMMUNICATED WITH
WRITTEN SYMBOLS. THE EVOLUTION OF HANDWRITING,

CYRILLIC

НАПОЛЕОН НАЧАЛ ВОЙНУ С РОССИЕЙ ПОТОМУ, ЧТО
ОН НЕ МОГ НЕ ПРИЕХАТЬ В ДРЕЗДЕН, НЕ МОГ НЕ

GREEK

ΣΤΙΣ ΠΎΛΕΣ ΤΟΥ ΔΆΣΟΥΣ Ο ΈΚΠΛΗΚΤΟΣ ΆΝΘΡΩΠΟΣ ΤΟΥ
ΚΌΣΜΟΥ ΕΊΝΑΙ ΑΝΑΓΚΑΣΜΈΝΟΣ ΝΑ ΕΓΚΑΤΑΛΕΊΨΕΙ ΤΙΣ

TYPEFACE NAME
Sava Pro

TYPEFACE DESIGNER
Jovica Veljovic
Hamburg, Germany

FOUNDRY
Adobe Systems, Incorporated

LANGUAGE
Latin, Greek, and Cyrillic

MEMBERS OF TYPEFACE FAMILY/SYSTEM
Regular, Medium, Light, Black, Bold,
and Semibold

Expo Sans™: *10 fonts in 5 weights = a hard-working typeface family*

Musical Events in 2004

Between 256 Farnsworth Street and 308 Riverside Ave: 4⅜ miles

VERA NOTIO FELICITATIS

Early English Paintings of Noted Personages of the XVIᵗʰ Century

DAILY DELIVERIES

A History of the Old English Letter Founderies

IT DOES GENUINELY MATTER that a designer should take trouble and take delight in his choice of typefaces. The trouble and delight are taken not merely for art's sake but for the sake of something so subtly and intimately connected with all that is human that it can be described by no other phrase than "the humanities." If *the tone of voice* of a typeface does not count, then nothing counts that distinguishes man from the other animals. The twinkle that softens a rebuke; the scorn that can lurk under civility; the martyr's super-logic and the child's intuition; the fact that a fragment of moss can pull back into the memory a whole forest; these are proofs that there is reality in the imponderable, and that not only notation but connotation is part of the proper study of mankind. **The best part of typographic wisdom lies in this study of connotation, the suitability of form to content.**

Expo Sans Light · *Light Italic* · Regular · *Italic* · Semibold · *Semibold Italic* · **Bold** · ***Bold Italic*** · **Black** · ***Black Italic*** ·

ABCDEFGHIJKLMNOPQRSTUVWXYZ abcdefghijklmnopqrstuvwxyz ÀÁÂÄÃÅÆÇ ÉÈËÊÍÌÏÎŁÑÓÒÔÖÕØŒŠÐÞÚÛÙÜÝŸŽ áà âäãåæçéèëêíìïîłñóòôöõøœšßðþúùûüýÿžfifl 1234567890$¢€¥£ƒ¤%‰#°µ*¶§†‡+<=>¬ ±÷×-({[•·.,:;""''",,«»‹›...¿?¡!/&\^_|¦~@ªº™©®]})
` ´ ^ ¯ ~ ¨ · ˚ " ¸ ˇ ABCDEFGHIJKLMNOPQRSTUVWXY ZÆŒØÁÀÂÄÃÅÆÇÉÈÊËÍÌÏÎŁÑÓÒÔÖÕØŒŠÐÞÚÛÙÜÝŸ Ž 1234567890$¢€¥£ƒ%‰o¿?¡!& 1234567890 1234567890($¢.,-) abdeèghilmnorst ($¢.,-)1234567890/0123 456789($¢.,-) 1234567890($¢.,-) ½¼¾⅛⅜⅝⅞⅓⅔

TYPEFACE NAME
Expo Sans

TYPEFACE DESIGNER
Mark Jamra
Portland, ME

FOUNDRY
Type Culture

MEMBERS OF TYPEFACE FAMILY/SYSTEM
Regular, Regular Italic, Light, Light Italic,
Black, Black Italic, Bold, Bold Italic, Semibold,
and Semibold Italic

INDUSTRIOUS HEALTH CARE PROFESSIONAL

Miracle worker

ABLE TO KEEP TRACK OF OVER 26,375 SIMULTANEOUS EXPERIMENTS

Toiling in the lab night and day

Never has time for lunch break

FINALLY ARRIVES AT AN AMAZING BREAKTHROUGH

AMAZING

Insurance claims down 62%

Doctor, it hurts when I move my leg like this

THEN DON'T MOVE YOUR LEG

Healers

VACANT EMERGENCY ROOMS

Much-Needed Rest

GRUMPY WIZARDS MAKE TOXIC BREWS FOR THE EVIL QUEEN & JACK. LAZY MOVER QUIT hard packing of the papier-mâché jewelry boxes. Back at that quaint garden: jaunty zinnias vie with flaunting phlox. **Hark! 462 toxic jungle water vipers quietly drop on zebras for meals.** Newest farm hands (picking just sixteen quinces) prove strong but lazy. For only about $65, jolly hausfrau

GRUMPY WIZARDS MADE UP A TOXIC BREW FOR THE EVIL QUEENS & JACKS. Lazy movers quit hard packing of 6 pa pier-mâché jewelry boxes. **Back in a quaint garden, jaunty zinnias vied with the flaunting phlox.** Hark! 472 toxic jungle water vipers quietly drop onto zebras for meals! New farm hand farm hand (picking just sixty quinces

GRUMPY WIZARD MADE UP A TOXIC BREW FOR THE EVIL QUEEN & JACK. Lazy movers quit hardest packing of 26 papier-mâché jewelry boxes. **Back at my quaint gardens, jaunty zinnias vied without the flaunting phlox.** Hark! 4,875 toxic jungle and water vipers quietly drop onto these zebras for meals! New farm hands do

GRUMPY WIZARDS MADE TOXIC BREWS FOR EVIL QUEEN JACKIE. Lazy movers quit harder packing of my papier-mâché jewelry box. **But, back in my quaint garden: jaunty zinnias vie with flaunt ing phlox.** Hark! 472 toxic jungle water vipers quietly dropped onto tender zebras for delicious meals. GRUMPY WIZARD MADE TOXIC BREWS FOR EVIL QUEEN JACK. Lazy mover quit harder packing of these papier-mâché jewelry boxes. **Back in quaint gardens: jaunty zinnias might vie with flaunting phlox.** Hark! 27 toxic jungle water vipers will quietly drop onto 328 zebras for meals. New farm hands (picking just

TYPEFACE NAME
Amplitude

TYPEFACE DESIGNER
Christian Schwartz
New York, NY

FOUNDRY
The Font Bureau, Inc.

MEMBERS OF TYPEFACE FAMILY/SYSTEM
Regular, Medium, Book, Light, Black, Bold, and Ultra

Noam

HEBREW AND LATIN COMBINED

אליעזו בן יהודה נולד בליטא בשם אליעזר פרלמן. בנעוריו זכה לחינוך יהודי
תורני, אן טיט אונ זווק לימוו יו גם בגימנסיה כללית. מלחמת רוסיה וטורקיה
על הבלקנים, ההתעוררות הלאומית בקרב עמי הבלקן וגל הלאומית, שהציף
את רוסיה, קירבו לראשונה את בן יהודה הצעיר לעיון מעמיק בבעיות הלאומיות
המודרנית ולפעילות לחידוש הלאומית היהודית. בשנת 1878 עבר בן יהודה
לפריז כדי ללמוד רפואה. בפריז נתוודע לראשונה לבעיות השפה העברית, ובשנת
1880 החל לפרסם את מאמריו הראשונים בנושא זה. בן יהודה (Perlman) ראה
בהחייאת השפה העברית אמצעי ותנאי לחידושה של הלאומית היהודית. כשם
שעל היהדות להתאים עצמה לתנאי החיים של העולם המודרני, כך על העברית
לחדש פניה ולהיעשות שפה, שאפשר לנהל בה חיים בעולם המודרני. בשלהי 1881
הגיע בן יהודה לארץ ישראל. עלייתו של בן יהודה לארץ ישראל היה בה משום
צעד מהפכני, שכן איש מן המשכילים העברים ברוסיה לא מצא דרכו לא"י ואילו
בן יהודה Short phrase in English הטיף לעליה זו עוד לפני הפוגרומים.
עלייתו הייתה פועל יוצא מאמונתו כי תחיה לשונית הינה חלק בלתי נפרד מתחיה
לאומית־מדינית. בן יהודה ואשתו, דבורה, התיישבו בירושלים. מתוך קנאות
לשפה העברית, נדר בן יהודה שבביתו ידברו רק עברית. את בנו בכורו של בן
יהודה מקובל לראות כ"ילד העברי הראשון." עד מהרה נעשתה משפחת בן יהודה
מוקד חברתי ומקור לייריבות עם "הישוב הישן" בירושלים. ניסיונותיו של בן יהודה
להתקרב לישוב זה עלו בתוהו. בני "הישוב הישן" ראו במלחמתו למען החייאת
השפה מעשה של חילול (un peu de Français) הקודש ותלו בה מניעים
פוליטיים חתרניים, העלולים לפגוע ביחסי הישוב עם השלטונות הטורקיים. את
עיקר מאמציה הקדישה האגודה לפעולות שתכליתן להפיץ את השפה והתרבות
העברית. בסופו של דבר ניצחה השפה העברית. "תחיית השפה העברית היא
תופעה יוצאת דופן בתולדות העמים. בן יהודה וממשיכי דרכו הצליחו לחולל דבר
שלא עלה בידיהם של האירים, הוולשים, הברטונים... ועמים אחרים Universalis
de hominis juribus declaratio. Omnes homines liberi aequique
dignitate שלא גלו מעולם מארצם. העברית המודרנית היא אחד ההישגים
השלמים ביותר של הציונות: בעודה קולטת השפעות מכל הלשונות שהביאו אתם
היהודים ... היא גם הכלי העיקרי לקליטת היהודים בארץ ישראל..."

Noam is a coherent type family that holds both Latin and Hebrew serif text typefaces, each authentic to its own script. Such type family is not currently in existence. *Both typefaces were meant to function independently and betray no hint of them being designed to coexist alongside each other.* In other words, the Hebrew should not be apparent as Latin-influenced, nor the Latin to look Hebrew-influenced.

The Noam type family suggests a proper solution for the integration of texts in both scripts, as well as a fresh and contemporary alternative for use in newspaper and magazine design of either script.

ABCDEFGHIJKLMNOPQRSTUVWXYZ
abcdefghijklmnopqrstuvwxyz
àáâãäåāăąœæćċčçďđèéêěëēęfffifflffiflfflġĝ
ħìíîïīĩįijĵķĺļľłñńņňŋòóôõöōøǿœŕřśšßťùú
ûüũůūűuÿýŷ̈ÿźżžðþ &
ÀÁÂÃÄÅĀĂĄÆÆĆĊČÇĎĐÈÉÊĚ
ËĒĘĢĜĤHÌÍÎÏĪĨĮIJĴĶĹĻĽŁŃŅŇŊÒ
ÓÔÕÖŌŐØǿŒŔŖŘŚŠŠŤŦÙÚÛÜŨŪŮŰ
ŲŶÝŶŸŹŻŽÐÞ [ˇ´ˆ˜¯˘˙˚˝˛ˆˇ¸.]
{;:....-!i?¿'""'"",,} / | \—— (*†‡§¶^~¦¦_'"·)
‹@©®™℮› «€$¢¥£ƒ¤#°•» +±×÷=<>
0123456789% µ0123456789

TYPEFACE NAME
Noam

TYPEFACE DESIGNER
Adi Stern
Tel Aviv, Israel

LANGUAGE
Hebrew and Latin

MEMBERS OF TYPEFACE FAMILY/SYSTEM
Roman and Italic

Celebrate 25

25 books that take up about 18 inches of space on a bookshelf. Sounds fairly mundane when you say it like that, but look a little closer: Twenty-five years of capturing and preserving an international cross-section of the best in typographic design. Twenty-five years of unpacking precious submissions, esteemed judges agonizing over the meaning of excellence, tireless helpers setting up and taking down rooms full of entries, counting the precious chips stingingly tossed into paper cups that signify the demarcation between elation and disappointment for designers who have placed the aspirations of their hearts and souls on the line. Twenty-five years of assembling an exhibition that shares the finest efforts of the finest designers with more of their peers and admirers than you can count. And, yes, we are still using some of the original paper cups and chips, lovingly preserved from when we began this book twenty-five years ago.

In recognition of this milestone, we asked twenty-five designers who have participated significantly over the past quarter century to share with us and you their interpretation of a number from one to twenty-five. With no other requirement than that they fit on an 8 ½″ x 11″ page, we wished to give them the freedom to express a personal vision, unencumbered by the constraints of clients, committees, or focus groups. The results here are a tribute to the hard work and talents of many represented by a few whose accomplishments have set the tone for this competition and guided all of us in our efforts.

Daniel Pelavin
Chairman, Board of Directors
Type Directors Club

the Lonely
PORTRAIT GALLERY

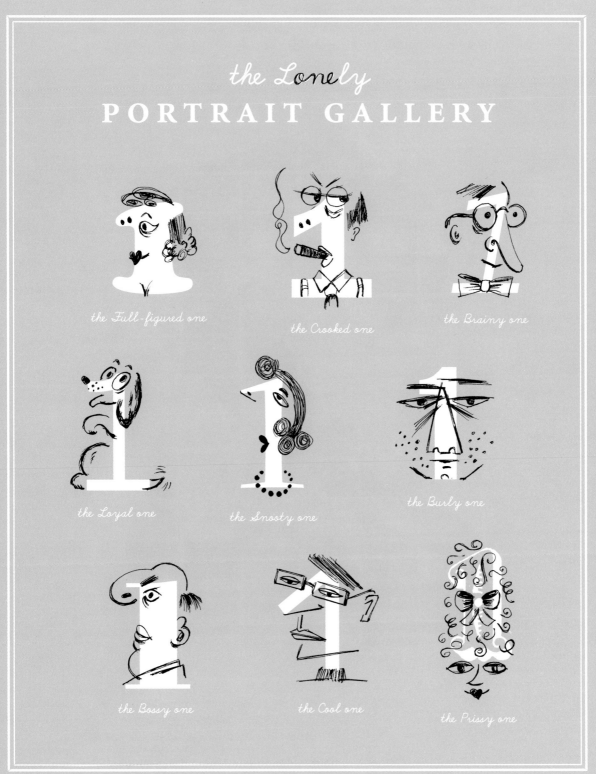

the Full-figured one

the Crooked one

the Brainy one

the Loyal one

the Snooty one

the Burly one

the Bossy one

the Cool one

the Prissy one

PLATE 111

SHARON WERNER

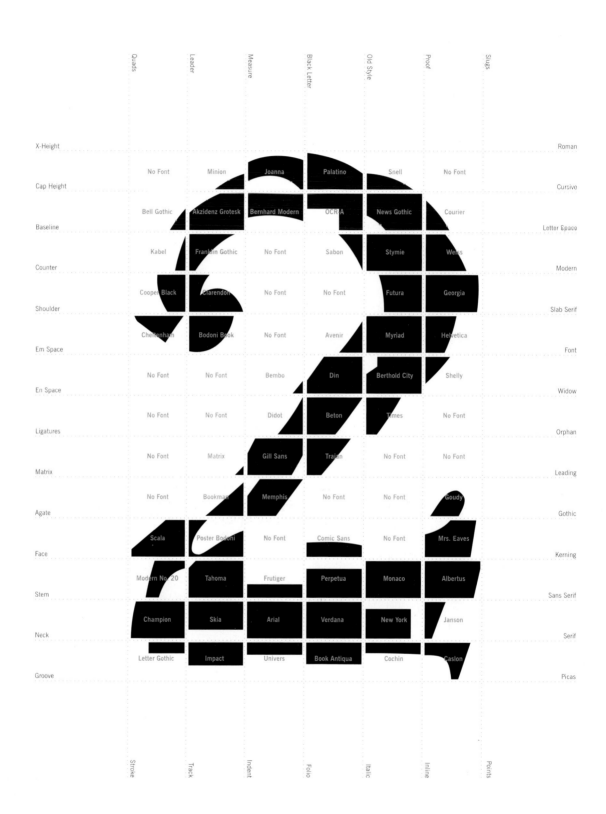

KIT HINRICHS

DAVID BERLOW

Matthew Carter

GAIL ANDERSON

GUNTER GERHARD LANGE

Lucky
SEVEN

CHARLES S. ANDERSON

LOUISE FILI

Nein is German for no; pronounced *nine*. The typeface is FF Unit Ultra, my fattest yet.

ERIK SPIEKERMANN

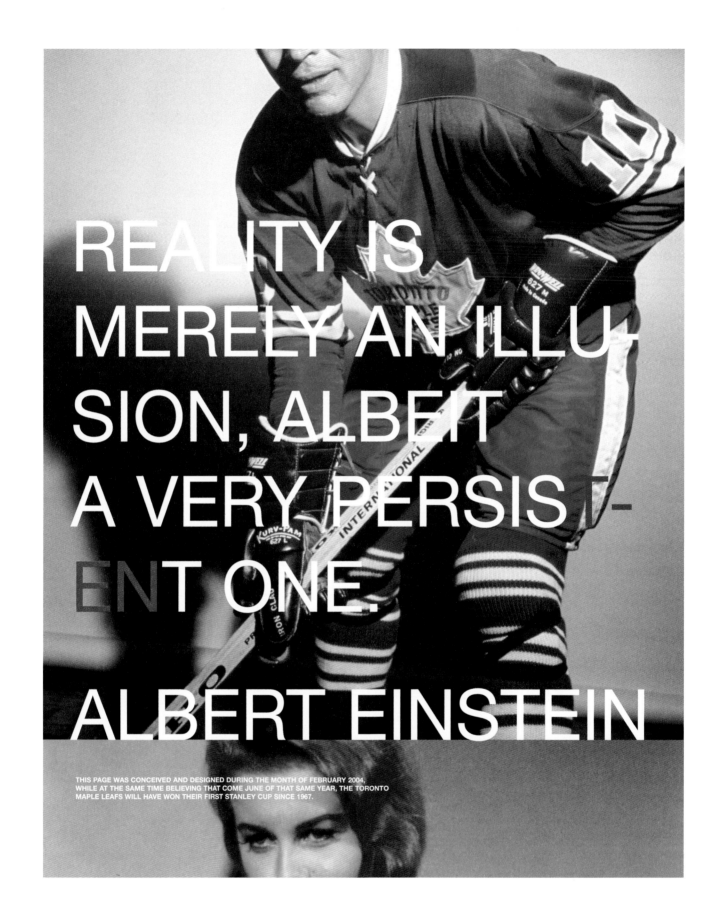

REALITY IS MERELY AN ILLUSION, ALBEIT A VERY PERSISTENT ONE.

ALBERT EINSTEIN

THIS PAGE WAS CONCEIVED AND DESIGNED DURING THE MONTH OF FEBRUARY 2004, WHILE AT THE SAME TIME BELIEVING THAT COME JUNE OF THAT SAME YEAR, THE TORONTO MAPLE LEAFS WILL HAVE WON THEIR FIRST STANLEY CUP SINCE 1967.

BILL DOUGLAS

elleven

FRED WOODWARD

PETER

ANDREW

JAMES

JOHN

PHILIP

BARTHOLOMEW

THOMAS

MATTHEW

JAMES

THADDAEUS

SIMON

JUDAS

BILL CAHAN

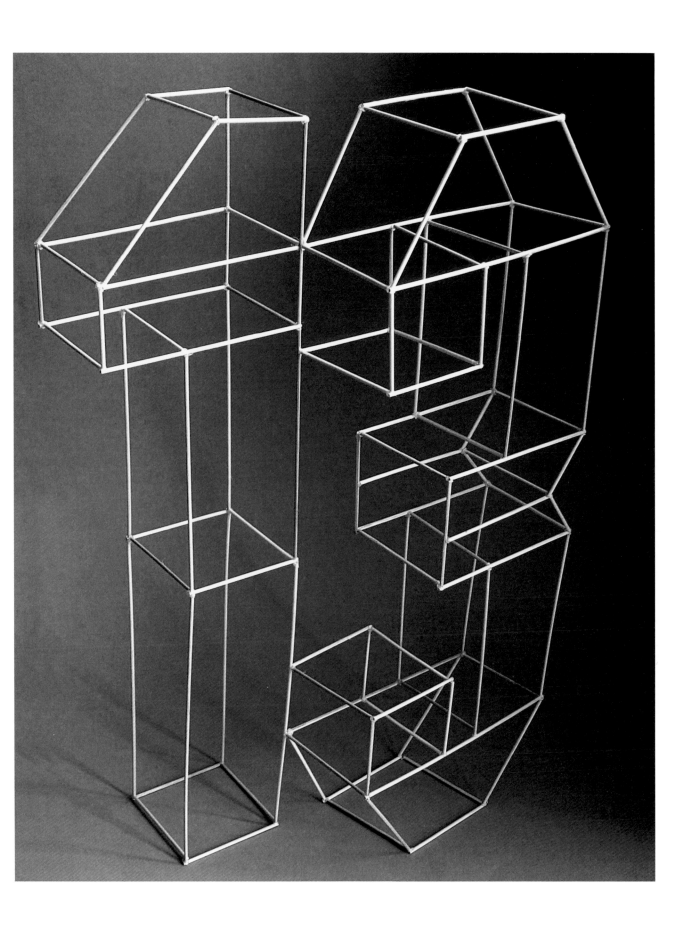

STEPHEN DOYLE

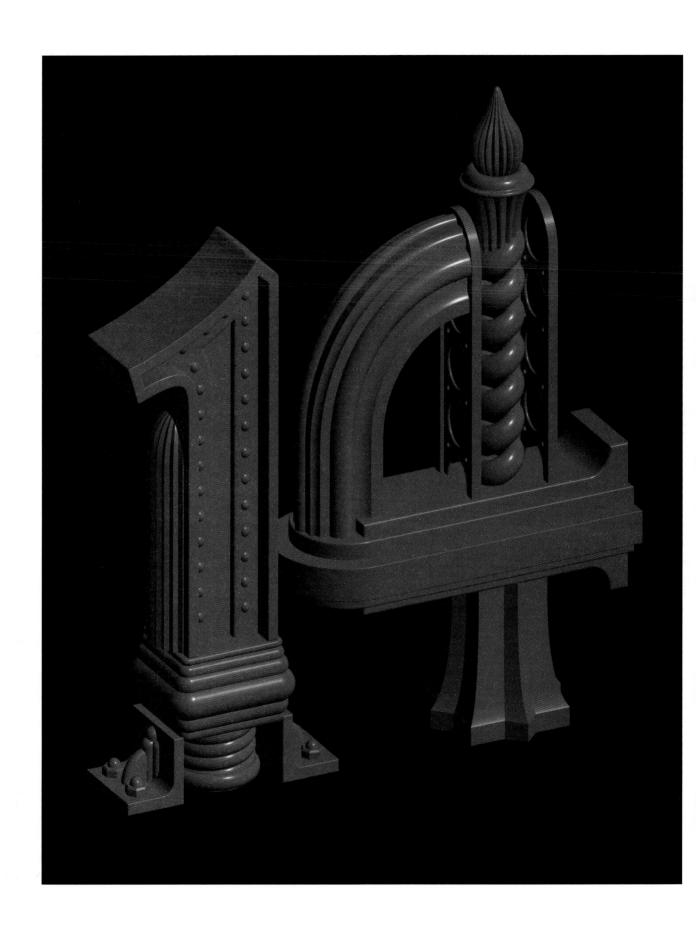

DANIEL PELAVIN

KLAUS HESSE

JOE DUFFY

XVII I II III IV V VI VII VIII IX X XI XII XIII XIV XV XVI

JACK ANDERSON

Rodrigo Sánchez

PAULA SCHER

Niklaus Troxler

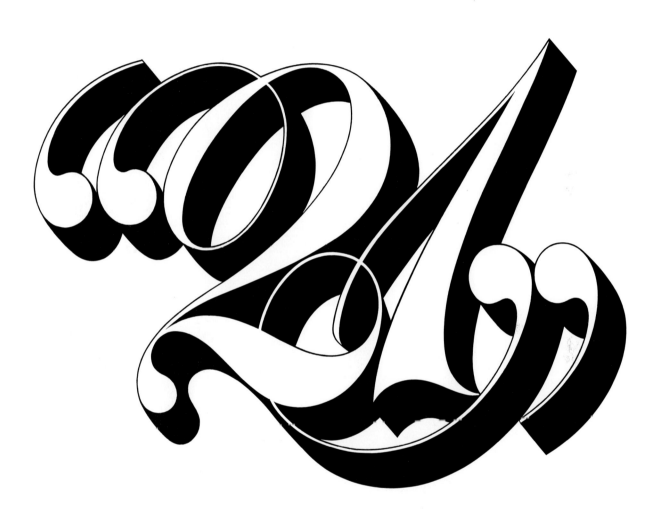

ED BENGUIAT

RICK CUSICK

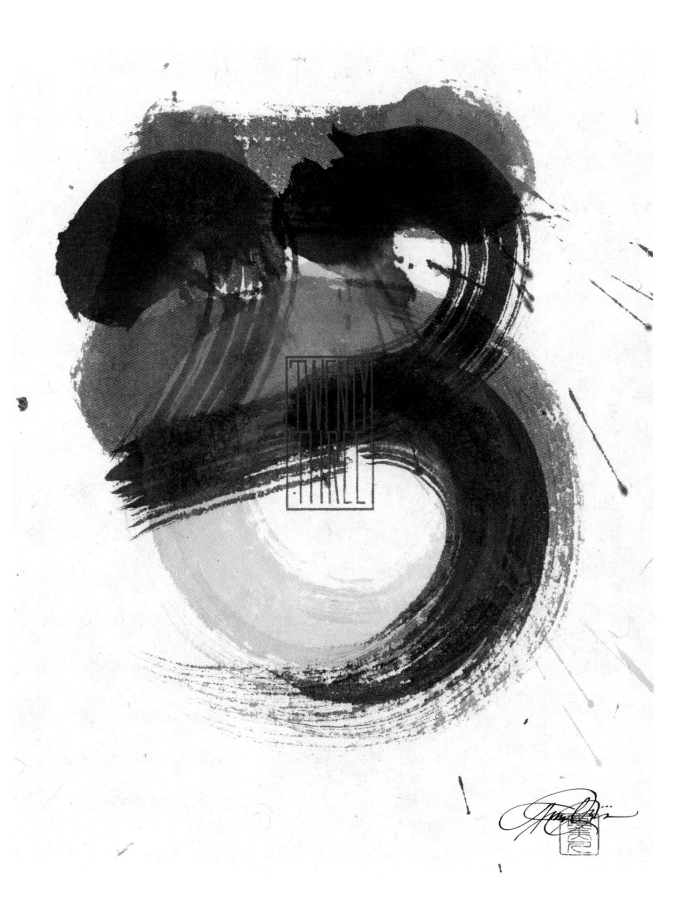

TIM GIRVIN

RICH ROAT

Cheap Type Trick
Take a **2** and a **5**
Turn them upside down and backwards...
Voila!

MILTON GLASER

1 Sharon Werner

Werner Design Werks, Inc. specializes in combining strong visual language with sound design solutions to create work that not only impacts commerce but also culture. This creative and business strategy has attracted and gained praise from not just one client but many, including Chronicle Books, Mrs. Meyer's–Clean Day, Mohawk Paper, and Target Corporation, to name a few. Werner Design Werks has been recognized with national and international awards and honors.

2 Kit Hinrichs

Kit Hinrichs is a partner in the San Francisco office of Pentagram, an international design consultancy. He is a graduate of the Art Center College of Design in San Francisco, and his work has been acclaimed for more than 35 years by design and cultural institutions. Kit has served on the AIGA Board of Directors and is a member of the Alliance Graphique Internationale.

3 David Berlow

David Berlow entered the type industry in 1978 as a letter designer for the respected Mergenthaler, Linotype, Stempel, and Haas type foundries. He joined the newly formed digital type supplier, Bitstream, Inc., in 1982. After Berlow left Bitstream in 1989, he founded The Font Bureau, Inc. with Roger Black, where he remains to this day.

4 Matthew Carter

Matthew Carter is a type designer and principal of Carter & Cone Type in Cambridge, Mass. He was awarded the Type Directors Club Medal in 1997. A book about his work, *Typographically Speaking*, based on a retrospective exhibition, is published by Princeton Architectural Press.

5 Gail Anderson

Gail Anderson is a senior art director at SpotCo, a New York City firm that handles a variety of projects primarily in theater and entertainment. For most of her adult life, Gail served as senior art director at *Rolling Stone* magazine. Her work has received awards from some nice places, including the Type Directors Club, and is in the permanent collections of the Cooper-Hewitt Design Museum and the Library of Congress.

6 Günter Gerhard

Günter Gerhard Lange was born in 1921 in Frankfurt/Oder, Germany. He served as art director for Berthold Types from 1972 on, where he has been responsible for the company's entire type program. His own types are licensed exclusively by Berthold. Gunter has won numerous awards, including the F.W. Goudy Prize in 1989, the TDC Medal in 2000, and the Design Prize Munich in 2003. An internationally recognized type designer and typographer, he has lectured in Berlin, Munich, and Vienna.

7 Charles S. Anderson

Established in 1989, the Charles S. Anderson Design Company has produced award-winning packaging, identity, and product design for a diverse list of clients. Characterized by its visual impact and humor, Charles S. Anderson Design Company's work has been influential in the industry both nationally and internationally and has been exhibited in museums worldwide.

8 Louise Fili

Fili is principal of Louise Fili Ltd, a New York-based studio that designs specialty food packaging and restaurant identities. Her work is in the permanent collections of the Library of Congress, the Cooper Hewitt Museum, and the Bibliotheque Nationale. She believes that type always looks better in Italian.

9 Erik Spiekermann

Erik Spiekermann is an information architect, type designer, and author. In 1979 he founded MetaDesign, Germany's largest design firm, which has offices in Berlin, London, and San Francisco. In 1988 he started FontShop. In July 2000, Erik left MetaDesign and now lives and works in Berlin, London, and San Francisco.

10 Bill Douglas

Bill Douglas is the founder of The Bang, a Toronto-based studio specializing in book and publication design. He is also the art director of the visual culture magazine *Coupe*. His house-league hockey career was cut short at the age of 14 when some hot dog broke his arm in four places, inadvertently propelling him into the world of art and design. Since then his work has been recognized by such institutions and design publications as *Communication Arts, Creative Review, Graphis, HOW,* the National Magazine Awards, and the Type Directors Club. Go Leafs.

11 Fred Woodward

Fred Woodward has served as *GQ's* design director since the March 2002 issue. *GQ* was named Magazine of the Year by the Society of Publication Designers in 2003. During his tenure at *Rolling Stone*, starting in 1987, it won National Magazine Awards for Design, Photography and General Excellence. He was chairman of American Illustration for the past decade and is currently president of SPD. In 1996 he was inducted into the Art Directors Hall of Fame.

12 Cahan & Associates

Cahan & Associates possesses a unique ability for honing in on a singular, emotional truth that makes people care, while consistently peeling away the marketing and exposing the truth within. The agency has won more than 2,000 awards, has been featured on CNN/CNBC, and in museum collections worldwide for packaging, identity, advertising, annual reports, and web design. Page design: Kevin Roberson.

13 Stephen Doyle

Stephen Doyle is creative director at Doyle Partners, a New York design studio with a reputation for creating programs implemented with discipline and imagination. Stephen often hybridizes design and artwork, fusing signs and symbols, merging public and private. He brings his background in editorial design to play in some unlikely places—from public spaces to exhibitions, communications to packaging. *I.D.* Magazine reports that he "rejects fashionable styles in favor of solid, functional approaches rooted in concept, not adornment…all without losing his sense of humor."

14 Daniel Pelavin

Daniel Pelavin is a board member and past president of the Type Directors Club owing to the fortunate positioning of his name on the ballot. It would be easier to mention the few he has not worked for over the past 25 years than to list a roster of his clients. His work, which encompasses illustration, typographic, and icon design, has been featured in numerous books and magazines. He has been an instructor of illustration, design, and lettering, has authored articles pertaining to design practice and education, and has lectured for design organizations throughout the United States and New Jersey. As chairperson of competitions for the TDC and the Society of Old Illustrators, his most satisfying contribution was to make certain that work by the judges was excluded from the entries.

15 Klaus Hesse

Klaus Hesse, born in 1954 in Elberfeld, Germany, studied photography and typography in Wuppertal. Afterwards he worked as art director in Hamburg, Munich, and Duesseldorf for advertising agencies such as Oglivy & Mather and GGK. Together with Christine Hesse he founded Hesse Design in 1988. Since 1999 he has held a chair for conceptual design at the Academy of Art and Design in Offenbach/Main.

16 Joe Duffy

Joe Duffy, chairman of Duffy Worldwide, has developed brand and corporate identities for such leading companies as BMW, Coca-Cola, McDonald's, and Starbucks. His understanding of how design affects consumer attitudes has lead to significant integrated programs for The Islands of the Bahamas, EDS, International Trucks, Minute Maid, Nuveen, and Nikon.

17 Jack Anderson

For the span of Hornall Anderson's 22 years, Jack has shaped the company's approach and guided various design teams in the areas of corporate and brand identity, collateral materials, packaging, environmental graphics, and digital media. His roster of clients is diverse and includes such highly recognizable companies as the Seattle Sonics, Space Needle, K2 Skis, Microsoft, Weyerhaeuser, and Jack in the Box.

18 Rodrigo Sánchez

Rodrigo Sánchez, born in Madrid in 1965, is the supplement art director of *El Mundo* newspaper in Madrid—an appointment equivalent to assistant director. Since joining *El Mundo* in 1992, he has designed the newspaper's Sunday and weekly magazines and youth, fashion, and style supplements. Before that he worked with the *ABC, Cinco Días*, and *El Sol* newspapers and for the weekly magazines *Mercado* and *Cambio 16*, all based in Madrid. Ranked among the highest newspaper design award winners in the world, Rodrigo holds a journalism degree from the Universidad Complutense of Madrid and is a self-taught graphic designer.

19 Paula Scher

Paula Scher has been a principal of the distinguished international design consultancy Pentagram since 1991. She has developed identity and branding systems, environmental graphics, packaging, and publication design for numerous clients, including Bloomberg L.P., Citibank, Jazz at Lincoln Center, *Metropolis, The New York Times Magazine*, Perry Ellis, The Public Theater, and New 42nd Street. She is a member of the Alliance Graphique Internationale (AGI) and the Art Directors Club Hall of Fame, and in 2001 she received the American Institute of Graphic Arts (AIGA) Medal, the profession's highest honor. In 2002 she published a career monograph, *Make It Bigger*.

20 Niklaus Troxler

Niklaus Troxler was born in 1947 in Willisau, Switzerland, where he opened his own graphic design studio after studying typography and graphic design at the Art School of Lucerne and a one-year job as an art director in Paris. He organizes jazz concerts (since 1966) and an annual jazz festival (since 1975) in his home town. He has won many important international design awards. Since 1998 he has been a professor at the State Academy of Fine Arts in Stuttgart, Germany. He is a member of AGI (Alliance Graphique Internationale) and its international secretary.

21 Ed Benguiat

Ed Benguiat is one of the most well-known, prolific type designers and lettering artists of our time. He has designed over 600 type fonts, including: Korinna, ITC Souvenir, Tiffany, Benguiat, Bookman, Modern Roman, Edwardian Script, and Caslon No. 225. His typefaces and logotypes include work for *The New York Times,* and *Esquire, McCall's, Photography* magazines and major corporations such as AT&T, A&E, and Estée Lauder. Ed was inducted into the Art Directors Club Hall of Fame in 2000 and he received the TDC Medal in 1989. Ed is a TDC past president (1990-1991). Other awards include: F. W. Goudy Gold Medal and the Distinguished Artist-Teacher Award, School of Visual Arts. He continues to teach at the School of Visual Arts in New York City.

22 Rick Cusick

Rick Cusick is a publications designer and lettering artist in Kansas City and is manager of font development at Hallmark. He taught design at the University of Kansas, art directed *Letter Arts Review* and designed the font, Nyx, for Adobe. His work has appeared in numerous international publications and exhibitions.

23 Tim Girvin

Girvin Design creates strategic design, building brands for nearly 30 years, with offices in Seattle and New York City and alliances in Paris and Tokyo.

24 House Industries

House Industries is a Delaware-based independent type foundry and design studio that markets original and unique fonts to the design community worldwide. House Industries can be reached at 800.888.4390, 302.234.2356, or www.houseindustries.com.

25 Milton Glaser

Milton Glaser has been a seminal figure in graphic design for over fifty years, originally as a founder of Pushpin Studio and in recent years as the head of the multidisciplinary design firm, Milton Glaser, Inc. Glaser draws on our entire visual history to work on the broadest possible cultural canvas, including, but not limited to, posters, logos, illustrations, magazine and newspaper designs, interior and exterior design, books, web sites, and design education. His new book on design, *Art Is Work*, was published in 2000.

TDC Officers

334

Type Directors Club Presidents

Frank Powers, 1946, 1947
Milton Zudeck, 1948
Alfred Dickman, 1949
Joseph Weiler, 1950
James Secrest, 1951, 1952, 1953
Gustave Saelens, 1954, 1955
Arthur Lee, 1956, 1957
Martin Connell, 1958
James Secrest, 1959, 1960
Frank Powers, 1961, 1962
Milton Zudeck, 1963, 1964
Gene Ettenberg, 1965, 1966
Edward Gottschall, 1967, 1968
Saadyah Maximon, 1969
Louis Lepis, 1970, 1971
Gerard O'Neill, 1972, 1973
Zoltan Kiss, 1974, 1975
Roy Zucca, 1976, 1977
William Streever, 1978, 1979
Bonnie Hazelton, 1980, 1981
Jack George Tauss, 1982, 1983
Klaus F. Schmidt, 1984, 1985
John Luke, 1986, 1987
Jack Odette, 1988, 1989
Ed Benguiat, 1990, 1991
Allan Haley, 1992, 1993
B. Martin Pedersen, 1994, 1995
Mara Kurtz, 1996, 1997
Mark Solsburg, 1998, 1999
Daniel Pelavin 2000, 2001
James Montalbano, 2002, 2003
Gary Munch, 2004

Type Directors Club Medal Recipients

Hermann Zapf, 1967
R. Hunter Middleton, 1968
Frank Powers, 1971
Dr. Robert Leslie, 1972
Edward Rondthaler, 1975
Arnold Bank, 1979
Georg Trump, 1982
Paul Standard, 1983
Herb Lubalin, 1984 (posthumously)
Paul Rand, 1984
Aaron Burns, 1985
Bradbury Thompson, 1986
Adrian Frutiger, 1987
Freeman Craw, 1988
Ed Benguiat, 1989
Gene Federico, 1991
Lou Dorfsman, 1995
Matthew Carter, 1997
Rolling Stone magazine, 1997
Colin Brignall, 2000
Günter Gerhard Lange, 2000
Martin Solomon, 2003

Special Citations to Type Directors Club Members

Edward Gottschall, 1955
Freeman Craw, 1968
James Secrest, 1974
Olaf Leu, 1984, 1990
William Streever, 1984
Klaus F. Schmidt, 1985
John Luke, 1987
Jack Odette, 1989

International Liaison Chairpersons

England
David Farey
HouseStyle
27 Chestnut Drive
Bexleyheath
Kent DA7 4EW
UK

France
Christopher Dubber
Signum Art
94, Avenue Victor Hugo
94100 Saint Maur Des Fosses

Germany
Bertram Schmidt-Friderichs
Verlag Hermann Schmidt
Mainz GmbH & Co.
Robert Koch Strasse 8
Postfach 42 07 28
55129 Mainz Hechtsheim

Japan
Zempaku Suzuki
Japan Typography Association
Sanukin Bldg. 5 Fl.
1-7-10 Nihonbashi-honcho
Chuo-ku, Toyko 104-0041

Mexico
Prof. Félix Beltran
Apartado de Correos
M 10733 Mexico 06000

South America
Diego Vainesman
181 East 93 Street
New York, NY 10128

Switzerland
Erich Alb
P. O. Box 5334
CH 6330 Cham

Vietnam
Richard Moore
21 Bond Street
New York, NY 10012

TDC Membership

Dona Abuaf '01 s
Marcelle Accardi '98 s
Christian Acker '02 s
Virginia Adamo '03 s
Erich Alb '96
Renee Alleyn '03 s
Natascha Ampunant '02 s
Jack Anderson '96
James Anderson '03 s
Christopher Andreola '03
Zorraine Angus '03 s
Debi Ani '01
Martyn Anstice '92
Katsunori Aoki '03
J.R. Arebalo, Jr. '03
Don Ariev '98
George Arriola '03
Robyn Attaway '93
Jaques Bagios '95
George Baier IV '04 s
Peter Bain '86
Marco Balecke '00
Bruce Balkin '92
Stephen Banham '95
Dirk Barnett '02
Neil Barnett '01
Cassandra Barry '03 s
Frank Baseman '03
Mark Batty '03
Barbara Baumann '96
Gerd Baumann '95
Clarence Baylis '74
Phillip Belnar '04 s
Felix Beltran '88
Ed Benguiat '64
Mark Berinato '03 s
Anna Berkenbusch '89
Ronald Bernard '02
John D. Berry '96
Peter Bertolami '69
Davide Bevilacqua '99
Tad Biernot '00
Klaus Bietz '93
Henrik Birkvig '96
R. P. Bissland '04
Roger Black '80
Marc Blaustein '01
Claas Blüher '01 s
Alan Boarts '96
Karlheinz Boelling '86
John Boland '03
Matteo Bologna '03
Gianni Bortolotti '98
Thad Boss '01
Monica Botto '03 s
Michelle Bowers '03
Jamie Boyle '99 s
Bud Braman '90
Henry Brimmer '03
Nathaniel Brockmann '04
Ed Brodsky '80
Craig Brown '04
David Bruck '03
Bill Bundzak '64
Marie Burke '04 s
Shana Burnett '03 s
Andrew Byrom '02
Bill Cahan '02
Mike Campbell '04
Ronn Campisi '88

Scott Carslake '01
Matthew Carter '88
Sergio Castro '01
Ken Cato '88
Paul Caullettt '98 s
Henrique Cayatte '01
Eduard Cehovin '03
Virginia Chan '00 s
Len Cheeseman '93
Eric Ping-Liang Chen '04
Jeff Chen '02 s
Joshua Chen '03
So-Hee Cheong '03
David Cheung, Jr. '98
Ian Chilvers '04
Kai-Yan Choi '90
Tswei Chuang-Wai '02
Seungmin Chung '03 s
Stanley Church '97
Nicholas Cintron '03 s
Travis Cliett '53
Graham Clifford '98
Tom Cocozza '76
Stuart Cohen '96
Angelo Colella '90
Ed Colker '83
Nick Cooke '01
Rodrigo Corral '02
Madeleine Corson '96
Fabio Costa '03
Susan Cotler-Block '89
Freeman Craw* '47
Carie Creegan '04 s
Juan Jose Gimeno Crespo '01
Martin Crockatt '02
Laura Crookston '00
Valerie Croome '03
Bart Crosby '95
Ray Cruz '99
Brian Cunningham '96
Rick Cusick '89
Michael Damare '98
Timea Dancs '01 s
Susan Darbyshire '87
Einat Lisa Day '97 s
Filip De Baudringhien '03
May De Castro '03
Jesus de Francisco '01
Josanne De Natale '86
Jean DeBenedictis '03
Matej Decko '93
Richard Dendy '00
Mark Denton '01
Claude A. Dieterich '84
Kirsten Dietz '00
Joseph DiGioia '96
Kathleen DiGrado '04
Chris Do '03
Lou Dorfsman '54
Pascale Dovic '97
Stephen Doyle '98
Christopher Dubber '85
Joseph P. Duffy III '03
Kim Duksoo '04 s
Albert Dungca '03 s
Simon Dwelly '98
Lutz Dziarnowski '92
Lasko Dzurovski '00
Jeremy Earl '03
Kathryn Eaton '03

Brian Edlefson '01
Friedrich Eisenmenger '93
David Ekizian '03
Dr. Elsi Vassdal Ellis '93
Garry Emery '93
Stefan Engelhardt '01
HC Ericson '01
Joseph Michael Essex '78
Florence Everett '89
Mary Jane Fahey '04
Peter Fahrni '93
John R. Falker '00
David Farey '93
Debbie Ferrari '04
Mark Fertig '04
Vicente Gil Filho '02
Louise Fili '04
Mary Filiatraut '03 s
Amy Finkel '03 s
Simon Fitton '94
Kristine Fitzgerald '90
Gonçalo Fonseca '93
John Fontana '04
Martin Ford '02 s
Carin Fortin '02
Dirk Fowler '03
Thomas Fowler '93
Brianna Fox '04 s
Jerold Fox '04
Alessandro Franchini '96
Carol Freed '87
Adrian Frutiger ** '67
Jason Fryer '04 s
Mario Fuhr '97
Louis Gagnon '02
Ohsugi Gaku '01
Catalina Garcia '03 s
Christof Gassner '90
Martina Gates '96 s
David Gatti '81
Cherilyn Gearhart '03 s
Lou Glassheim * '47
Howard Glener '77
Mario Godbout '02
David Goen '03 s
Eujin Goh '02
Giuliano Cesar Gonçalves '01
Victor Michael Gonzalez '03 s
Tara Gordon '03 s
Edward Gottschall '52
Rüdiger Götz '02
Norman Graber '69
Diana Graham '85
Austin Grandjean '59
Marion Grant '04 s
Katheryne Gray '04
Ewan Green '02
Stephen Green '97
Anges Laygo Gregorio '01
Simon Grendene '02 s
James Grieshaber '96
Amelia Grohman '02 s
Frank E.E. Grubich '96
Rosanne Guararra '92
Ivan Guarini '01
Christiane Gude '97
Olga Gutierrez de la Roza '95
Einar Gylfason '95
Peter Gyllan '97
Tomi Haaparanta '01

Brock Haldeman '02
Allan Haley '78
Debra Hall '96
Stéphane Halmai-Voisard '03 s
Angelica Hamann '03
Alison Hamilton '03 s
Benjamin Hancock '03 s
Dawn Hancock '03
Victoria Hanes '02 s
Graham Hanson '04
Egil Haraldsen '03
G. M. Harrington '03
Keith Harris '98
Knut Hartmann '85
Lukas Hartmann '03
Bonnie Hazelton '75
Amy Hecht '01
Eric Heiman '02
Arne Heine '00
Frank Heine '96
Hayes Henderson '03
Anthony Henriques '03
Mark Herd '03
Sally Hermanto '03 s
Ralf Herms '03
Earl M. Herrick '96
Ralf Hermannn '02 s
Andrea Herstowski '03
Klaus Hesse '95
Fons M. Hickmann '96
Jay Higgins '88
Cheryl Hills '02 s
Helmut Himmler '96
Norihiko Hirata '96
Charles Ho '03
Michael Hodgson '89
Barbara Hoffar '01 s
Ashley Hofman '04
Fritz Hofrichter '80
David Hollingsworth '03 a
Patrick Hornung '02 s
Kevin Horvath '87
Fabian Hotz '03
Diana Hrisinko '01
Michael Hrupeck '02
Anton Huber '01
Eva Hueckmann '01 s
Marilyn Hurey '03 s
Live Huse '03 s
Yann Hwang '03 s
Anthony Inciong '02
Yanek Iontef '00
Elizabeth Irwin '00
Donald Jackson ** '78
Christina Jackson '03
Ed Jacobus '03
Angela Jaeger '02
Michael Jager '94
Torsten Jahnke '02
Mark Jamra '99
Christopher Jankoski '04 s
Jenny Ji '04 s
Maria Johansson '03
Danielle Johnston '02 s
Frank Jonen '03
Matt Jones '03
Marie Kacmarek '03
David Kadavy '02 s
Otso Kallinen '00 s
John Kallio '96

Tai-Keung Kan '97
Won Suk Kang '02 s
I-Ching Kao '02 s
Richard Kegler '02
Kristin Keller '03 s
Brunnette Kenan '99
Deny Khoung '04 s
Habib Nabeh Khoury '03
Satohiro Kikutake '02
Hyun Jo Kim '03 s
Jang Hoon Kim '97 s
Soohun Kim '03 s
Rick King '93
Katsuhiro Kinoshita '02
Rhinnan Kith '01 s
Akira Kobayashi '99
Nana Kobayashi '94
Claus Koch '96
Boris Kochan '02
Masayoshi Kodaira '02
Jesse Taylor Koechling '98 s
Eileen Koehler '03 s
Jon Koenig '03 s
Steve Kopec '74
Anders Kornestedt '02
Marcus Kraus '97
Matthias Kraus '02
Daniel Krause '03 s
Stephanie Kreber '01
Bernhard J. Kress '63
Nicholas Kroeker '03
Katie Kroneman '02
Toshiyuki Kudo '00
Larry Kulp '02 s
Felix Kunkler '01
Christian Kunnert '97
Dominik Kyeck '02
Gerry L'Orange '91
Raymond F. Laccetti '87
Regina Lamberti '01 s
Melchior Lamy '01
John Langdon '93
Guenter Gerhard Lange '83
Jean Larcher '01
Yvon Laroche '04
Jessica Lasher '03
Marcia Lausen '01
James Lebbad '01
Christine Lee '02 s
Jua Lee '03 s
Yongsin Lee '03 s
Jennifer Lee-Temple '03
David Lemon '95
Olaf Leu '65
Jan Lindquist '01
Christine Linnehan-Sununu '04
Domenic Lippa '04
Wally Littman '60
Uwe Loesch '96
Oliver Lohrengel '04
Johana Londono '03 s
John Howland Lord ** '47
Alexander Luckow '94
Frank Luedicke '99
Gregg Lukasiewicz '90
Elizabeth MacFarlane '03 s
Michael MacNeill '02
Danusch Mahmoudi '01
Boris Mahovac '04
Bryan Mamaril '04

Donna Meadows Manier '00
John Mann '04
Marilyn Marcus '79
Jewels Marhold '03 s
Peter Markatos '03 s
Nicholas Markwald '02 s
Gabriel Meave Martinez '01
Christopher Masonga '03 s
Ted Mauseth '01
Andreas Maxbauer '95
Teevett McCandliss '04
Janie McDaniel '03 s
Rod McDonald '95
Cindy McEwan '03
Mark McGarry '02
John McGrew '01
Kelly McMurray '03
Marc A. Meadows '96
Matevz Medja '02
Roland Mehler '92
Uwe Melichar '00
Bob Mellett '03 s
Justin Meredith '03 s
Francesa Messina '01
Jill Mettendorf '03 s
Frédéric Metz '85
JD Michaels '03
Tony Mikolajczyk '97
Joe Miller '02
Ron Miller '02
John Milligan '78
Michael Miranda '84
Ralf Mischnick '98
Can Misirlioglu '03 s
Susan L. Mitchell '96
Bernd Moellenstaedt '01
Martin Moersdorf '03 s
Sakol Mongkolkasetarin '95
James Montalbano '93
Chemi Montes-Armenteros '03
Maureen Mooney '03 s
Richard Earl Moore '82
Minoru Morita '75
Michael Morris '04
Clark Most III '04
Lars Müller '97
Joachim Müller-Lancé '95
Gary Munch '97
Christopher Muniz '03
Matthew Munoz '02 s
Jerry King Musser '88
Alexander Musson '93
Louis A. Musto '65
Steven Mykolyn '03
Steve Namsinh '03
Margo Nelson '04
Cristiana Neri-Downey '97
Helmut Ness '99
Nina Neusitzer '03 s
Robert Newman '96
David Ng '00
Vincent Ng '04
Tim Nielsen '03
Charles Nix '00
Shuichi Nogami '97
Gertrud Nolte '01 s
Alexa Nosal '87
Stefan Nowak '04
Jack Odette '77
Kayako Ogawa '02 s

Robb Ogle '04
Akio Okumara '96
Robson Oliveira '02
Toshihiro Onimaru '03
Crystal Ott '03 s
Petra Cerne Oven '02 s
Robert Overholtzer '94
Ryan Pace '04 s
Michael Pacey '01
Norman Paege '99
Frank Paganucci '85
Enrique Pardo '99
Jim Parkinson '94
Guy Pask '97
Gudrun Pawelke '96
Lauren Payne '04
Harry Pearce '04
Alicia Peck '03
Daniel Pelavin '92
Triveni Perera '02 s
Oanh Pham-Phu '96
Jennifer Phillips '04 s
Ken Phillips '99
Max Phillips '00
Robert Pienciak '03 s
Clive Piercy '96
Ian Pilbeam '99
Albert-Jan Pool '00
Neil Powell '01
Will Powers '89
Suzanne Powney '03
Vittorio Prina '88
Mary Pritchard '04
James Propp '97
Jochen Raedeker '00
Erwin Raith '67
Sal Randazzo '00
Bob Rauchman '97
Evgeny Razjivin '03 s
Margaret Re '02
Ariana Reaven '03 s
Hans Dieter Reichert '92
Kasey Reis '02 s
Heather L. Reitze '01
Fabian Richter '01
Helge Dirk Rieder '03
Robert Rindler '95
Tobias Rink '02
Phillip Ritzenberg '97
Jose Rivera '01
Chad Roberts '01 s
Phoebe Robinson '02 s
Frank Rocholl '99
Adam Roe '03 s
Karen E. Roehr '04
Salvador Romero '94
Edward Rondthaler* '47
Kurt Roscoe '93
Giovanni Carrier Russo '03
Jennifer Russo '04 s
Erkki Ruuhinen '86
Timothy J. Ryan '96
Carol-Anne Ryce-Paul '01 s
Michael Rylander '93
Greg Sadowski '01
Gus Saelens '50
Mamoun Sakkal '04
Ilja Sallacz '99
David Saltman '66
Ina Saltz '96

Rodrigo Sanchez '96
Michihito Sasaki '03
Shinobu Sato '04
Nathan Savage '01
John Sayles '95
David Saylor '96
Hartmut Schaarschmidt '01
Hans Dirk Schellnack '01
David Schimmel '03
Peter Schlief '00 s
Hermann J. Schlieper '87
Holger Schmidhuber '99
Hermann Schmidt '83
Klaus Schmidt '59
Markus Schmidt '93
Christian Marc Schmidt '02 s
Bertram Schmidt-Friderichs '89
Guido Schneider '03
Werner Schneider '87
Markus Schroeppel '03
Eileen Hedy Schultz '85
Eckehart Schumacher-Gebler '85
Alan Schutte '04
April Scott '01 s
Peter Scott '03
Leslie Segal '03
Sylvette Sein '03 s
Todd Seipert '04 s
Enrico Sempi '97
Rizka Septiadi '04
Ronald Sequeira '04 s
Thomas Serres '04
Li Shaobo '04
Jessica Shatan '95
Paul Shaw '87
Elizabeth Sheehan '03
Christy Sheppard '03
W. Douglas Sherman, Jr. '04
Tamotsu Shimada '02
Hyewon Shin '03 s
Ginger Shore '04
Philip Shore, Jr. '92
Robert Siegmund '01 s
France Simard '03
Mark Simkins '92
Christopher Simmons '02
Scott Simmons '94
Finn Skodt '00
Martha Skogen '99
Eric Smith '03
Steve Snider '04
Felix Sockwell '03
Hee Young Sohn '02
Silvestre Segarra Soler '95
Martin Solomon '55
Jan Solpera '85
Ronnie Tan Soo Chye '88
Brian Sooy '98
Erik Spiekermann '88
Denise Spirito '02
Tonya Spruill '02 s
Frank Stahlberg '00
Rolf Staudt '84
Andrew Steeves '03
Dmitrios Stefanidis '04 s
Olaf Stein '96
Notburga Stelzer '02
Charles Stewart '92
Clifford Stoltze '03
Peter Storch '03

337

TDC Membership

William Streever '50
Jim Stringer '03
Ilene Strizver '88
Alexander Strube '03 s
Katja Stuke '97
Hansjorg Stulle '87
Mine Suda '04
Tracey Sutherland '02 s
Zempaku Suzuki '92
Annah Syta '03 s
Caroline Szeto '02 s
Laurie Szujewska '95
Douglas Tait '98
Yukichi Takada '95
Yoshimaru Takahashi '96
Milack Talia '01 s
Katsumi Tamura '03
Karen Tanaka '01
Jack Tauss '75
Pat Taylor '85
Rob Taylor '04
Martin Tazl '03
Anthony J. Teano '62
Marcel Teine '03
Régine Thienhaus '96
Wayne Tidswell '96
Eric Tilley '95
Colin Tillyer '97
Siung Tjia '03
Laura Tolkow '96
Gary Tooth '03
Giorgio Tramontini '01
Jakob Trollbäck '04
Klaus Trommer '99
Niklaus Troxler '00
Liling Tsai '03 s
Minao Tsukada '00
Liz Tufte '03 s
Marc Tulke '00
François Turcotte '99
Olivia Turner '03
Michael Tutino '96
Andreas Uebele '02
Diego Vainesman '91
Patrick Vallée '99
Christine Van Bree '98
JanVan Der Ploeg '52
Janine Vangool '01
Yuri Vargas '99
Thomas Vasquez '04
Leonardo Vazquez '02
Barbara Vick '04
Anna Villano '99 s
Robert Villanueva '02 s
Adam Vohlidka '02 s
Matthew Vohlidka '02 s
Edwin Vollenbergh '04
Annette von Brandis '96
Thilo von Debschitz '95
Alex Voss '98
Frank Wagner '94
Oliver Wagner '01
Allan R. Wahler '98
Jurek Wajdowicz '80
Sergio Waksman '96
Garth Walker '92
Min Wang '02
Hitomi Watanabe '03 s
Katsunori Watanabe '01
Harald Weber '99

Kim Chun Wei '02
Kurt Weidemann '66
Claus F. Weidmueller '97
Sylvia Weimer '01
Ramon Wengren '02
Marco Wenzel '02
Sharon Werner '04
Judy Wert '96
Alex W. White '93
Christopher Wiehl '03
Heinz Wild '96
Richard Wilde '93
K. Wilder '04
James Williams '88
Grant Windridge '00
Carol Winer '94
Conny J.Winter '85
Andi Witczak '04
Delve Withrington '97
Burkhard Wittemeier '03
Pirco Wolfframm '03
Daisy Wong '01
Loni M. Wong '04 s
Peter C. Wong '96
Fred Woodward '95
René Wynands '04
Sarem Yadegari '03 s
Azadeh Yaraghi '04 s
Sophia Yoon '01 s
Victoria Zal '03 s
Yun Zan '03 s
Hermann Zapf ** '52
David Zauhar '01
Roxana Zegan '03
Stephen Zhang '01
Maxim Zhukov '96
Piotr Zmuda '03
Roy Zucca '69
Jeff Zwerner '97

Sustaining Members
Diwan Software '03
Little Brown & Company '02
Pentagram Design, Inc.,
 San Francisco '02
Pentagram Design, Inc.,
 New York '02
Tiro Typeworks '04

* Charter member
** Honorary member
s Student member
a Associate member

Membership as of June 4, 2004

Typography Index

Typography Index

General Index

General Index

General Index